Guggenheim Museum Collection

Entries by

Bridget Alsdorf
Jan Avgikos
Jennifer Blessing
Matthew Drutt
Cornelia Lauf
J. Fiona Ragheb
Nancy Spector
Joan Young

Concepts by

Dore Ashton Julie Ault Germano Celant Lisa Dennison Judi Freeman Gary Garrels Michael Govan Linda Dalrymple Henderson Jon Ippolito Liz Kotz Rosalind Krauss Rose-Carol Washton Long John Miller **Bruce Brooks Pfeiffer** Joseph Thompson Coosje van Bruggen Diane Waldman

Guggenheim Museum Collection Ato Z

Nancy Spector, Editor

,N4 S642 2001 #46500004

N6487

This book is published on the occasion of the exhibition

The Global Guggenheim: Selections from the Extended Collection

Solomon R. Guggenheim Museum

February 9-April 22, 2001

This exhibition is sponsored by

Guggenheim Museum Collection: A to Z, Second, Revised Edition © 2001 The Solomon R. Guggenheim Foundation, New York. All rights reserved. First edition 1992.

Most of the works of art reproduced in this book are protected by copyright. For a partial listing of copyright notices, see "Photographic Credits and Copyright Notices" at the end of this book.

ISBN 0-89207-241-5 (softcover) ISBN 0-8109-6930-0 (hardcover)

Guggenheim Museum Publications 1071 Fifth Avenue New York, New York 10128 www.guggenheim.org

Hardcover edition distributed by Harry N. Abrams 100 Fifth Avenue New York, New York 10011 www.abramsbooks.com

Design: Emily Waters and Lauraleigh Bush Production: Elizabeth Levy, Cynthia Williamson, and Melissa Secondino Editorial: Meghan Dailey Cover design: Paul Carlos Cover photo: David Heald Printed in Germany by Cantz

Contents

6 Preface Thomas Krens

10
Introduction and Acknowledgments
Nancy Spector

16Solomon R. Guggenheim Museum
Building Diagram

17
A to Z:
Guggenheim Museum Collection
and Concepts in 20th-Century Art

350 Suggested Readings

376 Glossary of Terms

Preface

Nine years have passed and the century has changed since the first edition of this quidebook to the Solomon R. Guggenheim Museum's permanent collection was published. Now, on the threshold of the 21st century, the museum is, in many ways, a different institution than the one that reopened in 1992 after the two-year restoration and expansion of its landmark Frank Lloyd Wright building. Since that time the museum has redefined itself as a truly international institution, expanding not just architecturally but geographically through alliances with public and private trusts around the world. The model for this global museum network has been in place since 1976, when the Peggy Guggenheim Collection in Venice and the palazzo that houses it were begueathed to the Solomon R. Guggenheim Foundation in New York. With the subsequent establishment of the Guggenheim Museum SoHo (1992), the Guggenheim Museum Bilbao (1997). Deutsche Guggenheim Berlin (1997), and the Guggenheim Las Vegas (2001), as well as the formation in 2000 of a partnership with the State Hermitage Museum in St. Petersburg, the institution now directly participates in, rather than merely represents, cultures around the world. Today, the Guggenheim is a museum in multiple locations with access to shared collections, common constituencies, and joint programming. Nevertheless, it is the permanent collection of the Solomon R. Guggenheim Foundation that constitutes the very core of the institution, no matter how far-reaching its activities may be. Assembled over the past 70 years, and still a "work in progress," the collection embodies the museum's own, unique history, which has consistently intersected with and, on occasion, catalyzed the history of 20th-century art.

The story of the Guggenheim Museum is essentially the story of five very different private collections—Solomon R. Guggenheim's

collection of non-objective painting premised on a belief in the spiritual dimensions of pure abstraction: Justin K. Thannhauser's renowned array of Impressionist, Post-Impressionist, and early Modern masterpieces; Karl Nierendorf's holdings in German Expressionism; Katherine S. Dreier's paintings and sculptures of the historic avant-garde; and Dr. Giuseppe Panza di Biumo's vast holdings of European and American Minimalist. Post-Minimalist, Environmental, and Conceptual art—that have been augmented through the years by the museum's directors and curators to form one richly layered collection dating from the late 19th-century to the present. The metamorphosis from private collection to public museum is an extraordinary transition. For the Guggenheim, this occurred in 1937, when Solomon R. Guggenheim established a foundation empowered to operate a museum that would publicly exhibit and preserve his inventive but narrowly focused-holdings. The subsequent additions of private collections—each as idiosyncratic and passionate as the first—has led to the evolution from a museum dedicated solely to non-objectivity in art to one in which the history of Modernism. albeit with strongly stated preferences, is documented. This dynamic process continues today, an ongoing testimony to the meaningful dialogue between private collectors and a public trust.

The forward thrust of the permanent collection and its sustained development is manifest in this second, revised version of the Guggenheim's guidebook, which includes 42 new entries and a total of 96 new works of art that represent only a fraction of the museum's recent acquisitions. The collection has grown exponentially since the initial publication of *Guggenheim Museum: A to Z*, which, in 1992, could only begin to document the enormity of the Panza holdings that had just recently been acquired. The museum's primary acquisition committee—the

International Director's Council—was established in 1995, and it is through the inspired efforts of its esteemed members that the Guggenheim's collection of contemporary art has achieved such critical mass. Similarly, the museum's Young Collector's Council, founded in 1993, and Photography Committee, founded in 1998, have supported the museum's efforts to assemble an internationally significant collection of today's most trenchant art forms. And, perhaps most importantly, the Guggenheim has been the recipient of many significant gifts of art from individual patrons whose generosity must be noted here.

The museum's collection-building initiatives are perpetually ongoing in response to emerging talent as well as a mandate to fill in critical historical gaps. Therefore, a book of this nature is destined to be out of date the moment it is published. Be that as it may, the guidebook functions as an important document of the Guggenheim's permanent collection at this particular historical juncture by revealing the evaluative judgments of the period. This revised edition is the result of the curatorial staff's continued dedication to researching, interpreting, and presenting the museum's holdings. The book's contents encompass both the classic and the new, striking a balance between the two that reflects the dynamic tenor of the collection as a whole.

Under the expert direction of Nancy Spector, Curator of Contemporary Art, this revised guidebook represents a renewed attempt to create a fresh and timely approach to the collection, sensitive to the broad fields of understanding—social and political history, philosophy, psychoanalysis, and critical theory—that have become integral to meaningful dialogues about the visual arts. The result, we trust, will be both satisfying for the specialist and inviting to the museum's diverse visitors.

This book is published on the occasion of the exhibition *The Global Guggenheim: Selections from the Extended Collection.*This landmark exhibition is sponsored by Fireman's Fund Insurance Company and Delta Air Lines.

I would like to give special thanks to Frederick W. Reid, Executive Vice President and Chief Marketing Officer at Delta Air Lines for his personal commitment to the Guggenheim and his continued support of the museum's programs around the world. I would also like to thank Katherine Smith and Rhianna Quinn Roddy at Delta for their enthusiastic support of this exhibition.

This exhibition would not have been possible without the generous support of Fireman's Fund Insurance Company. In particular the Guggenheim is indebted to David R. Pollard, Division President, Fireman's Fund Insurance Company. I would also like to make special mention of Helen Lo and Maria Felice Cunningham at Fireman's Fund who have worked extremely hard to make our partnership with them a great success.

THOMAS KRENS
DIRECTOR, THE SOLOMON R. GUGGENHEIM FOUNDATION

Introduction and Acknowledgments

The expanded scope of this revised guide to the Guggenheim Museum collection reflects a wealth of new acquisitions as well as our ongoing reassessment of the art-historical canon as it is represented and perpetuated by museological practice. The current inclusion of works recently added to the collection along with ones long present, but only just reevaluated, attests to the fact that the museum habitually examines its own history while actively building for the future. The works illustrated and discussed in the following pages were thus selected for their historical and aesthetic significance with an eye toward creating a concise overview of the Guggenheim's exceptional collection of Modern and contemporary art from today's perspective.

The alphabetical arrangement of the guide—spanning Abramović to Zorio—was adopted to avoid the hierarchical and teleological impulses of chronological order as well as the often arbitrary categorizations that occur when an artist's work is presented exclusively within a specific aesthetic movement. Furthermore, this format reflects the fact that the Guggenheim does not divide its collection—or for that matter, its curatorial staff—by medium or time period, as is the case with most cultural institutions devoted to the visual arts. The alphabetical order also serves as a gentle parody of the prevalent notion of the art museum as an encyclopedia, filled with singular examples of myriad objects removed from their cultural contexts. To extend our play on the encyclopedia, we have interspersed texts on various concepts of 20th-century Western art—"Action," "Kitsch," "Non-Objective," "Spiritual," and the like—throughout the alphabet. Particular art-historical movements referred to in the entries. such as Cubism and Surrealism, are explicated in the glossary at the end of the book. Although intended as a self-reflexive meditation on the museum itself, this alphabetical array of artists, their works, and select

theoretical concepts has produced intriguing juxtapositions and revealed unexpected affinities. Collectively, the entries and concepts form a fragmented, yet coherent, survey of 20th-century thought and vision.

In early 2001, we are also publishing the contents of this book on the Guggenheim Museum's Web site (www.guggenheim.org). The online presentation of the collection will grow over time to include many more artworks than could be reproduced in a single guidebook. It will also include additional scholarly and contextual information, allowing for a richer experience by the viewer.

Guggenheim Museum Collection: A to Z reflects the contributions of numerous individuals: My coauthors, Bridget Alsdorf, Jan Avgikos, Jennifer Blessing, Matthew Drutt, Cornelia Lauf, J. Fiona Ragheb, and Joan Young brought insightful and provocative perspectives on Modern and contemporary art, as well as a great sensitivity to the works under discussion. The guidebook is also enhanced by the concepts on art provided by leading scholars and critics, whose unique and distinctive voices demonstrate the diversity of analytical methods in today's art community. Kim Paice compiled the thorough glossary of art-historical terms found at the end of this book, which was augmented for the revised edition by Vivien Greene and Lars Kokkonen. Special thanks are owed to architect Michael Gabellini, whose creative renderings of the Guggenheim Museum were used as the basis for the architectural overlay—a delightful, imaginary tour through the building. The drawings were brought to life by illustrator Tom Powers, of the Ivy League of Artists. I would like to acknowledge Emily Waters, former Chief Graphic Designer, who provided the initial redesign for this revised guide, which was thoughtfully implemented by Lauraleigh Bush, Graphic Designer. Paul Carlos

created the new cover design, which features the Guggenheim at night, illuminated by Dan Flavin's 1992 site-specific installation.

A project of this complexity and detail would not have been feasible without the invaluable organizational and editorial skills of our Publications Department. I want to specifically acknowledge Anthony Calnek, Managing Director and Publisher, who expertly oversaw the first edition of this guide and has enthusiastically supported our efforts to expand and update it in recent years. Meghan Dailey, Associate Editor, brought her art-historical expertise and keen editorial skills to the realization of this publication; she oversaw every editorial detail of this project with meticulous attention, and for this I am most grateful. Elizabeth Levy, Managing Editor/Manager of Foreign Editions handled all aspects of the book's production with great professionalism and care. Esther Yun. former Assistant Production Manager; Cindy Williamson, Assistant Production Manager; Melissa Secondino, Production Associate; Elizabeth Franzen, Manager of Editorial Services; Edward Weisberger, Editor; Rachel Shuman, Assistant Editor; and Carey Ann Schaefer, Editorial Assistant, all contributed to the successful realization of this publication. David Heald, Head Photographer, and Ellen Labenski, Associate Photographer, are largely responsible for the high caliber of reproductions in this book. Kim Bush, Manager of Photography and Permissions, lent critical assistance in gathering all illustrations. In addition to writing entries, Bridget Alsdorf, Collections Curatorial Assistant, and Joan Young, Assistant Curator, deftly handled myriad research questions.

I would particularly like to thank my colleague Lisa Dennison, Chief Curator and Deputy Director, for her essential support of this project. We have worked closely together on defining and implementing the museum's collection-building initiatives, specifically as they pertain to postwar and contemporary art. Without her collaboration, this revised guidebook would have little new material. And finally, my gratitude goes to Director Thomas Krens, whose invigorating vision of the Guggenheim has made it possible to continuously expand and interpret the collection in meaningful ways.

NANCY SPECTOR

CURATOR OF CONTEMPORARY ART

Sponsor's Statement

On behalf of Fireman's Fund Insurance Company and its employees, we are proud to support *The Global Guggenheim: Selections from the Extended Collection*. This partnership defines our commitment to fostering the preservation and presentation of masterworks of art history.

Through the Guggenheim's pioneering global relationships and innovative collection-sharing strategies, the museum's collection has grown on an international scale. On the occasion of this exhibition, the Guggenheim will, for the first time, bring together masterpieces from its extended holdings, presenting works from locations in New York, Venice, Bilbao, and Berlin. Seen in concert, the collections offer a unique view of 20th-century art, highlighting the history of the avant-garde from Impressionism and early Modernism through Abstract Expressionism, Minimalism, and Pop.

At Fireman's Fund, we believe that fine art is meant to be enjoyed—in museums and in people's homes. That's why we provide customized, high-value insurance protection that gives our customers the confidence to surround themselves with their cherished art.

We invite you to share our pleasure in viewing this collection.

DAVID R. POLLARD
DIVISION PRESIDENT

Sponsor's Statement

Since its founding in 1937, the Solomon R. Guggenheim Foundation has grown considerably, both geographically and idealistically. The first comprehensive collection exhibition of the museum's pre- and postwar holdings since 1992, *The Global Guggenheim: Selections from the Extended Collection* brings together masterpieces from the museum's international locations to celebrate the contributions of a worldwide avant-garde.

Delta is proud to help the Guggenheim realize this exhibition. As one museum group spanning an ever growing list of countries, the Guggenheim is uniquely positioned to exhibit some of the world's most inspiring artistic achievements.

FREDERICK W. REID

EXECUTIVE VICE PRESIDENT AND CHIEF MARKETING OFFICER

Solomon R. Guggenheim Museum

The commission to design a gallery for Solomon R. Guggenheim's Museum of Non-Objective Painting came to Frank Lloyd Wright by way of a letter from its director, Baroness Hilla Rebay von Ehrenwiesen, on June 1, 1943. "I want a temple of spirit, a monument!" she wrote.

Wright's first sketch showed a museum of six levels in a hexagonal plan around an open, central court. Each level contained a band of high windows, bringing diffused light in through horizontal glass tubes, much as in his S. C. Johnson and Son administration building of 1936–39. Additional light came from a central glass dome at the sixth level. On the plan of this first proposal, the architect wrote "continuous ramp," and the idea of a spiral-ramped building was born. Later studies portrayed the spiral getting either smaller or larger as it rose; the latter solution was eventually settled upon by Wright.

The architect described his scheme as one in which the visitor would enter the building on the ground level, take an elevator to the top, and descend the gradually pitched ramp until returning to the entrance. At any point during the descent one could look over the parapet of the central court and see where one was. Each complete circle brought one around to the elevator.

The rising costs of building materials as well as changes in the museum's own program brought on a series of steady delays, each demanding new plans and working drawings from Wright's office. But finally in August of 1956 ground was broken on Fifth Avenue between 88th and 89th streets, and construction launched. Wright last visited the job site in January 1959, by which time the basic form of the building was in place. He died on April 9 of the same year, and the completed museum, by now renamed the Solomon R. Guggenheim Museum, opened to the public in October.

The greatest change that has occurred in the last 41 years is an addition designed by Gwathmey Siegel and Associates Architects, which provides four additional floors of exhibition space and two floors of office space. This addition, completed in 1992, engages the Frank Lloyd Wright rotunda behind the triangular stair tower at the second, fifth, and seventh floors, but does so in such a way that the drama and completeness of the main ramp is not impaired or disturbed.

BRUCE BROOKS PFEIFFER

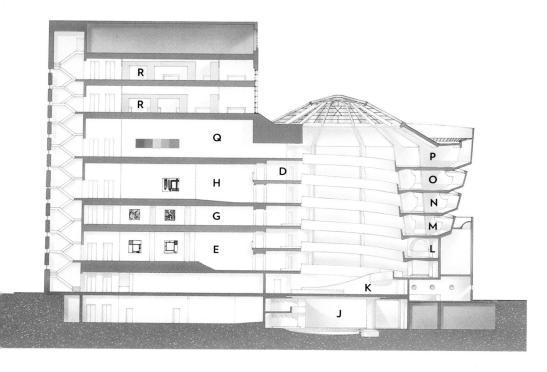

- A Main Entrance
- B Guggenheim Café Entrance
- C The Sackler Center for Arts Education
- D Guggenheim Store
- E Annex Level 2
 Thannhauser Gallery
- F Annex Level 3 Thannhauser Gallery
- **G** Annex Level 4 Thannhauser Gallery Robert Mapplethorpe Gallery
- **H** Annex Level 5 The Honorable Samuel J. and Ethel LeFrak Sculpture Terrace and Gallery
- I High Gallery
- J Peter B. Lewis Theater

- K Ronald O. Perelman Rotunda
- L Rotunda Level 2
 Aye Simon Reading Room
 Andrew and Denise Saul
 Galleries
- M Rotunda Level 3
 Guggenheim Family Galleries
- N Rotunda Level 4
- O Rotunda Level 5
 The Honorable Samuel J. and
 Ethel LeFrak Galleries
- P Rotunda Level 6
- Q Annex Level 7
- R Staff Offices

Drawings by Michael Gabellini based on Gwathmey Siegel and Associates Architects' drawings. Illustrated by Tom Powers, Ivy League of Artists.

A to Z: Guggenheim Museum Collection

Action

The concept of action forcefully entered visual-arts commentary when Harold Rosenberg articulated it in his celebrated essay from 1952, "The American Action Painters." "At a certain moment," he wrote, "the canvas began to appear to one American painter after another as an arena in which to act. . . . His act-painting is of the same metaphysical substance as the artist's existence." Rosenberg drew his image from his impression of American Abstract Expressionist painters such as Willem de Kooning and Jackson Pollock, but comparable diction was also used in Europe, where terms such as Art Informel, Art Autre, and Tachisme were used to discuss works by Hans Hartung, Matta, and Wols, among others. The theories behind these terms also identified the gesture—or act—of painting as the most significant aspect of the painter's process.

Such postwar thoughts were drawn from several prewar sources. The emphasis on gesture as a self-mirroring process was derived from Surrealist doctrine, in which "pure psychic automatism" was thought to free the artist from stylistic convention and rationalist construction. In the process of automatist drawing, the artist would, in André Breton's phrase, heed "thought's dictation" without mental preconceptions and interference, and, ideally, in full freedom.

The issue of freedom loomed large after the cataclysm of World War II, and action was fused with ethical and philosophical concerns. The notion that an individual can be defined by his or her acts was implicit in existentialism. Jean-Paul Sartre declared that "a man is not other than a series of undertakings." Other philosophers stressed the "lived" experience in aesthetics, as opposed to theoretical doctrine. In the phenomenology of Martin Heidegger and Edmund Husserl and the writings of John Dewey and William James, the concept of the lived experience was applied to a dynamic aesthetic in which the whole being of the viewer is in action as a work of art is contemplated.

DORE ASHTON

Marina Abramović b. 1946, Belgrade, Yugoslavia

Since the beginning of her career in Belgrade during the early 1970s, Marina Abramović has pioneered the use of performance as a visual art form. The body has always been both her subject and medium. Exploring the physical and mental limits of her being, she has withstood pain, exhaustion, and danger in the quest for emotional and spiritual transformation. This particular blend of epic struggle and self-inflicted violence, was borne out of the contradictions of her childhood: both parents were high-ranking officials in the Socialist government, while her grandmother, with whom she had lived, was devout Serbian Orthodox. Though personal in origin, the explosive force of Abramović's art spoke to a generation in Yugoslavia undergoing the tightening control of Communist rule.

The tensions between abandonment and control lay at the heart of her series of performances known as *Rhythms* (1973–74). In *Rhythm* 5,

"The subject is always the same. It's always about the body and about performing." Abramović lay down inside the blazing frame of a wooden star. With her oxygen supply depleted by the fire, she lost consciousness and had to be rescued by concerned onlookers. In *Rhythm 10*, she plunged a knife between the spread fingers of one hand, stopping only after she had cut herself 20 times. Having made an audio

recording of the action, she then played back the sound while repeating the movements—this time trying to coordinate the new gashes with the old. Using her dialogue with an audience as a source of energy, Abramović created ritualistic performance pieces that were cathartic and liberating. In Rhythm O, she invited her audience to do whatever they wanted to her using any of the 72 items she provided: pen, scissors, chains, axe, loaded pistol, and others. This essay in submission was played out to chilling conclusions—the performance ceased when audience members grew too aggressive. Truly ephemeral, Abramovic's earliest performances were documented only by crude black-and-white photographs and descriptive texts, which she published as an edition years later choosing the most iconic images to represent the essence of her actions. Since 1976 she has utilized video to capture the temporal nature of her art. Cleaning the Mirror #1 is composed of five stacked monitors playing videos of a haunting performance in which Abramović scrubs a grimecovered human skeleton on her lap. Rich with metaphor, this 3-hour action recalls, among other things, Tibetan death rites that prepare disciples to become one with their own mortality.

N.S.

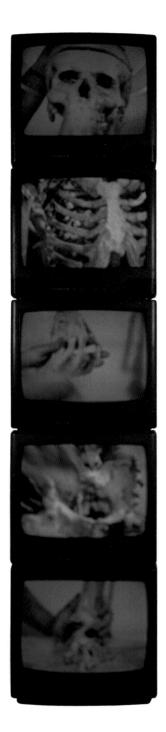

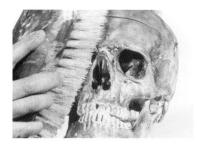

Cleaning the Mirror #1, 1995. Five-channel color video installation with stacked monitors, 112 x 24 ½ x 19 inches overall. Edition 2/3. Purchased with funds contributed by the International Director's Council and Executive Committee Members, 98,4626.a-.e

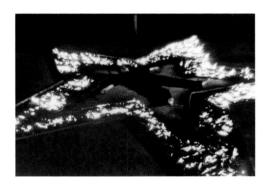

Rhythm 5, 1974, published 1994 (detail). Gelatin-silver print with inset letterpress panel; photograph: 22 7/s x 31 3/s inches; text panel: 9 3/4 x 6 3/s inches. Artist's Proof 1/3. Gift, Willem Peppler. 98.5214.a.,b

Vito Acconci b. 1940, Bronx, N.Y.

Vito Acconci's career-long exploration of the self has been articulated through poetry, photography, performance, film, video, installation, and architecture. What began as an investigation of the artist's own body in space—how it interacts with a given environment and how, in turn, that location affects it—has evolved into the construction of space itself. This trajectory is inscribed from the private, photographic recording of the body in a designated site to his more recent creation of sites for public engagement. The relationship of the private to the public—and how the self participates in the surrounding world—has been a constant theme in Acconci's art.

"My attention . . . is on 'art doing'—ways to make art—rather than on 'art experiencing' ways to see art." In 1969, already a published poet, Acconci made his first visual artworks, moving from the static domain of the printed page to the dynamic space of the empirical world. Combining photographs with texts, the artist documented task-oriented activities—jumping, stretching, bending, etc.—that he performed specifically for the lens. In *Grasp*, Acconci acknowledges the archival capabilities of photography—"camera as grasp, photo as storage"—but fore-

grounds the performative act of picture taking, of physically seizing an image. This project announces the dialogue between camera and body that is essential to Acconci's subsequent work, particularly in the series of videos and Super-8 films made between 1969 and 1974 in which he obsessively contemplates his own body as a (gendered) site. These privately filmed performances (which are also documented in photo/text panels) involve a level of corporeal manipulation that borders on masochism—Acconci is shown plucking hairs from around his navel, throwing soapy water into his eyes, and cramming his fist in his mouth. In Conversions II, the second in a trilogy of films interrogating the rigidity of gender binarism, the artist attempts to feminize his unquestionably male body by hiding his genitals between his legs. By casting his own masculinity into question, by performing its absence, Acconci problematizes the dictum that the male (or female) subject is a coherent being.

Acconci's recent TELE-FURNI-SYSTEM, an installation designed for watching video (his own and those of other artists), invites each visitor to interact with the environment by choosing his or her own viewing positions from a menu of different architectural options. Each monitor serves as a separate video channel and a building block in the network of stairs, benches, and lounges that constitute the piece. Here it is the viewer who activates the space by physically engaging with it and contemplating the panoply of moving images on display.

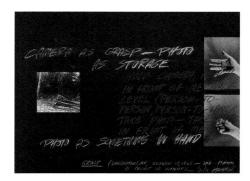

Grasp, 1969.
Black-and-white photographs and chalk on board, 30 x 40 inches. Purchased with funds contributed by the International Director's Council and Executive
Committee Members. 97.4568

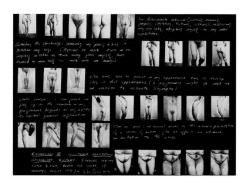

Conversions II: Insistence, Adaptation, Groundwork, Display, 1971.
Black-and-white photographs and chalk on board, 30 x 40 inches. Purchased with funds contributed by the International Director's Council and Executive
Committee Members. 97.4569

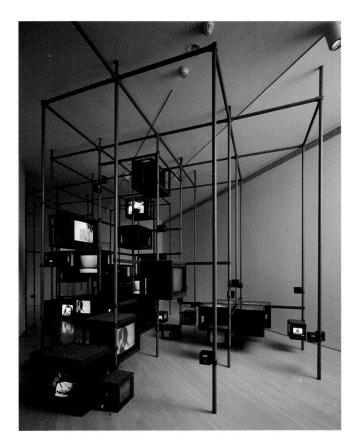

TELE-FURNI-SYSTEM, 1997.

Multichannel video installation with monitors, speakers, and steel and pipe armature; dimensions, videos, and number of components variable. Purchased with funds contributed by the International Director's Council and Executive Committee Members. 97.4567

Josef Albers b. 1888, Bottrop, Germany; d. 1976, New Haven

Although the relationship of photography to Josef Albers's work in other mediums has been regarded as tangential, it is now clear that for him it was an important means toward abstraction. Albers took up photography at the Bauhaus around 1928 and continued working with it until the end of his career. The medium permitted him to isolate particular phenomena— a time of year, an emotional state, a physical condition—which he would in turn extrapolate in his later nonobjective paintings, drawings, and prints. Albers argued that photography is the flattest of all visual arts: because of the monocular mechanics of the camera's lens, it does not render spatial illusion, making it ideal for certain aesthetic inquiries.

"Photography is still a child among the crafts . . . It has all the advantages and disadvantages of childhood. It is still unafraid of spontaneity and directness which are its characteristics."

His early photographs reflect traditional Bauhaus concerns with form and materials, particularly with regard to quotidian objects.

Untitled (Laundry on Clothesline) captures a moment when soft, lifeless clothing suddenly acquires volume through the otherwise invisible presence of wind. Another work that transforms the mundane into a study in contrasting properties is Let Hands Speak Summer 1930. This image takes as its subject the mannequin, a favorite icon of Dada artists, who considered it an ideal representation of mindless, characterless, bourgeois culture. But Albers found the mannequins to have a graceful, human quality that lent itself to studies in formal oppositions of hard and soft, straight and curved.

The compositional strategies of montage and collage were used by many Bauhaus artists as a means of rendering the frenetic nature of the modern metropolis. For Albers, these techniques were used to convey a singular concern for temporality and emotion, as evidenced in his portraits of friends and colleagues. Composed of multiple views that exploit the camera's ability to render a subject serially, Mrs. Lewandowski, Munich, Ascona VIII 1930 consists of four images of the wife of a colleague arranged to suggest the passage of time, as though lifted from a sequence of frames of a motion picture or a contact sheet. Scale is manipulated by altering the distance between the figure of the woman and the picture plane. This flattening of the subject was in keeping with Albers's increasing interest in planarity, which would manifest itself not only in photographic works, but in his celebrated abstract paintings of the following decade.

M.D.

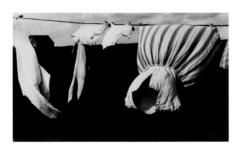

Untitled (Laundry on Clothesline). ca. 1929. Gelatin-silver print. $4\frac{3}{6} \times 6\frac{7}{6}$ inches. Gift, The Josef and Anni Albers Foundation. 96.4502.13

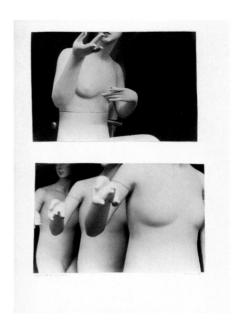

Let Hands Speak Summer 1930, 1930. Gelatin-silver print collage, 16 1/4 x 11 1/4 inches. Gift. The Josef and Anni Albers Foundation. 96.4502.2

Mrs. Lewandowski, Munich, Ascona VIII 1930, 1930. Gelatin-silver print collage. 16 ½ x 111½ inches. Gift, The Josef and Anni Albers Foundation. 96.4502.3

Albers

Albers was a professor at the Bauhaus before leaving his native Germany in 1933 for America, where he taught at Yale University and Black Mountain College, among other art schools. As a teacher, his influence in this country was enormous and may be detected in the works of a diverse range of artists, including Peter Halley, Donald Judd, and Robert Rauschenberg.

Impossibles dates from Albers's years at the Bauhaus and represents his experiments with nontraditional materials and techniques. The mechanical means of producing such glass pieces allowed him to achieve the discipline and detachment that he considered necessary to create nonrepresentational

"No smock, no skylight, no studio, no palette, no easel, no brushes, no medium, no canvas. No variation in texture, or 'matière,' no personal handwriting, no stylization, no tricks, no 'twinkling of the eyes.' I want to make my work as neutral as possible."

forms. Like other artists of his generation, Albers moved from a figurative style of picture-making to geometrically based abstraction. Homage to the Square: Apparition, painted in 1959, is a disarmingly simple work, composed of four superimposed squares of oil color applied with a palette knife directly from the tube onto a white, primed Masonite panel. It is part of a series that Albers began in 1950 and that occupied him for 25 years. The series is defined by an unmitigating adherence to one pictorial formula: the square. The optical effects Albers created—shimmering color contrasts and the illusion of receding and advancing planes—were meant not so much to deceive the eye as to challenge the viewer's faculties of visual reception. This shift in emphasis from perception willed by the artist

to reception engineered by the viewer is the philosophical root of the *Homage to the Square* series. Albers tried to teach the mechanics of vision and show even the uninformed viewer how to see. He was always proud that many nonart students took his classes at Yale.

The Homage to the Square series is also distinguished by the carefully recorded inscriptions of technical details on the back of each panel. This codification of the making of the painting, along with the reductively systematic application of colors, anticipated much of the art of the mid-1960s, when painting was stripped of the transcendental, and (in the case of Conceptual art) the paint was often left out altogether.

C.L.

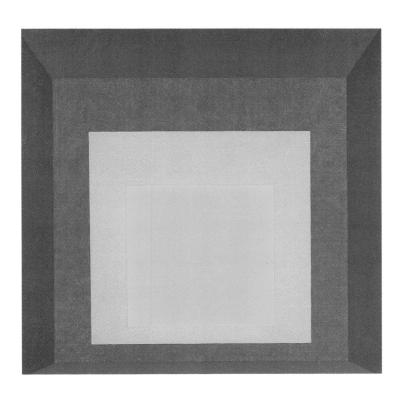

Homage to the Square: Apparition. 1959. Oil on Masonite, 47 ½ x 47 ½ inches. 61.1590

Impossibles, 1931. Sand-blasted flashed glass, 1711/6 x 141/6 x 11/6 inches. Gift, The Josef Albers Foundation. 91.3878

Carl Andre b. 1935, Quincy, Mass.

The work of Carl Andre occupies an essential transitional position in contemporary art. The artist himself places it in a tradition spanning Constantin Brancusi to Henry Moore, yet historically it rests within the more recent context of ideational gestures, starting with the early paintings of Frank Stella. The Guggenheim Museum's collection covers a wide range of Andre's oeuvre, including the viewer-interactive 10 x 10 Altstadt Copper Square, in which space is defined by both the work and the spectator who is free to walk across it; Fall, an angle of hot-rolled steel; and Trabum, a cube made of nine interlocking beams of Douglas fir.

These examples embody the characteristic features of Andre's sculpture,

"My works are not the embodiments of ideas or conceptions."

such as the use of ready-made materials, the employment of modular units, and the articulation of three-dimensionality through a considerate eration of its negative as well as positive space. Andre has sought to reduce the vocabulary of 20th-century sculpture to basic phonemes such as squares, cubes, lines, and diagrams. In his avowed transition from the exploration of form to that of structure and of place,

Andre has placed significant emphasis on the relation between site and viewer. His pseudoindustrial, untheatrical arrangements hover between being ideas and testing the limits of physical presence.

Poetics play an important role in Andre's work, manifested most literally by his experiments with linguistic equivalents to his sculpture. Since the 1960s he has created poems and, in the tradition of concrete poetry, situated the words on the page as if they were working drawings. He has often reached to ancient languages for titles in his attempt to craft a primordial language of form; for example, the title *Trabum* is derived from the Latin for log or timber. Andre's consistent search for the simplest, most rational models embodies a moral philosophy as well as an artistic practice.

C.L.

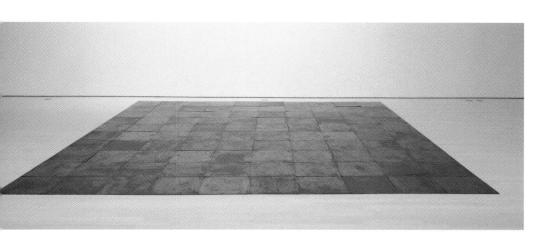

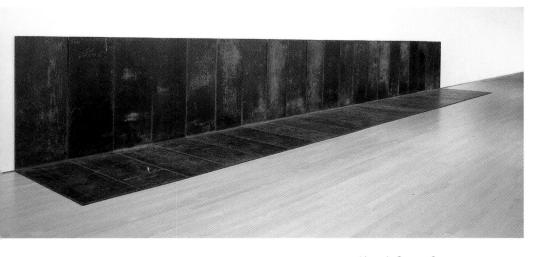

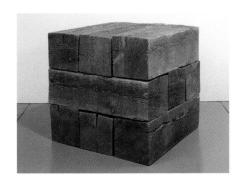

10 x 10 Altstadt Copper Square.

Düsseldorf, 1967.

Copper; 100 units, ³/₆ x 19 ¹¹/₆ x 19 ¹¹/₆ inches each; ³/₆ x 197 x 197 inches overall. Panza Collection. 91.3673.a-.vvvv

Fall, New York, 1968.

Hot-rolled steel: 21 units, 71% x 28 x 72%6 inches each; 72 x 588 x 72 inches overall. Panza Collection. 91.3670.a-.u

Trabum, 1977.

Douglas fir; Nine units, 12 x 12 x 36 inches each: 36 x 36 x 36 inches overall. Purchased with funds contributed by the National Endowment for the Arts in Washington, D.C., a Federal Agency: matching funds donated by Mr. and Mrs. Donald Jonas. 78.2519.a-.i

Alexander Archipenko b. 1887, Kiev; d. 1964, New York City

No doubt it was a sense of pride and more than an inkling of historical place that prompted the young Alexander Archipenko to inscribe these two works with his name and "1913 Paris." Soon after arriving in Paris at the age of 20, the Ukrainian artist could claim membership in the prestigious Section d'Or group, putting him in the company of the Duchamp brothers, Pablo Picasso, and Guillaume Apollinaire. *Carrousel Pierrot* and *Médrano II* are souvenirs of this heady time.

None of Archipenko's colleagues would have missed the allusions in these works to the Cirque Médrano (which many artists frequented), the vogue for puppetry, or the jesters in Picasso's paintings. Harlequins and saltimbanques were traditional stand-ins for the artistic persona; they also offered a unique package of shapes and colors for formal resolution.

Carrousel Pierrot fits into Archipenko's lifelong fascination with the possibilities of polychromy and the abstract figure in the round. Reminiscing about the origin of Carrousel Pierrot, Archipenko later recalled that he was inspired by a festival where "dozens of carrousels with horses, swings, gondolas and airplanes imitate the rotation of the earth." Médrano II is almost anomalous within Archipenko's oeuvre. Although it relates to the later "sculpto-paintings" for its crossover between two disciplines, the work is the only extant example of the theme of a figure in motion, with which Archipenko experimented in two other works (Médrano I and Woman in Front of Mirror, both destroyed). In this investigation, he was keeping pace with Marcel Duchamp, who had explored this theme in his 1912 painting Nude Descending a Staircase. Also aware of the advances of Synthetic Cubism, Archipenko incorporated reflective glass, wood, and metal into Médrano II. In two early poems, Archipenko's friend and supporter Apollinaire had featured saltimbanques and a protagonist named Columbine, who "disrobes and / Admires her reflection in the pool." Perhaps this was the inspiration for the dancer in Médrano II, who seems to gaze at her own image in a mirror.

C.L.

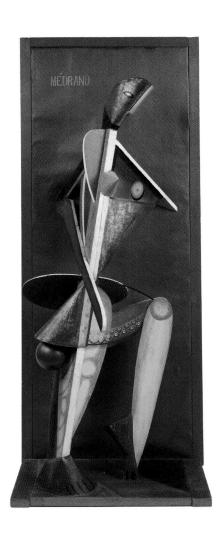

Médrano II, 1913–14. Painted tin, wood, glass, and painted oilcloth, 49 $\frac{7}{10}$ x 20 $\frac{1}{12}$ x 12 $\frac{1}{12}$ inches. 56.1445

Carrousel Pierrot, 1913.
Painted plaster, 24 x 19 1/6 x 13 3/6 inches.
57.1483

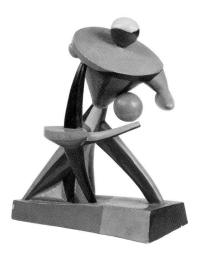

Jean Arp b. 1886, Strasbourg, Alsace-Lorraine; d. 1966, Basel

As a founding member of Dada, Jean Arp was among those artists who espoused a rejection of traditional bourgeois values and taste. Arp's response to illusionistic art, which he saw as a bogus reproduction of reality, was to create an abstract art that would ultimately be a truer indication of reality because its generative principles would echo nature's. His method included the expression of chance, informed by the Dadaists' desire for liberation from so-called rationality. For Arp, chance also represented a fundamental law of the organic realm, and his first reliefs, made during the war, are colorful and witty evocations of plant and animal forms on layered wooden panels.

"These works, like nature, were ordered 'according to the law of chance.'" In the early 1930s Arp developed the principle of the "constellation," employing it in both his writings and artworks. As applied to poetry, the principle involved using a fixed group of words and focusing on the various ways of combining them, a technique that he compared to "the inconceivable multiplicity with which nature arranges a flower species in a field." In making his *Constellation* reliefs, Arp

would first identify a theme—for example, five white biomorphic shapes and two smaller black ones on a white ground—then recombine these elements into different configurations. Constellation with Five White Forms and Two Black, Variation III is the last of three versions of this theme.

Rather than doggedly copying nature, Arp's variations are poetic evocations of the metamorphosis and change inherent to the cycle of life.

While Arp worked on his reliefs through the 1920s and early 1930s he was actively engaged with both Surrealism and the approach to pure abstraction associated with Neo-Plasticism. Membership in these movements was usually mutually exclusive, but Arp's diplomacy enabled him to maintain contact with both. His work, like Joan Miró's, engaged Surrealism at the level of process, for he used automatist strategies to get beyond the constrictions of rational thought. Yet, like Piet Mondrian, he believed in the Neoplatonic goal of representing a higher plane of reality through abstraction.

J.B.

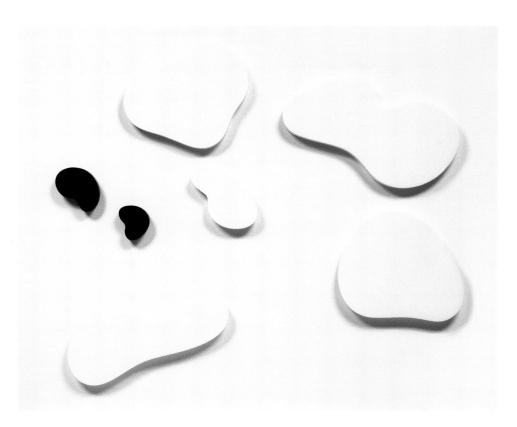

Constellation with Five White Forms and Two Black, Variation III. 1932.
Oil on wood, 23 1/6 x 29 1/6 inches. 55.1437

Avant-Garde

The term "avant-garde" is usually used to describe the engine of thrust and forward motion that aids art in its progression from one stage to another. It is closely aligned with the term "Modernism," and both concepts have been used as analytical springboards for discussions of art produced roughly between 1860 and 1960. This period, the "machine age," coincided with European and American dominance of the world militarily, politically, and economically. Following World War II, this balance of power began to break down. The 1960s saw an acceleration of the process, and by the 1970s only the shell of the old order remained intact.

The shifting postwar situation coincided with a sense of the failure of progress both as a historical condition and as a legitimate concept. Belief in the avant-garde necessarily was attenuated, if not lost, within this analysis. But the redefinition of art is an ongoing issue. The question is whether the term avant-garde itself should be attached to what is now a different set of conditions from that of the previous epoch or if it might be better to let it fall into disuse.

At the beginning of a new century, it is clear that a redefinition of progress and of the nature of the avant-garde *is* possible. We may find a new way to look forward, to engage the future, to challenge the present. One striking possibility is that the avant-garde may no longer bear a direct lineage to the traditions of European painting and sculpture, even as transformed by the great Modern artists of the early 20th century. A different continuum of cultural precedents and influences is possible, as is a new balance between Europe and America, within Europe, and between the West and Asia, the Arab world, Latin America, Africa, or elsewhere.

A vitally diverse cultural expression is now emerging, even under economic duress, from various regions, countries, and groupings of people. If avantgarde can be equated with radical challenge and formative synthesis and creativity, then the concept remains alive, even if we let the term itself go. Its validity is assured if we acknowledge its achievements by in turn expanding our own terms of evaluation and understanding. In this sense the vanguard functions to push us toward the recognition of the new against the historical claims of the past.

GARY GARRELS

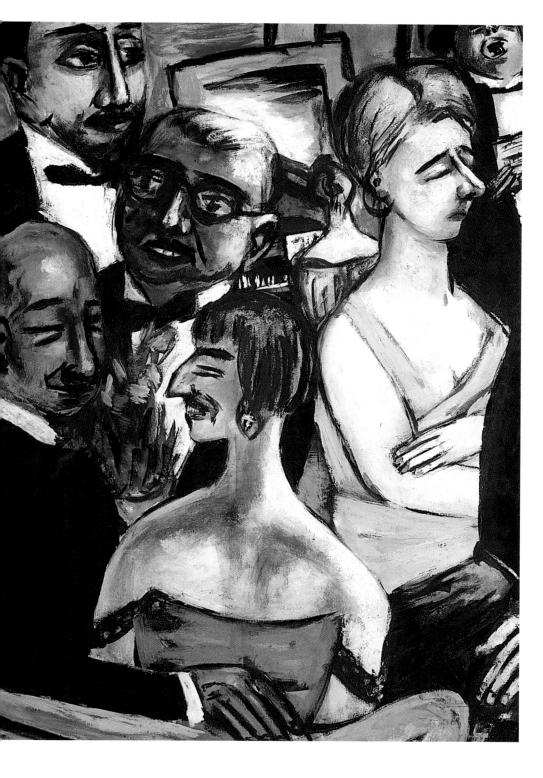

Francis Bacon b. 1909, Dublin; d. 1992, Madrid

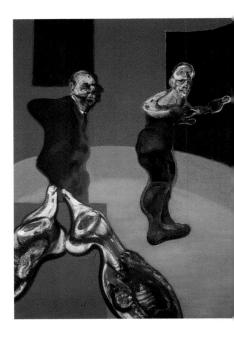

In 1944, one of the most devastating years of World War II, Francis Bacon painted *Three Studies for Figures at the Base of a Crucifixion*. With this horrific triptych depicting vaguely anthropomorphic creatures writhing in anguish, Bacon established his reputation as one of England's foremost figurative painters and a ruthless chronicler of the human condition.

"The greatest art always returns you to the vulnerability of the human situation." During the ensuing years, certain disturbing subjects recurred in Bacon's oeuvre: disembodied, almost faceless portraits; mangled bodies resembling animal carcasses; images of screaming figures; and idiosyncratic versions of the Crucifixion.

on. One of the most frequently represented subjects in Western art, the Crucifixion has come to symbolize far more than the historical and religious event itself. Rendered in modern times by artists such as Paul Gauguin, Pablo Picasso, and Barnett Newman, this theme bespeaks human suffering on a universal scale while also addressing individual pain. The Crucifixion appeared in Bacon's work as early as 1933. Even though he was an avowedly irreligious man, Bacon viewed the Crucifixion as a "magnificent armature" from which to suspend "all types of feeling and sensation." It provided the artist with a predetermined format on which to inscribe his own interpretive renderings, allowing him to evade narrative

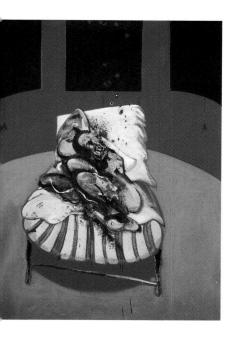

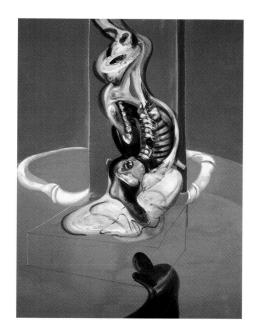

content—he disdained painting as illustration—and to concentrate, instead, on emotional and perceptual evocation. His persistent use of the triptych format (also traditionally associated with religious painting) furthered the narrative disjunction in the works through the physical separation of the elements that comprise them.

That Bacon saw a connection between the brutality of slaughterhouses and the Crucifixion is particularly evident in the Guggenheim's painting. The crucified figure slithering down the cross in the right panel, a form derived from the sinuous body of Christ in Cimabue's renowned 13th-century *Crucifixion*, is splayed open like the butchered carcass of an animal. Slabs of meat in the left panel corroborate this reading. Bacon believed that animals in slaughterhouses suspect their ultimate fate. Seeing a parallel current in the human experience—as symbolized by the Crucifixion in that it represents the inevitability of death—he has explained, "we are meat, we are potential carcasses." The bulbous, bloodied man lying on the divan in the center further expresses this notion by embodying human mortality.

Three Studies for a Crucifixion, March 1962. Oil with sand on canvas; three panels, 78 x 57 inches each. 64.1700.a-.c

Matthew Barney b. 1967, San Francisco

Imagine a biological and metabolic force converting into tangible form. And as that force transmogrifies and begins to take shape, it must follow one rule: it cannot subdivide into separate entities, even though it is compelled to do so at every turn. This is the process that governs Matthew Barney's CREMASTER series, a five-part film cycle accompanied by related sculptures, photographs, and drawings. Begun in 1995, with a projected completion date of 2002, the cycle describes the evolution of form through elaborate biochemical and psychosexual metaphors. Eschewing chronological order, Barney has completed parts 4, 1, 5, and 2 of the series thus far, each of which narrates fantastical allegories of growth,

"[My work is] not so much about transcendence as about an intuitive state with the potential to transcend, and about the kind of intuition that is learned through understanding a physical process." transformation, and physical transcendence. Taking the cremaster muscle (which controls testicular contractions in response to external stimuli) as their conceptual departure point, the films circulate around anatomical conditions of "ascension" and "descension" to metaphorically describe imaginary beings suspended in states of latency. In Barney's eccentrically erotic universe, nothing is construed as simply one thing or the other. Rigid dualistic categories—male/female, entropy/order—give way to an enclosed system capable of self-mutation. Hybrid creatures revel in zones of genital indeterminacy, struggling to retain their polymorphous nature.

Barney manipulates a different theatrical genre in each of the CREMASTER films. In CREMASTER I—a fusion of Busby Berkeley-style dance routines and Leni Riefenstahl's choreographic vision of Third Reich athletics chorus girls form shifting outlines of reproductive organs on a football field. Their movements are determined from above by a starlet, who miraculously inhabits two Goodyear blimps simultaneously and creates anatomical diagrams by lining up rows of grapes. Her goal? To hover indefinitely in this zone of total "ascension," a metaphoric field of gender ambiguity. CREMASTER 2 is a gothic Western with strong psychobiographical undertones. Premised on the story of Gary Gilmore, who was executed in Utah for murder in 1977, the narrative traces the progenitive forces behind an individual's fate—the causal factors in a life gone terribly wrong—as they are reflected in, and witnessed by, the epic landscape. CREMASTER 5 is set against the baroque backdrop of an 18th-century opera house. Performed as a lyric opera complete with ribboned Jacobin pigeons, a lovelorn queen, and her tragic hero, this narrative of "descension" flows from the gilded proscenium arch of the theater to the agueous underworld of Budapest's Danube River to humid thermal baths inhabited by hermaphroditic water sprites. The hero's resistance to self-division reaches its final conclusion in death and apotheosis.

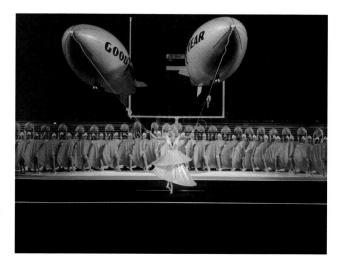

CREMASTER 1, 1996.

Silkscreened video disk, cast polyester, prosthetic plastic, patent vinyl, and self-lubricating plastic vitrine; color video with audio, 00:40:30; vitrine: 51 x 48 x 36 inches. Edition 10/10. Purchased with funds contributed by the International Director's Council. 96.4516 Shown here: production still.

CREMASTER 2, 1999.

Silkscreened digital video disk, tooled saddle leather, sterling silver, beeswax, polycarbonate honeycomb, acrylic, and nylon vitrine, with 35mm print; digital video transferred to film with audio, 1:19:00; vitrine: 38 % x 40 x 46 % inches. Edition 8/10. Purchased with funds contributed by the International Directors Council and Executive Committee Members. 99:5303 Shown here: production still.

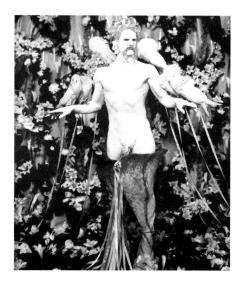

CREMASTER 5, 1997.

Laser disk, polyester, acrylic, velvet, nylon, sterling silver, and acrylic vitrine with 35mm print; digital video transferred to film with audio, 00:54:30; vitrine: 37 1/4 x 47 1/4 x 35 1/4 inches. Edition 5/10. Purchased with funds contributed by the International Director's Council and Executive Committee Members. 97.4570 Shown here: production still.

Georg Baselitz b. 1938, Deutschbaselitz, Germany

The dark of night laps at the edges of *The Gleaner*, a fire burns on the upper left, and a sunlike shape hovers beneath the lone figure. Yet Georg Baselitz's monumental, somber work was painted during a decade of well-being in Germany, when the generation of the *wirtschaftswunder*—the economic miracle—was only interrupted in its relentless quest for stable prosperity by the occasional political scandal or terrorist attack. How does this image, so clearly a representation of an existentialist condition, address the complex issues facing postwar German art and society?

The key lies in the orientation of the gleaner, searching for sustenance in a barren landscape: the figure is depicted upside down. Baselitz has used this device consistently since 1969–70, his intention being, in part, to sub-

vert the criteria for viewing paintings. To this end, Baselitz inverts, and thus negates, the subjects of his work. He cites but does not pay homage to the mythic protagonists that, as in Wagner's epic operas, have so often been the focus of German art and culture. For Baselitz, the individual is the locus of redemption and the cause for despair. He has painted a great number of his antiheroes in guises ranging from military costumes to stark nudity.

"An object painted upside down is suitable for painting because it is unsuitable as an object."

Baselitz once termed his technique a nonstyle. The upside-down figure, brutality of gesture, and emotive yet distanced strokes have, however, long since become highly recognizable trademarks. Ironically, Baselitz, who initially sought to replace the congealed expressionism sweeping Europe with a fresh, aggressive style, and comparably controversial subjects, is now regarded as one of the foremost artists of Germany and has been accorded retrospective exhibitions internationally. His work strongly influenced the generation of painters that came of age during the early 1980s. But unlike the Neo-Expressionists he inspired, Baselitz does not rehash past styles, nor is his milieu truly international. Baselitz's painting remains a deeply felt and authentic engagement with the spiritual depletion of the postwar period in Germany.

The Gleaner, August 1978.
Oil and tempera on canvas, 129 1/10 x 98 3/10 inches. Purchased with funds contributed by Robert and Meryl Meltzer. 87.3508

William Baziotes b. 1912, Pittsburgh; d. 1963, New York City

William Baziotes's paintings are freely improvised, intuitive affairs created in the spirit of Surrealist automatism. Each canvas, he claimed in 1947, "has its own way of evolving. . . . Each beginning suggests something. . . . The suggestion then becomes a phantom that must be caught and made real." For Baziotes, the "reality" he aspired to exists only in a poetic realm, one in which color and form serve as analogues for psychological and emotional states. This use of visual metaphor was inspired by the artist's love for poetry, particularly that of Charles Baudelaire, whose theory of "correspondences" proclaimed the fundamental equivalence of all things

"The things in my painting are intended to strike something that is an emotional involvement—that has to do with the human personality and all the mysteries of life, not simply colors or abstract balances."

in nature and the capacity of any designated thing to symbolize something beyond itself. By the late 1940s Baziotes achieved his signature formal motif—delicate, semitranslucent, biomorphic shapes suspended within aqueous fields of muted color—which invokes the Baudelairian world of allusion and association. "The emphasis on flora, fauna and beings," explained the artist about his painting, "brings forth those strange memories and psychic feelings that mystify and fascinate all of us."

Baziotes shared his keen interest in nature with other artists of the New York School, who were motivated simultaneously by their search for primordial truths and their fascination with scientific inquiry. What bridged these two utopian investigations was the microscope; the invisible world of protean forms it revealed promised to disclose the origins of life. This preoccupation with identifying metaphysical features of the organic realm may illuminate Baziotes's predilection for marine imagery, as demonstrated in Aquatic, a painting of serpentine forms swimming through a calm, watery world. The symbolic possibilities of the ocean are vast and Baziotes drew on many of its meanings. Aquatic has been interpreted as an expression of the artist's romantic vision of the sea as a domain of symbiotic relationships. The artist was captivated by the mating practice of eels, which swim through the ocean, rarely touching but always together. The delicately intertwined lines in the picture have been thought to represent these faithful eels on their course through the watery depths. Dusk, one of many pictures relating to nocturnal themes, is a lyrical evocation of a contemplative moment, the nuanced ebb of time between day and night, the half-light of evening.

Aquatic, 1961.
Oil on canvas, 66 x 78 ⅓ inches.
Collective anonymous gift. 63.1630

Dusk, 1958. Oil on canvas, 60 3/6 x 48 1/4 inches. 59.1544

Rernd and Hilla Becher Bernd Becher, b. 1931, Siegen district, Germany Hilla Becher, b. 1934, Berlin

In 1990 Bernd and Hilla Becher, a husband-and-wife team, received an award at the Venice Biennale. Although photography is their exclusive medium, the prize was granted in another category—sculpture. This ingenious gesture by the Biennale jury testifies to the artists' success in creating an art form that falls beyond existing aesthetic parameters.

Since 1957 the Bechers have traveled throughout Europe and North America taking black-and-white photographs of industrial architecture: water towers, coal silos, blast furnaces, lime kilns, grain elevators, preparation plants, pithead gears, oil refineries, and the like. They organize their photographs into series based exclusively on functional typologies and

arrange them into grids or rows. This serves both to invoke and reinforce the sculptural properties of the architecture—they have called the subjects of their photographs "anonymous sculptures" the forms of which are primarily determined by function. Through this method the artists reveal the diverse structural and material variations found within specific kinds of edifices. The water towers comprising the sequence presented here, for example, are all constructed of metal, yet they differ vastly in form. Such differences are underscored by constants that prevail from series to series: the

photographs are usually taken from the same angle, the light is evenly distributed, and the prints are identical in size.

The photographs, particularly those of now-demolished structures, refer to specific historical periods, particularly the late-19th-century shift to industry. When contemplated in our postindustrial society, these images can be interpreted as nostalgic ruminations on a lost era. But they do not lack a critical edge. The intense and obsessive nature of the Bechers' project mirrors and discloses the relentless order of industrial production. a phenomenon that has had monumental implications for the economy and the environment.

The serial repetition of the Bechers' work, coupled with its focus on industrialization, has inspired comparisons to Minimalism. The artists, who avoid any form of categorization, would not necessarily condone such an analogy. It is telling, however, that one of the finest appreciations of the Bechers to have been written is by Minimalist sculptor Carl Andre.

N.S.

"We wanted to provide

a viewpoint or rather a

grammar for people to

different structures."

-Bernd Becher

understand and compare

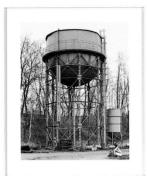

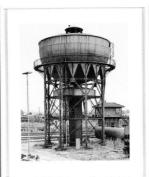

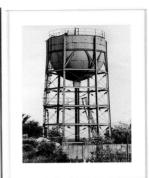

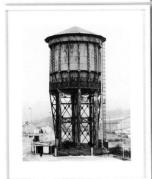

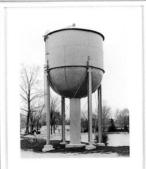

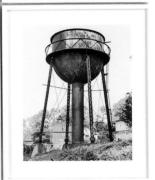

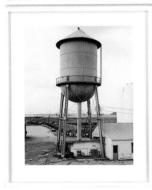

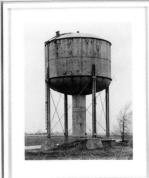

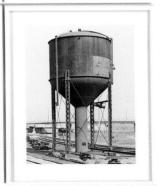

Water Towers, 1980.
Black-and-white photographs,
mounted on board, 61% x
49% inches overall. Purchased with
funds contributed by Donald Jonas.
81,2793.1-.9

Max Beckmann b. 1884, Leipzig, Germany; d. 1950, New York City

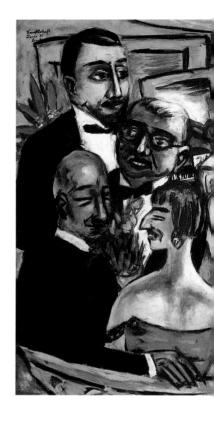

Paris Society is Max Beckmann's portrait of émigrés, aristocrats, businessmen, and intellectuals engaged in disjointed festivity on the eve of the Third Reich. Beckmann painted the work on an invitation from the German embassy in Paris. A series of sketches shows that he had conceived of the composition as early as 1925. By 1931, when he completed it, accusations

"Everywhere I find deep lines of beauty in the suffering and endurance of this terrible fate." and slander against the freethinking artist had begun to mount in Germany, and the somber character of *Paris Society* seems to reflect his sense of foreboding. Beckmann spent much of his time in Paris, although financial hardship stemming from his persecution led him to give up his studio there one year later. He eventually emigrated to Amsterdam and then to the U.S.

Paris Society is rife with ambiguities. The event depicted is a black-tie party, although the socialites gathered there seem strangely depressed. Some of the figures in the composition were identified by the artist's widow, Mathilde Beckmann. They include the central figure, Beckmann's

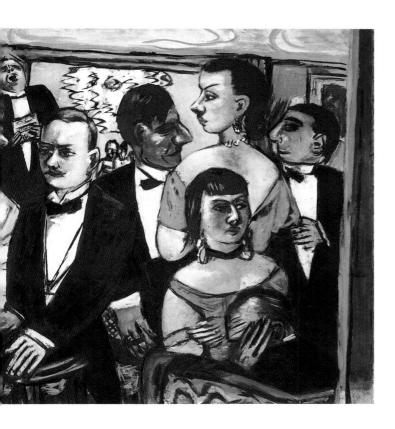

friend Prince Karl Anton Rohan; the Frankfurt banker Albert Hahn, at the far right; the music historian Paul Hirsch, seated at the left; the German ambassador Leopold von Hoesch, at the lower right, with his head in his hands; and possibly Paul Poiret, the French couturier, standing at the left. But why they are together in this scene and what their peculiar postures denote remain a matter of speculation.

In café, hotel, and beach scenes, Beckmann had proven himself to be a mordant painter of modern life, and some German critics counted him among the artists of the Neue Sachlichkeit (New Objectivity). The universalizing tendency of his moral allegories, however, diverged from the political satire of his colleagues, such as Otto Dix and George Grosz. Beckmann's paintings do not succumb to precise interpretation. In spite of their period detail, they seem to represent a condition rather than a historical moment.

Paris Society, 1931. Oil on canvas, 43 x 69 1/8 inches. 70.1927

Joseph Beuys b. 1921, Krefeld, Germany; d. 1986, Düsseldorf

These works by Joseph Beuys may be said to reflect three distinct phases in the artist's career. *Animal Woman*, an example of Beuys's early work, is closely tied to his years in the workshop of his teacher, Ewald Mataré. Beuys accentuated the fetishistic character of the work by finishing the various casts of the statue (there are seven casts and one artist's proof) with different patinas. The grossly enhanced sexual characteristics of *Animal Woman*, notably the hips and breasts, are in keeping with the type of nature imagery that Mataré and he favored during the late 1940s; a primordial female nude was a recurring subject of Beuys's work at this time.

"My personal history is of interest only in so far as I have attempted to use my life and person as a tool, and I think this was so from a very early age." By 1962 Beuys had ceased creating objects, turning his attention to performance art and sculptural experiments with nontraditional materials. F. I. U.: The Defense of Nature exemplifies the way his life came to merge with his art. The work refers to an ecological campaign that Beuys and his dealer, Lucrezia de Domizio, waged in the 1980s with the help of his students at the art academy he had founded to encourage creativity—the Free International University (hence the F. I. U. of the title). The campaign required the use of a car, pamphlets, copper tubing, and spades that were meant to be

plunged vigorously into the Italian countryside. Beuys sold the car, its contents, and two blackboards as part of his routine transformation of performance materials into artworks that would in turn fund other projects.

Encounter with Beuys (a title probably given by de Domizio) consists of a vitrine containing felt, fat, copper pieces, and cord, the materials he used repeatedly to describe significant events in his life. The first two materials refer to the pivotal incident in his life, a wartime plane crash in which mountain people saved his life by wrapping him in felt and fat; copper was used by Beuys to represent spiritual conduction, while cord as a readymade has fascinated artists from Piero Manzoni to Dorothea Rockburne. The placement of autobiographical objects in a vitrine relates particularly to his major 1985 exhibition in Naples, where he installed a series of golden plates and vitrines, suggesting the burial hall of a king. Beuys favored the vitrine for its ready association to ethnographic installations. As part of his fusion of rituals and their fetishes, he believed that art and artifacts could not always be distinguished from one another.

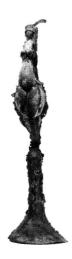

Animal Woman, 1949, cast 1984. Bronze, 18 3/8 x 5 1/4 x 4 inches. 85.3256

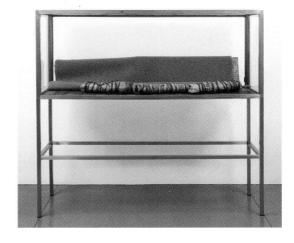

F.I.U.: The Defense of Nature, 1983–85. Automobile, shovels, copper pieces, pamphlets, and slate blackboard; dimensions vary with installation. 85.3315.a-.e

Encounter with Beuys, 1974–84.
Vitrine containing felt, copper, fat, and cord, 75 x 78 1/4 x 23 1/2 inches. Purchased with funds contributed by The Gerald E.
Scofield Bequest. 87.3522.a-.h

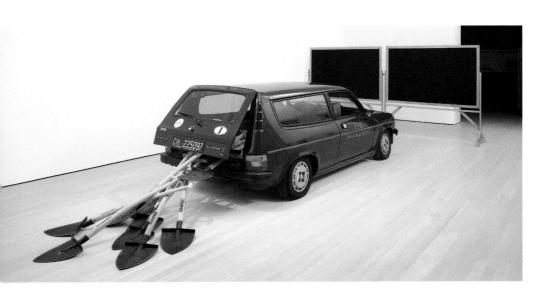

Beuys

Beuys's public discussions—lectures on politics, aesthetics, metaphysics, and social relations that often served as catalysts for other work—exemplify his role as artist, teacher, and activist. One such discussion was held in Vienna on April 4, 1979, at the Galerie Nächst St. Stephan, where Beuys had been invited to speak in the context of a debate surrounding the use of Vienna's Palais Lichtenstein as a museum for modern art. Earlier that same year, the gallery had given Beuys the opportunity to create an installation entitled Basic Room-Wet Laundry, a manifestation of his provocative contention that the baroque palace was as useful for hanging wet laundry as it was for displaying art. The April 4 discussion grew directly from that project. During the discussion, Beuys referred to a chalk drawing on a blackboard that showed the chemical formula for making soap. Using the soap-making process as a metaphor for social relations and its colloidal character as an analogy for the stages of fetal development, he then spoke of the cyclical nature of feminine cleansing, associating virginity and motherhood with cleanliness and impurity respectively. The lecture also related back to the notion of washing as "the traditional domain of women" presented in Basic Room-Wet Laundry. These themes were further brought to bear upon the machinations and politics of the art world, which the artist viewed with contempt. The installation Virgin, April 4, 1979, is a kind of "representation" of that lecture, and utilized the essential elements that comprised this cycle of works—soap, blackboard, a table and chair, and the single light bulb,

In the summer of that same year, Beuys made *Virgin Basic-Wet Room Laundry* for a major exhibition at the Vienna Secession. A further iteration of the previous two installations and lectures, this was to have been the grandest presentation of the subject of the *Virgin*. However, Beuys decided to isolate some (though not all) of the elements of the piece as independent objects after a vandal had damaged the work; *Virgin*, April 4, 1979/June 23, 1979, consists solely of the blackboard from the Vienna installation. Beuys reworked the imagery to evoke more painterly results, which he achieved by rubbing soap directly onto the surface in broad circular movements. The dual date refers to both that of the original idea—in this case, back to the April 4 discussion—and the date the piece was constituted as a self-contained object, rather than referring to the date of its actual creation, a practice occasionally used by Beuys to underscore his belief that "thinking-art."

M.D.

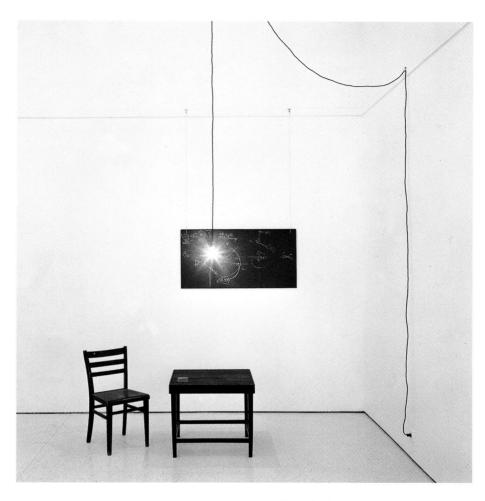

Virgin, April 4, 1979. Chalk on blackboard, chalk and soap bar on wood table, wood chair, electrical cable, socket, and light bulb; dimensions vary with installation. 94.4265.a-.e

Virgin, April 4, 1979/June 23, 1979. Chalk, tempera, wood, and soap on blackboard, 33 ½ x 49 ½ inches. 94.4264

Beuys

Terremoto means earthquake in Italian; more specifically, on November 23, 1980, it meant the destruction of a small city on the volcanic heights above Naples. At the invitation of a Neapolitan cultural center, Beuys and several other artists made works to commemorate the lost lives and other effects of the disaster. The Guggenheim Museum's Terremoto, constructed in Rome at roughly the same time, is a pendant to the Neapolitan work. Although its title and date tie it specifically to the Neapolitan earthquake, it also refers to a contemporary political situation.

This installation reiterates Beuys's public support of independence for this region of Italy. An Italian flag, wrapped in felt, is draped against an ancient typesetting machine that was once used in the production of the newsletter of a leftist political party. Lotta Continua (The fight continues). Grease has been smeared on the keys of the machine, rendering them dysfunctional. A blackboard on the floor leans against a small oil drum, as if elemental lessons would suffice to educate people to the inequities of capitalism. More blackboards form an altar around the printing machine. They bear alchemical symbols and chalk drawings of skulls, which might represent the victims of the quake.

The manifestos glued to the printing machine refer to the Action Third Way, a theory of political activism that Beuys helped to develop in the late 1970s; it argues for an economic system based neither on the values of Western capitalism nor on the monopolies of the state created by 20th-century interpretations of Marxism. One important element of the Third Way is an emphasis on ecology. Beuys alludes to this in *Terremoto* by opposing technology with organic substances, and printed texts with handwritten ones. He developed this further in the larger environmental installations dating from the last years of his career, which are among his most far-reaching works, enormous in scope, magnificent in their intention, and involving hundreds of participants. They center around a single theme: his call for a change in thinking that develops out of personal understanding rather than from technological advances.

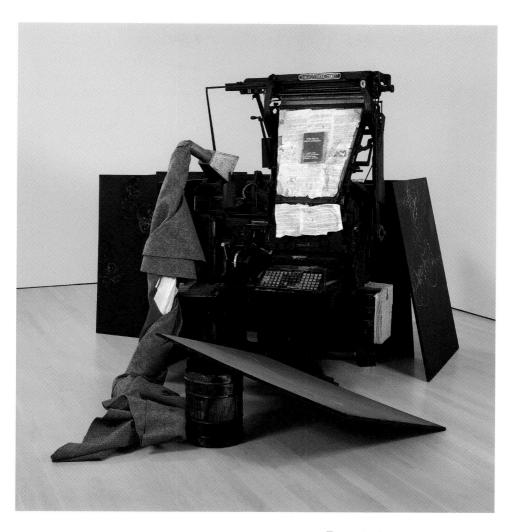

Terremoto, 1981.

Typesetting machine, Italian flag, felt, nine blackboards with chalk drawings and diagrams, metal container with fat and lead type, cassette recorder with tape, and brochure, 80 x 137 3/4 x 193 inches. 91.3960.a-.n

Ross Bleckner b. 1949, New York City

In his 1979 article "Transcendent Anti-Fetishism," Ross Bleckner called for an art of the "psychologized object" that would connect with a "larger psychological, social, and political reality." The desire to reexamine the allegorical and metaphorical dimensions of art that arose among artists in the late 1970s was a response to the primacy of formal and perceptual issues at this time and the heated denial of content in critical writing about Minimalism. These issues were also central to the 1980s revival of painting, of which Bleckner was a significant figure, providing a model for other artists developing conceptually based work. He made canvases that bridge the gap between the transcendental ideals of high Modernist abstraction and Minimalism's assertion of the picture plane as a strictly material surface. In his attempt to revive painting after its critically pronounced death, Bleckner rehabilitated the debased style of Op Art, softening the authority of its hard edges in his early 1980s stripe paintings.

"The way I chose to address it [the AIDS crisis] was by making certain elements of my work act as memorials." In 1984 Bleckner began a body of work incorporating ghostly semitransparent imagery set against dark, spatially illusionistic fields. Through a proliferation of floating urnlike vessels, trophies, garlands, and flowers, the artist created a morbid fin-de-siècle dream space. The memorial symbols in these works have been widely per-

ceived as a response to the AIDS epidemic and its profound impact on the art world. Bleckner's subsequent motifs are even more elegiac and directly related to the ravages of AIDS—starry skies; the architecture of basilicas; markings resembling Kaposi's sarcoma and immunodeficient cells; and a constant suggestion of a glowing, otherworldly light.

Throbbing Hearts maintains the melancholy quality of all Bleckner's work. The passages of luminous red pigment floating on a silvery gray field suggest the pulsing hearts of the painting's title. Like other iconic forms in the artist's work, the heart—traditionally considered the bodily seat of love and faith—is richly evocative. Bleckner's hearts may be considered metonymic allusions to individual beings. "I have always thought of painting as skin, in a sense holding things back, 'in place,' existing tensely over that that it represses," Bleckner said in a 1988 interview. "The painter then X-rays parts that the skin covers and uncovers them. The metaphor is obviously figurative (skin protecting the fragility of that that it conceals) but I want the result to be abstract: it transforms itself in the making from the idea of an organ (like a throbbing close to the chest) into an idea about just throbbing."

J.B.

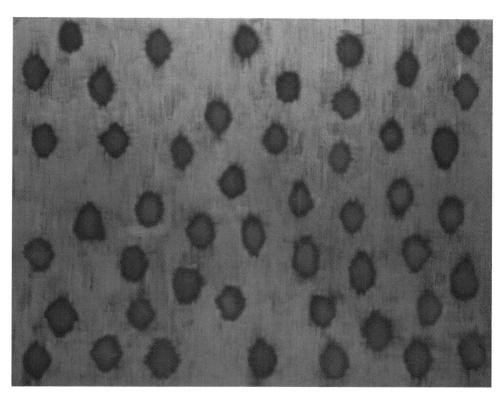

Throbbing Hearts, 1994.
Oil, powdered pigment, and wax on canvas, 96 % x 120 ¼ inches. Gift of the artist. 95.4485

Pierre Bonnard b. 1867, Fontenay-aux-Roses, France; d. 1947, Le Cannet, France

At the time Bonnard was painting this summer breakfast scene, Rockefeller Center stood half built and Europe was gearing itself for war. Yet the modern world seems all but ignored in Bonnard's painting, which harks back to the artistic tenets of the late 19th century, its vibrant colors conjuring up the canvases and theories of Paul Gauguin's circle. Around 1890, Bonnard belonged to the Nabis (from the Hebrew word for "prophet"), a group that tended to paint mystical or occult scenes in order to invoke extraordinary psychic states. As this painting shows, Bonnard still lent a hallucinatory aura to the everyday some 40 years later.

Bonnard resolutely painted subjects such as *Dining Room on the Garden* for most of his life, being called an *intimiste* and *très japonard* for his attempts to create a charged psychological moment in a virtually non-perspectival domestic space. This painting, one of more than 60 dining-room scenes he made between 1927 and 1947, is neither decorative (as these works have often been called) nor is its subject truly his first concern. *Dining Room on the Garden* sets out to capture the moment and the intrinsically ungraspable play of mood and light. On close inspection, the colored areas within the flattened picture plane lose their relation to the objects depicted: a chair melds into the window frame; the window echoes the painting's borders, becoming a view within a view; and Marthe, the painter's oft-depicted wife, merges passively into her surroundings. It is in his ability to create a timeless microcosm while laying bare the gesture of applying paint to canvas that Bonnard's Modernism is revealed.

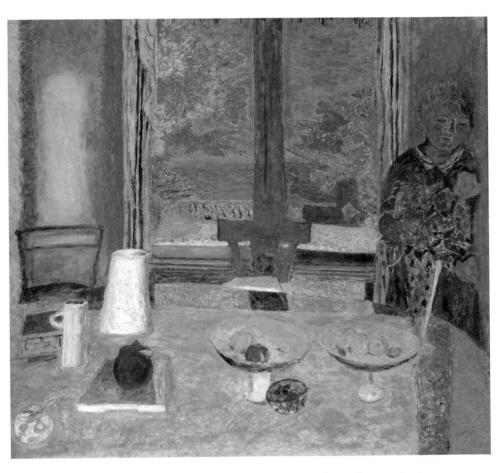

Dining Room on the Garden, 1934–35. Oil on canvas, 50 x 53 ¼ inches. Gift, Solomon R. Guggenheim. 38.432

Louise Bourgeois b. 1911, Paris

Nearly ten years after Louise Bourgeois moved to New York from her native Paris, she embarked on a series of approximately 80 carved and assembled wooden sculptures known as Personnages, which embody the essential themes and obsessions of all her subsequent work. Described by Bourgeois as her first truly mature artistic effort, these life-size, semiabstract, vaguely anthropomorphic sculptures created between 1945 and 1955 functioned as surrogates for real people close to her—some departed, some forsaken, and some eminently present. Seventeen of these Personnages—including Dagger Child—were featured in a solo exhibition at New York's Peridot Gallery in 1949. The installation underscored the sculptures' figurative quality. Shown without bases, the thin, freestanding, vertical forms inhabited the room in small clusters like visitors conversing while perusing the exhibition. Bourgeois considered this spatial arrangement a critical component of the presentation because she intended to create a "reconstruction" of her past with this display of surrogates. Motivated by homesickness, a churning resentment over familial betraval dating from her childhood, a desire to connect with loved ones, and a wish to control those who perturbed her, the Personnages were as much conjured as they were carved, nailed, and painted. The presence of autobiographical references, the symbolic content of abstract form, and the staged interaction between objects in space—all enduring motifs in Bourgeois's art—were conjoined in this early, pivotal exhibition and, in their fusion, perfectly anticipated her haunting installation work of the 1990s, which invokes psychological conditions of the body through architectural metaphors.

The *Personnages* had clear associations with avant-garde art of the late 1940s, particularly in their totemlike structures, which can be read as a three-dimensional correlate to the totemic forms in the early work of Jackson Pollock, Mark Rothko, and Mark Tobey. At the time that Bourgeois created these sculptures, she was exhibiting regularly with members of the soon-to-be-christened New York School. And as a European émigré she was well versed in the Surrealists' fascination with the "primitive" in relation to the unconscious. Regardless of such shared concerns, Bourgeois has always spoken with an unmistakably unique voice, one that struggles to articulate the vicissitudes of her life. *Femme Volage*, for instance, is a self-described self-portrait. With this in mind, it is possible to see the *Personnages* also as stylized images of the sewing tools—needles, bobbins, and so on—that in Bourgeois's visual vocabulary have come to symbolize her parents, who were tapestry restorers.

Dagger Child, 1947–49. Painted wood, 76 1/8 x 5 3/8 x 5 1/8 inches. 92.4001

Femme Volage, 1951. Painted wood, 73 x 18 x 13 inches. 92.4002

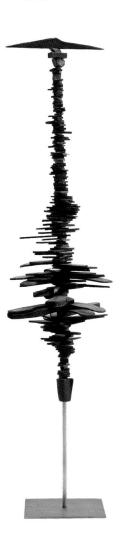

Bourgeois

The designation of an artist's "late work"—as in the case of Paul Cézanne or Pablo Picasso—often implies a slackening of formal criteria and an introspective, if not nostalgic, attitude that results, ultimately, in a clarity of vision. For Bourgeois, these qualities have held true for an aesthetic production spanning six decades, during which she has created a rich and ever-changing body of work that oscillates between abstraction and the visceral representation of psychic states. What unifies Bourgeois's myriad drawings, installations, and sculptural essays in marble, wood, metal, plaster, or latex is an intense emotional substance that at once exposes facets

"The subject of pain is the business I am in. To give meaning and shape to frustration and suffering. What happens to my body has to be given a formal aspect. So you might say, pain is the ransom of formalism." of her own personal history and confronts the bitter-sweet ordeal of being human. Present throughout the oeuvre is a fusion of seeming opposites, a deliberate dismantling of Western dualistic thought, which rends male from female, order from chaos, good from evil, pleasure from pain. In many of her anthropomorphic sculptures, Bourgeois merges images of breasts and vaginas with representations of penises to create ambiguous but, nevertheless, complete entities. The tension between diametrically opposed emotional states—aggression and impotence, desire and rejection, terror and fortitude—is explored in her most recent work.

In haunting assemblages of collected objects that trigger memory and association, Bourgeois contemplates the various permutations of pain. According to the artist, the elegant sculpture Le Défi symbolizes selfpreservation in the face of adversity and anguish. Composed of delicately but tenaciously balanced shelves supporting manifold glass containers and mirrors, all of which have belonged to Bourgeois, Le Défi suggests the strength achieved by acknowledging, even embracing, vulnerability. Whereas her carved stone sculptures represent defense against pain through rigidity—a resistance under pressure—the open, transparent vessels in this work signify, for Bourgeois, the courage to reveal feelings of inadequacy, fear, and loneliness. The soft light that shines through them from a hidden source of illumination expresses the will to adopt this particular strategy of defense, in which one is utterly exposed yet selfpossessed and thus secure. Fragile yet resilient, ephemeral yet exceedingly tangible, Le Défi is essentially a three-dimensional poem that bespeaks the emotional struggles at the core of Bourgeois's art.

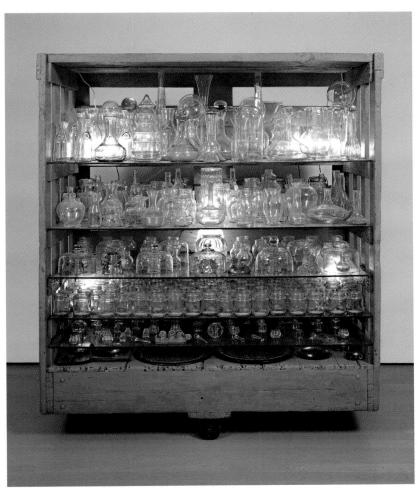

Le Défi, 1991. Painted wood, glass, and electrical light, 67 ½ x 58 x 26 inches. 91.3903

Constantin Brancusi b. 1876, Hobitza, Romania; d. 1957, Paris

When Constantin Brancusi moved to Paris from his native Romania in 1904, he was introduced to Auguste Rodin, the French master sculptor who was then at the height of his career. He invited Brancusi to join his atelier as an apprentice, but the younger artist—with the confidence, stubbornness, and independence of youth—declined, claiming that "nothing grows in the shade of a tall tree." Brancusi rejected Rodin's 19th-century emphasis on theatricality and accumulation of detail in favor of radical simplification and abbreviation; he suppressed all decoration and explicit

"Simplicity is not an objective in art, but one achieves simplicity despite oneself by entering into the real sense of the thing." narrative referents in an effort to create pure and resonant forms. His goal was to capture the essence of his subjects—which included birds in flight, fish, penguins, and a kissing couple—and render them visible with minimal formal means.

Brancusi often depicted the human head, another favorite subject, as a unitary ovoid shape separate from the body. When placed on its side, it evokes images of repose. Some of Brancusi's streamlined oval heads, whose forms recall Indian fertility sculptures in their fusion of egglike and phallic shapes, suggest the miracle of creation.

Brancusi's marble *Muse* is a subtle monument to the aesthetic act and to the myth that woman is its inspiration. The finely chiseled and smoothly honed head is poised atop a sinuous neck, the curve of which is counterbalanced by a fragmentary arm pressed against the ear. The facial features, although barely articulated, embody the proportions of classical beauty. As in the sculptor's *Mlle Pogany*, also of 1912, the subject's hair is coiffed in a bun at the base of the neck. But while *Mlle Pogany* is the image of a particular woman, *The Muse* is the embodiment of an ideal.

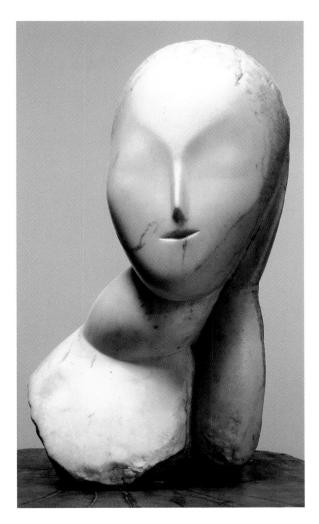

The Muse, 1912. Marble, 17 ³/₄ x 9 x 6 ⁵/₄ inches. 85.3317

Brancusi

The monumental oak *King of Kings* was originally intended to stand in Brancusi's *Temple of Meditation*, a private sanctuary commissioned in 1933 by the Maharaja Yeshwant Rao Holkar of Indore. Although never realized, the temple—conceived as a windowless chamber (save for a ceiling aperture) with interior reflecting pool, frescoes of birds, and an underground entrance—would have embodied the concerns most essential to Brancusi's art: the idealization of aesthetic form; the integration of architecture, sculpture, and furniture; and the poetic evocation of spiritual thought.

Wood elicited from Brancusi a tendency toward expressionism, resulting in unique carved objects. While his sculptures executed in stone or metal represent archetypal forms, such as birds in flight and sleeping figures, individual works in wood suggest specific characters or spiritual entities.

"Only the Africans and the Romanians know how to carve wood." For example, *King of Kings* may be interpreted as Brancusi's attempt to translate the power of Eastern religion into sculptural form. The work's original title was *Spirit of Buddha*, and Brancusi is known to have been familiar with Buddhism through the writings of the Tibetan philosopher Milarepa.

Although the extent to which Brancusi's work was inspired by African sculpture and Romanian folk carvings has been widely debated among scholars, it is clear that he was acutely responsive to "primitivizing" influences early in his career. Paul Gauguin's technique of direct carving to emulate the raw quality of indigenous Tahitian art inspired Brancusi to experiment with more daring approaches to sculpture than his academic training had previously allowed. Gauguin's aesthetic most likely prompted Brancusi to study tribal art, evident in the serrated patterns typical of African carvings on the bottom portion of Adam and Eve as well as on the sides of King of Kings. The overt sexual references in the former work may also have been inspired by "primitive" fetishes.

Sculptural sources from Brancusi's native country are also abundant: prototypes for the sequential designs of *King of Kings* have been found in Romanian vernacular architecture such as wooden gate posts and chiseled ornamental pillars. *The Sorceress* has been interpreted as the flying witch described in Romanian peasant tales. Brancusi never clarified the visual sources for his designs, pre ferring instead to promote an air of mystery surrounding the origins of his vision.

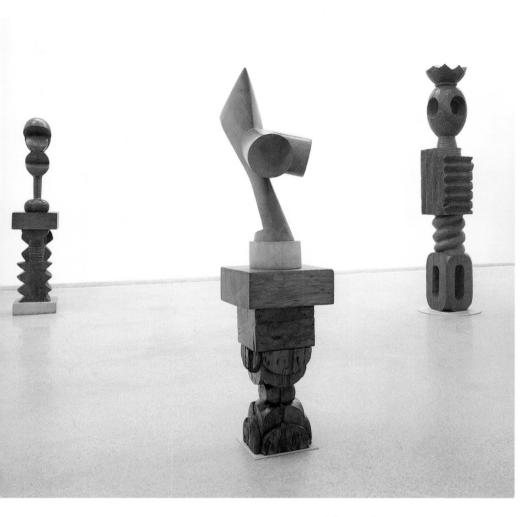

Adam and Eve, 1916–24. Chestnut (Adam) and oak (Eve), on limestone base, 94 x 18 3/4 x 17 1/4 inches overall. 53.1329.a-.d

The Sorceress, 1916–24.
Walnut on limestone base, 44 1/6 x 19 x 24 inches. 56.1448
Shown on Guard Dog, 1916. Oak, 29 1/6 x 15 1/4 x 14 1/4 inches. 58.1503

King of Kings, early 1930s. Oak, 118 3/8 x 19 x 18 1/8 inches. 56.1449

Georges Braque b. 1882, Argenteuil-sur-Seine, France; d. 1963, Paris

When Georges Braque abandoned a bright Fauve palette and traditional perspective in 1908, it was the inspiration of Paul Cézanne's geometrized compositions that led him to simplified faceted forms, flattened spatial planes, and muted colors. By the end of that year, Braque and Pablo Picasso, who first met in 1907, began to compare the results of their techniques and it became obvious to both artists that they had simultaneously and independently invented a revolutionary style of painting, later dubbed "Cubism" by Guillaume Apollinaire. During the next few years the new style blossomed with stunning rapidity from its initial formative stage to

"At this period I painted musical instruments, in the first place because I was surrounded by them, secondly because by their very nature they appertained to my conception of a still life and lastly because I was already working toward a tactile space."

high Analytic Cubism. The hallmarks of this advanced phase, so-called for the "breaking down" or "analysis" of form and space, are seen in an extraordinary pair of pendant works, *Violin and Palette* and *Piano and Mandola*

Objects are still recognizable in the paintings, but are fractured into multiple facets, as is the surrounding space with which they merge. The compositions are set into motion as the eye moves from one faceted plane to the next, seeking to differentiate forms and to accommodate shifting sources of light and orientation. In *Violin and Palette*, the segmented parts of the violin, the sheets of music, and the artist's palette are vertically arranged, heightening their corre-

spondence to the two-dimensional surface. Ironically, Braque depicted the nail at the top of the canvas in an illusionistic manner, down to the very shadow it cast, thus emphasizing the contrast between traditional and Cubist modes of representation. The same applies to the naturalistic candle in *Piano and Mandola*, which serves as a beacon of stability in an otherwise energized composition of exploding crystalline forms: the blackand-white piano keys all but disembodied; the sheets of music virtually disintegrated; the mandola essentially decomposed.

"When fragmented objects appeared in my painting around 1909," Braque later explained, "it was a way for me to get as close as possible to the object as painting allowed." If the appeal of still life was its implied tactile qualities, as Braque noted, then musical instruments held even more significance in that they are animated by one's touch. Like the rhythms and harmonies that are the life of musical instruments, dynamic spatial movement is the essence of Braque's lyrical Cubist paintings.

J.A.

Violin and Palette, autumn 1909. Oil on canvas, 36 1/8 x 16 7/8 inches. 54.1412

Piano and Mandola, winter 1909–10. Oil on canvas, 36 1/8 x 16 1/8 inches. 54.1411

Alberto Burri b. 1915, Città di Castello, Italy; d. 1995, Nice

In 1943 Alberto Burri, a doctor in the Italian army, was captured by the British and sat out the remainder of World War II in a Texas POW camp. He began to paint there, covering his stretchers with burlap when other materials were unavailable. Upon his return to Italy in 1946 Burri renounced his original profession and dedicated himself to making art.

Composition is one of his Sacchi (sacks), a group of collage constructions made from burlap bags mounted on stretchers, which the artist began making in 1949. One of Burri's first series employing nontraditional medi-

"Words are no help to me when I try to speak about my painting. It is an irreducible presence that refuses to be converted into any other form of expression. It is a presence both immanent and active." ums, the Sacchi were initially considered assaults against the established aesthetic canon. His use of the humble bags may be seen as a declaration of the inherent beauty of natural, ephemeral materials, in contradistinction to traditional "high" art mediums, which are respected for their ostentation and permanence. Early commentators suggested that the patchwork surfaces of the Sacchi metaphorically signified living flesh violated during warfare—the stitching was linked to the artist's practice as a physician. Others suggested that the hardships of life in postwar Italy predicated the artist's redeployment of the sacks in which relief supplies were sent to the country.

Yet Burri maintained that his use of materials was determined purely by the formal demands of his constructions. "If I don't have one material, I use another. It is all the same," he said in 1976. "I choose to use poor materials to prove that they could still be useful. The poorness of a medium is not a symbol: it is a device for painting." The title *Composition* emphasizes the artist's professed concern with issues of construction, not metaphor. Underlying the work is a rigorous compositional structure that belies the mundane impermanence of his chosen mediums and points to art-historical influences. The *Sacchi* rely on lessons learned from the Cubist- and Dada-inspired constructions of Kurt Schwitters.

Despite Burri's cool public stance, the *Sacchi* are examples of the expressionism widely practiced in postwar Europe, where such work was called Art Informel (in the U.S. it was called Abstract Expressionism). Artists used powerfully rendered gestures and accommodated chance occurrences to express the existential angst characteristic of the period.

J.B.

Composition, 1953.
Oil, gold paint, and glue on burlap and canvas, 33 1/8 x 39 1/2 inches. 53.1364

Alexander Calder b. 1898, Lawnton, Pa.; d. 1976, New York City

One fortuitous event associated with Alexander Calder's 1964–65 retrospective at the Guggenheim was the rediscovery of two wire sculptures made in 1928: Romulus and Remus and Spring (both are now in the museum's collection). A few years after he constructed these witty, figurative works, Calder stored them away in a closet. On retrieving them he commented, "I'd always thought these particularly humorous, but now they look like good sculpture." Romulus and Remus represents the mythological founders of Rome being suckled by a protective she-wolf. This scene, often depicted in Western art, is rendered here in a most whimsical manner: both the boys' genitals and the wolf's nipples are represented by wooden doorstops. The sculpture's armature consists of a single wire that is twisted and bent to suggest both volume and void. Romulus and Remus is a drawing executed in space; its calligraphic outline is the equivalent of Calder's

"I think best in wire."

rapid, abbreviated pencil-and-pen sketches of acrobats and animals.

Although entertaining and uncomplicated in execution, it explores issues critical to 20th-century sculpture: the interchangeability of space and mass, translucency, and the relation of two- to three-dimensionality. While Calder experimented with other unusual materials, his favorite medium was wire. Its flexibility and capacity to vibrate may have inspired his kinetic sculptures.

Dating from 1932, Calder's first hanging sculptures of discrete movable parts powered by the wind were christened "mobiles" by Marcel Duchamp. It is now a vernacular art form, but when Calder invented it the mobile was viewed as an avant-garde achievement, a sculptural counterpart to Joan Miró's paintings of buoyant, biomorphic figures and Jean Arp's abstract reliefs. Although they are nonfigurative, Calder's hanging mobiles, particularly the monumental yet delicate *Red Lily Pads*, retain references to the natural world: the dancing and spinning of the disks evoke the intangible qualities of the air that propels them. According to art historian Rosalind Krauss, the mobiles—as interconnected vertical structures in space—create a sense of volume analogous to that of the human body. In their surrender to the pull of gravity and their displacement of space through motion, the mobiles become anthropomorphic metaphors.

Red Lily Pads, 1956. Painted sheet metal, metal rods, and wire, 42 x 201 x 109 inches. 65.1737

Romulus and Remus, 1928. Wire and wood, $30 \frac{1}{2} \times 124 \frac{1}{2} \times 26$ inches. 65.1738.a-.c

Paul Cézanne b. 1839, Aix-en-Provence; d. 1906, Aix-en-Provence

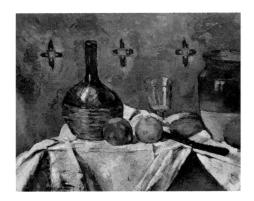

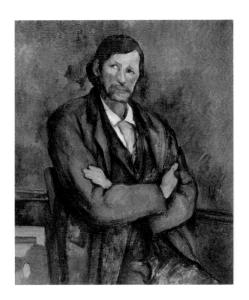

Paul Cézanne's shimmering landscapes, searching portraits, and complex still lifes may be viewed as the culmination of Impressionism's quest for empirical truth in painting. His work was motivated by a desire to give sculptural weight and volume to the instantaneity of vision achieved by the Impressionists, who painted from nature. Relying on his perception of objects in space as visually interrelated entities—as forms locked into a

"I think of art as personal apperception. I place this perception in sensation, and I require that the intelligence organize it into a work of art." greater compositional structure—Cézanne developed a style premised on the oscillation of surface and depth. Each tiny dab of color, as demonstrated on the mottled apples in *Still Life: Flask, Glass, and Jug.* indicates a spatial shift while simultaneously calling attention to the two-dimensional canvas on which it rests. This play of illusion, along with the conceptual fusion of time and space, has led Cézanne to be considered the foremost precursor of Cubism.

The artist's late work, created in relative isolation in the south of France, is marked by an intensification of his perceptual analysis coupled with an increasingly introspective sensibility. In *Man with Crossed Arms*, the strangely distorted, proto-Cubist view of the sitter—his right eye is depicted as if glimpsed from below and the left as if seen from above—contributes an enigmatic, contemplative air to the painting. This portrait

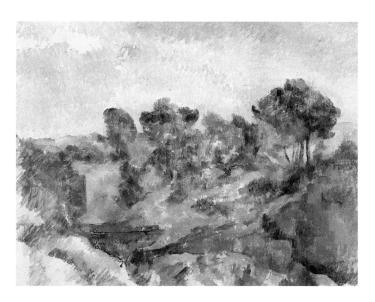

of an anonymous sitter has come to be seen as a psychological study of quiet resignation and reserve—characteristics often attributed to Cézanne during the last decade of his life.

The artist's obsession with the nuances of spatial construction and optical effect is evinced in the numerous landscapes painted during this late period. In the abandoned and overgrown quarries known as Bibémus, east of the town of Aix-en-Provence, Cézanne discovered a rough, partially man-made, and intensely chromatic landscape that suited his geometrizing style. Between 1895 and 1899 he proceeded to visually explore the geographic and tonal variations that occurred in this remote, deserted area. In the Guggenheim's canvas, Cézanne's restless strokes and intermittent patches of complementary colors form passages of flatness and volume that create at once a diaphanous surface pattern and an illusion of great depth. The artist's unique sensations of the terrain are manifest in this picture as a radiant tapestry that heralds the imminent advent of abstract painting.

Still Life: Flask, Glass, and Jug.

Oil on canvas, 18 x 21³/₄ inches. Thannhauser Collection, Gift, Justin K. Thannhauser, 78.2514.3

Man with Crossed Arms, ca. 1899. Oil on canvas, 36 1/4 x 28 5/6 inches. 54.1387

Bibémus, ca. 1894–95.
Oil on canvas, 28 1/8 x 35 1/8 inches.
Thannhauser Collection, Gift,
Justin K. Thannhauser. 78.2514.6

N.S.

Marc Chagall b. 1887, Vitebsk, Russia; d. 1985, St. Paul de Vence, France

After Marc Chagall moved to Paris from Russia in 1910, his paintings quickly came to reflect the latest avant-garde styles. In *Paris Through the Window*, Chagall's debt to the Orphic Cubism of his colleague Robert Delaunay is clear in the semitransparent overlapping planes of vivid color in the sky above the city. The Eiffel Tower, which appears in the cityscape,

"Oh! If astride the stone chimera of Notre Dame I could manage with my arms and my legs to trace my way in the sky!

There it is! Paris, you are my second Vitebsk!"

was also a frequent subject in Delaunay's work. For both artists it served as a metaphor for Paris and perhaps modernity itself. Chagall's parachutist might also refer to contemporary experience, since the first successful jump occurred in 1912. Other motifs suggest the artist's native Vitebsk. This painting is an enlarged version of a window view in a self-portrait painted one year earlier, in which the artist contrasted his birthplace with Paris. The Janus figure in Paris Through the Window has been read as the artist looking at once westward to his new home in France and eastward to Russia.

Chagall, however, refused literal interpretations of his paintings, and it is perhaps best to think of them as lyrical evocations, similar to the allusive plastic poetry of the artist's friends Blaise Cendrars (who named this canvas) and Guillaume Apollinaire.

Years after Chagall painted *The Soldier Drinks* he stated that it developed from his memory of tsarist soldiers who were billeted with families during the 1904–05 Russo-Japanese war. The enlisted man in the picture, with his right thumb pointing out the window and his left index finger pointing to the cup, is similar to the two-faced man in *Paris Through the Window* in that both figuratively mediate between dual worlds—interior versus exterior space, past and present, the imaginary and the real. In paintings such as these it is clear that the artist preferred the life of the mind, memory, and magical symbolism over realistic representation.

In Green Violinist Chagall evoked his homeland. The artist's nostalgia for his own work was another impetus in creating this painting, which is based on earlier versions of the same subject. His cultural and religious legacy is illuminated by the figure of the violinist dancing in a rustic village. The Chabad Hasidim of Chagall's childhood believed it possible to achieve communion with God through music and dance, and the fiddler was a vital presence in ceremonies and festivals.

Paris Through the Window,

1913.

Oil on canvas, 53½ x 55¾ inches. Gift, Solomon R. Guggenheim. 37.438

Green Violinist, 1923–24. Oil on canvas, 78 x 42 ¾ inches. Gift, Solomon R. Guggenheim. 37.446

The Soldier Drinks, 1911–12. Oil on canvas, 43 x 37 ¼ inches. 49.1211

John Chamberlain b. 1927, Rochester, Ind.

John Chamberlain's dynamic agglomerations of scrap metal and used automobile bodies have been admired for translating the achievements of Abstract Expressionist painting into three-dimensional form. The whirling arabesques of color in wall reliefs such as *Dolores James* echo the energy

"I'm a collagist. A collagist fits things together."

and expressive power of paintings by Willem de Kooning; the heroic gist scale and animated diagonals suggest the canvases of Franz Kline.

er." Like the Abstract Expressionists before him, Chamberlain revels in the potential of his mediums. In a 1972 interview with critic Phyllis Tuchman he remarked, "I'm sort of intrigued with the idea of what I can do with material and I work with the material as opposed to enforcing some kind of will upon it." Chamberlain emphasizes the importance of "fit," or the marriage of parts, in his sculpture. As in other early works,

the various elements of Dolores James stayed in place by virtue of careful

balances when the sculpture was first assembled; later, the work was spot-welded to ensure its preservation.

Chamberlain's oeuvre appeared in the context of late-1950s assemblage or Junk Art, in which the detritus of our culture was reconsidered and reinterpreted as fine art. On some level, his conglomerations of automobile carcasses must inevitably be perceived as witnesses of the car culture from which they were born, and for which they serve as memorials. There is a threatening air about the jagged-edged protuberances in Chamberlain's sculptures, and the dirty, dented automobile components suggest car crashes; the artist, however, prefers to focus on the poetic evocations that his sculptures elicit.

Dolores James, 1962. Welded and painted steel, 76 x 97 x 39 inches. 70.1925

Francesco Clemente b. 1952, Naples, Italy

In the years around 1980, Francesco Clemente was one of a group of young Italian painters who broke free from the sterile abstraction of Minimalism and the humble materialism of Arte Povera, movements that had pronounced painting, especially figurative painting, a dead medium. The painting revival—identified as the Transavanguardia by critic Achille Bonito Oliva—that began in Italy sparked an international stylistic shift that persisted throughout the 1980s and involved artists such as Georg Baselitz, Anselm Kiefer, and Julian Schnabel. Also known as Neo-Expressionism, this movement revitalized painting and brought back individual expression by using sensuous color, gestural technique, narrative content, and the human figure on a grand scale.

"The body [is] a line.
The boundary between inner
and outer worlds. . . .
Outer worlds leak inside,
inner worlds pour out."

Scissors and Butterflies, although from a later stage in Clemente's oeuvre, exemplifies the most sensual and visually forceful aspects of this style. The painting reveals recurrent themes in Clemente's work: a sense of the exotic; explicit sexual imagery; and metamorphoses between human and animal forms. The eyelashes of the female figures have been transformed into elongated insect antennae, echoing the sharp, curving forms of the scissors blades. Individual

limbs are difficult to distinguish as the women's writhing bodies merge with and seem to penetrate each other. The pervasive sense of anxiety and violence—accentuated by the open scissors—intensify the composition's eroticism, as does the heated red and electric green palette. A radical take on the three graces, Clemente's provocative nudes are more than a fanciful trio in a dreamlike setting. At once feminine and masculine, whimsical and savage, passive and hostile, these muses transgress traditional boundaries.

Clemente's metaphoric vocabulary is deeply rooted in the body, and the artist's many variations on the human form indicate its primacy as a symbol for how he envisions the world. Representing both wholeness and fragmentation, freedom and constriction, the body is Clemente's ultimate vehicle for expressing life's dualities, especially in the many portraits and self-portraits produced throughout his career. In this painting, the fragile delicacy of butterfly wings is juxtaposed with the women's salacious positions and the sharp, menacing scissors. As in much of Clemente's work, bodily orifices—eyes and genitals—are prominent. For him, these sensitive regions serve as channels between the interior realm of the psyche and the exterior world of nature, culture, and "the other." An artist with close ties to Italy, America, and India, Clemente has always used the influence of foreign cultures to explore the interface between self and surroundings.

Scissors and Butterflies, 1999. Oil on linen, 91 x 92 inches. 99.5280

Collaboration

Collaboration has both positive and negative connotations. It means working jointly, either in a partnership with varying degrees of equality, or in a communal effort that enriches the self. At the same time it implies sacrificing part of one's individuality in order to adapt to the personality of the other, which may lead to an irreversible loss of identity. And since World War II, especially in France, a collaborator is also someone who sides with the enemy.

Merce Cunningham and John Cage, 1963. Photo © Jack Mitchell.

As an alternative to the predominant tradition of light-footed immortal muses descending from their pedestals to bestow genius upon artists, poets, and scientists, collaboration posits the model of the twins Castor and Pollux, who in living and dying alternately share immortality between one another. The nonhierarchical attitude of mutual give-and-take is perfectly embodied in the artists Gilbert and George, who since 1967 have presented themselves side by side as "living sculptures." Both artists have fused their twoness into one consciousness, a united we-form.

There are as many different collaborations as there are collaborators. One of the most moving was the eight-year-long partnership between the young Polish student of mathemat-

ics and physics Marie Sklodowska and the brilliant French physicist Dr. Pierre Curie. Their leap into the unknown was a joint adventure; they cooperated inseparably as one mind. In their notebooks they referred to one another only in terms of "we found" and "we observed."

One of the most desirable forms of collaboration occurred between the choreographer Merce Cunningham and the composer John Cage, who worked both cooperatively and independently. Like two electrodes forming an arc, the two artists never stopped being involved in one another's experiments. At the same time they respected one another's individuality, such as when the dancers do not rely on the sound or when the music varies rhythmically from performance to performance while the total length of the dance is the same.

If a collaboration succeeds, it always appears inevitable in retrospect. When Stan Laurel was asked how he and Oliver Hardy first met, and how they developed into a team, Stan's casual answer summed up that of most successful teammates: "I always explained we just sort of came together—naturally."

COOSJE VAN BRUGGEN

Collage

In their experiments with Cubism, Georges Braque and Pablo Picasso proposed a new art form in which the subject of the café collided with the surface plane of the painting. At once serious and tongue-in-cheek, they methodically reexamined painting and sculpture and gave each medium some of the characteristics of the other. In the process they invented collage.

It was Braque who purchased a roll of simulated oak-grain wallpaper and began cutting out pieces of the paper and attaching them to his charcoal drawings. Picasso immediately began to make his own experiments in the new medium. Their use of papier collé (a term used to distinguish cut and pasted papers from the more inclusive term collage) signaled the beginning of a new approach to art. Picasso and Braque placed great value on commonplace materials and objects and on subjects drawn from the everyday world: a newspaper, a bottle of ale, or a pipe are redolent with meaning. References to current events, such as the war in the Balkans, and to popular culture enriched the content of their art. The artists also extended their experiments to include sculpture constructed out of found objects and flimsy two-dimensional materials such as cardboard.

The Futurists and the Dadaists employed collage to protest entrenched values, while the artists of the Russian avant-garde used photomontage, an outgrowth of collage, to demonstrate their support for a progressive world order. For the Surrealists, collage served as a surrogate for the subconscious. Pop artists recognized it as a means of directly incorporating elements of popular culture into their work. Robert Rauschenberg expanded collage in his own way by creating Combines, assemblages of paintings and found objects that were intended, he said, to act in the gap between art and life.

Emphasizing concept and process over end product, collage has brought the incongruous into meaningful congress with the ordinary. With its capacity for change, speed, immediacy, and ephemerality, collage is ideally suited to the demands of this and the prior century. It is a medium of materiality, a record of our civilization, a document of the timely and the transitory. It is no wonder that today's artists continue to use collage as a way of giving expression to the unorthodox, both in art and life.

DIANE WALDMAN

Joseph Cornell b. 1903, Nyack, N.Y.; d. 1972, Flushing, N.Y.

After his first exposure to Surrealist collage in 1931, Joseph Cornell began to work in that format, eventually extending it into three-dimensional box structures. Unlike many European Surrealists, however, he was less interested in disturbing the viewer than in evoking enchanted worlds past and yet to come. Cornell incorporated printed images and found objects into his boxes, which were often conceived in series. Space Object Box: "Little Bear, etc." motif is part of the Winter Night Skies series, which includes fragments of celestial maps of the northern sky. The focus of the map fragment in Space Object Box is the constellation Ursa Minor—the "Little Bear" of the title. The "etc." refers to the other personifications of stars that the artist has colored, including Cameleopardalis, the giraffe, and Draco, the dragon. The blue cork ball and the ring suggest the moon and its orbit:

"It all looks as though it came from a sailor's sea chest and just 'happened' rather than being made in these times." their movement along the two metal rods alludes to the unending cycle of celestial change. The toy block with a horse on its face is probably a punning reference to Pegasus, a square constellation.

Andromeda appears in a box from the Hotel series, Untitled (Grand

Hôtel de l'Observatoire), which also contains an image of the head of Draco on a small cylinder hanging from a rod along the roof of the box; the cascading chain could refer to the long trail of stars called the Dragon's Tail. Mottled royal-blue pigment in the glistening white paint evokes the sparkling of stars in the sky. By incorporating the names of Grand Hotels, cut and pasted like hotel stationery in a scrapbook, Cornell nostalgically recalled the souvenirs of travelers. This box seems to promote the heavens as a place of respite, a view that may reflect the artist's education as a Christian Scientist. Mary Baker Eddy, the charismatic founder of the religion, believed that modern scientific theory holds a key to understanding our world. In a book that Cornell called the most important to him after the Bible, she wrote, "The astronomer will no longer look up to the stars—he will look out from them upon the universe." Cornell, who lived most of his life on Utopia Parkway in Queens, never went to Europe, although his boxes are often filled with tokens of European culture. He could no more visit the 19th-century Old World of his imagination than he could visit the stars, but he could dream about these places and invoke them in his boxes.

J.B.

AND Grand Hölel tie l'Observatoire

Space Object Box: "Little Bear, etc." motif, mid-1950s-early 1960s.
Box construction and collage, 11 x 17 ½ x 5 ¼ inches. 68.1878

Untitled (Grand Hôtel de l'Observatoire), 1954.

Box construction and collage, 18 $\frac{5}{6}$ x 12 $\frac{15}{6}$ x 3 $\frac{7}{6}$ inches. Partial gift, C. and B. Foundation, by exchange. 80.2734

Cultural Activism

The White House, the Capitol building, and the Supreme Court are not the only venues for political activity. Cultural production also occurs on socially and politically inflected terrain. All art is political, but some announces its orientation or opposition more overtly. Inevitably every artwork advocates something, whether a political position or a type of descriptive system—even art that presents itself as an autonomous aesthetic object advocates viewing it that way. The processes by which art is taught, made, distributed, financed, shown, and used are not neutral, but are shaped by historical, economic, and social dynamics. One role of cultural activism is to articulate critical readings of these processes and to

examine the relationship between artists and social structures, including the art industry.

Whether generated individually or collectively, and distributed at either traditional or nontraditional venues, how resolutely politicized artistic activity is manifest depends upon many factors, including purpose, location, material parameters, and the issues at stake. Historically, the visual arts have been politicized for a variety of aims, but activist impulses have been particularly forceful from the 1960s to the present. Many artists have sought to reconnect art to a broader cultural context, making work that functions explicitly as social critique. Protest campaigns, such as those orchestrated by the Art Workers Coalition, Black Emergency Cultural Coalition, and the Guerrilla Girls, have been deployed to counter the elitism of the art world and the absence of women and minorities in museum exhibitions and collections. Alternative artist-run venues—such as

112 Greene Street, Artists Space, and ABC No Rio in New York—were created in the 1970s and 1980s to challenge the hierarchy of the commercial gallery system. Collectives such as Group Material have sought to control the display and distribution of their work and to express a strategy that operates outside the confines of museums and galleries. During these decades artists appropriated the strategies of advertising and mass culture; the collective Gran Fury used billboards and posters to disseminate information about AIDS and comment on deficient public and governmental responses to the epidemic.

Cultural activism can illuminate crucial links between culture, politics, and social agency. Activism is contextual; the material and methodologies it employs are constantly shifting. Critical activities, including those outlined above, have expanded accepted notions of the possible functions and definitions of art.

Group Material, AIDS **Timeline**, 1991. Mixed-media installation

Willem de Kooning b. 1904, Rotterdam, The Netherlands; d. 1997, East Hampton, N.Y.

Although often cited as the originator of Action Painting, an abstract, purely formal and intuitive means of expression, Willem de Kooning most often worked from observable reality, primarily from figures and the land-scape. From 1950 to 1955, de Kooning completed his famous *Women*

"Content, if you want to say, is a glimpse of something, an encounter, you know, like a flash. It's very tiny very tiny, content." series, integrating the human form with the aggressive paint application, bold colors, and sweeping strokes of Abstract Expressionism.

These female "portraits" provoked not only with their vulgar carnality and garish colors, but also because of their embrace of figural representation, a choice deemed regressive by many of de Kooning's Abstract Expressionist contemporaries, but one to which he consistently returned for many decades.

Composition serves as a bridge between the Women and de Kooning's next series of work, classified by critic Thomas Hess as the Abstract Urban Landscapes (1955–58). According to the artist, "the landscape is in the Woman and there is Woman in the landscapes." Indeed, Composition reads as a Woman obfuscated by de Kooning's agitated brushwork, clashing colors, and allover composition with no fixed viewpoint. Completed while the artist had a studio in downtown New York, Composition's energized dashes of red, turquoise, and chrome yellow suggest the frenetic pace of city life, without representing any identifiable urban inhabitants or forms.

Painted 20 years later, after de Kooning moved to East Hampton, New York, seeking to work in greater peace and isolation, ... Whose Name Was Writ in Water takes nature as its theme. Water was a favorite subject of the artist, and he devised a rapid, slippery technique of broad impasto strokes with frayed edges, speckled with drips, to convey its fluidity and breaking movement. The title, taken from an epigraph on Keats's tomb, which de Kooning had seen on a trip to Rome in 1960, is, according to critic Harold Rosenberg, "the closest de Kooning can come to saluting overtly the impermanence of existence, and things in a state of disappearance." Always aiming to reinforce the content of his work with his technique, de Kooning reworked his canvases over and over again, making each painting a composite of evanescent visual traces. The scrambled pictorial vocabulary and condensed space of the urban landscapes was gradually diffused in de Kooning's later work. More open compositions, a less cluttered palette, and looser, liquid brushstrokes reveal a painter relieved of the nervous, claustrophobic atmosphere of city life and newly at peace with his rural surroundings.

Composition, 1955.

Oil, enamel, and charcoal on canvas, 79 1/8 x 69 1/8 inches. 55.1419

...Whose Name Was Writ in Water, 1975.

Oil on canvas, 76 3/4 x 87 3/4 inches. By exchange. 80.2738

Robert Delaunay b. 1885, Paris; d. 1941, Montpellier, France

Robert Delaunay chose the view into the ambulatory of the Parisian Gothic church Saint-Séverin as the subject of his first series of paintings, in which he charted the modulations of light streaming through the stained-glass windows and the resulting perceptual distortion of the architecture. The subdued palette and the patches of color that fracture the smooth surface of the floor point to the influence of Paul Cézanne as well as to the stylistic elements of Georges Braque's early Cubist landscapes. Delaunay said that the Saint-Séverin theme in his work marked "a period of transition from Cézanne to Cubism."

"What is of great importance to me is observation of the movement of colors. Only in this way have I found the laws of complementary and simultaneous contrasts of colors which sustain the very rhythm of my vision." Delaunay explored the developments of Cubist fragmentation more explicitly in his series of paintings of the Eiffel Tower. In these canvases, characteristic of his self-designated "destructive" phase, the artist presented the tower and surrounding buildings from various perspectives. Delaunay chose a subject that allowed him to indulge his preference for a sense of vast space, atmosphere, and light, while evoking a sign of modernity and progress. Like the soaring vaults of Gothic cathedrals, the Eiffel Tower is a uniquely French symbol of invention and aspiration. Many of Delaunay's images of this structure and the surrounding city are views from a window

framed by curtains. In *Eiffel Tower* (painted in 1911, although it bears the date 1910) the buildings bracketing the tower curve like drapery.

The artist's attraction to windows and window views, linked to the Symbolists' use of glass panes as metaphors for the transition from internal to external states, culminated in his *Simultaneous Windows* series. (The series derives its name from the French scientist Michel-Eugène Chevreul's theory of simultaneous contrasts of color, which explores how divergent hues are perceived at once.) Delaunay stated that these works began his "constructive" phase, in which he juxtaposed and overlaid translucent contrasting complementary colors to create a synthetic, harmonic composition. Guillaume Apollinaire wrote a poem about these paintings and coined the word Orphism to describe Delaunay's endeavor, which he believed was as independent of descriptive reality as was music (the name derives from Orpheus, the mythological lyre player). Although *Simultaneous Windows (2nd Motif, 1st Part)* contains a vestigial green profile of the Eiffel Tower, it is one of the artist's last salutes to representation before his leap to complete abstraction.

J.B.

Saint-Séverin No. 3, 1909–10. Oil on canvas, 45 x 34 ¼ inches. Gift, Solomon R. Guggenheim. 41.462

Share the state of the state of

Simultaneous Windows (2nd Motif, 1st Part), 1912.
Oil on canvas, 21 1/1 x 18 1/4 inches. Gift, Solomon R. Guggenheim. 41.464

Eiffel Tower, 1911. Oil on canvas, 79½ x 54½ inches. Gift, Solomon R. Guggenheim. 37.463

Walter De Maria b. 1935, Albany, Calif.

Walter De Maria is best known for his 1977 Lightning Field. A rectangular grid in New Mexico measuring one mile by one kilometer and containing 400 stainless-steel lightning rods, it serves as an arena for observing meteorological activity. The artist has also brought such ordered experiences of the landscape into the gallery, translating distance, measure, and nature into abstract tableaux known as Earthrooms, in which accretions of soil, rocks, gravel, or peat fill the floors of architectural structures. De Maria's reputation as an Environmental artist—linking him with Michael Heizer, Nancy Holt, and Robert Smithson—acknowledges only one facet of his challenging oeuvre. Less appreciated is De Maria's early association with Fluxus and performance in San Francisco prior to his arrival in New York in 1960. From his exposure to the work of composer La Monte Young and dancer Simone Forti, among others, De Maria developed an interest in task-oriented, gamelike projects that resulted in viewer-interactive sculptures. For example, his Boxes for Meaningless Work (1961) is inscribed with the instructions, "Transfer things from one box to the next box back and forth, back and forth, etc. Be aware that what you are doing is meaningless." This participative component was retained, but only metaphorically, in the artist's small-scale, polished-

aluminum floor sculptures in shapes that possess significant iconic impact—the cross, the six-pointed star, and the swastika. The hollow interiors of the sculptures form narrow channels containing metal spheres. By including these seemingly movable balls, De Maria again evoked the notion of game-playing, but given the narrative association of the symbols, it seems an ironic gesture.

Conceived of separately, but now often exhibited together, *Cross, Star,* and *Museum Piece* manifest how ancient symbolic configurations have undergone various interpretive transmutations: the cross, mark of Christianity, has also been discovered on Egyptian tombs; the six-pointed star, sign of Judaism, first appeared on Bronze and Iron Age relics; and the swastika, emblem of Nazism, was once representative of prosperity, regeneration, and goodwill. By titling the swastika *Museum Piece*, De Maria seems also to have been commenting on the neutralizing effects of the museum environment, in which cultural artifacts, removed from their original contexts, can be reduced to visual equivalences.

Cross, 1965-66.

Aluminum, 4 x 42 x 22 inches. 73.2033

Star, 1972.

Aluminum, 4 x 44 x 50 inches. 73.2035

Museum Piece, 1966.

Aluminum, 4 x 36 x 36 inches. 73.2034

Jim Dine b. 1935, Cincinnati

During the early 1960s Jim Dine was part of a loosely affiliated group of artists—including Red Grooms, Claes Oldenburg, and Lucas Samaras—who extended the gestural and subjective implications of Abstract Expressionist painting into outrageous performances, subsequently known as Happenings. Inspired by John Cage's radical approach to musical composition, which involved chance, indeterminacy, and an emphatic disregard for all artistic boundaries, they sought to transgress preexisting aesthetic values. Dine and Oldenburg brought this sensibility to bear on a two-artist exhibition called *Ray-Gun*, held at the Judson Gallery in New York in February and March 1960. For the show, each artist made an installation consisting of a chaotic configuration of found and manipulated objects. In Dine's jumbled environment, *The House*, the walls and ceiling

"The object is used to make art, just like paint is used to make art." of the gallery were effaced by an agglomeration of painted cloth, fragmented domestic objects, scrawled slogans, crumbled paper, and suspended metal bedsprings. Scattered throughout were cardboard signs spelling out various household platitudes, such as BREAKFAST IS READY and GO TO WORK. Dine claimed that the juxtaposition of these and other banal phrases with the surrounding

domestic wreckage revealed the potential violence inherent to a home. His critique of the myth of the happy home was amplified by anthropomorphic references—painted eyes, faces, and other body parts—that were hidden or lost amid the detritus. This accretion of fragmented figures, discarded articles, and tattered elements is present, albeit in abbreviated form, in Dine's sculpture *Bedspring*, which may have been part of (or at least inspired by) *The House*.

A year later Dine began making paintings of discrete items—a hat, a necktie, and the necklace in *Pearls*, composed of rubber ball halves covered with metallic paint. Although often construed as Pop art emblems, these paintings, which include the names of the depicted objects and, in some cases, collage elements, are more conceptually oriented than the playful and bold appropriations of popular imagery made by Roy Lichtenstein, James Rosenquist, and Andy Warhol. By so blatantly and provocatively combining word, image, and object, Dine invited an investigation into the presumed difference between representation and reality, the construction of meaning, and the arbitrary nature of language.

N.S.

PEARLS

Bedspring, 1960.

Mixed-media assemblage on wire bedspring, 52 1/4 x 72 x 11 inches. Purchased with funds contributed by the Louis and Bessie Adler Foundation, Inc., Seymour M. Klein, President. 85.3258

Pearls, 1961. Oil and collage on canvas, 70 x 60 inches. Gift, Leon A. Mnuchin. 63.1681

Stan Douglas b. 1960, Vancouver, British Columbia

Stan Douglas utilizes forms of popular entertainment—cinema and television—to destabilize narratives that depict society as a unified, homogeneous front with one history, one set of desires, and one value system. Whether emulating the evening news during the 1968 race riots or restaging a scene from Alfred Hitchcock's *Marnie*, Douglas disrupts representational systems by introducing unsettling elements of difference. Issues of race and class infiltrate his entire project.

Douglas's *Monodramas*, ten 30- to 60-second videos conceived as interventions into commercial television, interrupted the usual flow of advertis-

"Pictures, words, sounds my work relies on means that you must mistrust because so many traces of power and oppression are stored away in them and their history, the history of their exploitation. This is the fundamental irony about my work." ing and entertainment when broadcast nightly in British Columbia for three weeks in 1992. These micronarratives mimic television's editing techniques, but as kernels of a story they refuse to cohere. They are tales of dysfunction and dislocation, misanthropy and misunderstanding: a car and a school bus nearly collide at an intersection, only to drive away; a pedestrian greets an Afro-Canadian man he encounters on the street but is told in response, "I'm not Gary." When the videos were aired unannounced during commercial breaks, viewers called the station to inquire about what was being sold, their responses evincing how the media can refocus attention from content to consumption.

The film installation *Der Sandmann* investigates the intersection of history and memory as witnessed against the backdrop of post–Cold War Germany. Shot on 16mm film in the old Ufa studios near Potsdam, the piece fuses E.T.A. Hoffmann's eponymous tale, Freud's citation of it in "The Uncanny," his study of repression and repetition, as well as the social impulses behind 19th-century German urban planning, which instituted the *Schrebergärten*, plots of leasable land on which the poor could grow their own food. Projected as two separate but intersecting videos showing the garden at different chronological points—in use during the 1960s and as a construction site some 20 years later—*Der Sandmann* contemplates temporality and the transformative effects of history.

Nu•tka• similarly utilizes image bifurcation, this time to explore the history of colonialization on Vancouver Island, where English and Spanish fleets battled over trade routes in the 18th century. Films of the landscape—the only imagery shown—are superimposed on one screen so that the footage appears doubled. This formal effect is echoed by the soundtrack, which includes excerpts from the sea captains' diaries, which become increasingly paranoid and irrational. At key moments in the narrative all visual and verbal elements meld together in exquisite clarity.

Monodramas, 1991 (detail).
Ten videos, 00:00:30–00:00:60 each; ten gelatin-silver prints with text, 11 x 20 inches each. Edition 5/5. Purchased with funds contributed by the International Director's Council. 96.4508.1-.11

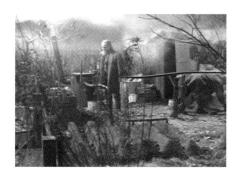

Der Sandmann, 1994 (detail). Two-track 16mm black-and-white film projection and stereo soundtrack; 00:09:50; room: 14¾ × 26¼ × 39½ feet; screen: 13⅓ × 9⅙ feet. Edition 1/2. Gift, The Bohen Foundation. 2000.57

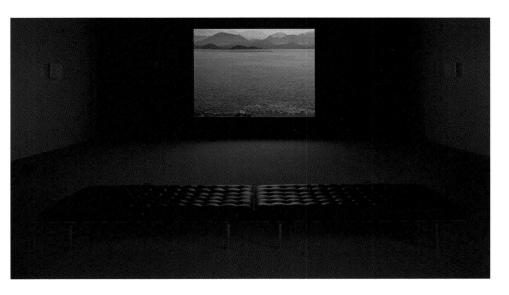

Nu•tka•, 1996.
Single-channel color video projection and quadraphonic soundtrack; 00:06:50; room: 14 ½ x 26 ½ x 39 ½ feet; screen: 13 ½ x 9 ⅙ feet. Edition 1/2. Gift, The Bohen Foundation. 2000.59

Jean Dubuffet b. 1901, Le Havre, France; d. 1985, Paris

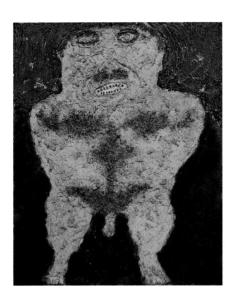

A grotesque male nude dominates *Will to Power*, his gritty roughness, burly proportions, inlaid stone teeth, and glass fragments for eyes giving him a fierce and threatening air. But the figure's aggressive machismo is itself threatened by the very stance he assumes: hands held behind the back, his gesture is either one of unexpected receptivity or of helpless

captivity. The title refers to a central tenet of Nazi ideology, taken from the philosophy of Friedrich Nietzsche. But in a single deft stroke, Dubuffet's caricature mocks Fascism's claims to authority as it emasculates romanticized male aggression.

"I would like people to look at my work as an enterprise for the rehabilitation of scorned values, and, in any case, make no mistake, a work of ardent celebration."

Dubuffet's painting style, which he called Art Brut (raw art), was contrary to everything expected of a painter in the French tradition and dealt a serious blow to the usual aesthetic assumptions. Inspired by graffiti and art made by the mentally ill, Dubuffet insisted that

his protest was against specious notions of beauty "inherited from the Greeks and cultivated by magazine covers." In *Triumph and Glory*, the female nude—treated by most artists with veneration—receives no more charitable treatment than her male counterpart in *Will to Power*. One of 36 female nudes known as the *Corps des dames* series, she lacks psycho-

logical presence and personal identity, and could easily be perceived as an abomination.

While the art of "primitive" cultures and unschooled practitioners was of special importance to Dubuffet, he was also interested in a disparate array of found objects and materials. Door with Couch Grass, an assemblage of several paintings that he cut down and pieced together to represent a wall, doorstep, and the ground, typifies his insatiable interest in found patterns, textures, and materials. The extraordinary range of techniques that Dubuffet employed in this work includes creating successive layers of paint by shaking a brush over the painting and covering it with a spray of tiny droplets, scattering sand over the surface, and scratching it with the tines of a fork. In his attempt to rehabilitate values and materials dismissed by Western aesthetics, what mattered to Dubuffet was unbridled energy, spontaneity, and truth to self—and with them, a spirit of insubordination and impertinence.

Will to Power, January 1946. Oil, pebbles, sand, and glass on canvas, 45 1/4 x 35 inches. 74.2076

Triumph and Glory, December 1950. Oil on canvas, 51 x 38 inches. 71.1973

Door with Couch Grass, October 31, 1957. Oil on canvas with assemblage, 74½ x 57½ inches. 59.1549

Marcel Duchamp b. 1887, Blainville, France; d. 1968, Neilly-sur-Seine, France

In 1911, Marcel Duchamp, the great iconoclast of 20th-century art, was still adhering to the conventions of easel painting, formal composition, narrative structure, and individual inspiration. His formative years were bracketed by studies at the Académie Julien in Paris in 1904–05 and participation in the artistic circle known as the Puteaux Group, which gathered at the home of his older brothers and fellow artists, Raymond Duchamp-Villon and Jacques Villon, after 1910. During this period, Duchamp moved rapidly through a succession of Modernist styles before renouncing painting altogether in 1913 in favor of an art that privileged the intellectual over the optical.

Prior to this conversion, which would radically alter the development of Western art, Duchamp frequently painted the members of his family. A relatively realistic canvas from 1910 depicts his brothers engrossed in a

"Painting should not be exclusively retinal or visual; it should also have to do with gray matter, with our urge for understanding." game of chess in their garden while his two sisters look on. The significantly more abstracted painting *Sonata* (1911), is a portrait of the artist's mother and sisters as a musical ensemble; their fragmented and interlocking bodies echoing Cubism's dissolution and rearrangement of forms in space. *Apropos of Little Sister* similarly fractures the integrity of the figure to reinforce its interrelationship with the surrounding composition. The sitter is Magdeleine, Duchamp's youngest sibling, who was 13 at the time. She is seated, reading a book by

candlelight; her attenuated limbs and curving spine form a sinuous S-curve that reverberates in the loosely painted environment around her.

Toward the end of 1911, Duchamp returned to the theme of chess, creating a series of at least six drawings and two Cubist paintings of his brothers completely absorbed by the game. The Guggenheim drawing was produced late in the sequence, perhaps between the execution of the two canvases, given that its shades of green and tan watercolor relate to the palette of the latter painting. Rendered on lined stationery from Paris's Hotel Lutetia, the drawing is intimate in scale but dense with visual information. The profiles of the two players interlock above the perspectival game board; vectors radiating out from center represent the intense intellectual activity at play. Chess pieces float freely in this abstracted world, suggesting that the space depicted is a purely cerebral realm. For Duchamp, who would soon devote himself to playing chess exclusively and only intermittently producing conceptual work involving readymades, linguistic strategies, and mechanistic imagery, chess was the perfect art form in that it engaged one's "gray matter" rather than one's retina.

N.S.

Apropos of Little Sister, October 1911. Oil on canvas, 28 3/4 x 23 5/6 inches. 71.1944

Study for Chess Players, late 1911. India ink and watercolor on lined wove paper, 8 ½ x 7 ½ inches. Gift, Estate of Katherine S. Dreier. 53.1339

Fischli/Weiss Peter Fischli, b. 1952, Zurich David Weiss, b. 1946, Zurich

Peter Fischli and David Weiss have been collaborating since 1979 on a body of work that celebrates—with great humor and intelligence—the sheer banality of everyday existence. As contemporary flaneurs, they observe their world with bemused detachment, reveling in the mundane and turning every undertaking into a leisure activity. Their earliest projects lampooned the seriousness of high art: for Wurstserie (1979) they playfully photographed curious arrangements of sausages and luncheon meats to emulate the tableaux of genre paintings. The iconic themes of Western culture are parodied in a 1981 ensemble of 250 roughly hewn clay figurines representing such extraordinary events as Anna O Dreaming the First Dream Interpreted by Freud; Marco Polo Showing the Italians Spaghetti.

"We don't think we have a spiritual or philosophical problem, and now we must find a way to show this to the world." Brought Back from China; and For the First Time, Mick Jagger and Brian Jones Going Home Satisfied After Composing "I Can't Get No Satisfaction." By the end of the 1980s, the duo had expanded their repertoire to embrace an iconography of the incidental, creating deadpan photographs of kitsch tourist attractions and airports around the world. For their contribution to the 1995 Venice Biennale, at which they represented Switzerland, Fischli/Weiss exhibited 96 hours of video on 12 monitors that documented what they called

"concentrated daydreaming"—real-time glimpses into daily life in Zurich: a mountain sunrise, a restaurant chef in his kitchen, sanitation workers, a bicycle race, and so on.

Fischli/Weiss's delight in the ordinary is given perfect form in their flower portraits—dazzlingly colorful, close-up shots of myriad garden plants in bloom or various stages of decay. As in all the previous work in their conceptually driven practice, the flowers undermine conventional distinctions between high and low art—a culturally enforced contrast the artists once derided in a clay sculpture of two dachshunds, one standing on its hind legs, the other on all fours. Fashioned in the spirit of amateur photography in both subject and style, the flower portraits employ the technique of double exposure to achieve dizzying layered effects. The process allowed the artists to exploit their collaborative approach: one would shoot an entire roll of film in a suburban rose garden; the other would rewind it and then shoot the same roll in a park in Zurich. Deliberately decorative, these photographs push the limits of acceptability in Conceptual art. The cumulative effect of 111 different pictures, which can be installed in a room like wallpaper, glimpsed image by image as in a print portfolio, or seen singularly as a framed photograph, is one of abundance and kaleidoscopic visual pleasure.

Untitled (Flowers), 1997–98 (details and installation view). Portfolio of 111 inkjet prints, 29 1/2 x 42 1/3 inches each. Edition 3/9. Purchased with funds contributed by the International Director's Council and Executive Committee Members, 99.5267

Flatness

Beginning with Edouard Manet, artists progressively abandoned the illusion of depth achieved through linear perspective. They exchanged the Renaissance concept of mimesis for an ideated notion of flatness in which figure and ground, shape and field seem to merge indissolubly on the canvas. This affirmation of the flatness of the picture plane became a distinguishing characteristic of Modernist painting.

In the formalist tradition of art criticism, flatness is inseparable from aesthetic value, or what Clement Greenberg—formalism's leading voice—defined as "quality." This aspect of Greenberg's doctrine has been the most polemical in recent critical reevaluations of his work, but nonetheless his definition of painting's reduction to flatness is still the most complete. Greenberg applied the Kantian model of self-definition to support his view that each art must isolate and make explicit that which is unique to the nature of its medium. The "irreducible essence" of pictorial art, he wrote in his 1965 essay "Modernist Painting," is the coincidence of flattened color with its material support: "Flatness, two-dimensionality, was the only condition painting shared with no other art, and so Modernist painting oriented itself to flatness as it did to nothing else."

Greenberg championed a narrow lineage of artists who insistently asserted two-dimensionality. He credited Manet with creating the first Modernist paintings because they declared the restricted space of the picture plane so frankly. Greenberg included Paul Cézanne because the placement and shape of the flat brushmarks in his paintings recall the shape of the flat rectangle on which they were placed. Cézanne, and the Cubists after him, also solved the passage from the contour of an object to its inhabited space without violating the integrity of the flat continuum of the picture surface. He described Piet Mondrian as the flattest of all easel painters, while he identified Jackson Pollock's strength as deriving from the tension inherent in the constructed, re-created flatness of the surface. Greenberg concluded his retrospective account with the Color Field painters, whose technique of staining the weave of the canvas visibly weds figure and ground. His list stops short of Frank Stella's Black Paintings on the grounds that they pushed painting so far into the third dimension that they verged on becoming "arbitrary objects"—and therefore sacrificed their "quality."

LISA DENNISON

Dan Flavin b. 1933. Jamaica, N.Y.; d. 1996, Riverhead, N.Y.

Employing only commercial fluorescent lights in his work, Dan Flavin devised a radical new art form that circumvented the limits imposed by frames, pedestals, or other conventional means of display. His embrace of the unadorned fluorescent fixture as an aesthetic object placed him at the forefront of a generation of artists whose use of industrial materials, emphasis on elementary forms, and nonhierarchical relationships among component parts became the salient characteristics of Minimalism.

The additive composition of the nominal three (to William of Ockham), dedicated to the 14th-century English philosopher, exemplifies Flavin's use

"What has art been for me? In the past, I have known it (basically) as a sequence of implicit decisions to combine traditions of painting and sculpture in architecture with acts of electric light defining space." of the fluorescent tube as a basic building block. The artist's installations became increasingly complex while remaining bound to the limited palette and standard lengths in which the fixtures were commercially produced. His subsequent development of a vocabulary of "corners," "barriers," and "corridors" engaged the environment his work occupied and revealed his interest in reconceptualizing sculpture in relation to space. The first of his barrier pieces, greens crossing greens (to Piet Mondrian who lacked green), transforms and even inverts the conventional museum experience by literally invading the viewer's space and prohibiting access to the gallery. The reference to

Mondrian is in keeping with Flavin's practice of dedicating individual works to family, friends, or historical figures of significance to him.

The artist Mel Bochner credited Flavin's practice as embodying "an acute awareness of the phenomenology of rooms." This awareness stemmed from Flavin's rejection of studio production in favor of site-specific "situations" or "proposals" (as the artist preferred to classify his work) and is nowhere more evident than in his 1971 installation for the Guggenheim, untitled (to Ward Jackson, an old friend and colleague who, during the Fall of 1957 when I finally returned to New York from Washington and joined him to work together in this museum, kindly communicated). Initially occupying one full turn of the museum's ramps, and according to the artist, "critically fitted to the inconsistent dimensions of the variable architecture." the work was conceived so that it could be extended to fill the entire rotunda, as was done in 1992. At that time, Flavin created untitled (to Tracy, to celebrate the love of a lifetime), a new work dedicated to his fiancée that rose from the rotunda floor in a celebratory manner, suffusing the space with a warm pink glow. Together these installations amplified the Frank Lloyd Wright interior, exemplifying Flavin's career-long concern with light, space, and color.

J.F.R.

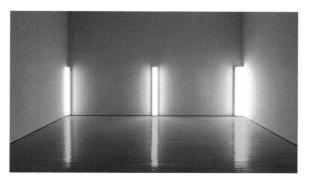

the nominal three (to William of Ockham). 1963.

Fluorescent light fixtures with daylight lamps; each fixture: 6 feet; 72 x 212 ½ x 5 inches overall. Edition 2/3. Panza Collection. 91.3698

greens crossing greens (to Piet Mondrian who lacked green), 1966. Fluorescent light fixtures with green lamps; fixtures: 2 and 4 feet; 53 x 230 ½ x 147 inches overall. Panza Collection. 91.3705

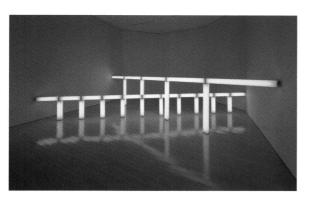

untitled (to Ward Jackson, an old friend and colleague who, during the Fall of 1957 when I finally returned to New York from Washington and joined him to work together in this museum, kindly communicated). 1971. Fluorescent light fixtures with daylight.

pink, yellow, green, and blue lamps; fixtures: 2 feet and 8 feet. Partial gift of the artist in honor of Ward Jackson. 72.1985 untitled (to Tracy, to celebrate the love of a lifetime), 1992. Fluorescent light fixtures with pink lamps; each fixture: 8 feet. 92.4017

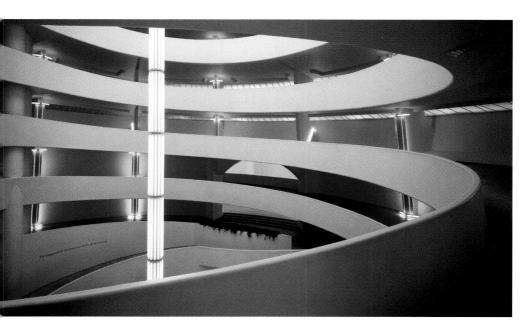

Lucio Fontana b. 1899, Rosario de Santa Fé, Argentina; d. 1968, Commabio, Italy

Lucio Fontana's respect for the advancements of science and technology during the 20th century led him to approach his art as a series of investigations into a wide variety of mediums and methods. As a sculptor, he experimented with stone, metals, ceramics, and neon; as a painter he attempted to transcend the confines of the two-dimensional surface. In a series of manifestos originating with the *Manifesto blanco (White Manifesto)* of 1946, Fontana announced his goals for a "spatialist" art, one that could engage technology to achieve an expression of the fourth

dimension. He wanted to meld the categories of architecture, sculpture, and painting to create a groundbreaking new aesthetic idiom.

"There is a new consciousness in formation in humanity, and so much so that it is no longer necessary to represent a man, a house, or nature. What is necessary is to create spatial sensations with one's own imagination."

From 1947 on Fontana's experiments were often entitled *Concetti* spaziali (Spatial Concepts), among which a progression of categories unfolds. The artist's polychrome sculptures brought color, considered to be under the dominion of painting, into the realm of the three-dimensional. With his *Pietre* (stones) series, begun in 1952, he fused the sculptural with painting by encrusting the surfaces of his canvases with heavy impasto and colored glass. In his *Buchi* (holes) cycle he punctured the surface of his canvases, breaking the

membrane of two-dimensionality in order to highlight the space behind the picture. From 1958, Fontana purified his paintings by creating matte, monochrome surfaces, thus focusing the viewer's attention on the slices that rend the skin of the canvas. Paintings such as *Spatial Concept*, *Expectations* are among these *Tagli (cuts)*, whose violent jags enforce the idea that the painting is an object, not solely a surface.

Many of Fontana's proclamations echo Futurist declarations made before World War I. The artist's wish that his materials be integrated with space, his need to express movement through gesture, and his interest in states of being (exemplified in his use of the word "expectations" in the title of this work), suggest the artist's familiarity with the work of Umberto Boccioni, a leading Futurist sculptor, painter, and theorist whom Fontana cited as an inspiration.

J.B.

Spatial Concept, Expectations, 1959. Water-based paint on canvas, 49 ⅓ x 98 ⅙ inches. Gift, Mrs. Teresita Fontana, Milan. 77.2322

Fourth Dimension

The fourth dimension was a highly popular concept in the early 20th century and figured in the theoretical underpinnings of nearly every Modern art movement. The statement by the Cubist painter and theorist Albert Gleizes quoted here brings together the two major characteristics of the fourth dimension in early Modern art theory: its primary, geometric orientation as a higher spatial dimension, as well as its metaphorical association with infinity and resultant function as a new code name for the sublime.

The idea that space might have additional dimensions had developed during the 19th century with the emergence of n-dimensional geometries (geometries of more than three dimensions). Both n-dimensional geome-

"Beyond the three dimensions of Euclid we have added another, the fourth dimension, which is to say the figuration of space, the measure of the infinite." —Albert Gleizes tries and the curved spaces of non-Euclidean geometry encouraged recognition of the relativity of human perception. The theme of the inadequacy of sense perception was already present in popular literature by the 1880s. Beyond the general resurgence of idealist philosophy in the late 19th century, which augmented this distrust of visual reality, discoveries such as the X-ray (1895) provided scientific proof of the limited range of visual perception, further encouraging speculation about alternative kinds of spaces. However, it was not until the years around 1910 in Paris that expressions of artistic interest in the fourth dimension occurred.

With its roots in geometry, the fourth dimension was not thought of as time itself—a view that would become dominant only after 1919 with the popularization of Einstein's theory of relativity. Instead, it signified a higher geometric dimension, of which our three-dimensional world might be merely a section. The fourth dimension could thus serve as a rationale for Cubist artists to reject such three-dimensionally oriented techniques as one-point perspective and the traditional modeling of figures. If the Cubists sought to depict forms as they might appear in four dimensions, other artists such as František Kupka, Kazimir Malevich, and Piet Mondrian interpreted the notion in more mystical terms and found in the existence of an invisible, higher-dimensional reality support for the creation of totally abstract artworks. Often associated with the evolution of "cosmic consciousness," the fourth dimension in this view also embodied belief in humankind's potential to transcend present limitations and in the need for new forms of language in art, music, and literature.

LINDA DALRYMPLE HENDERSON

Fragmentation

By their nature, fragments indicate the existence of some previously complete entity. Be they the broken remains of a classical Greek sculpture or stanzas from a lost poem, fragments inspire contemplation of the passage of time and thereby induce memory and nostalgia. During the 19th century museums began collecting relics and ruins from other eras, their value increasing in direct proportion to their age. Decontextualized and displayed in this somewhat obsessive manner, vestiges of previous cultures became highly romantic emblems of the past. Charles Baudelaire located the spirit of modernity in such poeticized artifacts, recognizing that at every historical juncture there exists a fleeting consciousness of the present. By "modernity" he referred to "the ephemeral, the fugitive, the contingent, the half of art whose other half is the eternal and the immutable." Toward the fin-de-siècle, artists embraced the fragmentary as a formal strategy with which to capture the transitory moment. Impressionist paintings often suggest a study or an unfinished sketch, as do Auguste Rodin's abbreviated anatomical sculptures, which appear as if in eternal formation.

Such aesthetic fragmentation of perceived experience reflected the vast economic, social, and cultural disruptions of society initiated toward the end of the 19th century with the advent of industrialization. In Marxist terms, this phenomenon inaugurated a radical disjunction between labor and its products. In the psychological realm, the notion of subjective reality as a seamless construct was suspended when Sigmund Freud construed the human psyche as a tripartite, and not necessarily integrated, entity. The art created during the first part of the 20th century—the splintered planes of Cubist and Futurist art, the disjointed figures in German Expressionist painting, and the strange juxtapositions found in Surrealist imagery—may be read as visual analogues to the social and psychic fragmentation of reality. Those artists involved with Dada, Pop, Nouveau Réalisme, Neo-Dada, and Neo-Conceptual strategies have increasingly utilized the flotsam of everyday existence by drawing formal elements and subject matter from mass culture, often emulating cinematic montage and advertising techniques. As a critical mirror to our society and its representations—mediated imagery, movie trailers, MTV, and the World Wide Web-contemporary art has embraced the fragment as an end in itself.

Robert Delaunay, Simultaneous Windows (2nd Motif, 1st Part), 1912 (detail).

Paul Gauguin b. 1848, Paris; d. 1903, Marquesas Islands

Prior to his first voyage to Tahiti in 1891, Paul Gauguin claimed that he was fleeing France in order "to immerse myself in virgin nature, see no one but savages, live their life, with no other thoughts in mind but to render the way a child would . . . and to do this with nothing but the primitive means of art, the only means that are good and true." Gauguin's desire to reject Western culture and merge with a naive society for the sake of aesthetic and spiritual inspiration reflects the complex and problematic nature of European "primitivism." A concept that emerged at the end of the 19th century, "primitivism" was motivated by the romantic desire to discover an unsullied paradise hidden within the "uncivilized" world, as well as by a fascination with what was perceived as the raw, unmediated sensuality of cultural artifacts. This voyeuristic engagement with under

"You will always find vital sap coursing through the primitive arts. In the arts of an elaborate civilization. I doubt it!" developed societies by artists, writers, and philosophers corresponded to French imperialistic practices—Tahiti, for example, was annexed as a colony in 1881.

The artist's idyllic Tahitian landscapes In the Vanilla Grove, Man and

Horse and Haere Mai reveal the contradictions between myth and reality that are inherent to "primitivism." Both canvases probably depict the area surrounding Mataiea, the small village in which Gauguin settled during the fall of 1891. As richly hued tapestries of flattened forms, they are, however, only evocations of the lush Tahitian terrain, reflecting the simplicity of form sought by the artist during his first visit to the island. Gauguin derived the pose of the man and horse in In the Vanilla Grove not from a scene he found in Tahiti but from a frieze on the quintessential monument of Western culture, the Parthenon. Gauguin painted the phrase "Haere Mai," which means "Come here!" in Tahitian, onto the other canvas in the lower-right corner, but it does not appear to coincide with the content of the painting. The artist, who spoke little of the native language at that time, often combined disparate Tahitian phrases with images in an effort to evoke the foreign and the mystical. Evidently, this practice was designed to make the paintings more enticing to the Parisian public, who craved intimations of the distant and the exotic.

In the Vanilla Grove, Man and Horse, 1891. Oil on burlap, 28 1/4 x 36 1/4 inches. Thannhauser Collection, Gift, Justin K. Thannhauser. 78.2514.15

Haere Mai, 1891. Oil on burlap, 28 ½ x 36 inches. Thannhauser Collection, Gift, Justin K. Thannhauser. 78.2514.16

Alberto Giacometti b. 1901, Borgonovo, Switzerland; d. 1966, Chur, Switzerland

Alberto Giacometti was 20 years old when he settled in Paris in order to pursue the career of a sculptor. He studied classical sculpture and the predominant Cubist idioms, but it was not until he began to interpret "primitive" objects that he was able to liberate himself from the influence of his teachers. Spoon Woman, one of the artist's first mature works, explores the metaphor employed in ceremonial spoons of the African Dan culture, in which the bowl of the utensil can be equated with a woman's womb. But Giacometti's life-size sculpture reverses the equivalence. As the art historian and theorist Rosalind Krauss has noted, "By taking the metaphor and inverting it, so that 'a spoon is like a woman' becomes 'a woman is like a spoon,' Giacometti was able to intensify the idea and to make it universal by generalizing the forms of the sometimes rather naturalistic African carvings toward a more prismatic abstraction."

Giacometti joined the ranks of the Surrealists in 1929, only to break with them acrimoniously six years later, when he decided to work from models rather than strictly from his imagination. Yet even in *Nose* there is something of the Surrealist tendency toward the fantastic in the incredible proboscis. In this work, Giacometti suspended a head from a cross bar in a rectangular cage, thus implying that the pendant head could be prodded to swing, the nose further extending beyond the confines of its prison. There is a vague threat in the shape of the head: the configuration of nose, skull, and neck recalls the barrel, chassis, and handle of a gun. However, the wide-open mouth suggests a scream of anguish, and the cord attaching it to its cage evokes the gallows. *Nose* should be seen within the context of postwar existential angst that was voiced by Jean-Paul Sartre, a friend of the artist.

In *Diego*, a painting of his brother, Giacometti continued in this vein, insinuating the loneliness caused by each individual's isolation within his own existence. Like the head in *Nose*, the solitary Diego is presented in the confines of a cagelike structure of lines denoting the architecture of the room. The atmosphere of melancholy is further suggested both by the artist's muted palette that seems to drain life from the sitter, and the figure's near-transparency in a haze of reworked paint.

J.B.

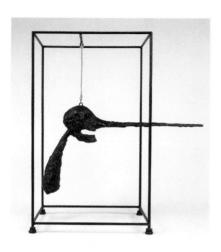

Nose, 1947, cast 1965. Bronze, wire, rope, and steel, $31\% \times 38\% \times 15\%$ inches overall. 66.1807

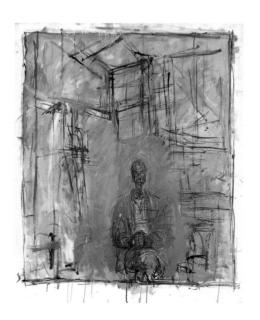

Diego, 1953. Oil on canvas, 39½ x 31¾ inches. 55.1431

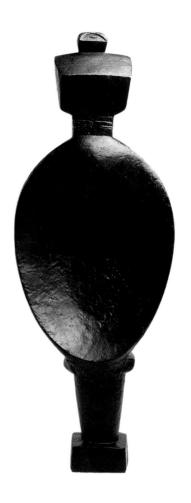

Spoon Woman, 1926. Bronze, 56 ½ x 20 ¼ x 8 ½ inches. 55.1414

Gilbert and George Gilbert, b. 1943, Dolomites, Italy George, b. 1942, Devon, England

Since 1965, when Gilbert and George met and began working and living together, they have merged their identities so completely that we never think of one without the other; no surnames, individual biographies, or separate bodies of work hinder their unique twinship. Furthermore, they make no distinction between their life and their art; they *are* their own

"We want people to bring their life to our exhibitions, not their knowledge of art.

True art has to overcome and speak across the barriers of knowledge. We are opposed to art that is about art. A load of string stuck on a wall isn't art—it's a trick.

We believe that art has a real function to advance civilization."

works of art. In 1967 they began public appearances in the guise of "living sculptures": identically attired in proper business suits, their faces and hands covered with a metallic patina, they paraded themselves at cultural events (they later toured to museums and galleries) playing the game of robotized bronze statues that mirrored the spectacle of art in popular culture. The range of their art has grown to include photography, drawing, painting, written texts, film, and performance. Their presence is clearly felt in their work, which often includes self-portraits.

In the large photo-piece Dream, the two artists appear with a beautiful young man from London's East End (where Gilbert and George live and where they find many of their male models) who poses as an archetype of youth and innocence. In their roles as both patrons and worshippers they playfully exploit the tradition of

ecclesiastical stained-glass window imagery, which their photographic works have mimicked since the early 1970s. Their technique—collaging black-and-white photographs that are dyed with lurid colors and overlaid with a Modernist grid—synthesizes religious, popular-culture, and high-art motifs in order to render their message as directly as possible. In *Dream* and many related works, Gilbert and George use the particulars of East End society and the British urban homosexual experience, filtered through their own personal experiences, to create contemporary allegories. They include their own images in order to cast themselves as symbolic stand-ins for a larger group.

J.A.

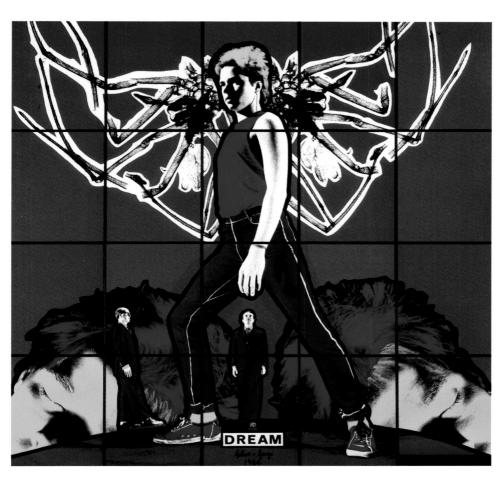

Dream, 1984. Photo-piece; 20 panels, 95½ x 99½ inches overall. Gift, C.E.D.E.F., S.A., Geneva. 86.3412.a-.t

Robert Gober b. 1954, Wallingford, Conn.

Robert Gober's rich and unsettling iconography—from the dysfunctional sinks and handcrafted furniture to the truncated body parts and storm drains—has unfolded sequentially over the past 25 years. Each new work seemed unprecedented and startlingly fresh in its bold narrative form. But much of Gober's innovative vocabulary was already articulated in his early Slides of a Changing Painting (1982–83), which documents the permutations of a single canvas that he altered over a year's time, photographing each modification until he had thousands of individual records. Whittled down to 89 slides, the piece functions today as a key to Gober's practice. Projected in sequence, each image morphs into another, revealing a

"What the pipe was about was an underground conduit of things that flow—maybe sorrowful things, but not necessarily. Things that flow beneath the everyday."

transformative process at work: a human body becomes a landscape and then an architectural interior, stairs descend a man's chest into a basement, a culvert pipe diverts a stream across a torso. Water is a pervasive presence throughout; it cascades down a mountainside, forges a stream through a woman's breastbone, and pours forth from cantilevered drainpipes. Gober has repeatedly returned to this mutating inventory as sources for his work. It is almost a map of his creative unconscious.

The culvert pipe was not realized in sculptural form until 1994, when Gober began three enigmatic pieces: an oversize box of tissues penetrated by a metal pipe, an armchair impaled by this same drain pipe, and a huge box of lard divided by a cruciform of pipes. These juxtapositions of domestic objects with industrial conduits metonymically connect Gober's previous furniture pieces—beds, cribs, dog baskets—to his earlier sinks, which, like the culverts, are vehicles for water. The artist revisited this sculptural equation and its intimations of sexual aggression in his epic 1997 installation that included a life-size Madonna figure pierced through the center by a culvert pipe—a complex, haunting symbol amidst an environment of running water and storm drains.

In this untitled piece, a six-foot culvert uncannily and inexplicably penetrates a willow basket, once again creating a surreal image linking motifs in Gober's oeuvre. The oversize basket, handwoven by the artist, harks back to his dog beds of the mid-1980s, their pillows imprinted with quaint yet menacing images of geese and stags, favored prey of hunting canines. The gothic connotations of those works resonate in the present sculpture, particularly in its pierced state. It is interesting to note that Gober's initial concept for his 1997 installation—in which the secular, sacred, and psychological are fused—involved the placement of a large, woven basket in the center of the gallery, the space eventually occupied by the Virgin Mary.

Untitled, 1998–99.
Willow and silver-plated bronze, 19½ x
70½ x 41½ inches. Purchased with funds
contributed by the International
Director's Council and Executive
Committee Members. 2000.113

Natalia Goncharova b. 1881, Nechaevo, Russia; d. 1962, Paris

Natalia Goncharova and Mikhail Larionov, her collaborator and companion for more than 60 years, experimented with contemporary French stylistic trends before developing a Neo-primitive vocabulary inspired by indigenous Russian folk art. In late 1912 the two artists fashioned a fusion of Cubo-Futurism and Orphism known as Rayism. Cats, painted shortly thereafter, exemplifies the new style.

Using intersecting vectors of color to depict refracted light rays, Rayist works recreate the surface play of light on objects. This perceptual

"The principle of movement in a machine and in a living being is the same, and the whole joy of my work is to reveal the balance of movement." approach to painting was based on scientific discoveries concerning the nature of vision, advances that had also influenced Neo-Impressionist color theories, the Cubist analysis of form, and the Futurist emphasis on dynamic lines. The nationalistic strain apparent in Italian Futurist manifestos also pervades Rayist tracts, in which the Russian theory is posited as a unique synthetic achievement of the East. In the preface to the catalogue of her 1913 Moscow retrospective exhibition, Goncharova wrote: "For me the East means the

creation of new forms, an extending and deepening of the problems of color. This will help me to express contemporaneity—its living beauty—better and more vividly."

Cats, which appears to represent two black felines with a tabby in between, illustrates the Rayist view that objects may serve as points of departure for explorations on the canvas. Goncharova used darts of color to suggest the effects of light on the cats' shiny coats and the way that adjacent surfaces reflect neighboring hues. The dynamic slashes of black and white evoke the energized, machine-inspired compositions of the Futurists.

The artist's brilliant color recalls Robert Delaunay's exuberant depictions of the Eiffel Tower as well as Russian woodblock prints and painted trays. Cats also suggests the richly hued integration of animals and their environment that Franz Marc was developing contemporaneously in his own synthesis of Cubism and Futurism. Yet unlike Marc and other German Expressionist painters, Rayist painters did not seek to express spiritual goals through their art.

J.B.

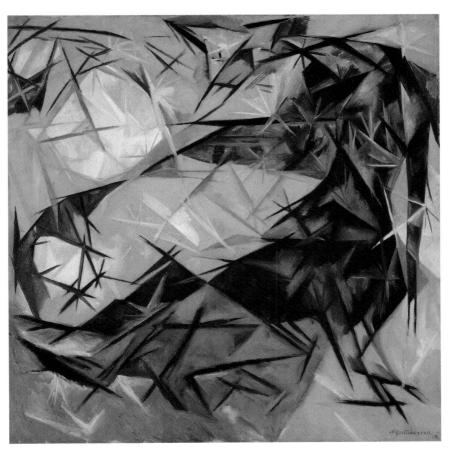

Cats (rayist percep.[tion] in rose, black, and yellow). 1913. Oil on canvas, 33 1/4 x 33 inches. 57.1484

Felix Gonzalez-Torres b. 1957, Guáimaro, Cuba; d. 1996, Miami

Felix Gonzalez-Torres's pristine stacks of imprinted paper and eccentric candy spills—which he arranged in corners and across floors—are subversive rearticulations of Minimalism's nonrepresentational aesthetic. While recalling Carl Andre's metal carpets, Donald Judd's sequenced boxes, and Robert Morris's Corner Piece of 1964, they undermine the supposed neutrality of such work. He reintroduced what has been sublimated in much Modernist art—desire, loss, vulnerability, and anger—with a potent but quiet poignancy through texts inscribed on giveaway paper sheets and subtitles appended to "untitled" works. Free for the taking and replaceable, Gonzalez-Torres's perpetually shrinking and swelling sculp-

"This [type of] work is mostly personal. It is about those very early hours in the morning, while still half asleep, when I tend to visualize information, to see panoramas in which the fictional, the important, the banal, and the historical are collapsed into a single caption."

tures defy the macho solidity of Minimalist form, while playfully expanding upon the seriality of the genre and the quotidian nature of its materials.

His early text pieces are lists of seemingly random historical incidents followed by the dates of their occurrence, for example, *Pol Pot 1975 Prague 1968 Robocop 1987 H Bomb 1954 Wheel of Fortune 1968 Spud.* Concurrently, he created similar inventories of gay-rights events and the AIDS crisis, culminating in the 1989 Greenwich Village billboard on which he commemorated in list form a history of oppression, illness, and activism. A self-acknowledged gay man

who suffered the death of his longtime companion, Gonzalez-Torres expressed his grief and love for this man—as well as his outrage at a social system that marginalizes homosexuals—in much of his work. A stack piece bearing the simple message "Memorial Day" gives a new, haunting meaning to this generally trivialized American holiday: the festive and seductive spill of silver-wrapped candies subtitled *Placebo* (1991) ironically invokes the controversial and discriminatory modes of drug-testing in AIDS research. *Untitled (Public Opinion)*, a 700-pound spill of black-rod licorice pieces, displayable as either a corner piece or a carpet, is a dark, aggressive work. The missilelike shape of the candy and its brooding, almost sinister, appearance alludes to our culture's pervasive militaristic outlook and hostile hegemonic stance. As an artwork produced in a conservative political climate, the sculpture also refers to the still pervasive censorship in America and suggests that public opinion is not as informed as it once was

Untitled (Public Opinion), 1991.
Black rod licorice candy, individually wrapped in cellophane (endless supply); ideal weight, 700 pounds, dimensions variable. Purchased with funds contributed by the Louis and Bessie Adler Foundation, Inc., and the National Endowment for the Arts Museum Purchase Program. 91.3969

Grid

The Egyptians constructed their pyramids on a perfect square representing the four corners of the world, the supports of the heavens, and the four winds; they designed their figurative sculptures using a grid based on the measure of a human handbreadth. In the present, grids underlie the design of most Modern architecture—even the terrazzo floor of Frank Lloyd Wright's spiral Guggenheim Museum reflects a pattern of circles inscribed in a squared grid.

The squared grid was the key to the Renaissance invention of linear perspective, a conceptual tool by which painters could represent an abstract model of the world. Persisting through the 19th century as an essential

instrument of pictorial representation, the Renaissance grid was a means of objective measurement of the real, and at the same time, in its pure optical geometry, a reflection of spiritual order and human perfection—of man made in God's image.

The grid has been a dominant motif of Modern art, used both to explore the real and what is beyond and behind that reality. With horizontal and vertical brushstrokes that mimic the gridlike weave of the canvas, Paul Cézanne fused the foreground, middleground, and background of his painted landscapes to the concrete reality of the picture plane and the rectangular boundary of its frame. Piet Mondrian utilized the linear horizontal and vertical elements of the grid to develop an entirely abstract painting embodying essential structures that underlie both a spiritual and a material world.

The historic origins and uses of the grid are tied as much to the physical reality of architecture as to the illusionist optics of painting. The modern grid also conveys the modularity of time and mechanization of the machine age—it can be seen in film frames, for example, and boxes on an assembly line—epitomized by Andy Warhol's grid of silkscreened Mona Lisas, electric chairs, and Campbell's soup cans. In Warhol's works the images themselves break down into a photographic grid of dots for mechanical printing.

Marcel Duchamp, the great conceptual artist of this century, publicly gave up making art in order to devote himself to playing chess. In doing so, he recast the Renaissance grid in the form of the 64 squares of a chessboard—a fixed platform, with fixed rules, accommodating any variation of moves and an infinite array of expressive possibilities.

MICHAEL GOVAN

Marcel Duchamp and Man Ray playing chess on a Paris rooftop in René Clair's film *Entr'acte*, 1924.

Andreas Gursky b. 1955, Leipzig, Germany

Andreas Gursky's photographic vision is extraordinarily precise. Every image—whether of a Rhine landscape, rave dance floor, or factory interior—unfolds to reveal an intrinsic organizing principle. Teasing an eccentric geometry out of each of his subjects, Gursky reorders the world according to his own visual logic, accumulating myriad tiny details to offer a sense of harmonic coherence. There is a documentary impulse behind Gursky's work, one inherited from his German forebears—August Sander, the early 20th-century encyclopedic chronicler of occupational typologies, and his own professors, Bernd and Hilla Becher, who systematically record architectural relics of the industrial age. Gursky's subject matter is latecapitalist society and the systems of exchange that organize it, and his

"A visual structure appears to dominate the real events shown in my pictures. I subjugate the real situation to my artistic concept of the picture." practice is equally totalizing and taxonomic. His pictures may be described as modern-day versions of classical history painting in that they reproduce the collective mythologies that fuel contemporary culture: travel and leisure (sporting events, clubs, airports, hotel interiors, art galleries), finance (stock exchanges, sites of commerce), material production (factories, production lines), and information (libraries, book pages, data). Large in scale and brilliantly lit, Gursky's color photographs emulate the physicality of oil on canvas.

Despite the traditions he invokes both formally and conceptually, Gursky has no pretense to objectivity. He digitally manipulates his images combining discrete views of the same subject, deleting extraneous details, enhancing colors—to create a kind of "assisted realism." The traders on the floor of the Singapore stock exchange, in Gursky's version, all wear the same shade of red, yellow, or blue jacket. And his epic view of the Stockholm public library, a perfect hemisphere of color-coded books. omits the actual floor, which, in reality, includes an escalator that would have marred the symmetrical beauty of the image. According to art historian Norman Bryson, the critical paradox of Gursky's photography lies in its dual commitment to objectively observing the social strata at work in the world and to aestheticizing empirical reality, an impulse that almost sabotages the science of his project. In this dialectic, the artist provocatively undermines photography's claims for "truth," offering, instead, as Bryson suggests, an inquiry into the subjective dimensions of all representations of the social.

Library, 1999.
Cibachrome print, mounted to Plexiglas;
Plexiglas: 79 x 142 inches; image: 61¾ x
126 1¾ 6 inches. Edition 2/6. Purchased
with funds contributed by the
Photography Committee. 99.5305

Singapore Stock Exchange, 1997.
Cibachrome print, mounted to Plexiglas;
Plexiglas: 641/4 x 1041/4 inches; image:
52 x 921/4 inches. Edition 6/6.
Purchased with funds contributed by the
Photography Committee. 98.4627

Peter Halley b. 1953, New York City

Two Cells with Conduit resembles the Hard-edge paintings of Ellsworth Kelly, Brice Marden, and Kenneth Noland, but while the work of those artists may be described as "abstract," Peter Halley prefers the designation "diagrammatic" for his precise, austere arrangements. He conceives of his vocabulary of squares, bars, and rectangles as coded referents to the way in which geometry pervades our world. Life in late-capitalist culture, according to Halley's own critical writing, has been inscribed and circumscribed by geometric networks: think of the urban grid, the office tower, the high-rise apartment building, the correctional institution, the parking

"The 'stucco' texture is a reminiscence of motel ceilings. . . . The Day-Glo paint is a signifier of 'low budget mysticism.' It is the afterglow of radiation." lot. Halley's morphological investigations also focus on the traditional manner in which geometric abstraction has been perceived. By invoking the formal attributes of Minimalist art—rigid planes of color, unitary shapes, and nonhierarchical compositions—and mapping a narrative sensibility onto them, Halley calls the supposed neutrality of such art into question.

As both author and artist, Halley has drawn upon the writings of the French theoreticians Michel Foucault and Jean Baudrillard to articulate and substantiate his dual critique of culture and art. Foucault's analysis of the geometric organization of industrial society, particularly institutional modes of confinement, inspired Halley to transform a Minimalist square into a prison cell by adding three vertical bars to the form. In response to Baudrillard's exploration of postindustrial culture—its reliance on information systems, media representation, and an economy that privileges image over product—Halley shifted to schematized depictions of enclosed spaces, linked to the world through a network of electronic, telephonic, and fiber-optic conduits. The division of Two Cells with Conduit into two discrete portions suggests an architectural section; the squares above represent prototypical urban dwellings while the line below indicates the hidden, technological underworld of pipes, cables, and wires connecting them. Begun in 1981, the cell-and-conduit paintings demonstrate what Halley has described as the "seductive" geometry of 1980s culture, epitomized by the irreal space of the video game. The Day-Glo colors and ersatz stucco paint—known as Roll-a-Tex—make these canvases into emblems of a social reality, in which artifice replaces empirical experience.

Two Cells with Conduit, 1987.

Day-Glo, acrylic, and Roll-a-Tex on canvas; two panels, 78 5/4 x 155 1/4 inches overall. Purchased with funds contributed by Denise and Andrew Saul and Ellyn and Saul Dennison. 87.3550.a. .b

Ann Hamilton b. 1956, Lima, Ohio

Ann Hamilton is best known for large-scale installations laden with richly sedimented layers of meaning. These mesmerizing and often inscrutable works, which are frequently placed outside traditional museum spaces, deploy unconventional materials as a way to elicit sensory responses and to obliquely reference historical and cultural meanings derived from the artist's studies of a particular site. Her repertoire of materials has included several tons of horsehair, thousands of honey-coated pennies, beetle-infested turkey carcasses, and hundreds of pounds of work uniforms. Typically, a lone individual intently engaged in a repetitive task—burning words from a book, wringing his or her hands in honey, or unraveling a length of fabric—inhabits her environments, lending the intimacy

"Much of my work is a way to
approach the gap between
language and experience,
hamilton thus tree poreal impulses

language and experience, between the factual description of a situation and the perception of a situation." Hamilton thus translates intellectual and social constructs into corporeal impulses, building up a collage of metaphors that speak to the conditions of lived experience as well as to the history of a particular place. With their allusions to experience, memory, and

desire, her installations mine the intersection between the individual body and the social body. By emphasizing material presence and appealing to the senses, they suggest that knowledge is gained both corporeally and intellectually. This notion is also conveyed by the works' scale, which transforms the traditional relationship between viewer and object by literally bringing the viewer into the physical space of the artwork.

Hamilton's work foregrounds sensory experience and evokes memories that are rooted in the body, operating in a seemingly prelinguistic or entirely nonverbal realm. These four untitled videos—originally components of larger installations—convey visually what is experienced haptically. In each piece, an ordinary somatic function—speaking: hearing—which is nonetheless rooted in the intellect, is compromised and overwhelmed by a purely tactile sensation. Water runs down a neck in untitled (dissections . . . they said it was an experiment), deluges an ear in untitled (the capacity of absorption), and floods a mouth in untitled (linings), while in untitled (aleph) rocks fill a mouth that struggles to create speech. The only video that incorporates sound, untitled (aleph) takes its name from the shape the mouth forms in the transition between silence and speech. The visceral quality of Hamilton's installations is captured in concentrated form in these videos, which transfix the viewer with their intimate explorations of bodily experience.

J.F.R.

untitled (dissections . . . they said it was an experiment), 1988/1993.
Color-toned video and LCD screen (silent); 00:30:00; 3 1/2 x 4 1/2 inches.
Edition 3/9. Gift, Peter Norton Family Foundation. 94.4261

untitled (the capacity of absorption), 1988/1993.
Color-toned video and LCD screen (silent); 00:30:00; 3 ½ x 4 ½ inches.
Edition 3/9. Gift, Peter Norton Family Foundation. 94.4260

untitled (linings), 1990/1993.
Color-toned video and LCD screen (silent); 00:30:00; 3 ½ x 4 ½ inches.
Edition 3/9. Gift. Ginny Williams Family Foundation. 94.4259

untitled (aleph), 1992/1993. Color-toned video and LCD screen, with sound; 00:30:00; $3\frac{1}{2} \times 4\frac{1}{2}$ inches. Edition 3/9. Gift, Ginny Williams Family Foundation. 94.4258

Eva Hesse b. 1936, Hamburg; d. 1970, New York City

When Eva Hesse came to maturity as an artist during the mid-1960s, the women's movement and the sexual revolution were emerging as powerful, liberating forces in the U.S. It was a time when voices of the counterculture gained widespread recognition. The urge toward radical reappraisal and reform was manifest in the art world as well—Pop art and Minimalism

"This piece does have an option."

displaced Abstract Expressionism through their categorical dismissal of artistic subjectivity and the heroic gesture. Almost immediately, however, artists questioned the geometric rigidity of Minimalism and the limitations of the Pop idiom. Finding inspiration in the

human body, the random occurrence, the process of improvisation, and the liberating qualities of nontraditional materials such as industrial felt, molten lead, wax, and rubber, these artists mined a new aesthetic sensibility variously known as Anti-Form, Post-Minimalism, or Process art.

During her brief career Hesse contributed to this radical undermining of artistic convention with her abstract yet sensual sculptural works. She rejected the standard attributes of monumental sculpture—volume, mass, and verticality—in favor of eccentric forms made from rope, latex, and cheesecloth, all of which decompose with time. Her goal, she explained, was to portray the essential absurdity of life. In formal terms, this theme

was realized through a wedding of contradictions: "order versus chaos, stringy versus mass, huge versus small," in the artist's words. Acutely aware of the challenges faced by a female artist in a predominantly male environment, Hesse may have utilized such formal opposites as a metaphor for her own position in the art world and to emphasize the inherent strength of flexibility and vulnerability.

Expanded Expansion is a sculptural embodiment of opposites united. Both permanence and deterioration operate in the piece: fiberglass poles—rigid, durable entities—are juxtaposed with fragile, rubber-covered cheesecloth. While its height is determined by the poles, the width of the piece varies with each installation; like an accordion or curtain, it can be compressed or extended. Its repetitive units echo the programmatic seriality of Minimalism, but here they accentuate Hesse's desire to illuminate her view that "if something is absurd, it's much more exaggerated, more absurd if it's repeated." The very redundancy of the title reinforces this idea.

Expanded Expansion, 1969. Reinforced fiberglass poles and rubberized cheesecloth; three units of three, five, and eight poles, respectively: 122 x 60 inches; 122 x 120 inches; and 122 x 180 inches; 122 x 300 inches overall. Gift, Family of Eva Hesse. 75.2138.a-.c

Hans Hofmann b. 1880, Weissenburg, Bavaria; d. 1966, New York City

Hans Hofmann's life affirms the importance of art as an essential activity of society. "Providing leadership by teachers and support of developing artists is a national duty, an insurance of spiritual solidarity," wrote Hofmann in 1931. "What we do for art, we do for ourselves and for our children and the future."

Hofmann's greatness lay in the consistency and uncompromising rigor of the artistic standards he devised and his aptitude for teaching those principles to a devoted and diverse body of students. Hofmann founded and taught at art schools from 1915 until 1958, and he inspired a wide range of artists, from Lee Krasner and Burgoyne Diller to Irene Rice Pereira. He is best remembered for teaching the fundamental issues of postwar abstraction: the employment of color and nonrepresentational forms, and the artist's ability to weave sophisticated relationships between

"Pure must not mean poor."

them. As one student, the painter Wolf Kahn, reports, "We were like a religious order . . . in the search for formal perfection." For many of Hofmann's students, this search consisted solely of formal innovation. Hofmann's own work as a painter does not center on original veries; rather, it is a glowing synthesis of other movements such as

discoveries; rather, it is a glowing synthesis of other movements such as Expressionism and De Stijl. This forces us to reexamine the definition of artistic "invention" and question the assumption that art must be seen in terms of discrete meaningful objects. In Hofmann's case, art might better be judged as a model from which to teach.

The Gate was painted in 1959–60 as part of a series of works loosely devoted to architectonic volumes. Hofmann used rectangles of color to reinforce the shape of his essentially unvarying easel-painting format. Although The Gate is subjectless, Hofmann insisted that, even in abstraction, students should always work from nature in some form. With determination, a viewer can see that the complex spatial relationship established by the floating planes of color begins to resemble the gate of the title.

C.L.

The Gate, 1959–60.
Oil on canvas, 75 ½ x 48 ½ inches.
62.1620

Jenny Holzer b. 1950, Gallipolis, Ohio

Jenny Holzer began the *Truisms* series in 1977 as a distillation of an erudite reading list from the Whitney Independent Study Program in New York City, where she was a student; by 1979 she had written several hundred one-liners. Beginning with A LITTLE KNOWLEDGE GOES A LONG WAY and ending with YOUR OLDEST FEARS ARE THE WORST ONES, the *Truisms* employ a variety of voices and express a wide spectrum of biases and beliefs. If any consistent viewpoint emerges in the edgy, stream-of-consciousness provocations it is that truth is relative and that each viewer must become an active participant in determining what is legitimate and what is not. Since the *Truisms*, Holzer has used language exclusively and has employed myriad ways to convey her messages. Selections from her

"The Truisms were, or at least were as close as I could make them to, genuine clichés. . . . They were unequivocal individually, but as a series, because they came from a zillion different points of view, you had to sort things out for yourself and figure out what it meant."

Inflammatory Essays series, for example, appeared on unsigned, commercially printed posters, which were wheat-pasted on buildings and walls around Manhattan

When such Holzer phrases as ABUSE OF POWER COMES AS NO SURPRISE and MONEY CREATES TASTE flashed from the Spectacolor board above Times Square in 1982, it marked her first appropriation of electronic signage. In doing so, she brought her disquieting messages to a new height of subversive social engagement. Her strategy—placing surprising texts where normal signage is expected—gives Holzer direct access to a large public that might not give "art" any consideration, while allowing her to undermine forms of power and control that often go unnoticed.

In Holzer's 1989 retrospective installation at the Guggenheim Museum, blinking messages from her various series, programmed to an insistent but silent beat, raced the length of an L.E.D. display board installed along the winding inner wall of Frank Lloyd Wright's spiral ramp. The museum's rotunda was transformed into a dazzling electronic arcade. In bringing her art from the street to the museum, Holzer focused on an audience that differed markedly from the unsuspecting passerby. The Guggenheim visitors who stood beneath the revolving ribbons of red, green, and yellow aphorisms were more likely to be aware that this installation brought up such issues as the viability of public art, the commodification and consumption of art, and the conflation of the personal and the political—in short, some of the pressing issues of American art in the 1980s.

J.A.

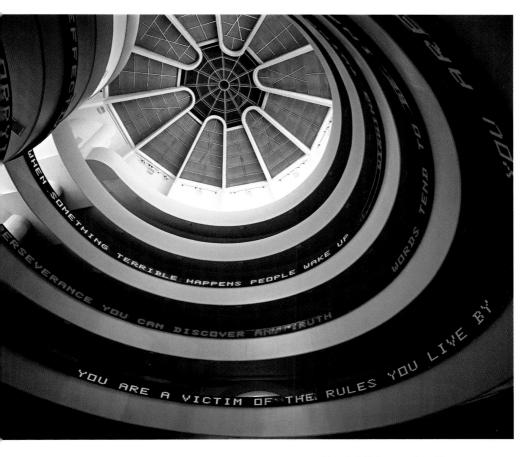

Untitled (Selections from Truisms, Inflammatory Essays, The Living Series, The Survival Series, Under a Rock, Laments, and Child Text). 1989. Extended helical tricolor L.E.D. electronic-display signboard in two sections; site-specific dimensions. Partial gift of the artist, 89.362; and Gift of Donatella and Jay Chiat. 96.4499

Rebecca Horn b. 1944, Michelstadt, Germany

Located in the nexus between body and machine, Rebecca Horn's work transmogrifies the ordinary into the enigmatic. In a career that has spanned more than 30 years and traversed varied stylistic ground—from performance to sculptural installations and feature-length films—Horn has continually returned to the body, the source of her beginnings as an artist. Her sculptural props and related performances of the 1960s and 1970s grew out of a lengthy period of physical recuperation during which she was limited to working while confined to bed. Both protective and restrictive, her sculptural prostheses and cocoonlike garments—the horn of a unicorn that emerges from the head of its wearer's nearly naked body, gloves that increase the fingers' reach nearly tenfold—simultaneously extend and

encumber the body, forming artificial appendages that force a Kafkaesque rumination on the treachery of the body's vagaries.

"My machines...have a human quality and they must change. They get nervous and must stop sometimes. If a machine stops. it doesn't mean it's broken. It's just tired. The tragic or melancholic aspect of machines is very important to me."

In the early 1980s the augmented body ceded in Horn's work to mechanized sculptural installations in which ordinary objects spring to life and engage in carefully choreographed ballets. These beguiling and unsettling contraptions in which spoons seem to kiss and violins to serenade one another take on a bodily tempo as they spasmodically whir and rest and whir again. In *Blue Monday Strip* vintage typewriters are liberated from the orderly office world and set akimbo, transformed into an unruly lot whose keys chatter

ceaselessly in a raucous dialogue. Occasionally, as if to squelch their staccato, a spatter of blue paint showers on them. As in the sexualized world of Horn's inventions, here the clacking machines seem to personify a pool of glum secretaries who find themselves once again behind their typewriters on a Monday morning, as suggested by the title.

Whether mechanomorphic bodies or anthropomorphic machines, all of Horn's works are fraught with sexual allusions and the ache of desire. In *Paradiso*, created specifically for the Guggenheim Museum on the occasion of Horn's 1993 retrospective there, two swollen, breastlike funnels are suspended high above the museum's rotunda. With metronomelike regularity, a milky liquid is excreted from the breasts and falls into the pool far below, creating an almost palpable tension in which the entire building seems to hold its breath in anticipation of the next drip. The reference to Dante implicit in the work's title is underscored by crackling lightning rods, and the dark and haunting companion piece to this light-filled and ethereal work—*Inferno*, installed concurrently at the Guggenheim Museum SoHo.

J.F.R.

Paradiso, 1993.

Plexiglas, pumping system, lightning machines, fox machines, water, and ink; dimensions vary with installation. Gift of the artist. 93.4232

Blue Monday Strip, 1993. Typewriters, ink, metal, and motors, approximately 1921/4 x 137 inches overall. Gift of the artist. 93.4231

Roni Horn b. 1955, New York City

Two blocks of blue glass—identical but different—sit on the floor in relative proximity to one another. Transparent wells of light, they are at once pure depth and reflective surface. As in Roni Horn's metal sculpture—including pairs of solid copper cones—a perfect convergence between interior and exterior transpires. Only here, the oscillation between the two dimensions is visible, even palpable. The work is one of Horn's "pair objects," which exploit the principle of duplication in order to explore the concept of unity. The twin components reveal themselves simultaneously and sequentially. Through its repetition of form, *Untitled (Flannery)* embodies a here and a there. It is a site marked by traversal and progression, requiring the viewer to move from one element to the other in a

"In the end, I keep coming back to this desire to circumvent things which interface between actual experience and perceptions of it." dialectical experience of part to whole. Ideally installed with one block illuminated by sunlight and the other nearby in shadow, the work imagines the passage of a day from dawn until dusk; its temporal narrative also encompasses a now and a then.

Untitled (Flannery) is an ode to blueness. Profoundly allusive, blue can connote a musical genre; a state of melancholy; or an aristocratic pedigree. Blue is visible everywhere in nature; it is the color of the ether that surrounds us. Blue is a tangible reality, but one that

remains infinitely out of reach. According to the artist, the sculpture is a window that opens onto a state of blueness, the depths of which mine metaphysical and psychological territories.

The diptych *Dead Owl*—for which the artist photographed a stuffed snowy owl twice—is also a pair object. This work derives from *Arctic Circles*, the seventh volume of Horn's ongoing series of publications collectively entitled *To Place*, in which she maps her physical and emotional interaction with the topography, climate, and architecture of Iceland, a country she has traveled to repeatedly since 1975. Each volume engages a distinct system of knowing, a way of recording perception that reveals as much about Iceland as it does Horn's own insights into her ever-shifting identification with this island nation. A photographic essay, *Arctic Circles* records the endless horizon of the North Sea, the feathers of an eider nest, and the rotating beacon of a lighthouse, invoking in form the very circumference of Iceland. The owls' double stare, as it loops outward and back, seems to form a figure eight—the sign of infinity—while the dual images perpetuate a constant and essential shifting between identity and difference.

Untitled (Flannery). 1996–97.
Optically clear blue glass: Two parts, 11 x 33 x 33 inches each. Edition 1/3. Purchased with funds contributed by the International Director's Council and Executive
Committee Members. 98.4624.a..b

Dead Owl, 1997. Two Iris prints, 29 x 29 inches each. Edition 1/15. Gift of the artist and Matthew Marks Gallery. 98.4644.a..b

Imaginary

In the desert the mirage is imaginary while the oasis is real and life-sustaining. Plato conceived of painting as a mirage, "a man-made dream for waking eyes," but because it artificially imitates reality without truly being what it represents, he considered it ethically deficient. Truth to nature has been reasserted in different guises, from the Renaissance ideal of the painting as a window onto the world to the mid-19th-century Realism of Gustave Courbet, who contended, "Show me an angel and I'll paint it."

The concept of the imaginary as a fundamental value of art is rooted in the Enlightenment's privileging of the individual creative genius. Artists have pursued various methods of liberating the mind in order to access the marvelous, such as looking to children, "primitives," and the insane for inspiration or using psychoanalytic techniques and mind-altering substances to stimulate the unconscious. As the individual became the source of originality, the Western male artist was driven to construct himself in opposition to a nonself. The oneiric realms explored by the Symbolists and Surrealists, for example, were based on projections of an exotic and erotic imaginary world implicitly opposed to a reality envisioned as Western, mundane, and masculine.

Since the early 20th century the difference between the real and the imaginary has been problematized by the latter's usurpation of the former. From the moment when Marcel Duchamp chose his first readymade in the 1910s, a strain of literal realism has been evident in art, but it carries conceptual baggage. Is a Hoover that is used to clean simply a vacuum cleaner, and the one in Jeff Koons's *Hoover Convertible* art? The vacuum cleaner on the pedestal really is what it represents, but it doesn't yield Truth as Plato supposed. Cinematic fables like *E.T.* (1982) made the marvelous seem more ordinary by featuring familiar brand-name products, while the real is fictionalized in recent "reality"-based TV programs. The synthetic realism of advertising is the most persistent and pervasive visual mapping of the modern imagination. Nowadays, the imaginary masquerades as the real, reflecting a world where the most "real" object is the commodity.

J.B.

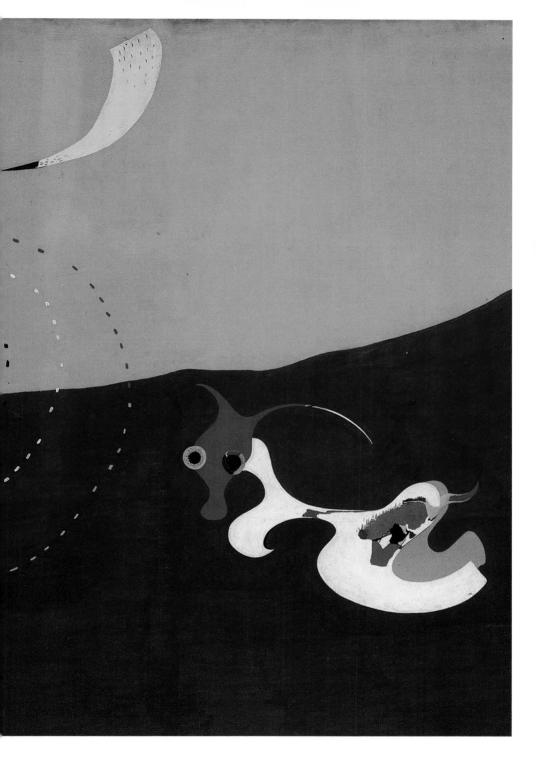

Index

Imagine a photograph of nothing. Would it be a representation of empty space, pure light, total blackness, a blank surface, or an image of the word "nothing"? A photograph has to be a photograph of something, or evidence of the chemical processes of photography itself. This necessity of the photographic sign to carry the referent within itself is what Charles Sanders Pierce, American Pragmatist and founder of the American school of semiotics, labeled the index. Produced by a physical, contiguous connection between sign and referent, the indexical sign "would lose the character that makes it a sign if its object were removed." This is true of

nonphotographic signs such as the residue of human contact: a thumbprint pressed into plaster or a cast shadow.

As Rosalind Krauss has argued, the indexical became a primary characteristic of contemporary art in the 1970s, when the status of the photographic sign as the only evidence of "what has been" moved to center stage with the introduction of Performance art, Body art, and Environmental art. In the 1980s, the phenomenological terrain of the index was leveled an important aesthetic and philosophical blow with the introduction of Cindy Sherman's *Untitled Film Stills* (1977–80). While the body of Sherman the artist is always present in these photographs, there is a "she" that is also present who alludes to, while never being a precise index of, cinematic memory, gesture, and actual mise-en-scène. With the subsequent introduction of digital photography into contemporary art, as in Andreas Gursky's photographic tableaux made from digitally

Matthew Barney, CREMASTER 4, 1994, production still.

Informe

Was it a coincidence that in 1929, at just the time Joan Miró entered what he termed "anti-painting," Georges Bataille enunciated the principle of formlessness in the "dictionary" entry he wrote for the word (*l'informe*) in the magazine he edited, *Documents?* Or that during the periodical's brief life (1929–30), the sculptor Alberto Giacometti should have been praised for producing the experience of "failure," or that Salvador Dalí should have developed an aesthetic of the edible—the destruction of form through eating?

Alberto Giacometti,
Suspended Ball, 1930.
Plaster and metal. 24 x 14 1/2 x
13 1/2 inches. Alberto Giacometti
Foundation, Kunsthaus Zürich.

If the 1920s are celebrated for the consolidation of an aesthetic of form, whether through the careers of the great abstract painters or the major architects or design schools (like the Bauhaus), the end of the decade brought an attack on formal thinking. As Bataille explained, dictionaries—like works of art or literature—should be operational: rather than bestowing form by giving definitions, their job should be to strip things of their idealizing cloaks of abstraction to reveal their materiality, a materiality that is formless.

Although Bataille's analogue for the *informe* was the crushed spider or the blob of spittle, and though Mirô's detour from painting took the form of working with trash, Giacometti's example of formlessness cannily assumed a highly polished, even geometrically simple set of shapes. The formlessness generated by *Suspended Ball* came instead from how it short-circuited the structural logic of form, which Bataille had spoken of categorically. Based on opposition, every category of thought is maintained not simply by what it names but by what it opposes: good as opposed to bad, male to female, life to death. Giacometti's work, containing a cleft ball hung so that it could swing over a recumbent wedge produced just this

stymieing of categories in that its "erotics" enacted a blurring of gender, the wedge appearing both labial and phallic, the ball cast as both active and passive.

Not surprisingly, given Modernism's commitment to an aesthetics of form, the accounts of artists such as Giacometti or Miró have until recently omitted their connections to Bataille and to *Documents*, passing as well over the theoretical implications of the *informe*. These implications are not just tied to Surrealism, however, but extend to much postwar art as well, whether in the French movement of *décollage* or in Robert Morris's notion of "anti-form" or Robert Smithson's concept of entropy.

ROSALIND KRAUSS

Donald Judd b. 1928, Excelsior Springs, Mo.; d. 1994, Marfa, Tex.

In the early 1960s Donald Judd abandoned painting, having recognized that "actual space is intrinsically more powerful and specific than paint on a flat surface." His move into three dimensions was coincident with a growing acknowledgment among other artists of his generation of the physical environment as an integral aspect of an artwork. Minimalist sculpture broke with illusionistic conventions by translating compositional concerns into three dimensions, rendering the work a product of the exchange between the object, the viewer, and the environment.

"Painting and sculpture have become set forms. A fair amount of their meaning isn't credible. The use of three dimensions isn't the use of a given form."

In his 1965 treatise "Specific Objects," Judd championed recent work that was neither painting nor sculpture by a diverse range of artists such as Lee Bontecou, Mark di Suvero, Claes Oldenburg, and Frank Stella. His endorsement of "the thing as a whole" rather than a composition of parts stemmed from what he saw as the strength and clarity asserted by singular forms, the unitary character of which resulted from the conflation of color, image, shape, and surface. Judd's earliest freestanding sculptures were singular, boxlike forms constructed of wood or metal. The simple shape of *Untitled* (1968), with its slightly recessed upper surface, is readily intelligible as a

whole and thus avoids the compositional effects that for Judd diluted a work's power. As the artist's exploration of three-dimensional space became more complex, his aversion to such effects was manifested in a number of strategies designed to subordinate a work's individual components to the whole.

Like the rectangular shape with which he began, Judd's rows and progressions are legible systems that reoccur in his oeuvre. In its repetition of serial forms and spaces, the vertical stack of *Untitled* (1969) literally incorporates space as one of its materials along with highly polished copper, creating a play between positive and negative that coheres as a totality. Similarly, in *Untitled* (1970), the application of a dual Fibonacci progression (a mathematically based sequence in which each number is the sum of the two previous two: 0, 1, 1, 2, 3, 5, and so on) imparts an internal logic to both solid and void alike, the anodized color of the boxes throwing the mathematical system into greater relief. While spatial concerns were foremost for Judd, color and materials always remained central to his conception of art. A sustained and rigorous investigation of space and form, his work is tempered by a rich palette of industrial materials, such as stainless steel, aluminum, and translucent Plexiglas, the varied surfaces and finishes of which lend a sumptuous air to an otherwise austere undertaking.

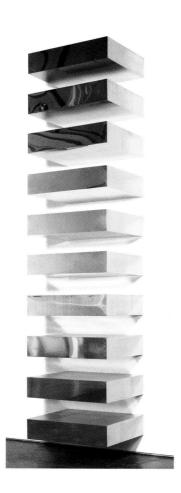

Untitled, 1969. Copper; ten units, 9 x 40 x 31 inches each, with 9-inch intervals; 170 x 40 x 31 inches overall. Panza Collection. 91.3713.a-.j

Untitled, 1968. Enamel on aluminum, 22 x 50 x 37 inches. Panza Collection, Gift. 91.3711

Untitled, 1970. Clear anodized and purple anodized aluminum, $8\,\% \times 253 \times 8$ inches. Panza Collection. 91.3715

Vasily Kandinsky b. 1866, Moscow; d. 1944, Neuilly-sur-Seine, France

Vasily Kandinsky's use of the horse-and-rider motif symbolized his crusade against conventional aesthetic values and his dream of a better, more spiritual future through the transformative powers of art. The rider

"His storming riders are his coat of arms." —August Macke on Kandinsky is featured in many woodcuts, temperas, and oils, from its first appearance in the artist's folk-inspired paintings, executed in his native Russia at the turn of the century, to his abstracted landscapes made in Munich during the early 1910s. The horseman was also incorporated into the cover designs for Kandinsky's theoretical manifesto of 1911, *On the Spiritual in Art*, and the contemporaneous *Blue Rider Almanac*, which he coedited with Franz Marc.

In 1909, the year he completed *Blue Mountain*, Kandinsky painted no less than seven other canvases with images of riders. In that year his style became increasingly abstract and expressionistic and his thematic con-

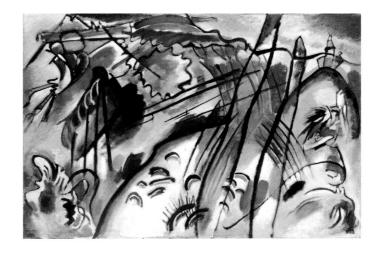

cerns shifted from the portrayal of natural events to apocalyptic narratives. By 1910 many of the artist's abstract canvases shared a common literary source, the Revelation of Saint John the Divine; the rider came to signify the Horsemen of the Apocalypse, who will bring epic destruction after which the world will be redeemed. In both Sketch for Composition II and Improvisation 28 (second version) Kandinsky depicted—through highly schematized means—cataclysmic events on one side of the canvas and the paradise of spiritual salvation on the other. In the latter painting, for instance, images of a boat and waves (signaling the global deluge), a serpent, and, perhaps, cannons emerge on the left, while an embracing couple, shining sun, and celebratory candles appear on the right.

Blue Mountain, 1908–09. Oil on canvas, 41 ¾ x 38 inches. Gift, Solomon R. Guggenheim. 41.505

Sketch for Composition II.

Oil on canvas, 38 3/8 x 51 5/8 inches. 45.961

Improvisation 28 (second version),

Oil on canvas, 43 1/8 x 63 1/8 inches. Gift, Solomon R. Guggenheim. 37.239

Kandinsky

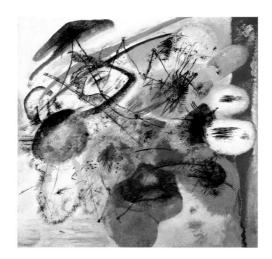

With its undulating colored ovals traversed by animated brushstrokes, *Black Lines* is among the first of Kandinsky's truly nonobjective paintings. The network of thin, agitated lines indicates a graphic, two-dimensional sensibility, while the floating, vibrantly hued forms suggest various spatial depths.

By 1913 Kandinsky's aesthetic theories and aspirations were well developed. He valued painterly abstraction as the most effective stylistic means through which to reveal hidden aspects of the empirical world, express subjective realities, aspire to the metaphysical, and offer a regenerative vision of the future. Kandinsky wanted the evocative power of carefully chosen and dynamically interrelated colors, shapes, and lines to elicit specific responses from viewers of his canvases. The inner vision of an artist, he believed, could thereby be translated into a universally accessible statement.

He realized, however, that it would be necessary to develop such a style slowly in order to foster public acceptance and comprehension. Therefore, in most of his work from this period he retained fragments of recognizable imagery. "We are still firmly bound to the outward appearance of nature and must draw forms from it," he wrote in his essay "Picture with the

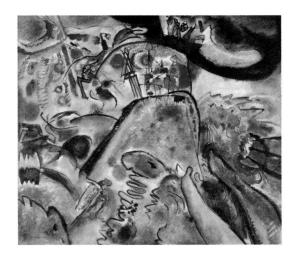

White Edge," but suggested that there existed a hidden pictorial construction that would "emerge unnoticed from the picture and [would thus be] less suited to the eye than the soul." Painting with White Border, for instance, was explained by Kandinsky as a response to "those . . . extremely powerful impressions I had experienced in Moscow-or more correctly, of Moscow itself." To illustrate the spirit of the city, Kandinsky included an extremely abbreviated image of a Russian troika driven by a trio of horses (the three diagonal black lines in the upper-left portion of the canvas). The mass of swirling colors and lines in the center has been convincingly interpreted as the figure of a lance-bearing St. George on horseback, an allusion to Moscow's tsarist tradition (the state seal of Peter the Great included an emblem of the saint). Small Pleasures is filled with veiled imagery of the Last Judgment, as in many of his paintings, but its title suggests other readings. In an essay on the work, Kandinsky wrote that his goal "was to let . . . [himself] go and scatter a heap of small pleasures upon the canvas."

Black Lines, December 1913.
Oil on canvas, 51 x 51 15/4 inches. Gift, Solomon R. Guggenheim. 37.241

Painting with White Border,

Oil on canvas, 55 1/4 x 78 1/8 inches. Gift, Solomon R. Guggenheim.

Small Pleasures, June 1913. Oil on canvas, 43 ¼ x 47 ⅙ inches. 43.921

Kandinsky

When Kandinsky returned to his native Moscow after the outbreak of World War I, his expressive abstract style underwent changes that reflected

"It is said that in art it is not necessary and even dangerous to have intuition. This is the point of view of a few young [Russian] painters who push the materialistic viewpoint to absurdity." the utopian artistic experiments of the Russian avant-garde. The emphasis on geometric forms, promoted by artists such as Kazimir Malevich, Aleksandr Rodchenko, and Liubov Popova in an effort to establish a universal aesthetic language, inspired Kandinsky to expand his own pictorial vocabulary. Although he adopted some aspects of the geometrizing trends of Suprematism and Constructivism—such as overlapping flat planes and clearly delineated shapes—his belief in the expressive content of abstract forms alienated him from the majority of his Russian colleagues, who

championed more rational, systematizing principles. This conflict led him to return to Germany in 1921. *In the Black Square*, executed two years later, epitomizes Kandinsky's synthesis of Russian avant-garde art and his own lyrical abstraction: the white trapezoid recalls Malevich's Suprematist paintings, but the dynamic compositional elements, resembling clouds, mountains, sun, and a rainbow, still refer to the landscape.

In 1922 Kandinsky joined the faculty of the Weimar Bauhaus, where he discovered a more sympathetic environment in which to pursue his art. Originally premised on a Germanic, expressionistic approach to artmaking, the Bauhaus aesthetic came to reflect Constructivist concerns and styles, which by the mid-1920s had become international in scope. While there, Kandinsky furthered his investigations into the correspondence between colors and forms and their psychological and spiritual effects. In Composition 8, the colorful, interactive geometric forms create a pulsating surface that is alternately dynamic and calm, aggressive and quiet. The importance of circles in this painting prefigures the dominant role they would play in many subsequent works, culminating in his cosmic and harmonious image Several Circles. "The circle," claimed Kandinsky, "is the synthesis of the greatest oppositions. It combines the concentric and the eccentric in a single form and in equilibrium. Of the three primary forms, it points most clearly to the fourth dimension."

Composition 8, July 1923. Oil on canvas, 55 1/a x 79 1/a inches. Gift, Solomon R. Guggenheim. 37.262

In the Black Square, June 1923. Oil on canvas, 38 ¾ x 36 ¼ inches. Gift, Solomon R. Guggenheim. 37.254

Several Circles, January–February 1926.

Oil on canvas, 55 1/4 x 55 3/6 inches. Gift, Solomon R. Guggenheim. 41.283

Kandinsky

Although Kandinsky was forced to leave Germany in 1933 due to political pressures, he did not allow the mood of desolation pervading war-torn Europe to enter the paintings and watercolors that he produced in France, where he remained until his death in 1944. His late works are marked by a general lightening of palette and the introduction of organic

"Abstract art, despite its imagery; breaking away from the rigidity of Bauhaus geometry, he emancipation, is subject here turned to the softer, more malleable shapes used by Paris-based also to 'natural laws,' and is artists associated with Surrealism, such as Jean Arp and Joan Miró. obliged to proceed in Kandinsky's late, often whimsical, paintings were also influenced by the same way that nature did the playful, intricately detailed compositions of his longtime friend previously, when it started and Bauhaus colleague Paul Klee. in a modest way with protoplasm and cells, progressing very gradually to increasingly

During his first years in France, Kandinsky experimented with pigments mixed with sand, a technical innovation practiced during the 1930s by many Parisian artists, including André Masson and Georges Braque. Although Kandinsky utilized this method only until 1936, he created several paintings with rich, textured surfaces such

as Accompanied Contrast, in which the interconnected colored planes and smaller floating patterns project slightly from the canvas. Always attentive to and appreciative of contemporary stylistic innovations, Kandinsky inevitably brought his own interests to bear on any aspects he would bor-

complex organisms."

row. As art historian Vivian Barnett has pointed out, his employment of biomorphic forms—a motif favored by Surrealist painters as well as by Klee—attests more to his fascination with the organic sciences themselves, particularly embryology, zoology, and botany. During his Bauhaus years, Kandinsky had clipped and mounted illustrations of microscopic organisms, insects, and embryos from scientific journals for pedagogical purposes and study. He also owned several important sourcebooks and encyclopedias from which depictions of minuscule creatures found abstract equivalences in his late paintings. A schematized pink-toned embryo, for instance, floats in the upper-right corner of Dominant Curve, while the figures contained within the green rectangle in the upper-left corner resemble microscopic marine animals. Various Actions is imbued with similar organic figures hovering above a celestial blue field. These buoyant, biomorphic images, often presented in pastel hues, may be read as signs of Kandinsky's optimistic vision of a peaceful future and hope for postwar rebirth and regeneration.

Accompanied Contrast.

March 1935.
Oil with sand on canvas, 38 1/4 x 63 1/6 inches. Gift, Solomon R.
Guggenheim, 37,338

Dominant Curve, April 1936. Oil on canvas, 50 1/2 x 76 1/2 inches. 45.989

Various Actions,

August-September 1941.
Oil and enamel on canvas, 35 1/8 x 45 1/4 inches. 47.1159

Mike Kelley b. 1954, Detroit, Mich.

A self-proclaimed "blue-collar anarchist," Mike Kelley conducts a revolution that is not one of active aggression or trailblazing polemics. Instead, he has devised an aesthetics of delinquency through which he identifies with the underdog and debunks the two organizing principles of 20th-

"As a child, I couldn't appreciate why you'd want to believe something you couldn't understand. I think it made me wary of belief in anything. I'd always say, 'Well, who says?'"

century thought: capitalism and psychoanalysis. As a student at Cal Arts in Los Angeles during the mid-1970s, he developed a unique performance style. At that time Kelley's sculptures were "demonstrational" in the sense that he "performed" them by using the works as props during performances that incorporated Surrealist-inspired, trancelike writings with sculptural objects and dance. He created bizarre systems of logic that inverted the reductivist, critical tendencies of Conceptual art while introducing a vocabulary that was decidedly irreverent, even adolescent in tone. Although he stopped

performing in 1986, his subsequent stand-alone sculptures still function as sites in which narratives of transgression unfold.

Riddle of the Sphinx embodies many of Kelley's themes and, to some extent, sums up his initial post-performance project entitled Half a Man, in which he embraced dejection as the antithesis of masculine authority. He conceived this series in reaction to the heroicized, masculinist tenor of what he calls "I-beam" Minimalism and the slick commodity critique of Neo-Conceptualism. The Half a Man project flaunts a stereotypically

feminized sensibility, utilizing knitted afghans, sewn banners with slacker slogans, and old, grungy stuffed animals. In order to prevent empathetic identification with the toys, he arranged them according to typologies or placed them on afghans to stress figure-ground relationships in an ironic evocation of painterly convention. Eventually, he concealed the animals under the afghans, deliberately repressing their visual appearance in a pitiful version of hide-and-seek. In Riddle of the Sphinx, he substituted metal bowls for the veiled toys, the number of which corresponds to the guestion posed to Oedipus in Sophocles's drama: What walks on four legs in the morning, two at noon, and three in the evening? The passage of this metaphorical day is echoed in the hues of the afghan, which range in color from pale to dusky and match, in a kitsch moment, an accompanying print of Mount Fuji. Solving the riddle with the answer "Man" (as the measure of all things). Oedipus conquers the Sphinx and secures his own tragic fate. By situating the founding myth of patriarchy and Freudian psychology in the playfully pathetic realm of this floor-bound, camouflaging installation, Kelley associates the Oedipal complex—and, by extension, castration anxiety—with his antihero, the "half a man."

Riddle of the Sphinx, 1991.
Knitted afghan, stainless-steel bowls, and photograph; floor piece: 312 x 156 x 5 inches; photograph: 18 x 23½ inches. Purchased with funds contributed by the International Director's Council and Executive Committee Members. 98.4625.a-.k

Ellsworth Kelly b. 1923, Newburgh, N.Y.

With his keen eye for contour, Ellsworth Kelly extracts visual "fragments" from the surrounding world—the sweeping curve of a Romanesque nave, a crescent moon, a barred window—and then condenses them into elemental colors and shapes. Although relentlessly abstract, his forms are anchored to the legible, to details of architecture or landscape, filtered through the artist's vision. Early in his career, Kelly adopted a philosophy of anti-illusionism that would change the parameters of painting and revise its relationship to sculpture. He began painting monochrome panels in the early 1950s and has been experimenting with this composition (or anti-composition) ever since in single and multipanel formats. With their anonymous, uninflected technique and absence of surface drawing, these

"I think that if you can turn off the mind and look at things only with your eyes, ultimately everything becomes abstract." pristine "painting-objects" established a new relationship between painting and its architectural context. By defining the structure and shape of each canvas through color—matte, uniform, and without gestural nuance—Kelly eliminated any figure-ground illusion and brought painting into the sculptural realm of objects; the painting itself became the figure, with the wall as its ground.

Blue, Green, Yellow, Orange, Red exemplifies Kelly's lucid, forthright style. Five monochrome panels are arranged in the order of the chromatic spectrum, the primary colors balanced by their intermediary values of green and orange. The concentrated colors are charged by their interaction with each other, and the work's size-monumental, yet at a human scale by virtue of its breakdown into vertical panels—further strengthens its presence. Dark Blue Curve signals Kelly's longtime interest in shaped canvases. It is this focus on peripheral shape identified by color that makes his paintings sculptural, engaging directly with their own forms and the walls around them. The shaped monochromes reinforce the anti-illusionistic project begun with Kelly's rectangular panels; unframed and unmarked save for their color, they are a more emphatic denial of the window-ontothe-world view of the traditional four-sided easel painting. Wright Curve, a steel sculpture designed for permanent installation in the Guggenheim's Peter B. Lewis Theater, is named after the museum's architect, Frank Lloyd Wright. Its affinity with the palette and geometry of the auditorium shows the artist's interest in encouraging site-specific experiences of his painting and sculpture. For Kelly, the transition between the two mediums is fluid: "sculpture for me is something I've brought off the wall."

B.A.

Blue, Green, Yellow, Orange, Red. 1966. Oil on canvas; five panels, 60 x 240 inches overall. 67.1833.a-.e

Dark Blue Curve, 1995. Oil on canvas, 46 x 190 inches. 96.4512

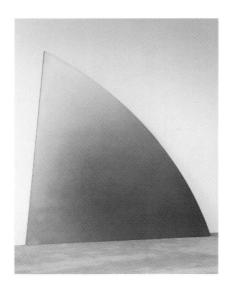

Wright Curve, 1996. Hot-rolled steel, 115 x 11/2 inches. Gift of the artist. 96.4513

Anselm Kiefer b. 1945, Donaueschingen, Germany

Born in Germany just months before the final European battle of World War II, Anselm Kiefer grew up witnessing the results of modern warfare and the division of his homeland. He also experienced the rebuilding of a fragmented nation and its struggle for renewal. Kiefer devoted himself to investigating the interwoven patterns of German mythology and history and the way they contributed to the rise of Fascism. He confronted these issues by violating aesthetic taboos and resurrecting sublimated icons. For example, in his 1969 Occupations series, Kiefer photographed himself striking the "Sieg Heil" pose. Subsequent paintings—immense landscapes and architectural interiors, often encrusted with sand and straw—invoke Germany's literary and political heritage. References abound to the Nibelungen and Wagner, Albert Speer's architecture, and Adolf Hitler.

"I work with symbols which link our consciousness with the past. The symbols create a kind of simultaneous continuity and we recollect our origins." Seraphim is part of Kiefer's Angel series, which treats the theme of spiritual salvation by fire, an ancient belief perverted by the Nazis in their quest for an exclusively Aryan nation. In this painting, a ladder connects a landscape to the sky. At its base, a serpent—symbolizing a fallen angel—refers to the prevalence of evil on earth. According to the Doctrine of Celestial Hierarchy, a 5th-century text, the seraphim "purify through fire and burnt offering." Kiefer used fire to

create the surface of *Seraphim*, and it is evident from this and many other works that he associates fire with the redemptive powers of art. This equivalence was suggested in the 1974 canvas *Painting = Burning*, in which the outline of a painter's palette is superimposed on a view of the war-torn earth. The actual burning of materials used in *Seraphim* suggests a more specific reading: the Latin word used to describe a sacrificial offering consumed by flames is "holocaust."

In 1991, the year of Germany's reunification, Kiefer left his homeland to travel the world; he eventually settled in the South of France. This change had a marked effect on the artist's style and themes, which ranged from the sunflowers of Arles to the queens of France. In a series of works devoted to French female royalty, Kiefer paid homage to the likes of Catherine de' Medici, Marie-Antoinette, and Anne d'Autriche. In Les Reines de France, the women are rendered like Byzantine icons against a background of distressed gold-leaf mosaic. This new iconography, while still engaged with the weight of history, indicates that Kiefer now approached his subject matter with admiration, even joy.

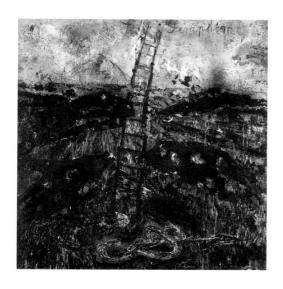

Seraphim, 1983–84.
Oil, straw, emulsion, and shellac on canvas, 126 ½ x 130 ½ inches. Purchased with funds contributed by Mr. and Mrs.
Andrew M. Saul. 84.3216

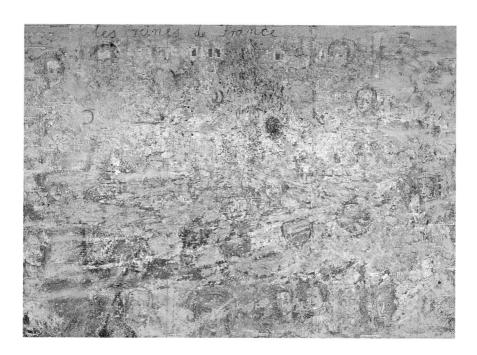

Les Reines de France, 1995. Emulsion, acrylic, sunflower seeds, photographs, woodcut, gold leaf, and cardboard on canvas; three panels, 220½ x 290½ inches overall. 97.4558.a-.c

Ernst Ludwig Kirchner b. 1880, Aschaffenburg, Germany; d. 1938, Davos, Switzerland

In 1905 Ernst Ludwig Kirchner joined Fritz Bleyl, Erich Heckel, and Karl Schmidt-Rottluff—all former architecture students who had turned to painting in search of greater self-expression and more immediate means of communication—to found a new art coalition: Die Brücke (The Bridge). The Dresden-based group, part of the larger German Expressionist movement, developed an aesthetic style defined by agitated, coarse lines and intense, blunt colors. Their intention was to wage battle against the constricting forces of bourgeois culture, which they associated with mediocrity, corruption, and weakness. Kirchner's emphasis on self-empowerment and absolute freedom from convention was manifested in his early art by the predominance of erotic subject matter. The female nude—crudely

rendered as "primitive" and submissive—served him and his colleagues as a sign of male domination and virility.

"The pressure of the war and the increasingly prevailing superficiality weigh more heavily than everything else."

Artillerymen, painted two years after Die Brücke's dissolution,
marked a change in subject matter. The picture depicts an assembly
of naked male soldiers, overseen by a clothed military official. Their
attenuated bodies are compressed into an airless, low-ceilinged
chamber. Created after Kirchner had been drafted into the German
army in 1914 and subsequently released on the grounds of mental instability, this image suggests the artist's sense of overwhelming vulnerability.

ity, this image suggests the artist's sense of overwhelming vulnerability. The naked, showering soldiers are powerless as individuals; their wills have been subjected to the rigidity and anonymity of military life. The view that Artillerymen represents Kirchner's horror of the war (and fear for his own life) is corroborated in a more overtly autobiographical painting from the same period, Self-Portrait as Soldier. In this oft-reproduced work, a gaunt uniformed Kirchner presents his own severed arm to the viewer, an allusion to the terror of artistic impotence and, ultimately, of death. The presence of a nude female model behind him extends the metaphor to include the possibility of castration, the fear of which would be particularly powerful given Kirchner's conflation of sexual prowess, cultural liberation, and aesthetic achievement.

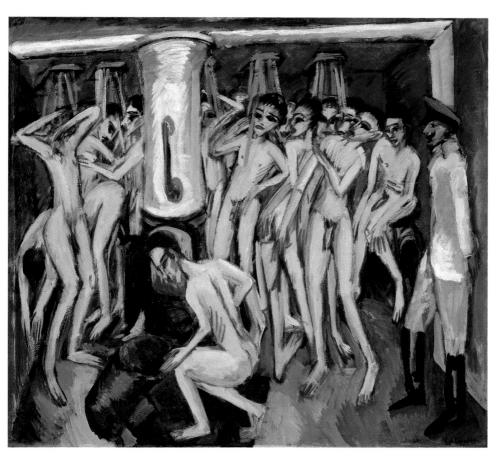

Artillerymen, 1915. Oil on canvas, 55 1/8 x 59 1/8 inches. By exchange. 88.3591

Kitsch

What is the quintessential icon of kitsch? Perhaps a plastic Venus de Milo statuette complete with working clock embedded in the stomach. An image such as this affords, among other things, a convenient reference point from which to draw a line between us, those who can be counted upon to know kitsch when they see it, and them, the untutored masses. Unfortunately for "us," whoever we might be, the reliability of such distinctions is more often than not questionable, if not illusory.

It was Clement Greenberg who, in his 1939 essay "Avant-Garde and Kitsch." strove to define the avant-garde as a last bastion against kitsch. In treating the vagaries of mass culture as a moral contaminant, however, he seriously underestimated its overall revolutionary potential and the extent to which traditional culture would be irrevocably transformed by the ongoing processes of industrialization. The dissolution of so-called high art was already well underway when the Dadaists incorporated imagery from popular magazines and newspapers into their photomontages. By the time "Avant-Garde and Kitsch" appeared, Surrealism, with its hybrid dream objects, had heralded an onslaught of Venus de Milo clocks to come. But beyond the progression of various art movements per se, Greenberg failed to comprehend how mass culture-as-spectacle enabled kitsch to gobble up authentic masterpieces, even the Venus de Milo herself. Charles Baudelaire foresaw this involution in his 1863 essay "The Painter of Modern Life": "The world—and even the world of artists is full of people who can go to the Louvre, walk rapidly, without so much as a glance, past rows of very interesting, though secondary, pictures, to come to a rapturous halt in front of a Titian or Raphael—one of those that would have been most popularized by the engraver's art; then they will go home happy, not a few saying to themselves, 'I know my Museum.'" Pop artists grappled with this condition in an effort to keep their art from becoming too corny. They showed that artists must address how spectacle inexorably saturates everyday life; failure to acknowledge this truth only perpetuates kitsch. This marked a curious reversal of the accustomed battle lines. Ironically, it is purist aesthetics that then became most vulnerable to kitschification.

JOHN MILLER

Paul Klee b. 1879, Münchenbuchsee, Switzerland; d. 1940, Muralto-Locarno, Switzerland

Paul Klee's persistent shifts in style, technique, and subject matter indicate a deliberate and highly playful evasion of aesthetic categorization. Nevertheless, it is virtually impossible to confuse a work by Klee with one by any other artist, even though many have emulated his idiosyncratic, enigmatic art. So accepted was his work that Klee was embraced over the years by the Blue Rider group, the European Dada contingent, the Surrealists, and the Bauhaus faculty, with whom he taught for a decade in Weimar and Dessau.

As part of the early 20th-century avant-garde, Klee formulated a personal abstract pictorial language. His vocabulary, which oscillates freely between the figurative and the nonrepresentational, communicates through a unique symbology that is more expressive than descriptive. Klee conveyed his meanings through an often whimsical fusion of form and text, frequently writing the titles to his works on the mats upon

"My self . . . is a dramatic ensemble."

which they are mounted and including words within the images le." themselves. Such is the case with The Bavarian Don Giovanni, in which Klee indicated his admiration for the Mozart opera as well as for certain contemporary sopranos, while hinting at his own amorous pursuits. A veiled self-portrait, the figure climbing the ladder is surrounded by five women's names, an allusion to the operatic scene in which Don Giovanni's servant Leporello recites a list of his master's 2,065 love affairs. Citing Klee's confession that his "infatuations changed with every

soubrette at the opera," art historian K. Porter Aichele has identified the Emma and Thères of the watercolor as the singers Emma Carelli and Thérèse Rothauser. The others—Cenzl. Kathi, and Mari—refer to models

with whom Klee had fleeting romantic interludes.

Although much of Klee's work is figurative, compositional design nearly always preceded narrative association. The artist often transformed his experiments in tonal value and line into visual anecdotes. *Red Balloon*, for example, is at once a cluster of delicately colored, floating geometric shapes and a charming cityscape. *Runner at the Goal* is an essay in simultaneity; overlapping and partially translucent bars of color illustrate the consecutive gestures of a figure in motion. The flailing arms and sprinting legs add a comic touch to this figure, on whose forehead the number "one" promises a winning finish.

The Bavarian Don Giovanni, 1919. Watercolor and ink on paper, 8 1/8 x 8 1/8 inches. 48.1172x69

Red Balloon, 1922. Oil (and oil-transfer drawing?) on chalk-primed gauze, mounted on board, 12 ½ x 12 ¼ inches. 48.1172x524

Runner at the Goal, 1921.
Watercolor and pencil on paper, bordered with watercolor on the cardboard mount, 15 ½ x 11 ½ inches overall. 48.1172x55

Klee

An assiduous student of music, nature, mathematics, and science. Klee applied this constellation of interests to his art at every turn. Even his purely abstract works have their own particular subject matter. In the Current Six Thresholds, an austere composition of horizontal chromatic stripes divided into smaller units and intersected by vertical bands, has been compared to landscape painting. A late Bauhaus work, it is part of a series of gridlike canvases that Klee painted after he returned from a trip to Egypt. His visual impressions of the Nile river valley are represented here through a highly schematized, geometric analogy composed of a square lattice motif and restrained tonal variations. Another geometric painting, New Harmony, demonstrates the artist's long-standing interest in color theory. Such flat configurations of painted rectangles appeared in Klee's work as early as 1915 and evolved as expressions of his equation of chromatic division with musical notation. This late canvas, painted in 1936, is the last such composition and, in typical Klee fashion, looks toward the new and innovative, rather than nostalgically backward. According to art historian Andrew Kagan, the composition is based on the principle of bilateral inverted symmetry (the right side of the canvas is an upsidedown reflection of the left) and the tonal distribution of juxtaposed, noncomplementary colors evokes the nonthematic, monodic 12-tone music of Arnold Schönberg. Kagan notes, in conjunction with this reading, that Klee used 12 hues in New Harmony, save for the neutral gray and the black underpainting.

Klee revealed a more socially and politically relevant side in his 1937 painting *Revolution of the Viaduct*, of which the Guggenheim's *Arches of the Bridge Break Ranks* is an earlier version. Created when Fascism was on the rise in Europe, the image of rebellious arches escaping from the conformity of a viaduct invokes public dissension while promoting individuality. It is a flippant but foreboding reference to Albert Speer's monolithic Nazi architecture as well as to official Soviet imagery of workers marching forward in unison. There is a poignant postscript to Klee's social critique: after the artist fled Germany in 1937 to his native Switzerland, 17 of his works were displayed in the Nazis' *Degenerate Art* exhibition, a show of Modern painting and sculpture that they considered too free-spirited and libertarian.

In the Current Six Thresholds, 1929. Oil and tempera on canvas, 17 1/6 x 17 1/6 inches. 67.1842

Arches of the Bridge Break Ranks. 1937. Charcoal on cloth, mounted on paper; cloth: 16 1/4 x 16 1/2 inches; paper: 19 1/10 x 18 1/10 inches. 48.1172x59

New Harmony, 1936. Oil on canvas, 36 ½ x 26 ½ inches. 71.1960

Yves Klein b. 1928, Nice; d. 1962, Paris

Yves Klein's first passion in life was judo. In 1952 he moved to Tokyo and studied at the Kodokan Judo Institute, where he earned a black belt. When he returned to Paris in 1955 and discovered to his dismay that the Fédération Française de Judo did not extol him as a star, he shifted his

"It is that extraordinary faculty of the sponge to become impregnated with whatever may be fluid that seduced me." attentions and pursued a secondary interest—a career in the arts. During the ensuing eight years Klein assembled a multifarious and critically complex body of work ranging from monochrome canvases and wall reliefs to paintings made with fire. He is renowned for his almost exclusive use of a strikingly resonant, powdery cobalt pigment, which he patented under the name "International Klein Blue," claiming that it represented the physical manifestation of cosmic energy that, otherwise invisible, floats freely in the air. In

addition to monochrome paintings, Klein applied this pigment to sponges, which he attached to canvases as relief elements or positioned on wire stands to create biomorphic or anthropomorphic sculptures. First exhibited in Paris in 1959, the sponge sculptures—all essentially alike, yet ultimately all different—formed a forest of discrete objects surrounding the gallery visitors. About these works Klein explained, "Thanks to the

sponges—raw living matter—I was going to be able to make portraits of the observers of my monochromes, who . . . after having voyaged in the blue of my pictures, return totally impregnated in sensibility, as are the sponges."

Klein's activities also included using nude female models drenched in paint as "brushes": releasing thousands of blue balloons into the sky; and exhibiting an empty, white-walled room and then selling portions of the interior air, which he called "zones" of "immaterial pictorial sensibility." His intentions remain perplexing 30 years after his sudden death. Whether Klein truly believed in the mystical capacity of the artist to capture cosmic particles in paint and to create aesthetic experiences out of thin air and then apportion them at whim is difficult to determine. The argument has also been made that he was essentially a parodist who mocked the metaphysical inclinations of many Modern painters, while making a travesty of the art market.

Untitled blue monochrome (IKB 82), 1959.

Dry pigment in synthetic resin on canvas, mounted on board, 36 ¼ x 28 ¼ x 1¼ inches. Gift, Estate of Geraldine Spreckels Fuller 1999. 2000.27

Blue Sponge, 1959.

Dry pigment in synthetic resin on sponge with metal rod and stone base, 39 x 12 x 10 inches. Gift, Mrs. Andrew P. Fuller. 64.1752

Franz Kline b. 1910, Wilkes-Barre, Pa.; d. 1962, New York City

Throughout the 1940s, while many artists of the nascent New York School were experimenting with Surrealist-inspired biomorphic abstraction, Franz Kline was painting landscapes and portraits. Consequently in 1950, when the artist showed large, gestural abstract paintings in his first solo exhibition, it appeared that he had experienced a wholesale conversion. Much has been made of a 1949 visit he paid to his friend Willem de Kooning, who asked Kline for some of the drawings he always carried in his pockets and projected them onto the wall, monumentalizing details of the sketches. While this episode may have been a catalyst for Kline's mature style, by the end of the 1940s his work was already yielding to a looser application of paint and a more emphatic expressionistic technique.

"People sometimes think I take a white canvas and paint a black sign on it, but this is not true. I paint the white as well as the black, and the white is just as important." Kline scored his success in the early 1950s with large canvases onto which he applied black and white commercial paint with house-painter's brushes. He became known as an Action painter because his work expressed movement and energy, emphasizing dynamic line. The characteristic black slashes of *Painting No. 7* suggest the full body movement of the artist as he spontaneously applied the paint, incorporating chance splatters and smearing. In fact, Kline's sings were constructed only to look as if they were painted in a

paintings were constructed only to look as if they were painted in a moment of inspiration—they usually resulted from the transfer of a sketch to the capyas.

Unlike de Kooning and Jackson Pollock, Kline never flirted with figuration in his abstract paintings and avoided spatial ambiguity. Painting No. 7 is among the artist's most straightforward statements; it also demonstrates his knowledge of art history. Kline's emphasis on the square in this and other works suggests his interest in Josef Albers and Kazimir Malevich. Art historian Harry Gaugh cites Piet Mondrian's Composition No. 1 as an influence, and also contends that the compositional structure of Painting No. 7 recalls James McNeill Whistler's Arrangement in Gray and Black, No. 1 (1871). Though the similarity between the latter two paintings might appear incidental, Kline referred to Whistler in other paintings, and the austere geometry of Whistler's canvas would have appealed to him.

J.B.

Painting No. 7, 1952.
Oil on canvas, 57½ x 81¾ inches. 54.1403

Oskar Kokoschka b. 1886, Pöchlarn, Austria; d. 1980, Montreux, Switzerland

In the Vienna of 1914, a woman having an abortion was cause for scandal, even within the confines of the relatively open-minded art world. When such a woman was the widow of a famous composer, unwed, and carrying

"This state of alertness of the soul or consciousness, expectant and receptive, is like an unborn child whose own mother might not be aware of it and to whom nothing from the outside world slips through."

on two love affairs simultaneously, her decision would alarm even the most sympathetic souls. Thus it is that the agonized knight errant of Oskar Kokoschka's painting is to this day read as an expression of the artist's pain over the death of an unborn child and the crumbling of his relationship with the fascinating, and quite unrepentant, Alma Mahler.

The central figure appears to be a self-portrait of Kokoschka, clad in the armor of a medieval knight. He lies errant, or lost, in a stormy landscape, his two attributes—a winged bird-man and a sphinxlike woman—in close proximity. The bird-man has been interpreted er as the figure of death or another self-portrait, while the sphinx-

either as the figure of death or another self-portrait, while the sphinx-woman has been seen as a stand-in for Mahler. A funereal sky bears the letters "E S," which probably refer to Christ's lament, "Eloi, Eloi, lama sabachthani" ("My God, my God, why hast Thou forsaken me?").

As if the self-equivalence with chivalry and the martyred Christ were not enough, the agitated brushwork and disturbing composition convince us of Kokoschka's spiritual discomfort.

If we look at *Knight Errant* within the context of Austrian art and compare it to the measured and ornate works of Hans Makart or even Gustav Klimt, Kokoschka's radicality emerges clearly. In what was still fin-de-siècle Vienna, *Knight Errant* was a notable exception for the immediacy of its imagery, which seemed to come more from the realm of psychoanalysis than from contemporary artistic trends. Indeed, Alma Mahler's first husband, Gustav, had consulted Sigmund Freud about his marriage, and the famous couple was apparently versed in psychoanalytic principles. But perhaps Kokoschka was equally influenced by his admiration for Baroque allegorical and literary motifs. Whatever their source, his emotion-charged images stem from a turbulently personal interpretation of Expressionism.

Knight Errant, 1915.
Oil on canvas, 35 ½ x 70 ½ inches.
48.1172 x380

C.L.

Joseph Kosuth b. 1945, Toledo, Ohio

In his 1969 essay "Art After Philosophy", artist and theoretician Joseph Kosuth argued that traditional art-historical discourse had reached its end. In its place he proposed a radical investigation of the means through which art acquires its cultural significance and its status as art. "Being an artist now," commented Kosuth, "means to question the nature of art. If one is questioning the nature of painting, one cannot be questioning the nature of art . . . That's because the word 'art' is general and the word 'painting' is specific. Painting is a kind of art. If you make paintings you are already accepting (not questioning) the nature of art."

"When you describe art, you are also describing how meaning is produced, and subjectivity is formed.

nature of art explicit. As an analytical proposition, art presupposes the existence of an aesthetic entity that fulfills the criteria of "artness." This criteria, as Marcel Duchamp proved with his readymades, could consist merely of the declaration "this is a work of art." Kosuth used this linguistic approach to explore the social, political, cultural, and economic contexts through which art is presented and thus In other words, you are defined. To demonstrate this discursive aspect of art, Kosuth emdescribing reality." ployed language itself as his medium. What resulted was a rigorously

conceptual art devoid of all morphological presence; intellectual

During this formative stage in his work, Kosuth made the tautological

provocation replaced perception as words displaced images and objects. This shift was signaled in Kosuth's First Investigations (subtitled Art As Idea As Idea), a series that includes photostats of dictionary definitions of words such as "water," "meaning," and "idea." Accompanying these photographic images are certificates of documentation and ownership (not for display) indicating that the works can be made and remade for exhibition purposes. This strategy of presentation represents Kosuth's attempt to undermine the preciousness of the unique art object and its privileged place in the museum. He sought to demonstrate that the "art" component is not located in the object itself but rather in the idea or concept of the work.

Along with other Conceptual artists Kosuth waged an attack on conventional aesthetics that has informed the strategies of a younger generation. From Kosuth's initial enterprise, these artists have inherited a deconstructive approach to art in which a critique of the production of meaning takes precedence over the communication of meaning.

wa-ter (wâ'ter), n. [AS. wæter = D. water = G. wasser, akin to Icel. vatn, Goth. watō, water, also to Gr. $v\delta\omega\rho$, Skt. udan, water, L. unda, a wave, water; all from the same root as E. wet: cf. hydra, otter¹, undine, and wash.] The liquid which in a more or less impure state constitutes rain, oceans, lakes, rivers, etc., and which in a pure state is a transparent, inodorous, tasteless liquid, a compound of hydrogen and oxygen, H₂O, freezing at 32° F. or 0° C., and boiling at 212° F. or 100° C.; a special form or variety of this liquid, as rain, or (often in pl.) as the liquid ('mineral water') obtained from a mineral spring (as, "the waters of Aix-la-Chapelle".

'Titled (Art as Idea as Idea) [Water],' 1966.

Photostat mounted on board, 48 x 48 inches. Gift, Leo Castelli, New York. 73.2066

Jannis Kounellis b. 1936 Piréa, Greece

Though born and raised in Greece, Jannis Kounellis reached artistic maturity in Italy. He immersed himself in his adopted homeland's rich aesthetic history, and came to trust that art's importance lies in its reflection of the complex web of beliefs and values at the heart of cultural development. Throughout history, Kounellis concluded, art evolved in response to and in expression of fundamental theological, intellectual, and political thought patterns. But he determined that postwar European society lacked appropriate aesthetic forms through which to reflect the fragmentary nature of contemporary civilization. Conventional painting and sculpture, as products of cultural unity, were no longer germane to the erratic situation he perceived. In 1967 he began producing sculptures, installations, and theatrical performances that intentionally embraced the fragmentary and the ephemeral. At that time, he was associated with a number of Italian artists who, for similar political and aesthetic reasons, were pursuing an analogous goal. Grouped together under the name Arte Povera, their work incorporated organic and industrial materials resulting in poetic confrontations between nature, culture, and the fabricated environment. To this end, Kounellis has blocked doorways and windows with accumulations of stones or wood fragments. He even went as far as to include live animals in his work in the attempt to formulate an entirely new paradigm through which to experience art. He also utilized fire in the form of butane torches and smoke residue to evoke the alchemical, transformative potential of the flame, while simultaneously referring to its destructive force.

By the end of the 1960s Kounellis's repertoire of materials included rock, wood, burlap, wool, steel, lead, gold, fire, and fragments of classical sculpture, which he has since employed in numerous combinations to formulate a body of work that is iconographically consistent yet stylistically variable. The metal wall reliefs, such as this work, are morphologically reminiscent of painting but conceptually distant. The fusion of organic and inorganic substances—here, a circle of golden wax embedded into a sheet of lead—symbolizes the shifting and unpredictable nature of meaning in art. Such a juxtaposition of contradictory materials serves perhaps as an allegory for human fragility and the inevitability of historical imperatives.

Untitled, 1987. Lead, wax, and metal, 79 x 711/4 x 71/4 inches. Gift, Annika Barbarigos. 87.3515

Barbara Kruger b. 1945, Newark, N.J.

Barbara Kruger juxtaposes photographs culled from the mass media with pithy slogans in a vigilantly constructed attack on the ways in which selfidentity, desire, and public opinion are manipulated and perpetuated. Her often caustic presentations—ranging from billboards, T-shirts, and posters to the signature red-bordered montages of words and images—play on clichés and cultural stereotypes to underscore and, eventually, undermine the persuasive power of representation. Distinctively feminist in orientation, the work also examines how gender difference is reinforced through media presentation. Traditionally, women have been displayed in film and advertising as objects of desire for the male viewer. The exception occurs when women are targeted by the media as consumers; only then do they become subjects, but merely as patrons of desirable images of themselves.

"I work with pictures and words because they have the ability to determine who we are, what we want to be, and what we become." Kruger brings the issue of gender identification into question through her ambiguous use of the neutral pronouns "I," "you," and "we" in her phrases, such as the following: YOUR GAZE HITS THE SIDE OF MY FACE; YOU MAKE HISTORY WHEN YOU DO BUSINESS; YOU INVEST IN THE DIVINITY OF THE MASTERPIECE; WHEN I HEAR THE WORD CULTURE, I TAKE OUT MY CHECKBOOK. To some extent, Kruger reconfigures the conventional gendered subject/object relationship by

bestowing the female voice with authority, but quickly subverts this mere reversal of power by scrambling the identities of speaker and audience.

Untitled (Not Perfect) is an early example of Kruger's mature work; it marks the transitional period between the artist's provocative, embroidered wall hangings and her photographic pieces. It is best understood when examined in concert with another work from 1980, Untitled (Perfect), in which the word "perfect" is written across an image of a woman's discreetly sweatered torso; her hands are clasped as if in prayer. In contrast to this image of chaste propriety—suggestive of the socially condoned behavior often required of women—Not Perfect depicts a pair of soiled male hands resting in a washbasin. The word "stain," albeit crossed out, points to the questionable source of the hands' discoloration. Is it spilled coffee or dirt or blood? Although intentionally indecipherable, the image suggests the sense of recklessness, adventure, and destruction stereotypically associated with the male in our culture.

Untitled (Not Perfect), 1980. Photograph, tape, and paint, mounted on paper board, 60 x 40 inches. Exxon Corporation Purchase Award. 81.2809

František Kupka b. 1871, Opočno, eastern Bohemia (Czechoslovakia); d. 1957, Puteaux, France

Although he moved to Paris at a young age, František Kupka's Bohemian origins, mysticism, and eccentric personality kept him at a distance from the avant-garde circles of the artistic capital. An individualist, he rejected association with any artistic school or trend, but his paintings' aggressive palette and dependence on color as a means of faceting form and conveying meaning show undeniable affinities with Fauvism and the work of Henri Matisse, as well as with Orphism, Robert Delaunay's color-based brand of Cubism. A devoted mystic, Kupka spent his life in search of a transcendental other reality, or "fourth dimension." One of the first non-objective artists, he extended his clairvoyant practice to his art as well, by uniting a metaphysical investigation of the human body and nature with daring color and abstract form.

"[P]ainting means clothing the processes of the human soul in plastic forms—to be a poet, a creator, to enrich life by new views." Theosophy—a synthesis of philosophy, religion, and science—guided Kupka's holistic approach to art. His paintings draw on a variety of sources, including ancient myths, color theory, and contemporary scientific developments. The invention of radiography at the turn of the century was especially significant for Kupka, whose search for an alternative dimension through a kind of painterly X-ray vision is captured in his monumental *Planes by Colors, Large Nude*. In this

work. Kupka rendered the figure of his wife, Eugénie, in vivid shades of purple, green, yellow, and blue, devising an innovative modeling technique based on color, not line or shade, that sections her body into tonal planes in such a way that her "inner form" is made visible. This unveiling of the unseen is crucial, for Kupka believed that it is only through the senses, through physical experience, that we can reach an extrasensory, metaphysical dimension and thereafter achieve an intuitive understanding of the universal scheme underlying existence.

Kupka painted *The Colored One* ten years after *Planes by Colors, Large Nude*. By then he had adopted a more boldly abstract mode of figural representation. (He would never abandon subject matter altogether, however, unlike pure abstractionists such as Piet Mondrian.) *The Colored One* also depicts a female nude, this one lying on her back with legs stretched upward, cradling a radiant yellow sun. Swirling forms outlined in concentrated colors convey the dominant theme in Kupka's work: the organic connections that intertwine human beings with the rest of nature and the cosmos.

B.A.

Planes by Colors, Large Nude, 1909–10. Oil on canvas, 59 ½ x 71 ½ inches. Gift, Mrs. Andrew P. Fuller. 68.1860

The Colored One, ca. 1919–20. Oil on canvas, 25 ½ x 21¼ inches. Gift, Mrs. Andrew P. Fuller. 66.1810

Wifredo Lam b. 1902, Sagua la Grande, Cuba; d. 1982, Paris

When Wifredo Lam arrived in Paris in 1938 he carried a letter of introduction to Pablo Picasso, with whom he had an immediate rapport. Soon he met many other leading artistic figures, among them André Breton, the dominant publicist and theorist of Surrealism. The Surrealists, who attempted to unleash the power of the unconscious through explorations of dream states and automatist writing, were fascinated by the mythologies of "primitive" people. They subscribed to an anthropology that perceived modern "primitive" cultures as the heirs to an integrated understanding of myth and reality, which they hoped to achieve themselves. Lam, as a

"I wanted with all my heart to paint the drama of my country, but by thoroughly expressing the negro spirit, the beauty of the plastic art of the blacks. In this way I could act as a Trojan horse that would spew forth hallucinating figures with the power to surprise, to disturb the dreams of the exploiters."

Cuban of African, Chinese, and European descent, seemed to the Surrealists to have privileged access to that undifferentiated state of mind. In 1942 the artist returned to Cuba, where he constructed a body of work in a Surrealist idiom, creating symbolic creatures engaged in ritual acts of initiation. Lam's vocabulary of vegetal-animal forms was inspired by Afro-Cuban and Haitian Santeria deities. He also associated with the nationalist poets of the Négritude movement, who relied in their work on the images and rhythms of their native culture.

Rumblings of the Earth represents a synthesis of Lam's concerns in his work of the 1940s. This painting melds his reaction to the European artistic legacy with his own goals and the indigenous

traditions of his country. Here, Lam referred to Picasso's 1937 *Guernica* through direct quotations and more abstract correspondences, but he transformed Picasso's political statement by replacing the central victim of *Guernica*, the horse, with a spectral presence bearing a large knife, described by Lam as "the instrument of integrity." An aggressive painting, *Rumblings of the Earth* includes vaginal and phallic references that focus the work thematically on the cycle of birth and death while suggesting ritual initiation and violence. For Lam, revolutionary violence was a means of liberation; in his hands, the victim in Picasso's canvas has become the aggressor.

In Zambezia, Zambezia Lam depicted an iconic woman partly inspired by the femme-cheval (horse-headed woman) of the Santeria cult. He frequently used the device of transmogrification of body parts to suggest magical metamorphosis, inspired by indigenous American and African ritual objects. In this painting it is manifested in the testicle "chin" of the figure.

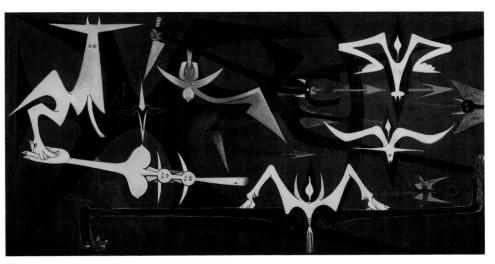

Rumblings of the Earth, 1950. Oil on canvas, 59 1/4 x 112 inches. Gift, Mr. and Mrs. Joseph Cantor. 58.1525

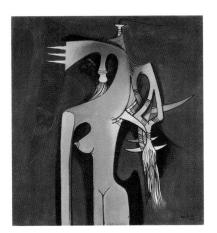

Zambezia, Zambezia, 1950. Oil on canvas, 49 1/2 x 43 5/4 inches. Gift, Mr. Joseph Cantor. 74.2095

Language

Since the 1960s language has become an increasingly common material for making visual art. The enigmatic statements of Lawrence Weiner, such as THE RESIDUE OF A FLARE IGNITED UPON A BOUNDARY, or Jenny Holzer's L.E.D. texts, are often disconcertingly similar to other kinds of written or printed materials like labels and advertising, yet they function as something else—independent works of art.

As titles, narration, or allegorical inscriptions, words appeared in paintings long before Modernism. It was not until the advent of Cubism however that language systematically entered the visual field, as snippets of text from newspapers, posters, and product labels, first carefully painted, and later collaged directly onto the canvas. This move coincided with the Cubist understanding of painting itself as a kind of language—as a series of coded signs that could be manipulated, fragmented, and rearranged independently of any subject depicted. The "concrete" or "nonsense" poetry of Raoul Hausmann, Kurt Schwitters, and other Dada artists often pulverized language into evocative shards of sound, letters, and graphic insignia.

In the 1960s Pop art employed language as a highly stylized visual sign, drawing from a world of commercial logos and brand names in which words increasingly take on a life of their own. Conceptually oriented artists like Dan Graham, Joseph Kosuth, and Robert Smithson created works that only existed in the form of publications. Projects by Robert Barry, Douglas Huebler, and others arranged language as sets of procedures or operations that could be documented photographically, or to produce a work, as in Sol LeWitt's wall drawings, which can be executed by others following detailed written directions.

This "performative" aspect of language presented as instruction initially came from experimental music, especially the work of composer John Cage in the 1950s. Artists such as George Brecht, Yoko Ono, La Monte Young, and others associated with the Fluxus group wrote short "scores" for simple actions that were performed or interpreted, like Young's Composition 1960 #10, "Draw a straight line and follow it" (1960) or Brecht's 1961 Word Event, which read simply "Exit." Just as language is an inherently open-ended structure not bound to its individual enactment or instantiation, such linguistically-based works often bypass the uniqueness of the material object to focus on process, perception, and the larger discursive context, using "the idea" as, in LeWitt's phrase, "a machine to make art."

LIZ KOTZ

Fernand Léger b. 1881, Argentan, Normandy, France; d. 1955, Gif-sur-Yvette, France

Art historian and critic Michel Seuphor proclaimed that 1912 was "perhaps the most beautiful date in the whole history of painting in France." That year marked the culmination of Analytic Cubism in the work of Pablo Picasso and Georges Braque as well as the maturation of Fernand Léger's idiosyncratic Cubist style, as manifested in his lively painting *The Smokers*. All three artists were inspired by Paul Cézanne in their quest for a means by which to accurately describe three-dimensional objects on a two-dimensional canvas. By breaking the represented figures or items into series of splintered planes and rendering them against—or within—a similarly faceted background, they created an entirely integrated space in which field and object interpenetrate one another. Of the three painters, Léger developed a vocabulary of more precisely delineated forms—his

"Beauty is everywhere, in the arrangement of your pots and pans, on the white wall of your kitchen, more perhaps than in your 18th-century salon or in the official museum."

In both *The Smokers* and *Nude Model in the Studio* the curving, overlapping planes describe the corporeal forms of each painting's subject while articulating an allover, rhythmically patterned surface. The resulting oscillation between volumetric body and dynamic space owes as much to Futurist aesthetics as to Analytic Cubism. By 1913 Léger had pushed his abstracting grammar to its logical

extreme in a series of nonobjective paintings entitled *Contrast of Forms*. Premised on the visual disparity between discrete geometric volumes, the series presents assorted calibrations of cylindrical, cubic, and planar units. As variations on a theme, each composition of alternating solids and voids offers a different play of light and shadow. The Guggenheim's canvas *Contrast of Forms* accentuates the linear armature and abbreviated modeling of the shifting geometric shapes. With these thoroughly abstract images, Léger's explorations of the Cubist idiom approached those of Robert Delaunay, whose *Simultaneous Windows* and brilliantly colored circular motifs of 1913 neared complete detachment from empirical reality. For Léger, however, this foray into total nonobjectivity was only temporary, as he would soon revive his penchant for figurative subjects.

The Smokers, December 1911– January 1912. Oil on canvas, 50 1/a x 38 inches. Gift, Solomon R. Guggenheim. 38.521

Contrast of Forms, 1913.
Oil on burlap, 38 1/6 x 49 1/4 inches. Gift, Solomon R. Guggenheim. 38.345

Nude Model in the Studio, 1912–13.
Oil on burlap, 50 3 x 37 5 inches. 49.1193

Léger

Fernand Léger's use of streamlined forms derived from mechanical imagery dates from World War I, when he served in the French army. His predilection for military hardware and its gleaming surfaces coincided with his feelings of solidarity with the foot soldiers surrounding him in the trenches. The machine aesthetic he adopted at this time reflected his hopes of creating a truly popular art form that would describe and inspire modern life. After the war, he turned away from the experiments with pure abstraction that characterized his earlier work and infused social meaning into his art; quasi-representational motifs emerged in lively paintings depicting soldiers, factory workers, bargemen, and pulsating urban environments. In works such as *The City* of 1919 and *The Mechanic* of 1920, Léger incorporated elements of Cubist fragmentation into his

"This freedom, this new space, could help . . . in the transformation of individuals, in the modification of their way of life." new pristine, mechanical syntax to evoke the energy of contemporary experience.

As a call to order resounded throughout postwar French society, Léger introduced the monumental, classical figure into his art. The absolute calm and stasis of *Woman Holding a Vase* demonstrates his affinities with the neo-antique depictions of women by his contem-

poraries Pablo Picasso and Gino Severini. It also shows Léger's sympathies with the Purist ideals of Amedée Ozenfant and Le Corbusier, who called for a revival of classical aesthetic consonance as a symbol of renewed social harmony. Léger's palette of blue, yellow, red, and black is indebted to Piet Mondrian's concurrent De Stijl paintings, further evincing Léger's identification with utopian and reconstructivist ideals of the 1920s and 1930s.

The result of over one hundred preparatory studies dating from as early as 1947, *The Great Parade* is a defining work within the artist's oeuvre. The joyful parade motif evolved out of several preceding themes in Léger's oeuvre—including cyclists, country outings, and the circus—that celebrated the leisure activities of the working class. The circus in particular is an accessible arena in which all spectators are equal, brought together in their delight over the clowns, trapeze artists, and animal acts. In this mural-size canvas—conceived on a scale appropriate to mass viewing—the interlocking figures perform their inspired feats along a horizontal swathe of blue, which is punctuated by a large red *C* for *cirque*. The final version of *The Great Parade*, painted one year before the artist's death, is the culmination of his career-long endeavor to both represent and reach a public beyond the small circle of connoisseurs familiar with fine art.

Woman Holding a Vase, 1927 (definitive state). Oil on canvas, 57 ⁵/₈ x 38 ³/₈ inches. 58.1508

The Great Parade, 1954 (definitive state). Oil on canvas, 117 3/4 x 157 1/2 inches. 62.1619

Sol LeWitt b. 1928, Hartford, Conn.

In the 1960s, the position that art could be generated by ideas rather than emotions was a radical one. Using mathematical and linguistic models, artists such as Hanne Darboven, Joseph Kosuth, and Lawrence Weiner began to explore the ramifications of this conceptual approach. For Sol LeWitt, this meant establishing systems of logic in the form of written instructions—such as "lines from the corner, sides, and center to points on a grid" or "all three-part variations on three different kinds of cubes"—that govern the outcome of an artwork in advance of its execution. The clarity of this process minimizes the singular emphasis on the appearance of a work as a discrete object, instead mining the relationship between linguistic and visual conventions of representation. Indeed, the apparent simplicity

"What the work of art looks like isn't too important. It has to look like something if it has physical form. No matter what form it may finally have it must begin with an idea." of these textual systems, whether applied to LeWitt's wall drawings or his modular structures, belies a visual complexity of seemingly endless permutation and establishes a conceptual foundation for a rigorous yet rich body of work.

Traditionally, the worked surface of a drawing has been understood as the most intimate and direct record of an artist's creative process; by leaving the execution to others, LeWitt ensures that his autographic touch is wholly absent. *Wall Drawing #146* exemplifies

LeWitt's method of rendering the work a product of an intellectual gambit that functions via the possibilities posed by the instructions: "all two-part combinations of blue arcs from corners and sides and blue straight, not straight and broken lines." Constituting a dialectic between simplicity and complexity, austerity and sumptuousness, the mural surfaces of the artist's wall drawings operate in the gap between the logical and lyrical.

LeWitt's serial grammar rejects the authority invested in the singular in favor of the repeatable and nonhierarchical, while the impermanent nature of his wall drawings privileges the momentary over the monumental. In this, his work discounts many of the most cherished notions that pervade Modernist accounts of art. Despite the conceptual strategies LeWitt devised to position form in the service of ideas, his work demonstrates that while concept may take primacy over its visual analogue, ultimately neither is in and of itself wholly sufficient.

J.F.R.

Wall Drawing #146, All two-part combinations of blue arcs from corners and sides and blue straight, not straight, and broken lines. September 1972.
Blue crayon; dimensions vary with installation. Panza Collection, Gift. 92.4160

Roy Lichtenstein b. 1923, New York City; d. 1997, New York City

In 1963 Roy Lichtenstein defended Pop art against its critics, contending that "there are certain things that are usable, forceful, and vital about commercial art." By choosing comic-book illustrations as a theme, and using simulated Benday dots to suggest cheap printing, Lichtenstein acknowledged (and perhaps questioned) the role of this popular form of entertainment in daily life. There is also an element of humor in creating fine art out of what has customarily been considered "low," a playfulness that is equally evident in the onomatopoeic caption and bellicose expression of the dog in *Grirrrrrrrr!!*

Lichtenstein cultivated imagery from the history of art while continuing to use the conventions of comics and advertisements. In *Preparedness* he

"[Pop art] is an involvement with what I think to be the most brazen and threatening characteristics of our culture, things we hate, but which are also powerful in their impingement on us." used the Benday-dot technique to make a wall-size painting (10 feet high by 18 feet wide) that suggests the work of Fernand Léger and the WPA artists of the 1930s, who painted monumental murals, readable at a distance, on themes of workers and everyday life. Lichtenstein followed this practice to an ironic and somewhat subversive end. Painted during a year when public opinion on the Vietnam War shifted dramatically, Lichtenstein's massive depiction of machinery and soldiers probes the conventions of selling the promises of the military-industrial complex, while quietly alluding to the naive optimism underlying a call to arms.

Lichtenstein often focused on the way his traditional and mass-media sources resolve the dilemmas of representing three dimensions on a flat picture plane, incorporating their solutions into his own work with witty exaggeration. Preparedness plays the fragmented Cubist collage space of Léger against comic-strip modes of suggesting form and the surface quality of objects. Lichtenstein's inclusion of an airplane window in the third panel of the painting foreshadows his engagement with modes of conveying the illusion of reflective glass, which he went on to explore in a series of paintings of mirrors. Interior with Mirrored Wall is a later development of this exploration. In a series of works depicting banal domestic environments inspired by furniture ads he found in telephone books, Lichtenstein continued his previous investigations of illusionistic representational devices, here by including the eponymous mirrored wall and the gleaming, polished grand piano. His references to high-art sources included his own work, which is shown framed on the wall. The floor covering also implicitly acknowledges Henri Matisse's use of decorative patterns.

J.B.

Grrrrrrrr!!, 1965. Oil and Magna on canvas, 68 x 56 ⅓ inches. Gift of the artist. 97.4565

Interior with Mirrored Wall, 1991.

Oil and Magna on canvas, 126 1/8 x 160 inches. 92.4023

Preparedness, 1968. Oil and Magna on canvas; three panels, 120 x 216 inches overall. 69.1885.a-.c

El Lissitzky b. 1890, Pochinok; d. 1941, Schodnia, near Moscow

El Lissitzky was the Russian avant-garde's unofficial emissary to the West, traveling and lecturing extensively on behalf of Russia's modern artists who believed that abstraction was a harbinger of utopian social values. Basing himself in Berlin and Hanover in the 1920s, Lissitzky helped produce publications and organize exhibitions promoting both Russian and Western art that shared a common vision of aesthetics steeped in technology, mass production, and social transformation.

While Lissitzky was teaching architecture and graphic design at the Artistic Technical Institute in Vitebsk, his art shifted from figuration to geometric abstraction. Under the tutelage of Suprematist painter Kazimir Malevich, Lissitzky began a body of work he would later call *Prouns* (an acronym for "Project for the Affirmation of the New" in Russian). These nonobjective compositions broadened Malevich's Suprematist credo of

"Art is the tool of universal progress."

collages, drawings, and prints, with both utopian and utilitarian aspirations. Blurring the distinctions between real and abstract space— a zone that Lissitzky called the "interchange station between painting and architecture"—the *Prouns* dwell upon the formal examination of transparency, opacity, color, shape, line, and materiality, which Lissitzky ultimately extended into three-dimensional installations that transformed our experience of conventional, gravity-based space. Occasionally endowed with cryptic titles reflecting an interest in science and mathematics, these works seem engineered rather than drawn by hand—further evidence of

pure painting as spiritually transcendent into an interdisciplinary system of two-dimensional, architectonic forms rendered in painted

Proun (Entwurf zu Proun S.K.) is exemplary of Lissitzky's unique enterprise. One of two studies for a larger oil painting, this composition uses different mediums to suggest a range of properties for the otherwise straightforward geometric forms, which become dynamic through their suspension within a precariously balanced visual field. Like all of the Prouns, this work is a highly refined object. Thus, while they parallel certain tenets of the Russian Constructivists, who used a similarly reductive visual vocabulary and sought to merge art and life through mass production and industry, Lissitzky's Prouns lack the rough-hewn experimental nature of Contructivist objects, remaining more on the side of aesthetics than utility.

the artist's growing conviction that art was above all rational rather than

M.D.

intuitive or emotional

Proun (Entwurf zu Proun S.K.), 1922–23. Gouache, india ink, pencil, conté crayon, and varnish on buff paper, 8 ½ 5 x 11 ½ inches. Gift, Estate of Katherine S. Dreier, 53.1343

Richard Long b. 1945, Bristol, England

To create his art, Richard Long walks hundreds of miles for days, even weeks at a time, through uncultivated areas of land: the countryside of England, Ireland, and Scotland; the mountains of Nepal and Japan; the plains of Africa, Mexico, and Bolivia. He documents these journeys with captioned large-scale photographs, maps, and lists of descriptive terms, which are exhibited as individual works. While traveling, Long sets specific tasks for himself, such as traversing an absolutely straight line for a predetermined distance, following the side of a river wherever it may lead, or picking up and then dropping stones at certain intervals along the way. While on these trips, the artist interacts with the landscape by creating modest sculptures from indigenous materials, thus attesting to his presence in the land. Circles or lines—Long's signature motifs—rubbed into the ground by repeated footprints or composed of assembled stones, drift-

"Nature has more effect on me than I on it."

on rising tides, thus negating human dominance over nature. His photoit." graphs remain the only evidence of these organic sculptures after
erosion has run its course. Unlike other artists who have manipulated the landscape to create Earthworks, such as Walter De Maria, Michael
Heizer, Robert Morris, Dennis Oppenheim, Robert Smithson, and James
Turrell, Long does not significantly alter the terrain by digging, burrowing,
sculpting, or constructing. He simply adjusts nature's placement of rocks
and wood to subtly demarcate geometric shapes.

wood, or seaweed are eventually dissolved by the wind, the rain, and

Long translates his deeply personal experiences in the wilderness into sculptures and mud drawings that are created for exhibition spaces and private collections. Pieces composed of flint, slate, feathers, pine needles, sticks, and other rustic materials become metaphors for the paths taken on his ramblings: the spirals, circles, and lines, if extended beyond the gallery walls, would trace actual distances traveled by the artist. The sculptures are not, therefore, representations of nature per se but rather aesthetic documents of Long's engagement with the land and poetic evocations of the beauty and grandeur of the earth. Such is the case with Red Slate Circle, which consists of 474 stones from a New York State quarry. When it is installed in the Guggenheim's rotunda, the monumental ring echoes the building's unique spiral while conjuring images of vast canyons, still lakes, and stone pathways leading into the distance.

Red Slate Circle, 1980. Red slate stones, 336 inches diameter. Purchased with funds contributed by Stephen and Nan Swid. 82.2895

Morris Louis b. 1912, Baltimore; d. 1962, Washington, D.C.

In 1953 Morris Louis visited the studio of Helen Frankenthaler, where he saw Mountains and Sea (1952), the first painting made with her signature "soak-stain" technique. This method of collapsing color into canvas by manipulating thinned acrylic washes into the unprimed cotton fabric had an immediate impact on Louis, who would translate it into his own idiom in a series of poured paintings created by gravity-pulled streams of luminescent color. These works, which he referred to as Veils, established Louis's mature style and aligned his work with that of other Color Field painters, such as Barnett Newman, Mark Rothko, and Clyfford Still at a moment when, for the first time since Impressionism, pure opticality held primacy over content and form.

The Veils cannot be traced to an objective referent, and it is this removal of any concrete figural source that allowed Louis to concentrate entirely

on the visual. By handling paint as a dye that penetrates the fibers of the canvas rather than as a topical layer brushed over it, he made figure and ground one and the same, uniting them through color. Furthermore, his pouring technique eliminated the gestural stroke that had been central to Abstract Expressionism, as in Jackson Pollock's signature drip or Willem de Kooning's frenetic brushwork,

allowing the velvety saturated canvas to radiate color in uninflected expanses paced only by the chromatic rhythm of vertical bands.

Some debate has surrounded the orientation of Louis's *Veils*, and this is true of the Guggenheim work in particular. Most of the *Veils* are hung in accordance with the way Louis made them, with a blank margin above where the pigment began its course down the canvas. According to critic Clement Greenberg, however, the artist was willing to experiment with inverted hangings and was loath to prescribe a particular orientation to a picture by signing it. *Saraband's* lengths of color, poured from the top as well as from the sides of the canvas, have been flipped on end, moving the pools of collected pigment to the top of the painting and reversing the gravitational flow. A faint, tentative signature in the bottom left corner of the painting has always served to guide its "upside-down" hanging, although several of Louis's closest contacts believe he preferred it the other way and was encouraged to sign it to support the preference of curator William Rubin, who owned the painting at the time it was first exhibited in 1960.

B.A.

"[Frankenthaler] was a bridge between Pollock and what was possible."

Kazimir Malevich b. 1878, near Kiev; d. 1935, Leningrad

The paintings of the Russian avant-garde have, in general, elicited two types of interpretation: one focuses on issues of technique and style; the other concentrates on social and political issues. The former method is usually applied to Kazimir Malevich's early paintings, grounded as they are in the forms of Cubism, Futurism, and other contemporaneous art movements; the latter largely avoids Malevich in favor of more politically engaged artists such as El Lissitzky, Aleksandr Rodchenko, and Vladimir Tatlin.

From the formalist's standpoint, *Morning in the Village after Snowstorm* is, in its mastery of complex colors and shapes, a perfect example of the newly created Russian style, Cubo-Futurism. The figures have been called a continuation of the genre types Malevich portrayed in his Neo-primitive paintings, their depiction seemingly reliant on Fernand Léger's work, which Malevich could have known from an exhibition in Moscow in February 1912 or through reproductions. This phase in Malevich's career has been seen as his formidable stopover on his journey toward abstraction and the development of Suprematism.

But to ignore the political and social dimensions of Malevich's art would be a disservice. Malevich came from humble circumstances and it is clear in autobiographical accounts that vivid memories of his country child-hood compensated for his lack of a formal art education. Morning in the Village after Snowstorm demonstrates that his hard-won skills as a sophisticated painter were rooted in an unmistakably Russian experience. If art can be said to augur the future, then Malevich's repeated decision—on the brink of the October Revolution—to depict peasants cannot have been merely coincidental.

C.L.

Morning in the Village after Snowstorm, 1912.
Oil on canvas, 31 1/4 x 31 7/6 inches.
52.1327

Edouard Manet b. 1832, Paris; d. 1883, Paris

In 1865 Edouard Manet shocked Parisian audiences at the Salon with his painting Olympia (1863), an unabashed depiction of a prostitute lounging in bed, naked save for a pair of slippers and a necklace. While not an unpopular subject in 19th-century French painting, the courtesan had rarely been portrayed with such honesty. The artist provoked a similar scandal when his painting Nana (1877)—depicting a coquettish young woman in a state of partial undress powdering her nose in front of an impatient client—was exhibited in a shop window on the boulevard des Capucines. Manet's attention to a motif conventionally associated with pornography reflected his desire to render on canvas the truths of modern life. It was a theme that symbolized modernity for many late-19th-century artists and writers, including Edgar Degas and Emile Zola, who devoted their work to realistic portrayals of the shifting class structures and mores of French culture. Images of courtesans may be found throughout Manet's oeuvre; Before the Mirror is thought to be one such painting, related iconograph-ically to Nana, but more spontaneous in execution. The artist's vigorous brushstrokes lend an air of immediacy to the picture. As in Nana, the corseted woman represented here admires her reflection in a mirror; but this particular scene is extremely private the woman, in quiet contemplation of her own image, is turned with her back to the viewer.

Manet's endeavor to capture the flavor of contemporary society extended to portraits of barmaids, street musicians, ragpickers, and other standard Parisian "types" that were favorite subjects of popular illustrated literature. Since the subject of *Woman in Evening Dress* is unidentified—conjecture that she might be the French actress Suzanne Reichenberg remains purely speculative—it is tempting to view this portrait as Manet's rendering of one such type: the fashionable Parisian bourgeois woman, complete with Japanese fan.

Both paintings exemplify Manet's use of seemingly improvised, facile brushstrokes that emphasize the two-dimensionality of the canvas while simultaneously defining form and space. From our vantage point, it is less Manet's choice of subject matter than the tension between surface and subject, in which the paint itself threatens to dissolve into decorative patterns, that defines his work as quintessentially Modern.

Before the Mirror, 1876.
Oil on canvas, 36 1/4 x 28 1/6 inches.
Thannhauser Collection, Gift, Justin K.
Thannhauser, 78.2514.27

Woman in Evening Dress, 1877–80. Oil on canvas, 68 ⅓ x 32 ⅓ inches. Thannhauser Collection, Gift, Justin K. Thannhauser. 78.2514.28

Robert Mangold b. 1937, North Tonawanda, N.Y.

Shortly after receiving an M.F.A. from Yale University in 1963, Robert Mangold worked as a guard at the Museum of Modern Art in New York. Reminiscing about the months he spent there, Mangold commented that even the greatest paintings began to lose their appeal after hours of uninterrupted viewing. The Mondrians were the exception, however, and actually looked "better and better over time."

Inspired, perhaps, by Piet Mondrian's reductivist tendency, Mangold emptied his painting of all external references, focusing instead on internal formal relationships. For this reason, his work is often described as Minimalist. But whereas much Minimalist painting and sculpture is premised on predetermined, mathematical progressions, rigid configurations, and industrial materials, Mangold's work is quite unsystematic.

"When all is said and done, I am a maker of images—nothing more and nothing less." The difference between Mangold's art and that of many of his contemporaries lies in its idiosyncratic, intuitive nature. His geometric compositions are frequently distorted: what appears to be a perfect circle or square drawn on a two-dimensional surface is partially contorted in order to fit within the confines of the shaped canvases. While he has worked in series to explore the various

permutations of such designs, Mangold has not limited himself to one specific strategy and often makes unique images. His palette, consisting of warm ochers, saturated blues, olive greens, and chocolate browns, among other hues, is more reminiscent of Italian frescoes than of the cool, detached tones and commercially mixed colors commonly used by artists associated with Minimalism.

In 1973 Mangold created at least four versions of *Circle In and Out of a Polygon*: two were executed on canvas and two on Masonite. In all four the interior graphite line becomes interchangeable with the top, left, and bottom borders of the support. Similarly, half of the circle is outlined on the acrylic surface, while the other half continues as the curved edge on the painting's right. Mangold challenges his viewers to mentally reverse such images in order to comprehend the compositional nuances of the geometric abstraction. It is this emphasis on the conceptual basis of vision that truly links Mangold to the Minimalists, who brought their audiences to an unprecedented level of perceptual awareness.

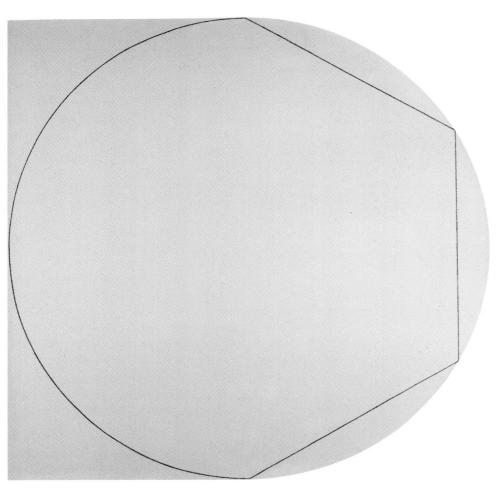

Circle In and Out of a Polygon 2.

Acrylic and black pencil on canvas, 72 ¹/₁₆ x 72 ⁷/₁₆ inches. Panza Collection. 91.3771

Robert Mapplethorpe b. 1946, Floral Park, N.Y.; d. 1989, Boston

Robert Mapplethorpe arrived in New York in the 1970s amid two simultaneous but disparate events: the rise of the market for photography as a fine art, and the explosion of punk and gay cultures. Originally trained in painting and sculpture, Mapplethorpe gravitated toward photography, first making erotic collages in 1969–70 with images cut from magazines, then creating his own images using a Polaroid camera. Within a few years he was exhibiting erotic male and female nudes, still lifes of flowers, and celebrity portraits, all made with a large-format camera. By the late 1970s his work had developed into a style that was at once classical and stylish yet retained the explicit homoerotic themes for which the artist is perhaps best known. Mapplethorpe's subject matter made his work a lightning rod for the contentious debates on public funding for the

"Somehow I was able to pick up the magic of the moment and work with it. That's my rush in doing photography." visual arts during the 1980s that would ultimately decimate the federal government's support for artists. However, this legacy of controversy tends to overshadow Mapplethorpe's aesthetic impact.

Although he occasionally worked with color, Mapplethorpe remained devoted to the minimal elegance of black-and-white photography, using the medium in part as an agent to explore certain paradoxes and binary relationships. In many of his works, for example, the

distinction between male and female is problematized: in *Ken and Tyler* the male assumes the more traditionally femininized role of the nude, while *Calla Lily* takes an object used as a cipher of femininity and redeploys it as a male organ. The black male nude is often juxtaposed with an emphatically white object—a shroud, marble statuary, flowers, or, in the case of *Ken and Tyler*, another nude male.

Mapplethorpe's sustained investigation of black-and-white photography may seem nostalgic next to the preference for color demonstrated by most artists working with photography in the 1980s. But his restricted palette, which recalls that of the modern masters whose work he emulated (especially George Platt Lynes), proved most effective at conveying the poetic and often melancholic quality of his subjects. At the height of his career, Mapplethorpe was stricken with AIDS. In contrast to earlier self-portraits in which Mapplethorpe assumed various personae such as rocker, leather fetishist, cross-dresser, fashion plate, and so on, Self-Portrait, taken about a year before his death, has a more somber mood. The photograph serves as a haunting document of the artist's transitory existence.

M.D.

Ken and Tyler, 1985.

Platinum print, 25⁷/₀ x 22¹/₄ inches. Edition 2/3.

Gift, The Robert Mapplethorpe Foundation.

96.4373

©The Estate of Robert Mapplethorpe.

Used by permission.

Calla Lily. 1986.
Gelatin-silver print, 23 1/2 x 19 3/4 inches.
Edition 10/10. Gift, The Robert Mapplethorpe
Foundation. 93.4302
© The Estate of Robert Mapplethorpe.
Used by permission.

Self-Portrait, 1988.
Gelatin-silver print, 26 ⅓ x 22 ⅓ inches.
Artist's Proof 1/1. Gift, The Robert
Mapplethorpe Foundation. 93.4305
© The Estate of Robert Mapplethorpe.
Used by permission.

Franz Marc b. 1880, Munich; d. 1916, Verdun

During the early years of this century, a back-to-nature movement swept Germany. Artists' collectives and nudist colonies sprung up in agricultural areas in the conviction that a return to the land would rejuvenate what was perceived to be an increasingly secularized, materialistic society. A seminarian and philosophy student turned artist, Franz Marc found this nature-oriented quest for spiritual redemption inspiring. His vision of nature was pantheistic; he believed that animals possessed a certain godliness that men had long since lost. "People with their lack of piety, especially men, never touched my true feelings," he wrote in 1915. "But animals with their virginal sense of life awakened all that was good in me."

"Is there a more mysterious idea for an artist than to imagine how nature is reflected in the eyes of an animal? ... We should contemplate the soul of the animal to divine its way of sight."

By 1907 he devoted himself almost exclusively to the representation of animals in nature. To complement this imagery, through which he expressed his spiritual ideals, Marc developed a theory of color symbolism. His efforts to evoke metaphysical realms through specific color combinations and contrasts were similar to those of Vasily Kandinsky, with whom, in 1911, he founded the Blue Rider, a loose confederation of artists devoted to the expression of inner states.

For Marc, different hues evoked gender stereotypes: yellow, a

"gentle, cheerful and sensual" color, symbolized femininity, while blue, representing the "spiritual and intellectual," symbolized masculinity. Marc's color theories and biography have been used by art historian Mark Rosenthal to interpret Yellow Cow. The frolicking yellow cow, as a symbol of the female principle, may be a veiled depiction of Maria Franck, whom Marc married in 1911. Extending this reading, Rosenthal sees the triangular blue mountains in the background as Marc's abstract self-portrait, thereby making this painting into a private wedding picture. Not all of Marc's paintings of animals are so sanguine, however. He often depicted innocent creatures in ominous scenes. Painted in 1913, The Unfortunate Land of Tyrol reflects the desolation caused by the Balkan Wars and their anticipation of pan-European battle; an Austro-Hungarian border sign included in the lower-left portion of the canvas indicates the vulnerability of this province. The cemetery and emaciated horses portend doom, but Marc's faith in the ultimate goodness of nature and the regenerative potential of war prevails: the rainbow and bird with outstretched wings reflect a promise of redemption through struggle.

Yellow Cow, 1911. Oil on canvas, 55 ³/₈ x 74 ¹/₂ inches. 49.1210

The Unfortunate Land of Tyrol, 1913. Oil on canvas, 51 5/8 x 78 3/4 inches. 46.1040

Brice Marden b. 1938, Bronxville, N.Y.

In the increasingly theoretical New York art world of the 1960s and 1970s, painting was displaced in favor of sculpture in a new mode that privileged concept over material, idea over sensory quality. When painting did appear, the prevailing aesthetic called for pristine, monochromatic surfaces that appeared to have been untouched by the artist's hand. Brice Marden departed from these stylistic strictures in search of something

"I believe these are highly emotional paintings not to be admired for any technical or intellectual reason but to be felt." more emotionally charged and personal. His early single-color panels reconcile the stringent subtractions of Minimalism with his more expressive impulses as a painter. Upon close inspection, Marden's matte canvases, layered with thick encaustic (his characteristic oil-and-wax technique), reveal the marks of the palette knife, the subtle ridges in the viscous material inflecting each panel's uniform color and opacity with impressions of the painter's

working process. This evidence, along with the artist's anachronistic tendency toward the lyrical, is what distinguishes his work from that of his Minimalist contemporaries who rely on a cool industrial quality.

Although Marden's paintings are non-objective, he often draws upon specific people, places, or other works of art as sources. Inspired by the austere palette of the Spanish masters Goya and Zurbarán, his early

paintings achieve a brooding gravity through subtle, low-key color combinations. D'après la Marquise de la Solana is a response to Goya's portrait of the Marquise, which Marden saw in the Louvre. His translation of the 18th-century figure into the language of reductivist abstraction is a potent distillation of the color, light, and mood in Goya's original. Delicately worked panels of peach, gray, and olive-taupe succinctly paraphrase the Marquise's elusive expression and dainty poise in the midst of a grand romantic landscape.

An unparalleled sensitivity to color as an expressive means is a defining characteristic of Marden's art. The five paintings in the *Grove Group* series, begun in 1973, were inspired by an olive grove on the Greek Island of Hydra, where the artist has spent time. Marden, who sees art as a "trampoline into spirituality," refers to these as "high-intensity paintings," intending his use of light and color to elicit an emotional response from the viewer. Color associations are usually detectable only through Marden's evocative titles; the two-toned composition of *Grove IV* is a response to the shimmering shift in color from the dark tops to lighter bottoms of the windblown leaves of olive trees.

D'après la Marquise de la Solana,

Oil and wax on canvas; three panels, 77 % x 117 % inches overall. Panza Collection. 91.3784.a-.c

Grove IV, 1976.

Oil and wax on canvas; two panels, 72 x 108 inches overall. Purchased with funds contributed by the National Endowment for the Arts, Washington, D.C., a Federal agency; matching funds contributed by Sidney Singer. 77.2288.a..b

B.A.

Agnes Martin b. 1912, Maklin, Saskatchewan, Canada

Agnes Martin's earliest experiments with an abstract idiom were based on her observations of the desert terrain of New Mexico, where she lived during the 1940s. It was there that she developed a personal vocabulary of provocative, abstract forms—similar to the formative biomorphic or pictographic works of William Baziotes, Adolph Gottlieb, and Mark Rothko—at a time when American artists were searching for the aesthetic means to convey subjective states and to intimate the existence of other, higher realities. By 1960 Martin had developed her signature grid pattern; the compositional motifs of these pristine, monochromatic paintings consist of a simple system of interlocking horizontal and vertical lines in

"My paintings have neither objects, nor space, nor time, not anything—no forms. They are light, lightness, about merging, about formlessness, breaking down form." an almost exclusively six-foot-square format. The titles of these geometrically organized pictures—Mountains, Dark River, Starlight, Leaf in the Wind, Orange Grove, Spring, and White Flower, to cite just a few—attest to Martin's persistent engagement with themes of the organic world, albeit in an abstract manner. At this time she distilled the appearance of empirical entities and expressed her own emotional response to nature through the most extreme economy of formal means. "Anything," Martin claimed in 1972, "can be painted without representation."

Unlike the more rigidly formulaic art of much Minimalist work, there is nothing systematic about Martin's use of the grid; the arrangement of coordinates shifts in scale and rhythm from work to work. The grid in White Flower—composed of intersecting white lines that form individual rectangles punctuated by symmetrical white dashes—resembles woven fabric. Consistent throughout Martin's mature oeuvre is an absolute equivalence of form. The compositions are emphatically nonhierarchical; no one component is privileged over another. The delicacy of Martin's style—promoted by the artist's frequent use of light graphite lines and cool tones such as pink and pale gray—masks her impulse toward stringent formal equality. Her paintings must be read as unitary entities, not as assemblies of single elements. This does not mitigate the complexity of their construction, however. The freely drawn grids, fragile, almost dissolving lines, and hushed tones of the paintings require quiet contemplation in order for the subtleties of their individual compositions to be revealed.

White Flower, 1960.
Oil on canvas, 71% x 72 inches.
Anonymous gift. 63.1653

Materials

The use of artistic materials in the 20th century can be divided into two periods: the first, through the 1940s, was one of insemination and gestation, while the second, spanning the 1950s through the present, has been one of birth and growth. For the Modernists, artistic material was viewed as a means by which art could capture life. In this sense, materials were a nutriment for feeding the embryonic eyesight in the womb of an affirmed and secure history. Thought was superimposed upon this history, shaking it up with dynamic explosions of energy, conscious and unconscious notions, rational and mystical suggestions. Although it tapped other cultures, it always stuck to its own terrain and its boundaries remained defined by the perimeters of a frame or base.

After World War II a new material body was born, revealing its obstacles and vitality. Action Painting in America and Art Informel in Europe brought the material of art into the light. Leaving its womb, material began an active, howling life. During the late 1950s, Neo-Dada and Pop artists began exalting the "lowly" materials of our world. These new materials could be a body and its organic traces, or cultural remnants that fetishize the icons of communication and consumerism. Painting and sculpture plunged into the maelstrom of things and objects, actions and bodies, possessing them and thereby transfiguring them. In the 1960s an effluvium of material passed through the wonders and witchcraft of Arte Povera and Environmental art. Their materials fascinated and awakened the viewers by putting them in touch with the breath, the inspiration of nature. With Minimalism and Conceptualism, the eruption of material led to the point of its disappearance. Such were the ecstasies of logic and planning that art was designated a pure condition of consciousness, in which neither subject nor object exists, and the process itself comes to light. Today, after entering the world, material has returned to itself, becoming persona through a second birth, claiming the right to be disparate and multiple. From Louise Bourgeois to Robert Mapplethorpe. this process carries the energy charge of an enigma, that of the "inner view," which can be evoked by the formulations of a morbid and ironic art or a profound and transgressive art. Thus, after insemination and gestation, after birth and adolescence, artistic material, in its growth, has begun to ponder its sensual and sexual identity.

GERMANO CELANT

Translated from the Italian by Joachim Neugroschel.

Henri Matisse b. 1869, Le Cateau-Cambrésis, France; d. 1954, Nice

Henri Matisse often painted the same subject in versions that range from relatively realistic to more abstract or schematic. At times the transition from realism to abstraction could be enacted in a single canvas, as is the case with *The Italian Woman*, the first of many portraits Matisse painted of a professional Italian model named Laurette. The purposefully visible pentimenti and labored convergence of lines bear witness to his perpetual struggle "to reach that state of condensation of sensations which constitutes a picture." Matisse was not interested in capturing momentary impressions; he strove to create an enduring conception.

From the earlier state of the portrait, which depicts a heavier woman, Matisse pared down Laurette's image, in the process making her

"What interests me most is neither still life nor landscape but the human figure. It is through it that I best succeed in expressing the nearly religious feeling that I have towards life." less corporeal and more ethereal. Using the conventions of religious painting—a frontal pose, introspective countenance, and flat background devoid of any indication of location—he created an icon of Woman. The emphatic eyes and brow, elongated nose, and pursed lips of her schematic face resemble an African mask, implying that Matisse, like so many Modern artists, equated the idea of Woman with the foreign, exotic, and "primitive"; he continued in this vein, posing the same model with a turban and a mantilla.

The spatial ambiguity of this portrait—the way the arms appear flat while the background overtakes a shoulder, for example—reveals Matisse's relationship to Paul Cézanne via the bolder experiments of Cubism. In a 1913 portrait of his wife, Matisse had played with the distinctions between volume and plane by including a flattened scarf that wraps around her arm. This treatment anticipates the shawl-like background of *The Italian Woman*. These paintings recall Cézanne's series of portraits of Madame Cézanne (one of which was owned by Matisse) both formally and iconographically, although Matisse's images are more radically schematized and distilled.

The austerity of color and severe reduction of *The Italian Woman* is characteristic of Matisse's work from 1914 to 1918. The art historian Pierre Schneider has suggested that these elements embody the artist's response to the devastation of World War I.

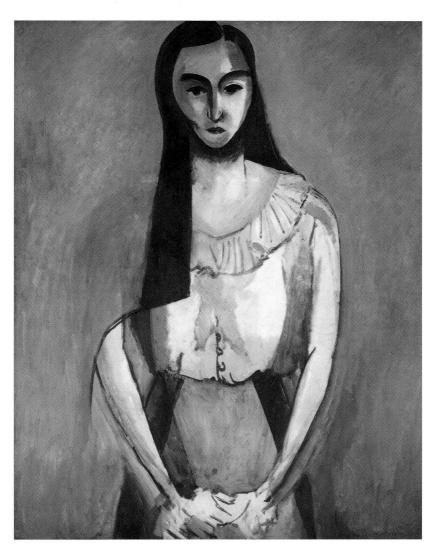

The Italian Woman, 1916. Oil on canvas, 45 15/16 x 35 1/4 inches. By exchange. 82.2946

Gordon Matta-Clark b. 1943, New York City; d. 1978, New York City

Like his father, the Surrealist painter Roberto Sebastian Matta Echaurren, Gordon Matta-Clark studied to be an architect. While it never became his profession, architecture—with its inextricable relationship to private and public space, urban development and decay—became his medium and subject matter. Using a practice that fused Conceptual art's critique of cultural institutionalization. Earth art's direct involvement with the environment, and Performance art's engagement with sheer physicality. Matta-Clark literally sliced into abandoned buildings to create dizzying, Piranesian spaces sculpted from voids and fissures. By destructuring existing sites, he sought to reveal the tyranny of urban enclosure. The economic implications of private property are at play in Matta-Clark's Fake Estates, which incorporate deeds to microplots of land—slivers of curbsides, and alleyways in Queens—that the artist bought at auction for 25 dollars a piece and combined with maps and montaged images of each site. Fascinated by the idea of untenable but ownable space, Matta-Clark purchased these residual parcels to comment on the arbitrariness of property demarcation.

Conical Intersect, Matta-Clark's contribution to the Paris Biennale of 1975, manifested his critique of urban gentrification in the form of a radical incision through two adjacent 17th-century buildings designated for demolition near the much-contested Centre Georges Pompidou, which was then under construction. For this antimonument, or "nonument," which contemplated the poetics of the civic ruin, Matta-Clark bored a tornado-shaped hole that spiraled back at a 45-degree angle to exit through the roof. Periscopelike, the void offered passersby a view of the buildings' internal skeletons.

Office Baroque, a lyrical cutting through a five-story Antwerp office building, was the artist's second-to-last architectural project before his untimely death. Inspired by overlapping teacup rings left on a drawing, the carving was organized around two semicircles that arced rhythmically through the floors, creating a rowboat shape at their intersection. Matta-Clark described the piece as "a walk through a panoramic arabesque." As in all his interventions, the building itself constituted the work of art. To counter the ephemeral nature of his sculptural gestures, he emulated their dynamic spatial and temporal qualities in unique photographs made by splicing and grafting negatives to create quasi-Cubistic images. No substitute for balancing precariously on the flayed edge of a structural cut, the photographs nevertheless document the essential aesthetic of Matta-Clark's "anarchitecture."

Conical Intersect, 1975.

Cibachrome print, mounted on mat board, 40 1/2 x 30 inches. Purchased with funds contributed by the International Director's Council and Executive Committee Members. 98.5229

Reality Properties: Fake Estates, Little Alley Block 2497, Lot 42, 1974

(posthumous assembly, 1992); detail. Property deed, site map, and photograph; framed photographic collage: 10 x 87 ¾6 x 1¾6 inches; framed photograph and documents: 20 ¾ x 22 ¾6 x 1 ¾6 inches. Purchased with funds contributed by the International Director's Council and Executive Committee Members. 98.5228.a,.b

Office Baroque, 1977.

Two Cibachrome prints, $20\frac{3}{16}$ x $39\frac{3}{14}$ and $19\frac{11}{16}$ x $39\frac{3}{14}$ inches. Purchased with funds contributed by the International Director's Council and Executive Committee Members. 98.5227.a..b

Mario Merz b. 1925, Milan

Mario Merz envisions the contemporary artist as a nomad, shifting from one environment to another and resisting stylistic uniformity while mediating between nature and culture. Since 1968 Merz has used the hemispherical form of the igloo—a transitory dwelling—to express his faith in the liberating powers of restlessness with the world and its values. He assembles the rounded structures with segmented, metal armatures, usually covering them with a net and bits of clay, wax, mud, burlap, or leather, glass fragments, or bundles of twigs. Phrases making political or literary references, spelled out in neon, often span the domes. The earliest such example, *Giap Igloo* (1968), bears a slogan attributed to the

"The igloo functions as a moldable hemisphere, transparent and luminous. . . . This creates a highly luminous intermediary space, becoming a study of transparency and light, like a gorgeous ampule from Murano or certain ancient glass vessels."

North Vietnamese military strategist General Vo Nguyen Giap: "If the enemy masses his forces, he loses ground; if he scatters, he loses strength." The contradiction inherent in this phrase captures Merz's conception of the igloo as a momentary shelter that, despite its perpetual relocation, remains a constant.

Merz often uses materials indigenous to the sites of his exhibitions to reinforce the nomadic essence of the igloo and its references to a humble economic system close to nature. For a 1979 show in Australia, for instance, he used eucalyptus leaves to blanket an igloo. He also adjusts the structure's scale and intricacy of design—more recent examples have been pierced by curving tables, surrounded

by stacks of newspapers, or clustered in groups—to correspond to the environment in which they are exhibited. *Unreal City*, created for the Guggenheim Museum's spiraling rotunda on the occasion of the artist's 1989 retrospective, is a tripartite igloo: the large, glass-covered structure is transparent and reveals smaller wood and rubber versions nestled within. As in all of Merz's sculptures (and much Arte Povera work in general), this piece embodies both beauty and violence: the shards of broken glass clamped onto this fragmented edifice are at once delicate and dangerous. The neon phrase "Città irreale" (Italian for "unreal city"), suspended across a wire-mesh triangle on the dome, refers to the intensely subjective, surreal quality of Merz's art. Although the nomadic artist may shift from one location or style or medium to another, creating momentary theaters of meaning, the sites visited are, ultimately and essentially, places in the mind.

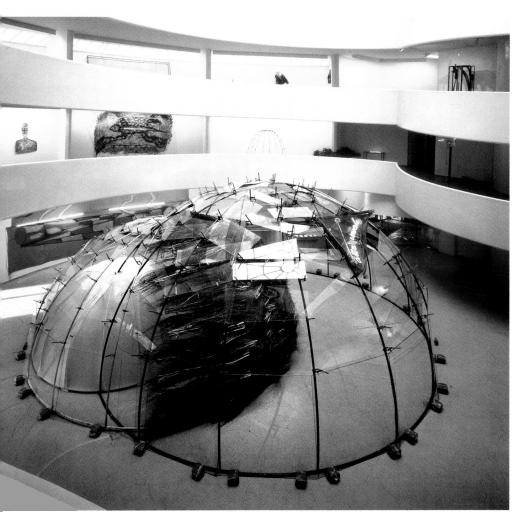

Unreal City, Nineteen Hundred Eighty-Nine, 1989.

Glass, mirror, metal pipes, twigs, rubber, clay, and clamps, 196% x 503 %6 x 392 inches overall. Gift of the artist. 89.3631.a-.g

Annette Messager b. 1943, Berck, France

Annette Messager embarked on her artistic career amid the tumultuous climate surrounding the May 1968 student uprisings in Paris. It was in this atmosphere of radicalism that she discovered that art could be found in the streets and in the tasks of everyday life, rather than solely within the cloistered realm of the museum. Some of her early pieces, such as Boarders at Rest (1971–72), in which she clothed dozens of embalmed sparrows in tiny hand-knit sweaters, and My Collection of Proverbs (1974), a selection of mostly misogynistic phrases about women hastily embroidered on unhemmed squares of cloth, use modest materials and techniques commonly associated with domesticity and often devalued as "women's work." Her nostalgia-laden gestures belie the subversive messages of social concern in her art, in which the conflict between

nature and civilization and the lack of sexual equality in society are recurrent themes.

"Art isn't made to reassure
. It should annoy;
it should disturb."

My Vows, a series begun in 1988, hovers between photography and sculpture. The works consist of numerous small black-and-white photographs of the human anatomy, often clustered in dense groupings, each print hung tenuously from the wall by a single, simple string. The body parts depicted in the photographs—from a calloused toe to an ankle to the close-up image of a breast—belong to men and women of all ages and types. Together the photographs form an inclusive representation of humanity that is equally old and young, masculine and feminine, sensual and base, and often simultaneously humorous and poignant. Ultimately, they reflect an understanding of humanity that is not categorized by physical difference. My Vows may also be understood in relation to Messager's Catholic heritage; the work resembles the assembled votive offerings left at pilgrimage sites by the faithful, which often include accumulations of handwritten notes or miniatures of ailing limbs for which cures are being sought. The work's solemn reference is

characteristic of the tension between lyricism and gravity that often

J.Y.

informs Messager's art.

My Vows, 1990. Gelatin-silver prints and string; dimensions vary with installation, approximately 74 x 71½ inches. Gift, Peter Norton Family Foundation. 93.4237

Joan Miró b. 1893, Barcelona; d. 1983, Palma de Mallorca

During the summer of 1923 Joan Miró began painting *The Tilled Field*, a view of his family's farm in Montroig, Catalonia. Although thematically related to his earlier quasi-realistic, Fauvist-colored rural views, such as *Prades*, *The Village*, this painting is the first example of Miró's Surrealist vision. Its fanciful juxtaposition of human, animal, and vegetal forms and its array of schematized creatures constitute a realm visible only to the mind's eye, and reveal the great range of Miró's imagination. While working on the painting he wrote, "I have managed to escape into the absolute of nature." *The Tilled Field* is thus a poetic metaphor that expresses Miró's idyllic conception of his homeland, where, he said, he could not "conceive of the wrongdoings of mankind."

"The most Surrealist of us all." —André Breton on Miró

The complex iconography of *The Tilled Field* has myriad sources, and attests to Miró's long-standing interest in his artistic heritage. The muted, contrasting tones of the painting recall the colors of Catalan Romanesque frescoes, while the overt flatness of the painting—space is suggested by three horizontal bands indicating sky, sea, and earth—and the decorative scattering of multicolored animals throughout were most likely inspired by medieval Spanish

tapestries. These lively creatures are themselves derived from Catalan ceramics, which Miró collected and kept in his studio. The stylized figure with a plow has its source in the prehistoric cave paintings of Altamira, which Miró knew well. Even the enormous eye peering through the foliage of the pine tree, and the eye-covered pine cone beneath it, can be traced to examples of early Christian art, in which the wings of angels were bedecked with many tiny eyes. Miró found something alive and magical in all things: the gigantic ear affixed to the trunk of the tree, for example, reflects his belief that every object contains a living soul.

Miro's spirited depiction of *The Tilled Field* also has political content. The three flags—French, Catalan, and Spanish—refer to Catalonia's attempts to secede from the central Spanish government. Primo de Rivera, who assumed Spain's dictatorship in 1923, instituted strict measures, such as banning the Catalan language and flag, to repress Catalan separatism. By depicting the Catalan and French flags together, across the border post from the Spanish flag, Miró announced his allegiance to the Catalan cause.

Prades, the Village, summer 1917. Oil on canvas, 25 % x 28 % inches. 69.1894

The Tilled Field, 1923–24.
Oil on canvas, 26 x 36½ inches. 72.2020

Miró

In 1925 Miró's work took a decisive turn, stimulated, according to the artist, by hunger-induced hallucinations involving his impressions of poetry. These resulted in the artist's "dream paintings," such as *Personage*, in which ghostly figures hover in a bluish ether. Miró explored Surrealist automatism in these canvases, attempting to freely transcribe his wandering imagination without preconceived notions. Although these images are highly schematic, they are not without references to real things, as the artist made clear. "For me a form is never something abstract," he said in 1948. "It is always a sign of some-thing. It is always a man, a bird, or something else." In these works Miró began to develop his own language of enigmatic signs: the forms in *Personage* depict

"I went quite a bit that year with poets because I felt that it was necessary to go a step beyond the strictly plastic and bring some poetry into painting." a large vestigial foot and a head with three "teeth" in its grinning mouth. The star shape often represents female genitalia in Miro's oeuvre, and the dot with four rays symbolizes the vision of a disembodied eye.

Two years later Miró reverted to imagery somewhat more grounded in reality. In Landscape (The Hare), among other works, he also returned to one of his favorite subjects, the countryside around his family's home in Catalonia. Miró said that he was inspired to paint this canvas when he saw a hare dart across a field on a summer evening. In Landscape (The Hare), this event has been transformed to emphasize the unfolding of a heavenly event. A primeval terrain of acid oranges and red is the landscape in which a hare with bulging eyes stares transfixed by a spiraling "comet."

By the late 1940s Miró was making canvases on a much larger scale and with broader markings. *Painting* of 1953 is more than 6 feet high by 12 feet wide and is characterized by loose, gestural brushstrokes and stained pigments. The calligraphic drawing style and open field of works such as *Personage* has, in *Painting*, metamorphosed into bold, energetic lines in a vast, cosmic atmosphere. Yet the star and sun, the animal-like forms, and the sprays of dots are signs of the artist's symbolic language developed in the 1920s.

Personage, summer 1925.
Oil and egg tempera (?) on canvas, 51
1/4 x 37 1/8 inches. 48.1172x504

Landscape (The Hare), autumn 1927. Oil on canvas, 51 x 76 % inches. 57.1459

Painting, 1953.
Oil on canvas, 76 ³/₄ x 148 ³/₄ inches. 55.1420

Amedeo Modigliani b. 1884, Livorno, Italy; d. 1920, Paris

When Amedeo Modigliani moved from Italy to Paris in 1906, the leading artists of the avant-garde were exploring the forms and construction of "primitive" objects. Inspired by Paul Gauguin's directly carved sculptures, which were exhibited in a retrospective that year, Constantin Brancusi, André Derain, Henri Matisse, and Pablo Picasso began to make archaizing stone and wood sculptures. Brancusi, with whom Modigliani developed a close friendship, exerted a strong influence on the Italian; this is particularly obvious in his attempts at carving between the years 1909 and 1915, when he made idol-like heads and caryatids with monumental and simplified forms.

Modigliani's sculptural concerns were translated into paint in *Jeanne Hébuterne with Yellow Sweater*, in which he portrayed his young companion as a kind of fertility goddess. With her highly stylized narrow face and blank eyes she has the serene countenance of a deity, and the artist's emphasis on massive hips and thighs mimics the focus of ancient sculptures that fetishize reproduction. Both this work and *Nude*, with their simplified, elongated oval faces, gracefully attenuated noses, and button mouths, suggest the artist's interest in African masks.

Modigliani painted the human figure almost exclusively and created at least 26 reclining female nudes. Although the impact of Modernist practice on his art was great, he was also profoundly concerned with tradition; the poses of *Nude* and similar works echo precursors by Titian, Goya, and Velázquez. Nevertheless, Modigliani's figures differ significantly in the level of raw sensuality they transmit. His nudes have often been considered lascivious, even pornographic, in part because they are depicted with body hair, but perhaps also due to the artist's reputation for debauchery. His nickname, Modi, rhymes with the French word *maudit* (accursed), a name he very likely acquired because of his lifestyle. Modigliani died of tuberculosis and complications probably brought on by substance abuse and hard living. The tragic fact that Jeanne Hébuterne, pregnant with their second child, committed suicide the next day has only contributed to the infusion of romantic speculation concerning Modigliani's work.

Nude, 1917. Oil on canvas, 28 ¾ x 45 ¼ inches. Gift, Solomon R. Guggenheim. 41.535

Jeanne Hébuterne with Yellow Sweater, 1918–19. Oil on canvas, 39½ x 25½ inches. Gift, Solomon R. Guggenheim. 37.533

László Moholy-Nagy b. 1895, Bacsbarsod, Hungary; d. 1946, Chicago

László Moholy-Nagy's utopian view that the transformative powers of art could be harnessed for collective social reform—a tenet embedded in much Modernist theory—reflected his early association with the leftist Hungarian group MA (Today), a coalition of artists devoted to the fusion of art and political activism. It was also tied to his long-standing affiliation with the Bauhaus, the German artistic and educational community founded by Walter Gropius and dedicated to the development of a universally accessible design vocabulary. With his Bauhaus colleagues, who included Josef Albers, Vasily Kandinsky, Paul Klee, and Oskar Schlemmer, he strove to define an objective science of essential forms,

"This urge of mine to supersede pigment with light has its counterpart in a drive to dissolve solid volume into defined space. When I think of sculpture, I cannot think of static mass. Emotionally, sculpture and movement are interdependent." colors, and materials, the use of which would promote a more unified social environment.

Moholy-Nagy firmly believed that the art of the present must parallel contemporary reality in order to successfully communicate meaning to a public surrounded by new technological advancements. Hence, he considered traditional, mimetic painting and sculpture obsolete and turned to pure geometric abstraction filtered through the stylistic influence of Russian Constructivism. Inspired by the structural and formal capacities of modern, synthetic materials, Moholy-Nagy experimented with transparent and opaque

plastics, particularly Celluloid, Bakelite, Trolitan, and Plexiglas. In 1923 he created his first painting on clear plastic, giving physical form to his profound interest in the effects of light, which would later be manifest in film and photography as well as in transparent sculptures, such as the kinetic *Dual Form with Chromium Rods*.

A II and AXL II illustrate how Moholy-Nagy translated his efforts to manipulate light "as a new plastic medium" onto the painted canvas. In the first painting, the colored parallelograms and circles appear to be almost translucent as one plane overlaps the next and their hues shift accordingly. In the second, the intersecting transparent forms read as converging beams of light. A sense of layered space, echoing the artist's three-dimensional plastic "paintings" constructed with clear, projecting planes, was thus achieved. The contrived play of shadow and illumination on these canvases underscores the artist's conviction that light could be harnessed as an effective aesthetic medium, "just as color in painting and tone in music."

A II, 1924. Oil on canvas, 45 % x 53 % inches. 43.900

AXL II, 1927. Oil on canvas. 37 x 29 ⅓ inches. Gift, Mrs. Andrew P. Fuller. 64.1754

Dual Form with Chromium Rods, 1946. Plexiglas and chrome-plated steel rods, 36 ½ x 47 ½ x 22 inches. 48.1149

Piet Mondrian b. 1872, Amersfoort, The Netherlands; d. 1944, New York City

For more than a decade after graduating from art school in 1897. Piet Mondrian created naturalistic drawings and paintings that reflect a succession of stylistic influences including academic realism, Dutch Impressionism, and Symbolism. During this period and intermittently until the mid-1920s Mondrian created more than a hundred pictures of flowers. Reflecting years later on his attraction to the subject, he wrote, "I enjoyed painting flowers, not bouquets, but a single flower at a time, in order that I might better express its plastic structure." The heavy crooked line of *Chrysanthemum* suggests Mondrian's debt to Post-Impressionism, specifically the work of Vincent van Gogh. In 1909 Mondrian became interested in theosophy, a type of philosophical mysticism that seeks to disclose the concealed essences of reality. "I too find flowers beautiful in

their exterior beauty," he wrote a few years later, "yet there is hidden within a deeper beauty."

"The life of modern cultured man is gradually turning away from the natural: life is becoming more and more abstract."

Mondrian was inspired by Paul Cézanne's method of breaking down compositional elements into facets of color. In *Still Life with Gingerpot I* Mondrian began to employ such avant-garde techniques as *passage* (brushwork that continues beyond the designated sof objects) and a generally looser handling of paint. Although

edges of objects) and a generally looser handling of paint. Although muted, the palette of *Still Life with Gingerpot I* repeats the buoyant blues and roses of Mondrian's earlier works, as well as their more naturalistic style of representation, exemplified by the retention of traditional perspective and the coherent integrity of the components of the still life such as the glass and saucepan.

Still Life with Gingerpot II takes the artist's first depiction of this motif to a much greater level of abstraction. The grid framework now interpolates the objects on the tabletop, and no vestiges of the glassware, stacked canvases, or window frame of the earlier composition remain. Mondrian's works of this period are characterized by a strong central motif (here the gingerpot) around which the rest of the picture revolves in a symmetrical fashion. While in later paintings Mondrian developed a more dispersed field, his overarching concern for balance and order remained constant.

Chrysanthemum, 1908–09. Charcoal on paper, 10 x 11 1/4 inches. 61.1589

Still Life with Gingerpot I, 1911–12. Oil on canvas, 25 3/4 x 29 1/2 inches. 295.76

Still Life with Gingerpot II, 1911–12. Oil on canvas, 37 ½ x 47 ½ inches. 294.76

Mondrian

When Mondrian saw Cubist paintings by Georges Braque and Pablo Picasso at a 1911 exhibition in Amsterdam, he was inspired to go to Paris. Tableau No. 2/Composition No. VII, painted a year after his arrival in 1912, exemplifies Mondrian's regard for the new technique. With a procedure indebted to high Analytic Cubism, Mondrian broke down his motif—in this case a tree—into a scaffolding of interlocking black lines and planes of color; furthermore, his palette of close-valued ocher and gray tones resembles Cubist canvases. Yet Mondrian went beyond the Parisian Cubists' degree of abstraction: his subjects are less recognizable, in part because he eschewed any suggestion of volume, and, unlike the Cubists, who rooted their compositions at the bottom of the canvas in order to depict a figure subject to gravity, Mondrian's scaffolding fades at the painting's edges. In works such as Composition 8, based on studies of

"We must see deeper, see abstractly and above all universally." Parisian building façades, Mondrian went even further in his refusal of illusionism and the representation of volume.

During the war years, Mondrian continued to move toward greater abstraction, rejecting diagonal lines and decreasing his reliance on his favored subjects—trees, seascapes, and architecture. Composition, which developed from studies of a church, is among the last of his works that can be traced to an observable source. Canvases like this make it clear that Mondrian's interest lay foremost in coming to terms with the two-dimensionality of the painted surface. For this work, the artist designed a strip frame (now lost), which he said prevented the sensation of depth created by traditional carved frames.

The inexorable consistency and internal logic of his solutions hint at a larger conceptual principle, which is outlined in great depth in the artist's extensive theoretical writings. Like many pioneers of abstraction, Mondrian's impetus was largely spiritual. He aimed to distill the real world to its pure essence, to represent the dichotomies of the universe in eternal tension. To achieve this, he privileged certain principles—stability, universality, and spirituality—through the yin/yang balancing of horizontal and vertical strokes. His philosophical framework was grounded in the Neoplatonic and Tantric-inspired texts of authors connected to the Theosophical Society, the Dutch branch of which had counted Mondrian as a member since 1909

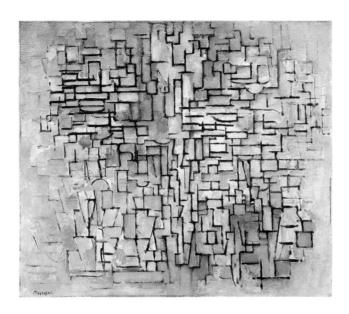

Tableau No. 2 / Composition No. VII, 1913. Oil on canvas, 41½ x 44¾ inches. 49.1228

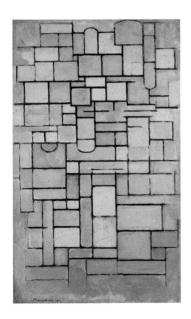

Composition 8, 1914. Oil on canvas, 37 1/8 x 21 7/8 inches. 49.1227

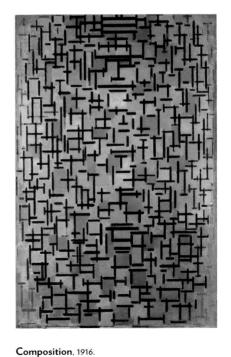

Oil on canvas with wood strip nailed to the bottom, $46\frac{7}{6} \times 29\frac{5}{6}$ inches. 49.1229

Mondrian

Mondrian was a member of the Dutch De Stijl movement from its inception in 1917. By the early 1920s, in line with De Stijl practice, he restricted his compositions to predominantly off-white grounds divided by black horizontal and vertical lines that often framed subsidiary blocks of individual primary colors. *Tableau 2*, a representative example of this period, demonstrates the artist's rejection of mimesis, which he considered a reprehensibly deceptive imitation of reality.

In 1918 Mondrian created his first "losangique" paintings, such as the later Composition No. 1, by tilting a square canvas 45 degrees. Most of these diamond-shaped works were created in 1925 and 1926 following his break with the De Stijl group over Theo van Doesburg's introduction of the diagonal. Mondrian felt that in so doing van Doesburg had betrayed the

"In painting the straight line is certainly the most precise and appropriate means to express free rhythm." movement's fundamental principles, thus forfeiting the static immutability achieved through stable verticals and horizontals. Mondrian asserted, however, that his own rotated canvases maintained the desired equilibrium of the grid, while the 45-degree turn allowed for longer lines.

Art historian Rosalind Krauss identifies the grid as "a structure that has remained emblematic of modernist ambition." She notes in these paintings by Mondrian, whose work has become synonymous with the grid, two signal opposing generative tendencies. Composition No. 1, in which the lines intersect just beyond the picture plane (suggesting that the work is taken from a larger whole), exemplifies a centrifugal disposition of the grid; Tableau 2, whose lines stop short of the picture's edges (implying that it is a self-contained unit), evinces a centripetal tendency. Krauss argues that these dual and conflicting readings of the grid embody the central conflict of Mondrian's—and indeed of Modernism's—ambition: to represent properties of materials or perception while also responding to a higher, spiritual call. "The grid's mythic power," Krauss asserts, "is that it makes us able to think we are dealing with materialism (or sometimes science, or logic) while at the same time it provides us with a release into belief (or illusion, or fiction)."

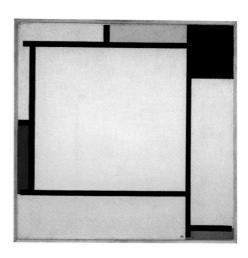

Tableau 2, 1922. Oil on canvas, 21½ x 21½ inches. 51.1309

Composition No. 1, 1930. Oil on canvas; 29 % x 29 % inches; vertical axis 41 % inches. Hilla Rebay Collection. 71.1936.R96

Robert Morris b. 1931, Kansas City, Mo.

In 1964, at New York's Green Gallery, Robert Morris exhibited a suite of large-scale polyhedron forms constructed from two-by-fours and gray-painted plywood. This kind of simple geometric sculpture came to be called Minimalist because it seemed to be stripped of extraneous distractions such as figural or metaphorical reference, detail or ornament, and even surface inflection. Sculptures like the Corner Piece, one component of the 1964 suite, boldly delineate the space in which they are located, thus defining the physical and temporal relationship of the viewer to the sculptural object.

Morris's sculptures often consist of industrial or building materials such as steel, fiberglass, and plywood, and were commercially fabricated according to the artist's specifications. The value of the "artist's hand"—

the unique gesture that defines an individual's skill and style—was inimical to Morris, and the work of art became, in theory, not an "original" object but a representation of the idea from which it was conceived. This notion allowed for the creation and destruction of a piece when necessary; Corner Piece, for example, can be refabricated each time it is to be exhibited.

"Simplicity of shape does not necessarily equate with simplicity of experience."

> In 1968 Morris introduced an entirely different aesthetic approach, which he articulated in an essay entitled "Anti-Form." In this and later writings he reassessed his assumptions underlying Minimalist art and concluded that, contrary to earlier assertions, the construction of such objects had relied on subjective decisions and therefore resulted in icons-making them essentially no different than traditional sculpture. The art that he, Eva Hesse, Richard Serra, and others began to explore at the end of the 1960s stressed the unusual materials they employed—industrial components such as wire, rubber, and felt—and their response to simple actions such as cutting and dropping. Pink Felt, for example, is composed of dozens of sliced pink industrial felt pieces that have been dropped unceremoniously on the floor. Morris's scattered felt strips obliquely allude to the human body through their response to gravity and epidermal quality. The ragged irregular contours of the jumbled heap refuse to conform to the strict unitary profile that is characteristic of Minimalist sculpture. This, along with its growing referentiality, led Morris's work of the late-1960s and early 1970s to be referred to by such terms as Anti-Form, Process art. or Post-Minimalism.

Untitled (Corner Piece), 1964. Painted plywood and pine, 72 x 102 x 51 inches overall. Panza Collection. 91.3791

Untitled (Pink Felt), 1970. Felt; dimensions vary with installation. Panza Collection. 91.3804

Robert Motherwell b. 1915, Aberdeen, Wash.; d. 1991, Provincetown

Robert Motherwell was only 21 years old when the Spanish Civil War broke out in 1936, but its atrocities made an indelible impression on him, and he later devoted a series of more than 200 paintings to the theme. The tragic proportions of the three-year battle—more than 700,000 people were killed in combat and it occasioned the first air-raid bombings of civilians in history—roused many artists to respond. Most famously, Pablo Picasso created his monumental 1937 painting *Guernica* as an expression of outrage over the events. From Motherwell's retrospective view, the war became a metaphor for all injustice. He conceived of his

Elegies to the Spanish Republic as majestic commemorations of human suffering and as abstract, poetic symbols for the inexorable cycle of life and death.

"The 'Spanish Elegies' are not 'political,' but my private insistence that a terrible death happened that should not be forgot[ten]. They are as eloquent as I could make them. But the pictures are also general metaphors of the contrast between life and death and their interrelations."

Motherwell's allusion to human mortality through a nonreferential visual language demonstrates his admiration for French Symbolism, an appreciation he shared with his fellow Abstract Expressionist painters. Motherwell was particularly inspired by the Symbolist poet Stéphane Mallarmé's belief that a poem should not represent some specific entity, idea, or event, but rather the emotive effect that it produces. The abstract motif common to most of the *Elegies*—an alternating pattern of bulbous shapes compressed between columnar forms—may be read as an indirect, open-ended reference to the experience of loss and the heroics of stoic resistance. The

dialectical nature of life itself is expressed through the stark juxtaposition of black against white, which reverberates in the contrasting ovoid and rectilinear slab forms. About the *Elegies*, Motherwell said, "After a period of painting them, I discovered Black as one of my subjects—and with black, the contrasting white, a sense of life and death which to me is quite Spanish. They are essentially the Spanish black of death contrasted with the dazzle of a Matisse-like sunlight." This and other remarks Motherwell made regarding the evolution of the *Elegies* indicate that form preceded iconography. Given that the *Elegies* date from an ink sketch made in 1948 to accompany a poem by Harold Rosenberg that was unrelated to the Spanish Civil War, and that their compositional syntax became increasingly intense, it seems all the more apparent that the "meaning" of each work in the series is subjective and evolves over time.

Elegy to the Spanish Republic No. 110, Easter Day. 1971. Acrylic with pencil and charcoal on canvas, 82 x 114 inches. Gift, Agnes Gund. 84.3223

Bruce Nauman b. 1941, Fort Wayne, Ind.

Bruce Nauman defies the traditional notion that an artist should have one signature style and a visually unified oeuvre. Since the mid-1960s the artist has created an open-ended body of work that includes fiberglass sculptures, abstract body casts, performances, films, neon wall reliefs, interactive environments, videos, and motorized carousels displaying castaluminum animal carcasses. If anything links such diverse endeavors, it is Nauman's insistence that aesthetic experience supersedes the actual object in importance. Perception itself—the viewer's encounter with his or her body and mind in relation to the art object—can be interpreted as the subject matter of Nauman's work. Using puns, claustrophobic passageways with surveillance cameras, and videotaped recitations of bad jokes, he has created situations that are physically or intellectually disorienting, forcing viewers to confront their own experiential thresholds.

Nauman adopted neon signage during the 1960s (perhaps in response to Pop art) to illustrate his Duchampian word plays. None Sing/Neon Sign is an anagram that, like Nauman's other semiotically playful neon pieces—Raw War and Run from Fear/Fun from Rear, for example—underscores the arbitrary relationship between a word's definition, what it sounds like, and what it looks like. A circular sign from 1967 of the spiraling neon phrase THE TRUE ARTIST HELPS THE WORLD BY REVEALING MYSTIC TRUTHS suggests, in retrospect and with irony, that these truths may be nothing more than the subtle distinctions between aesthetic illusion, artistic hype, and meaning.

Nauman enforces the contrast between the perceptual and physical experience of space in his sculptures and installations. Looking at the brilliant color emanating from *Green Light Corridor* prompts quite a different phenomenological experience than does maneuvering through its narrow confines. *Lighted Performance Box* provokes another experiential situation. As a rectangular column, it resembles the quintessential unitary Minimalist sculpture, yet the square of light cast on the ceiling from the lamp encased inside alters one's reading of the piece: the sense of a hidden, unattainable space, one that can only be experienced vicariously, is evoked. Thus, the performance alluded to in the title is only a private, conceptual act, initiated when viewers attempt to mentally project their own bodies into this implied interior place.

Green Light Corridor, 1970. Wallboard and fluorescent light fixtures with green lamps; dimensions variable, approximately 120 x 12 x 480 inches. Panza Collection, Gift. 92.4171

Lighted Performance Box, 1969. Aluminum and 1000-watt spotlight, 78 x 20 x 20 inches. Panza Collection. 91.3820

None Sing-Neon Sign, 1970. Ruby-red and cool white neon, $13 \times 24 \frac{1}{4} \times 1\frac{1}{2}$ inches overall. Edition 6/6. Panza Collection, 91.3825.a.

Louise Nevelson b. 1899, Kiev; d. 1988, New York City

Louise Nevelson's mature work emerged in the mid-1950s, when she began to assemble found wooden objects into constructions, most of which she painted uniformly black. In so doing she aligned herself with many contemporary artists who embraced found objects to create what has become known as Junk art, an aesthetic that stems from Pablo Picasso's invention, early in this century, of a sculpture of accumulation. Nevelson's large-scale wall constructions reflect her interest in pre-Columbian stelae as well. The scale and formal purity of the all-black and all-white sculptures, in which the frontal relief surface and uniform coloration focus the viewer on the play of light and shadow, also suggest the solemnity and grandeur of altar paintings.

"No matter how individual we humans are, we are a composite of everything we are aware of. We are the mirror of our times." In Luminous Zag: Night, 105 units are filled with rows of saw-toothed wooden beams or, in approximately a dozen cases, with column fragments or jumbles of finials. A complicated rhythmic pattern, suggesting a fuguelike musical composition, is created by the play of vertical and horizontal zigzags. Like Piet Mondrian's Broadway Boogie Woogie (1942–43), Nevelson's Luminous Zag: Night appears to be inspired by jazz music and its emphasis on improvisation within an established structure. The emphatic

chiaroscuro of the zigzag blocks suggests the dynamism of Broadway at night. In an interview, Nevelson addressed the prominent use of the color black in her work, saying that "it's only an assumption of the Western world that it means death, for me it may mean finish, completeness, maybe eternity."

White Vertical Water is the opposite of Luminous Zag: Night in terms of tension and tone. While the geometric regularity of the latter recalls urban architecture, the spontaneous irregularity of White Vertical Water evokes images of nature. The long undulating curves of the forms in the work's narrow vertical boxes mimic the cascading streams of a waterfall or the froth of white water, while the biomorphic cutout layers in the upperright squares, which recall the work of Jean Arp, suggest squirming fish. The materials and wall-like structure of Nevelson's monumental sculptures are akin to the fundamental elements of architecture, through which she created metaphorical analogies to urban and natural environments.

Luminous Zag: Night, 1971. Painted wood: 105 boxes, 120 x 193 x 10 1/4 inches overall. Gift, Mr. and Mrs. Sidney Singer. 77.2325.a-.bbbb

White Vertical Water, 1972. Painted wood; 26 sections, 216 x 108 inches overall. Gift, Mr. and Mrs. James J. Shapiro. 85.3266.a-.z

Isamu Noguchi b. 1904, Los Angeles; d. 1988, New York City

Isamu Noguchi was an American artist whose artistic education took place in the requisite arena for the avant-garde of the first half of the century: Paris. Yet he was of Japanese origin, and as he slowly came in touch with his own cultural roots he increasingly shifted his emphasis away from a formal aesthetic vocabulary founded on the works of sculptors such as Constantin Brancusi in favor of a uniquely Japanese appreciation for the innate beauty of even the simplest materials. His art reveals both a debt to 20th-century sculptural canons and a rare understanding of the means by which geological and organic materials can be transformed. He once remarked, "Abandoned stones which I become interested in invite me to enter into their life's purpose. It is my task to define and make visible the intent of their being."

Carl Andre made a similar transition to a Zen-like minimalism. Yet the works of the two artists are entirely different, perhaps because Noguchi belonged to the previous generation, for which, as he said, "sculpture comes from time-consuming difficulty, not industrial reproduction." This existentialist emphasis on the mastery of life's circumstances characterizes his early sets for the dances of Martha Graham and such sculptures as The Cry and Lunar.

The Lunar series came about in the 1940s, when Noguchi became fascinated by the reflection of light on form. Lunar is cut out of anodized aluminum and mounted, in contrast, on a wooden base. The aluminum is a softly reflective surface, sensitive to variations in light. The Cry, on the other hand, is malleable as a result of another natural force—wind. It was made in 1959 out of balsa wood, although it was cast in bronze a few years later. The Guggenheim Museum owns the balsa original, in which Noguchi attempted to create the lightest possible form of solid sculpture. Its elements are loosely connected so that they vibrate in response to air currents. Many of the qualities explored in The Cry and Lunar are also found in Noguchi's akari, the ethereal lamps for which he has become best known. Patterned on the paper lanterns hanging outside of traditional homes in Japan, the akari continued Noguchi's earlier interest in the potential luminosity and weightlessness of sculpture.

C.L.

The Cry. 1959.
Balsa wood on steel base,
86 1/4 x 29 1/2 x 19 1/4 inches overall.
66.1812

Lunar, 1959–60. Anodized aluminum with wood, 74½ x 24 x 11½ inches. 61.1596

Cady Noland b. 1956, Washington, D.C.

Cady Noland exposes the myth behind the promise of the American Dream. Her work addresses what she sees as America's anxiety over the country's failed pledge of freedom, security, and success for all. Combining iconic objects and images (flags, beer cans, celebrity photos, and the contents of tabloid newspapers) with base elements (grocery baskets, handcuffs, walkers, and portable metal barricades), Noland's output tends toward haphazard arrangements that signify impaired social and physical mobility. As in her massive 1989 installation of Budweiser beer cans,

"There is a method in my work which has taken a pathological trend. . . . I became interested in how, actually, under which circumstances people treat other people like objects. I became interested in psychopaths in particular, because they objectify people in order to manipulate them."

Noland's work also suggests a culture of excess and waste, a place in which the media and corporate interests distort events and objectify people. Her installations, which resemble works in progress rather than formal or finished pieces, speak of an abandoned plan—of hopes discarded like so many of the objects in her artwork.

The anxious America that Noland depicts developed in part in the wake of the Vietnam War, the Kennedy assassinations, the brutal treatment of protestors at the 1968 Democratic Convention in Chicago, and Watergate—events that threatened the country's image as a united, just, and invincible society. Noland has devoted many works to members of the cult of antiheroes, namely Lee Harvey Oswald and Patricia Hearst, who have long fascinated the public. Hearst's multiple personae, which ranged from fairytale princess to terrorist were subject to media exploitation (a

journalistic practice established by her own family's newspapers). Hearst particularly interested Noland. Transferring silkscreen enlargements of media imagery onto brushed aluminum supports, Noland portrayed her in all her various guises. For example, *SLA #4* features a torn newspaper photograph of Hearst and members of the Symbionese Liberation Army or SLA—her "kidnappers" and later comrades—encircling the leader Donald "Cinque Mtume" DeFreeze, who stands before the group's symbol, a seven-headed cobra.

Like Andy Warhol before her, Noland finds silkscreen to be a particularly appropriate medium with which to exploit her subject matter. By using the techniques of mass production and consumption, she further exaggerates the media's own language and asks the viewer to question its claims of truth. And for Noland, Hearst's seeming crisis of identity parallels America's own uncertain identity and profoundly expresses the disillusionment that the artist seeks to capture in her work.

SLA #4, 1990. Silkscreen on aluminum, 78 1/4 x 60 1/4 x 1/4 inches. Edition 4/4. Gift, Noah Garson and Ronald Schwartz. 99.5276

Non-Objective

The term "non-objective" is a very free (and misleading) translation of the German word gegenstandslos. Although "without objects" or "objectless" is a more accurate translation, "non-objective" has been used in the U.S. as a synonym for abstract art since its introduction and popularization by the German artist and curator Hilla Rebay. Rebay, who had come to the States in 1927, helped the industrialist Solomon R. Guggenheim assemble a group of primarily abstract works, including paintings by Robert Delaunay, Vasily Kandinsky, and László Moholy-Nagy, and became the first director of the Museum of Non-Objective Painting, as the Guggenheim was called from 1939 to 1952. She used the term "nonobjective" in the first catalogue of the collection, which she prepared for a traveling exhibition in 1936. In this catalogue and in others that followed, Rebay attempted to divide abstract painting in general and Kandinsky's paintings in particular into evolutionary stages of partly abstract ("objective abstraction") and abstract ("non-objective"). Kandinsky and other pioneering abstract painters such as Piet Mondrian did not like this translation of gegenstandslos. They felt it evoked the negative connotation of philosophical subjectivity, whereas they wanted to emphasize the universal and international aspects of their work. In Kandinsky's correspondence with Rebay from the 1930s, he agreed that for some paintings, such as his Black Lines of 1913, he had not utilized concrete objects to arrive at his imagery, but he indicated his dislike for her schematic quantifications. He had used the term gegenstandslos in earlier essays—in his 1913 autobiography, for example—to describe his goal of obscuring specific, material objects in his paintings, but Kandinsky more often relied on the word abstrakt to indicate the direction of his work. In an essay of 1935 he critiqued the tone of both gegenstandslos and "non-objective," explaining that the "non" and the "los" were devoid of positive meaning.

By the time the Frank Lloyd Wright building that now houses the Guggenheim collection opened in 1959, the Museum of Non-Objective Painting had changed its name to the Solomon R. Guggenheim Museum. In the ensuing years, usage of "non-objective," with its convoluted hierarchical classification of different types of abstraction and its suggestion of philosophical subjectivity, has steadily fallen out of favor.

ROSE-CAROL WASHTON LONG

Claes Oldenburg b. 1929, Stockholm, Sweden

Claes Oldenburg's absorption with the commonplace was first manifested in his personal collection of toys, plastic food, and knickknacks. These objects served as prototypes for the pieces the artist included in his early Happenings and installations. The burlesque Freighter and Sailboat—one of the first soft sculptures—originated as a playfully sagging prop in his 1962 series of ten performances Ray Gun Theater. Such sculptural articles played a more central role in Oldenburg's fabricated environment The Store (1961–62), in one version of which he filled a Manhattan storefront with colorfully painted plaster simulations of ordinary items—including articles of clothing and sundry food products—which he sold as merchandise. Because of its conflation of creativity with commerce, The Store is often cited as a quintessential moment in the emergence of Pop art.

"I never make representations of bodies but of things that relate to bodies so that the body sensation is passed along to the spectator either literally or by suggestion."

Oldenburg's enterprise, however, suggests many interpretations. The lumpy wares sold at *The Store* and their later incarnations as large-scale, stuffed vinyl sculptures—including a light switch, a toaster, and the pay telephone shown here—may be seen as substitutions for and references to the human body. Through their malleable forms and susceptibility to the effects of gravity, these supple sculptures often suggest specific anatomical parts:

hamburgers are breasts, a tube of toothpaste is a phallus. Passive and limp, but potentially arousable, the pieces allude to the sexual, a realm that has been repressed in much Modern, abstract art. By asserting the sensual through the mundane, Oldenburg explores the ways in which everyday objects are so much an extension of ourselves. Anyone familiar with Freud's interpret-ation of dreams, in which domestic items are surrogates for human anatomy, will find a similar equation in Oldenburg's art.

After 1964 the artist expanded the range of his work to include monumental public projects while continuing to maintain his engagement with the ordinary and to demonstrate his remarkable sense of humor. The proposed projects (which generally exist only as drawings, prints, and maquettes) include an enormous, buttered baked potato for Brooklyn's Grand Army Plaza. When actually constructed—such as the 24-foot-high lipstick set on an army tank at Yale University—the monuments activate their surrounding environments through a subversive mix of political provocation and entertainment.

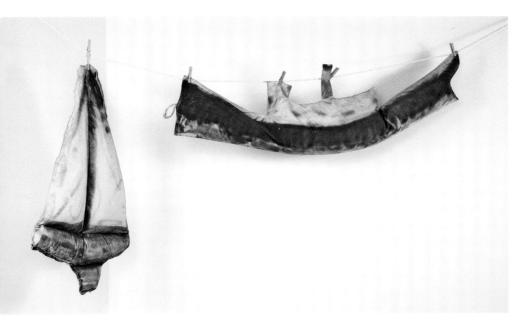

Freighter and Sailboat, 1962. Muslin filled with foam rubber, painted with spray enamel; freighter: 19 "/16 x 70 "/16 x 5 "5/6 inches; sailboat: 45 1/16 x 28 "5/6 x 5 5/16 inches. Gift, Claes Oldenburg and Coosje van Bruggen. 91.3904.a..b

Soft Pay-Telephone. 1963.
Vinyl filled with kapok, mounted on painted wood panel, 46 ½ x 19 x 9 inches. Gift. Ruth and Philip Zierler in memory of their dear departed son, William S. Zierler. 80.2747

Oldenburg / Coosje van Bruggen b. 1942, Groningen, The Netherlands

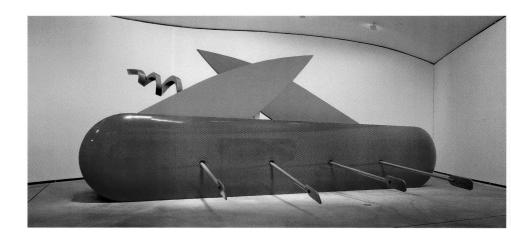

Since meeting in 1970, Oldenburg and his wife, Coosje van Bruggen, a writer and curator, have collaborated on more than 25 large-scale projects. In 1985 the city of Venice was introduced to the artists' humorously monumental vocabulary by The Course of the Knife, a twoday multimedia, multiwork, land-and-water spectacle that also involved human performers. As in Oldenburg's Happenings of the 1960s, objects in The Course of the Knife were transformed from props and sets into essential players, including an 18-foot-wide espresso cup and saucer. and Houseball, a 12-foot-diameter ball to which various pieces of foam furniture were bound. As a dramatic finale to the performance, the motorized sculpture Knife Ship I, a giant Swiss Army pocketknife set afloat like a colossal Venetian gondola, was launched from the Arsenale naval yard, its blade and corkscrew sails cleaving the air. Like many of their monuments to banal everyday items, Oldenburg and van Bruggen's Knife Ship I, in its absurdity, challenges viewers' ordinary relationship to objects and the environment.

Soft Shuttlecock was created specifically for the Frank Lloyd Wrightdesigned rotunda of the Guggenheim Museum by the artists in celebration of Oldenburg's 1995 retrospective there. While planning the exhibition, Oldenburg and van Bruggen were also developing a project for the Nelson-Atkins Museum of Art in Kansas City, Missouri, in which

four 18-foot-high shuttlecocks in plastic and aluminum are situated in the grass on either side of the museum, as if the building were a badminton net and the "birdies" fell during play. For the Guggenheim installation, the artists playfully engaged the same object, this time rendering it in more pliant materials. Early preparatory drawings show the shuttlecock transformed into a costume for a tightrope walker to wear while crossing the museum's rotunda. The final result was no less a daring interaction with the space. Oldenburg and van Bruggen draped the flaccid feathers of the shuttlecock over several ramps and suspended others from the skylight above with cables. Like the Nelson-Atkins installation, Soft Shuttlecock humorously deflates the imposing structure of the building by diminishing its relative scale, while underscoring the museum's institutional role as a site not only for culture and education but also for recreation and entertainment.

Knife Ship I, 1985.

Vinyl-covered wood, steel, and aluminum with motors; dimensions variable, maximum height 31 feet 8 inches x 40 feet 5 inches x 31 feet 6 inches. Gift, GFT USA Corporation, New York, 95,4489

Soft Shuttlecock, 1995.

Canvas, expanded polyurethane foam, polyethylene foam, steel, aluminum, rope, wood, duct tape, fiberglass, and reinforced plastic, painted with latex; nine feathers, each approximately 26 feet long, 6–7 feet wide; nosepiece: approximately 6 x 6 x 3 feet. Partial Gift, Claes Oldenburg and Coosje van Bruggen, New York. 95.4488

J.Y.

Francis Picabia b. 1879, Paris: d. 1953, Paris

Francis Picabia abandoned his successful career as a painter of coloristic, amorphous abstraction to devote himself, for a time, to the international Dada movement. A self-styled "congenial anarchist," Picabia, along with his colleague Marcel Duchamp, brought Dada to the New York art world in 1915, the same year he began making his enigmatic machinist portraits, such as *The Child Carburetor*, which had an immediate and lasting effect on American art. *The Child Carburetor* is based on an engineer's diagram of a "Racing Claudel" carburetor, but the descriptive labels that identify its various mechanical elements establish a correspondence between machines and human bodies; the composition suggests two sets of male and female genitals. Considered within the context created by Duchamp's contemporaneous work *The Bride Stripped Bare by Her Bachelors, Even*

"The machine has become more than a mere appendix to life. It has come to form an authentic part of human existence . . . perhaps its soul." (1915–23), as art historian William Camfield has observed, *The Child Carburetor*, with its "bride" that is a kind of "motor" operated by "love gasoline," also becomes a love machine. Its forms and inscriptions abound in sexual analogies, but because the mechanical elements are nonoperative or "impotent," the sexual act is not consummated. Whether the implication can be drawn that procreation is an incidental consequence of sexual pleasure, or simply

that this "child" machine has not yet sufficiently matured to its full potential, remains unclear. Picabia stressed the psychological possibilities of machines as metaphors for human sexuality, but he refused to explicate them. Beneath the humor of his witty pictograms and comic references to copulating anthropomorphic machines lies the suggestion of a critique—always formulated in a punning fashion—directed against the infallibility of science and the certainty of technological progress. The Child Carburetor and Picabia's other quirky, though beautifully painted, little machines (which he continued to make until 1922) are indeed fallible. If they are amusingly naive as science fictions or erotic machines, they are also entirely earnest in placing man at the center of Picabia's universe, albeit a mechanical one.

J.A.

The Child Carburetor, 1919.
Oil, enamel, metallic paint, gold leaf, pencil, and crayon on stained plywood, 49 1/4 x 39 1/6 inches.
55.1426

Pablo Picasso b. 1881, Málaga, Spain; d. 1973, Mougins, France

Pablo Picasso was still living in Barcelona when the 1900 World's Fair drew him to Paris for the first time. During the course of his two-month stay he immersed himself in art galleries as well as the bohemian cafés, night-clubs, and dance halls of Montmartre. Le Moulin de la Galette, his first Parisian painting, reflects his fascination with the lusty decadence and gaudy glamour of the famous dance hall, where bourgeois patrons and prostitutes rubbed shoulders. Picasso had yet to develop a unique style, but Le Moulin de la Galette is nonetheless a startling production for an artist who had just turned 19.

Parisian night life, teeming with uninhibited hedonism and vulgarity, was a popular theme in late-19th- and early 20th-century painting; artists such as Edgar Degas and Edouard Manet documented this enticing, ribald nocturnal realm. None was a more skilled chronicler or sympathetic observer of the demimonde than Henri de Toulouse-Lautrec, whose numerous paintings and graphics from the late 1880s and early 1890s of pleasure palaces and their roquish patrons were an early and important influence on Picasso. Reproductions of his expressive paintings appeared in French newspapers that circulated in Barcelona and were well known to Picasso before he came to Paris, but the firsthand experience of these canvases and the decadent culture they portrayed increased his admiration for Toulouse-Lautrec and the tradition in which they were painted. In Le Moulin de la Galette, Picasso adopted the position of a sympathetic and intrigued observer of the spectacle of entertainment, suggesting its provocative appeal and artificiality. In richly vibrant colors, much brighter than any he had previously used, he captured the intoxicating scene as a dizzying blur of fashionable figures with expressionless faces.

J.A.

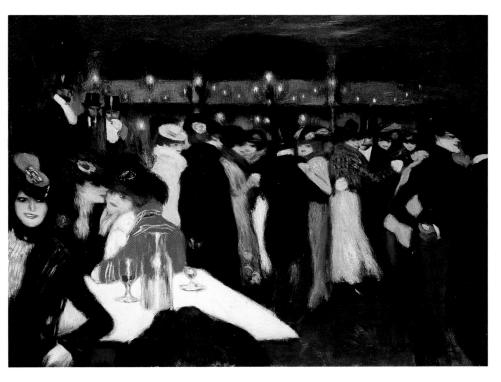

Le Moulin de la Galette, autumn 1900. Oil on canvas, 34¾ x 45¼ inches. Thannhauser Collection, Gift, Justin K. Thannhauser. 78.2514.34

Picasso

Images of labor abound in late-19th- and early 20th-century French art. From Jean-François Millet's sowers and Gustave Courbet's stone breakers to Berthe Morisot's wet nurses and Edgar Degas's dancers and milliners, workers were often idealized and portrayed as simple, robust souls who, because of their identification with the earth, with sustenance, and with survival, symbolized a state of blessed innocence. Perhaps no artist depicted the plight of the underclasses with greater poignancy than Picasso, who focused almost exclusively on the disenfranchised during his Blue Period (1901-04), known for its melancholy palette of predominantly blue tones and its gloomy themes. Living in relative poverty as a young, unknown artist during his early years in Paris, Picasso no doubt empathized with the laborers and beggars around him and often portrayed them with great sensitivity and pathos. Woman Ironing, painted at the end of the Blue Period in a lighter but still bleak color scheme of whites and grays, is Picasso's quintessential image of travail and fatigue. Although rooted in the social and economic reality of turn-of-the-century Paris, the artist's expressionistic treatment of his subject—he endowed her with attenuated proportions and angular contours—reveals a distinct stylistic debt to the delicate, elongated forms of El Greco. Never simply a chronicler of empirical facts, Picasso here imbued his subject with a poetic, almost spiritual presence, making her a metaphor for the misfortunes of the working poor.

Picasso's attention soon shifted from the creation of social and quasi-religious allegories to an investigation of space, volume, and perception, culminating in the invention of Cubism. His portrait Fernande with a Black Mantilla is a transitional work. Still somewhat expressionistic and romantic, with its subdued tonality and lively brushstrokes, the picture depicts his mistress Fernande Olivier wearing a mantilla, which perhaps symbolizes the artist's Spanish origins. The iconic stylization of her face and its abbreviated features, however, foretell Picasso's increasing interest in the abstract qualities and solidity of Iberian sculpture, which would profoundly influence his subsequent works. Though naturalistically delineated, the painting presages his imminent experiments with abstraction.

Woman Ironing. 1904. Oil on canvas, 45 1/4 x 28 1/4 inches Thannhauser Collection, Gift, Justin K. Thannhauser. 78.2514.41

Fernande with a Black Mantilla, 1905–06. Oil on canvas, 39 ½ x 31 ½ inches. Thannhauser Collection, Bequest of Hilde Thannhauser. 91.3914

Picasso

Cubism, which developed in the crucial years from 1907 to 1914, is widely regarded as the most innovative and influential artistic style of the 20th century. A decisive moment in its development occurred during the summer of 1911, when Georges Braque and Pablo Picasso painted side by side in Céret, in the French Pyrenees, each artist producing paintings that are difficult—sometimes virtually impossible—to distinguish from those of the other.

Picasso's still life Carafe, Jug. and Fruit Bowl, painted two summers before,

"The goal I proposed myself in making cubism? To paint and nothing more. And to paint seeking a new expression, divested of useless realism, with a method linked only to my thought—without enslaving myself or associating

myself with objective reality."

defined planes but are not yet complexly fragmented; forms still retain an illusion of volume; and perspective, though dramatically shortened, is not obliterated. At its climax, Braque and Picasso brought Analytic Cubism almost to the point of complete abstraction. Among such works is Picasso's Accordionist, a baffling composition that one of its former owners mistook for a landscape because of the inscription "Céret" on the reverse. With diligence, one can distinguish the general outlines of the seated accordionist, denoted by a series of shifting vertically aligned triangular planes, semicircular shapes, and right angles; the centrally located folds of the accordion and its keys; and, in the lower portion of the canvas.

the volutes of an armchair. But Picasso's elusive references to recognizable forms and objects cannot always be precisely identified and, as the Museum of Modern Art's founding director Alfred H. Barr, Jr. observed, "the mysterious tension between painted image and 'reality' remains."

In Landscape at Céret, another canvas painted that summer, patches of muted earthy color, schematized stairways, and arched window configurations exist as visual clues that must be pieced together. For this painting, as with all Cubist works, the total image must be "thought" as much as "seen."

J.A.

Carafe, Jug, and Fruit Bowl, summer 1909. Oil on canvas, 28 1/4 x 25 3/4 inches. Gift, Solomon R. Guggenheim. 37.536

Landscape at Céret, summer 1911. Oil on canvas, 25 1/2 x 19 1/4 inches. Gift, Solomon R. Guggenheim. 37.538

Accordionist, Céret, summer 1911. Oil on canvas, 51½ x 35½ inches. Gift, Solomon R. Guggenheim. 37.537

Picasso

One year before Picasso painted the monumental still life Mandolin and Guitar, Cubism's demise was announced during a Dada soiree in Paris by an audience member who shouted that "Picasso [was] dead on the field of battle"; the evening ended in a riot, which could be quelled only by the arrival of the police. Picasso's subsequent series of nine vibrantly colored still lifes (1924–25), executed in a bold Synthetic Cubist style of overlapping and contiguous forms, discredited such a judgment and asserted the enduring value of the technique. But the artist was not simply resuscitating his previous discoveries in creating this new work; the rounded, organic shapes and saturated hues attest to his appreciation of contemporary developments in Surrealist painting, particularly as evinced in the work of André Masson and Joan Miró. The undulating lines, ornamental

"We all know that Art is not truth. Art is a lie that makes us realize truth, at least the truth that is given us to understand." patterns, and broad chromatic elements of *Mandolin and Guitar* foretell the emergence of a fully evolved sensual, biomorphic style in Picasso's art, which would soon celebrate the presence of his new mistress. Marie-Thérèse Walter.

When Picasso met Marie-Thérèse on January 11, 1927 in front of Galeries Lafayette in Paris, she was 17 years old. As he was married at the time and she only a teenager, they were compelled to conceal their intense love affair. While their illicit liaison was hidden from public view, its earliest years are documented, albeit covertly, in Picasso's work. Five still lifes painted during 1927—incorporating the monograms "MT" and "MTP" as part of their compositions—cryptically announce the entry of Marie-Thérèse into the artist's life. By 1931 explicit references to her fecund, supple body and blond tresses appear in harmonious, voluptuous images such as Woman with Yellow Hair. Marie-Thérèse became a constant theme; she was portrayed reading, gazing into a mirror, and, most often, sleeping, which for Picasso was the most intimate of depictions.

The abbreviated delineation of her profile—a continuous, arched line from forehead to nose—became Picasso's emblem for his subject, and appears in numerous sculptures, prints, and paintings of his mistress. Rendered in a sweeping, curvilinear style, this painting of graceful repose is not so much a portrait of Marie-Thérèse the person as it is Picasso's abstract, poetic homage to his young muse.

Woman with Yellow Hair,

December 1931. Oil on canvas, $39\% \times 31\%$ inches. Thannhauser Collection, Gift, Justin K. Thannhauser. 78.2514.59

Mandolin and Guitar, 1924. Oil with sand on canvas, 55 1/4 x 78 1/4 inches. 53.1358

Camille Pissarro b. 1830, Saint Thomas, West Indies; d. 1903, Paris

The view represented here is a winding village path at the base of a cluster of houses in Pontoise, France, known as the Hermitage. Camille Pissarro lived there on and off between 1866 and 1883, choosing the rural environs of the provincial capital for a series of large-scale landscapes that have been called his early masterpieces. Pissarro's idyll, replete with villagers and neatly tended gardens, is more than just the naturalist painter's attention to perceived reality. It is a continuation of the French academic landscape tradition, which stretched from the allegories of

Poussin to the proto-Cubist landscapes of Paul Cézanne, who studied and worked with Pissarro.

"[Pissarro] is neither a poet nor a philosopher but simply a naturalist. He paints the earth and the sky—that is what he has seen, and you may dream dreams about it if you like."

—Emile Zola

Pissarro stripped his painting of the historical or sentimental overtones that characterized the landscapes of his immediate predecessors. And he made magisterial use of light and dark, demonstrating more than a mere interest in the effects of sun and shade. As art theorist Charles Blanc wrote at the time, this type of articulation was meant "not simply to give relief to the forms, but to correspond to the sentiment that the painter wishes to express, conforming to the conventions of a moral beauty as much as to the laws of natural truth."

The painterly conventions that Pissarro utilized in *The Hermitage* were established by Gustave Courbet, Edouard Manet, and the Barbizon school, but the painting is also a product of its era. In the same year that Marx published *Das Kapital*, Pissarro elected to depict a class of people that many critics considered a vulgar choice for the subject of a painting. Pissarro's later socialist sympathies aside, his work avoided the confines of traditional academic painting, which was centered on scenes far removed from the real world he hoped to describe. *The Hermitage*, however realistic an arcadian scene it appears to be, belongs to Pissarro's seemingly unfulfilled quest for a truthful manner of depiction. Shortly afterward he abandoned this Realist style for a looser brush and the atmospheric effects for which he is popularly known, the trademarks of Impressionism.

C.L.

The Hermitage at Pontoise, ca. 1867. Oil on canvas, 59 1/4 x 79 inches. Thannhauser Collection, Gift, Justin K. Thannhauser. 78.2514.67

Michelangelo Pistoletto b. 1933, Biella, Piedmont, Italy

Before 1962, when the mirror replaced the canvas in Michelangelo Pistoletto's work, he painted searching self-portraits to express a sense of cultural desolation and personal isolation. Concurrently, Pistoletto attempted to tackle what was perceived in some postwar art circles as the bankruptcy of traditional pictorial form. "It was a moment of great tension and no solution," he explained. "I had to find a way out of this dramatic situation of an art that reflected the need to recapture some indication of how to continue." Increasingly, the artist varnished the backgrounds of these portraits, thus creating reflective surfaces, and the decision to employ actual mirrors followed. For the initial incarnation of the mirror pieces, he silkscreened photographic images of men and women on highly polished steel plates. The life-size and lifelike figures seem to be

"A mirror is a way between visible and un-visible, as it extends sight beyond its seemingly normal faculties."

observing a phantasmic world beyond the looking glass. As viewers, we encroach upon what seems to be their private space as our own reflections peer back from the picture. In actuality, it is the very space we occupy. The uneasy shift between reality and representation is startling. For Pistoletto, the introduction of the mirror provided a liberating aesthetic strategy that ventured far beyond the play between art and life, pursued to varying degrees by other members

play between art and life, pursued to varying degrees by other members of the Arte Povera group. While the depicted figures are frozen in time, the reflective surfaces are infused with potentiality and indeterminacy. This temporal element, captured in the concept of the fourth dimension, is fundamental to Pistoletto's art. So is an appreciation of the semantic distinction between the definitions of "reflection": the word denotes both the occurrence of a visual likeness and the act of mental contemplation. Within this term is located the congruity between seeing and thinking, a phenomenon at the core of Pistoletto's conceptual project.

By the mid-1970s the artist had extended his experiments to create split reflective surfaces that, in essence, mirror themselves in an endless repetition of their own forms. Pistoletto also fragmented the mirror, breaking the reflected image into pieces and thereby exposing the deceptive nature of mimetic representation. Broken Mirror, as part of the larger Division and Multiplication of the Mirror series, is an elegant and challenging example of the artist's meditation on the nature of reflection and representation.

Broken Mirror, 1978.
Mirror with gilded frame; two pieces, 64 1/4 x 53 1/4 x 3 1/4 inches and 23 1/4 x 23 1/4 inches. Gift of the artist. 90.3652.a.,b

Jackson Pollock b. 1912, Cody, Wyo.; d. 1956, The Springs, N.Y.

The critical debate that surrounded Abstract Expressionism during the late 1940s was embodied in the work of Jackson Pollock. Clement Greenberg, a leading critic and Pollock's champion, professed that each discrete art form should, above all else, aspire to a demonstration of its own intrinsic properties and not encroach on the domains of other art forms. A successful painting, he believed, affirmed its inherent two-dimensionality and aimed toward complete abstraction. At the same time, however, the critic Harold Rosenberg was extolling the subjective quality of art; fervent brushstrokes were construed as expressions of an artist's inner self, and the abstract canvas became a gestural theater of private

"When I am in my painting,
I'm not aware of what I'm
doing. It is only after a sort of
'getting acquainted' period
that I see what I have been
about. I have no fears about
making changes, destroying
the image, because the
painting has a life of its own."

passions. Pollock's art—from the early, Surrealist-inspired figurative canvases and those invoking "primitive" archetypes to the later labyrinthine webs of poured paint—elicited both readings. Pollock's reluctance to discuss his subject matter and his emphasis on the immediacy of the visual image contributed to shifting and, ultimately, dialectic views of his work.

In 1951, at the height of the artist's career, *Vogue* magazine published fashion photographs by Cecil Beaton of models posing in front of Pollock's drip paintings. Although this commercial recognition signaled public acceptance—and was symptomatic of mass culture's inevitable expropriation of the avant-garde—Pollock continuously

questioned the direction and reception of his art. His ambivalence about abstract painting, marked by a fear of being considered merely a "decorative" artist, was exacerbated, and it was around this time that he reintroduced to his paintings the quasi-figurative elements that he had abandoned when concentrating on the poured canvases. Ocean Greyness, one of Pollock's last great works, depicts several disembodied eyes hidden within the swirling colored fragments that materialize from the dense, scumbled gray ground. "When you are painting out of your unconscious," he claimed, "figures are bound to emerge." Manifest in this painting is a dynamic tension between representation and abstraction that, finally, constitutes the core of Pollock's multileveled oeuvre.

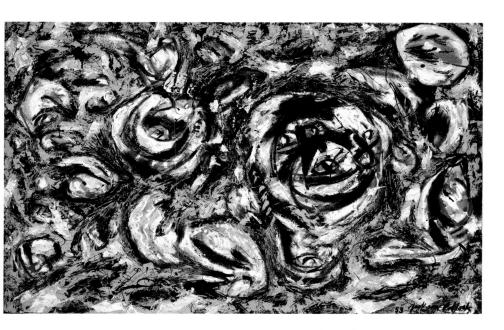

Ocean Greyness, 1953. Oil on canvas, 57 3⁄4 x 90 1⁄8 inches. 54.1408

Liubov Popova b. 1889, near Moscow; d. 1924, Moscow

The artists of the Russian avant-garde were distinguished from their Western counterparts in many ways, particularly in the extraordinary number of women in their ranks who were responsible for discovering new bases of artistic creation. Liubov Popova was among the most important of these early pioneers. Her development as an artist was encouraged through private lessons and frequent travel, which brought her into contact with a broad range of historical examples, from Italian Renaissance art and Russian medieval icons to Cubism and other Western vanguard styles. In 1912 she went to Paris with fellow painter Nadezhda Udaltsova to study painting at the Académie de la Palette under André Dunoyer de Segonzac, Henri Le Fauconnier, and Jean Metzinger. There she mastered the Cubist idiom and was probably exposed to Italian

Futurism, the two styles that would dominate her paintings of the next three and a half years.

"(FORM + COLOR + TEXTURE + RHYTHM + MATERIAL + ETC.) X IDEOLOGY (THE NEED TO ORGANIZE) = OUR ART."

After returning to Moscow in 1913, she quickly emerged as one of the primary exponents of Russian Cubo-Futurism, an amalgam of the faceted planarity of Cubism and the formal energy of Futurist art. *Birsk* was completed near the end of her involvement with this

style. Its crystalline structure is formally reminiscent of the views of houses in l'Estaque painted by Georges Braque and Pablo Picasso in 1908, but the vibrant palette attests to Popova's sustained interest in Russian folk and decorative art. *Birsk*, one of the few landscapes from this stage of Popova's career, was begun during a summer visit to the home of her former governess, who lived near the Ural Mountains in the small town of the painting's title.

The painting on the reverse of the same canvas, entitled *Portrait of a Woman*, shows Popova undertaking a subject that consistently occupied her during 1915: a figure situated in a Cubist-inspired composition. Although this work retains some representational elements, Popova's gradual move away from representation is evident in her forceful application of an abstract visual vocabulary. By the end of 1916 Popova was completely devoted to abstraction, joining Kazimir Malevich's Supremus group and creating paintings composed solely of dynamic geometric forms. These experiments in texture, rhythm, density, and color—which she called "painterly architectonics"—became the basis of her textile and theater designs of the 1920s. Like many of her Russian colleagues, Popova would ultimately renounce painting as obsolete and concern herself with the applied arts, which became synonymous with building a new society after the October Revolution.

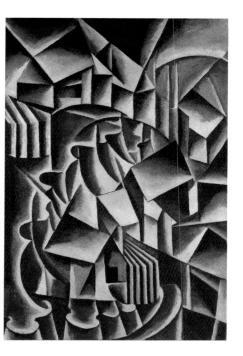

Birsk, 1916 (recto). Oil on canvas, 41 ¾ x 27 ⅓ inches. Gift, George Costakis. 81.2822.R

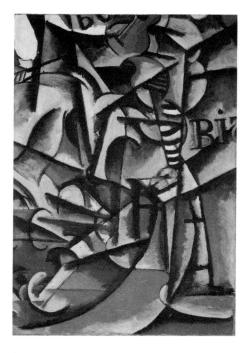

Portrait of a Woman (?), ca. 1915 (verso). Oil on canvas, 41½ x 28 inches. Gift, George Costakis. 81.2822.V

Martin Puryear b. 1941, Washington, D.C.

Martin Puryear raises, then resolves, contrary formal issues in the making of his abstract wooden sculptures, creating a dynamic equilibrium of antithetical forces. In works such as *Seer* he strives to balance the opposition of a volumetric, closed form with one that is open yet inaccessible. There is also a linear element to this sculpture: the wire is a kind of drawing in space, reminiscent of a Renaissance exercise in perspective, while the wooden circle on the floor outlines a base from which the wire chassis appears to have been extruded. Puryear's virtuoso ability to control wood stems from his knowledge of craft traditions. Though originally trained as a painter, in the mid-1960s the artist learned about indigenous carpentry in Africa and began to make wooden sculptures while in Sweden, where he observed Scandinavian woodworking techniques.

"The strongest work for me embodies contradiction, which allows for emotional tension and the ability to contain opposed ideas." The clarity of Puryear's forms, along with his interest in the physical response of the viewer to his objects, allies the artist to the Minimalist sculptors of the late 1960s. But the Minimalists' espousal of industrial materials and fabrication and their denial of metaphor were anathema to Puryear, who is committed to organic materials, handcraftsmanship, and poetic evocation through form. His work is akin to that of the Post-Minimalists, such as Eva Hesse, whose

more akin to that of the Post-Minimalists, such as Eva Hesse, whose constructions have organic connotations, even though they are often assembled from man-made elements.

The variety of sculptural methods and materials Puryear employs—he opposes bent wood with woven wire, for example, and integrates found objects into handmade structures—leads to myriad metaphorical interpretations. Seer evokes associations with architecture; the wire base of the object suggests both a yurt (the temporary home of nomadic Mongols) and the hull of a boat. It also incorporates the idea of a cage. Critics have noted intimations of violence and sexuality and a sense of frustrated energy in Puryear's work. Applying such a reading to Seer, one could interpret the lower section of the sculpture as a trap for invisible gases that are metaphorically funneled into the cone in a Duchampian play on sexual energy. The horn atop the cage might be seen as a portent of divinity, adding another layer of meaning. Looked at straight on, it reads as a spire, becoming a divining rod directed toward a celestial mark.

J.B.

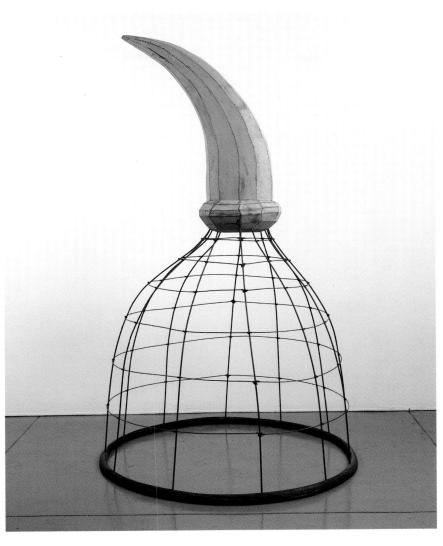

Seer, 1984.
Water-based paint on wood and wire, 78 x 52 1/4 x 45 inches. Purchased with funds contributed by the Louis and Bessie Adler Foundation, Inc., Seymour M. Klein, President. 85.3276

Robert Rauschenberg b. 1925, Port Arthur, Tex.

During the first five years of his career, Robert Rauschenberg engaged in formal approaches that have remained constant throughout his practice. These include building up and stripping away elements to create a compositional field and an intense focus on the quality of his materials. The latter is explored in some of the artist's earliest works, including his White Paintings series (1951), for which he applied house paint with a roller to achieve smooth, uninflected surfaces. These square and rectangular panels, presented singly or in multiple groupings, incorporated the surrounding environment by capturing the patterns and reflections of light and shadow, functioning, as John Cage observed, like a "clock of the room." These works continued in the monochromatic tradition of Kazimir Malevich's Suprematist Composition: White on White (ca. 1918) by reducing painting

"Painting relates to both art and life. Neither can be made. (I try to act in that gap between the two.)" to its essential qualities in order to represent pure experience. In his black paintings of 1951–53 Rauschenberg continued to work in a multipanel format and with a single color, but added texture to the surfaces by pasting layers of newspaper onto the canvas, alternately allowing the newsprint to show through or covering it completely with a shroud of black paint.

Rauschenberg's subsequent Red Paintings (1953–54) take the additive quality of the black canvases to further expressionistic ends. He commented on his color choice in an interview with art historian Barbara Rose many years later: "I was trying to move away from black and white. Black or white, not black-and-white. So I picked the most difficult color for me to work in." These complex surfaces, in which material including newsprint, comic strips, fabric, nails, and wood mingle with veils of red color, are further activated by the varied application of paint: drips, splatters, washes, heavy impasto, horizontal strokes, and pigment squeezed directly from the tube. Collage played a significant role in the creation of these works, including Untitled, which Rauschenberg partially framed with unembellished wooden blocks at the top and bottom edges. The fusion of the two-dimensional aspect of painting with the three-dimensionality of sculpture would be taken further in Rauschenberg's Combines, begun in 1954; indeed, Untitled and the other Red Paintings may be seen as a bridge to these seminal works, which would occupy Rauschenberg for the decade to follow.

J.Y.

Untitled (Red Painting), ca. 1953. Oil, fabric, and newspaper on canvas, with wood, 79 x 33 ½ inches. Gift, Walter K. Gutman. 63.1688

Rauschenberg

In 1962, Rauschenberg first used commercially produced silkscreens to make large-format paintings based on his own photographs and found media images. These silkscreens may be considered an extension of the transfer drawings he executed between 1958 and 1962, in which he directly transferred the contents of newspapers and magazines onto sheets of paper. Since he could photographically enlarge imagery on the silkscreens, this process freed him from the scale restrictions of the transfer technique and allowed him to easily reuse images in varied contexts, and as he wrote in a text within his print *Autobiography* (1968), "Began silk screen paintings to escape familiarity of objects and collage."

Barge, comprised of a single canvas measuring more than 30 feet in width, is the largest of the silkscreened paintings. This monumental work in black, white, and gray incorporates many of the motifs that Rauschenberg used again and again in his 79 silkscreen paintings: the urban environment, athletes, space exploration and flight, modes of transportation, and examples from art history. As was typical of his practice, Rauschenberg first explored this new medium in black and white; by summer 1963

he had introduced color. These paintings, including Untitled, best demonstrate the ways in which the artist exploited the imperfections of the silkscreen process, such as subverting a perfect registry by not aligning the screens or by not using all of the colors in the four-color process (blue, red, yellow, and black). The gestural application of color in certain areas and the addition of found articles (a technique reminiscent of his earlier Combines), like the metal and plastic objects in Untitled, assert their handmade nature. His works also include personal references. In Untitled Merce Cunningham, with whom Rauschenberg has collaborated on theater and costume design since 1954, is the central image. The use of recognizable popular imagery and the application of a commercial technique led critics to identify Rauschenberg with other artists working in this idiom, including Andy Warhol, who also began to use the silkscreen process in his work at this time.

Barge, 1963. Oil and silkscreened ink on canvas, 79 1/8 x 386 inches. Solomon R. Guggenheim Museum, New York and Guggenheim Bilbao Museoa, with additional funds contributed by Thomas H. Lee and Ann Tenenbaum; 'the International Director's Council and Executive Committee Members; and funds from additional donors: Ulla Dreyfus-Best; Norma and Joseph Saul Philanthropic Fund: Elizabeth Rea: Eli Broad: Dakis Joannou; Peter Norton; Peter Lawson-Johnston: Michael Wettach: Peter Littmann: Tiqui Atencio: Bruce and Janet Karatz: Giulia Ghirardi Pagliai, 97,4566

Untitled, 1963. Oil, silkscreened ink, metal, and plastic on canvas, 82 x 48 x 61% inches. Purchased with funds contributed by Elaine and Werner Dannheisser and The Dannheisser Foundation. 82.2912

J.Y.

Rauschenberg

The pursuit of new techniques has been a continuous theme of Rauschenberg's work. During a trip to Cuba in spring 1952, the artist first experimented with transfer drawings, taking printed images, primarily from newspapers and magazines, placing them face down on sheets of paper, and then rubbing the backs of the images with an empty ballpoint pen or other burnishing device to transfer the original to the paper. The technique, which Rauschenberg continues to use, has been described as imparting a veiled quality, which the artist heightens by applying paint, pencil, and crayon marks over the transferred images. *Yellow Body* exemplifies a technical development in which Rauschenberg applied a chemical solvent, such as lighter fluid, to the preprinted image, facilitating a clearer and more complete transfer.

Both *Untitled* (1952) and *Yellow Body* demonstrate Rauschenberg's concentrated interest in the popular media and his practice of juxtaposing myriad recognizable images. The iconography of these works, which also recalls that of his early silkscreen paintings, includes modes of transportation, astronauts, athletes, and fragments of comic strips. Often an autobiographical reference will be part of this varied mix. *Yellow Body* includes images of fellow Port Arthur, Texas native Janis Joplin (whom Rauschenberg met in 1968 at the New York nightclub Max's Kansas City) and Joplin's band, Big Brother and the Holding Company.

After his move to rustic Captiva Island off the Gulf Coast of Florida in 1970, Rauschenberg's focus shifted from urban and pop culture to an abstract idiom. He adopted unconventional materials, such as cardboard, paper bags, and silk, reflecting his consistently innovative approach to art making. By altering these materials only slightly, the artist emphasized their inherent colors and textures. Rauschenberg transferred newsprint to torn pieces of cheesecloth using an old Fuchs and Lang proofing press, which he had acquired shortly after his arrival in Captiva. The process not only transmitted visual texture but also a physical imprint, shaping the fabric into tail-like lengths to which the artist applied watercolor. For *Untitled* (1974), Rauschenberg then inserted the fabric between two sheets of paper, leaving the paper unadorned apart from the impression left by the form of the cheesecloth and his signature. The resulting "kite" is exhibited with only the paper pinned to the wall, allowing the fabric tails to catch the passing breeze.

J.Y.

Yellow Body, 1968.

Solvent transfer on paper with pencil, watercolor, gouache, and wash, 22 ½ x 30 inches. Gift of the artist in honor of the Robert Rauschenberg Foundation. 98.5219

Untitled, 1952.

Transfer on paper with gouache, watercolor, crayon, pencil, and cut paper, $10\,\%$ x $8\,\%$ inches. Gift of the artist in honor of the Robert Rauschenberg Foundation. 98.5222

Untitled, 1974.

Embossed paper, solvent transfer, and watercolor on cheesecloth, 50 ½ x 24 1/16 inches. Gift of the artist in honor of the Robert Rauschenberg Foundation. 98.5225

Ad Reinhardt b. 1913, Buffalo, N.Y.; d. 1967, New York City

Ad Reinhardt's writings on art read as a litany of negative aphorisms. Describing his signature black paintings, which he focused on exclusively from 1953 until his death in 1967, he wrote: "A free, unmanipulated, unmanipulatable, useless, unmarketable, irreducible, unphotographable, unreproducible, inexplicable icon." These canvases—muted black squares containing barely discernable cruciform shapes—challenge the limits of visibility. Reinhardt's strategy of denial echoed his conviction that Modernism itself was a "negative progression," that abstraction evolved as a series of subtractions, and he was creating the last or "ultimate paintings." Rather than forecasting the death of painting as a viable art form, however, Reinhardt was instead affirming painting's potential to transcend the contradictory rhetoric that surrounded it in contemporary

"The only way to say what abstract art or art-as-art is, is to say what it is not." criticism and the increasing commercial influences of the market. As art historian Yve-Alain Bois suggests in his study of the artist, what Reinhardt hoped to realize recalls the aspirations of Negation Theology, a method of thought—evident in Platonism, Neo-Plationism, and early Christianity—employed to comprehend the

Divine by indicating everything it was not. The artist's attraction to the mystical side of negation arose from his appreciation of Eastern art and religion, namely the abstract, all-over patterning of Islamic design, the poetically reductive space of Chinese and Japanese landscape painting, and the meditative, ascetic quality of Zen Buddhism. The last he encoun-tered through his friendship with the poet Thomas Merton, who was also a Trappist monk and authority on Zen. Reinhardt saw his own dark canvases, with their classic, geometric compositions, monastic repudiation of anything extraneous, and contemplative depth as a fusion of Eastern and Western traditions

However hermetic Reinhardt's black paintings may seem, they were not created in a vacuum. The kind of profound, self-reflexive abstraction he advocated was partially a product of, and reaction to, the climate of Cold War America. Despite the iconoclasm of his aesthetic discourse, Reinhardt was actively engaged in political and social issues throughout his life. During the early 1940s, his editorial cartoons appeared in the leftist newspapers *The New Masses* and *PM*. Later, he participated in the antiwar movement, protesting against America's involvement in Vietnam, and donated his work to benefits for civil rights activities. An aesthetic moralist, Reinhardt sought to create an art form that—in its monochromatic purity—could overcome the tyrannies of oppositional thinking.

N.S.

Abstract Painting, 1960–66. Oil on canvas, 60 x 60 inches. By exchange. 93.4239

Gerhard Richter b. 1932, Wlatersdorf-Oberlausitz, Germany

In 1963, prompted by the proliferation of media-generated imagery that saturated the contemporary landscape, Gerhard Richter and fellow artists Konrad Lueg (a.k.a. Konrad Fischer) and Sigmar Polke founded Capitalist Realism as a critique of consumer culture. Throughout the 1960s and

"The photograph is the most perfect picture. It does not change; it is absolute, and therefore autonomous, unconditional, devoid of style. Both in its way of informing, and in what it informs of, it is my source."

1970s, Richter continued to use media images as the basis for his exploration of the relationship between painting and photography. Working in a highly eclectic and seemingly incompatible range of approaches, from figuration and landscapes to gestural abstractions and monochromes, and refusing a signature style, the artist has evaded the normative discourse of art history.

Richter has stated, "I am suspicious regarding the image of reality which our senses convey to us and which is incomplete and limited," and his insistence on the illusionistic nature of painting has given way

to a painterly practice that underscores the mediated experience of reality by creating paintings based on found and familiar photographs. *Atlas*, a vast compilation of such imagery begun in 1962 and expanded over the years, is testimony to the importance of the photographic within Richter's oeuvre. Photographs, from the artist's perspective, provide a pretext for

a painting, injecting a measure of objectivity and eliminating the processes of apprehension and interpretation. While not based on a specific photographic source, the mirrorlike forms of *Passage* exemplify a lack of emotive presence in their muted grey and white palette and formal austerity that is in keeping with the artist's efforts to demystify the traditions of high culture.

In 1976, Richter's "pictures"—so-called by the artist in order to avoid an emphasis on the painterly—made a decisive move toward abstraction in a series of richly polychromed canvases. Given his conviction that "pure painting is ridiculous anyway," Richter turned again to photography as a means to mediate the highly subjective bent of abstract painting, executing small sketches that he photographed and then translated into large-scale canvases. More recently, he has continued in this style, while dispensing with the photographic intermediary. The highly gestured surfaces of works such as *Korn* can thus be best understood not as expressive paintings in the shadow of Abstract Expressionism, but as part of an ongoing project to contest the venerated tropes of authenticity and subjectivity.

Passage, 1968.

Oil on canvas, 78 3/4 x 78 3/4 inches. Gift, The Theodoron Foundation.

Korn, 1982.

Oil on canvas, $98\frac{1}{4} \times 78\frac{3}{4}$ inches. Gift of the artist. 84.3195

J.F.R.

Faith Ringgold b. 1930, New York City

During the late 1960s and the 1970s Faith Ringgold played an instrumental role in the organization of protests and actions against museums that had neglected the work of women and people of color. Her paintings from this period are overtly political, and present an angry, critical reappraisal of the American dream glimpsed through the filter of race and gender relations. Ringgold's more recent aesthetic strategy, however, is not one of political agitation or blatant visual provocation. Instead, she has come to embrace the potential for social change by undermining racial and gender stereotypes through impassioned and optimistic presentations of black female heroines.

"After I decided to be an artist, the first thing that I had to believe was that I, a black woman, could penetrate the art scene and that I could do so without sacrificing one iota of my blackness, or my femaleness, or my humanity."

Ringgold's vehicle is the story quilt—a traditional American craft associated with women's communal work that also has roots in African culture. She originally collaborated on the quilt motif with her mother, a dressmaker and fashion designer in Harlem. That Ringgold's great-great-great-grandmother was a Southern slave who made quilts for plantation owners suggests a further, perhaps deeper, connection between her art and her family history. One of Ringgold's early efforts, dating from 1982, tells the tale of the stereotyped Aunt Jemima through painted images, sewn fabric, and handwritten texts. The naive, folk-art quality of the quilts is part of Ringgold's scheme to emphasize narrative over style, to convey information rather than to dazzle with elaborate technique.

Tar Beach, the first quilt in Ringgold's colorful and lighthearted series entitled Women on a Bridge, depicts the fantasies of its spirited heroine and narrator Cassie Louise Lightfoot, who, on a summer night in Harlem, flies over the George Washington Bridge. "Sleeping on Tar Beach was magical . . ." explains Cassie in the text on the quilt, "only eight years old and in the third grade and I can fly. That means I am free to go wherever I want to for the rest of my life." For Ringgold, this phantasmic flight through the urban night sky symbolizes the potential for freedom and self-possession. "My women," proclaimed Ringgold about the Women on a Bridge series, "are actually flying; they are just free, totally. They take their liberation by confronting this huge masculine icon—the bridge."

N.S.

Tar Beach (Part I from the Woman on a Bridge series), 1988.

Acrylic on canvas bordered with printed, painted, quilted, and pieced cloth, 74 1/1 (8 ½ inches. Gift, Mr. and Mrs. Gus and Judith Lieber. 88.3620

Mark Rothko b. 1903, Dvinsk, Russia; d. 1970, New York City

With paintings such as *Untitled (Violet, Black, Orange, Yellow on White and Red)*, Mark Rothko arrived at his mature idiom. For the next 20 years he would explore the expressive potential of stacked rectangular fields of luminous colors. Like other New York School artists, Rothko used abstract means to express universal human emotions, earnestly striving to create an art of awe-inspiring intensity for a secular world.

In order to explain the power of his canvases, some art historians have cited their compositional similarity to Romantic landscape painting and Christian altar decoration. Anna Chave suggests that Rothko's early

"The fact that lots of people break down and cry when confronted with my pictures shows that I communicate with those basic human emotions. The people who weep before my pictures are having the same religious experience I had when I painted them."

interest in religious iconography underlies his later work. She sees a reference to a Madonna and Child in *Untitled (#17)*, an apparently abstract work that developed out of the Surrealistic biological fantasies that he had been painting in the early 1940s. For Chave, mature paintings such as *Untitled (Violet, Black, Orange, Yellow on White and Red)* metaphorically encompass the cycle of life from cradle to grave, in part by harboring an oblique reference to both adorations and entombments. The stacked rectangles may be read vertically as an abstracted Virgin bisected by horizontal divisions that indicate the supine Christ. Even without Chave's argument, it is clear that Rothko hoped to harness the grandeur of religious painting. The principles of frontality and iconic imagery in his

mature works are common to traditional altarpieces, and both formats have similar dimensions and proportions. Often larger than a human being, Rothko's canvases inspire the kind of wonder and reverence traditionally associated with monumental religious or landscape painting.

It was Rothko's euphoric veils of diaphanous pure color that led critics to praise him as a sensualist and a colorist, which pained him because he believed that his champions had lost sight of his serious intentions. For him the canvases enacted a violent battle of opposites—vertical versus horizontal, hot color versus cold—invoking the existential conflicts of modernity. The Black Paintings, begun in the year before the artist's suicide, confirm Rothko's belief that his work encompassed tragedy. The desolation of canvases such as Untitled (Black on Grey), drained of color and choked by a white border—rather than suggesting the free-floating forms or veiled layers of his earlier work—indicate that, as Rothko asserted, his paintings are about death.

J.B.

Untitled (Violet, Black, Orange, Yellow on White and Red). 1949. Oil on canvas, 81 ½ x 66 inches. Gift, Elaine and Werner Dannheisser and The Dannheisser Foundation. 78.2461

Untitled (# 17), 1947.
Oil on canvas, 47 ³/₄ x 35 ¹/₂ inches.
Gift, The Mark Rothko Foundation, Inc.
86.3420

Untitled (Black on Grey), 1969/1970. Acrylic on canvas, 80 ¼ x 69 ¼ inches. Gift, The Mark Rothko Foundation, Inc. 86.3422

Henri Rousseau b. 1844, Laval, France: d. 1910, Paris

Henri Rousseau endured the art-historical misfortune of being a working-class late bloomer—he was a Sunday painter who only began to paint seriously in his 40s—with what seemed to his critics little natural talent. His unsentimental, haunting images nonetheless drew the attention of a literary and artistic coterie hungry for fresh recruits. How did Rousseau, whose style still commands belittling adjectives such as "naive" and "simple," escape relegation to the margins of art history? It was, as the writer André Malraux has pointed out, the former toll clerk's friendship with a legion of well-established masters that has by and large guaranteed his place in the history of Modern art. During his lifetime Rousseau became something of a sensation within the relatively small Parisian art scene. His astonishing works were celebrated by Guillaume Apollinaire,

"We are the two greatest painters of the epoch." —Henri Rousseau to Pablo Picasso Alfred Jarry, and Pablo Picasso, and he came to be considered a major force by artists such as Max Beckmann, Vasily Kandinsky, and Fernand Léger only a few years after his pauper's death.

To the extent that he had limited official success while he lived,
Rousseau can be said to have invented himself—he barged uninvited into exhibitions and dinner parties alike, assuming the posture of an honored guest—just as he invented images unlike anything around him.
Canvases such as Artillerymen and The Football Players have been interpreted as Rousseau's quirky attempts to depict modern times, whether with a dapper military company as in the former example, or with the four natty enthusiasts of a new sport, rugby, in the latter. It is to his credit that we still have no adequate words to describe a painting in which rugby players look like pajama-clad twins, or one in which 14 identical handlebar mustaches succeed in delivering a spirited image of an artillery battery.

C.L.

Artillerymen, ca. 1893–95. Oil on canvas, 31 1/6 x 39 inches. Gift, Solomon R. Guggenheim. 38.711

The Football Players, 1908.
Oil on canvas, 39 ½ x 31 5% inches.
60.1583

Robert Ryman b. 1930, Nashville, Tenn.

Throughout his career, Robert Ryman has attempted to eliminate illusionism and outside references from his work, focusing instead on the fundamental properties of the materials he employs. He has confined himself to the color white, yet disclaims its importance. "It was never my intention to make white paintings," he insisted in a 1986 interview with critic Nancy Grimes. "And it still isn't. . . . The white is just a means of exposing other elements of the painting." These "other elements" include varieties of paint (oil and acrylic) and supports (canvas, paper, and metals).

"White enables other things to become visible." as well as the process of binding them. He investigates the properties of these elements methodically, yet responds spontaneously to the unpredictable exigencies caused by their interaction.

Ryman's *Classico 4* is one of a series of compositions consisting of multipanel paintings on a specific type of paper called Classico. For each work in the series, Ryman attached a configuration of heavy, creamy white sheets of the paper to a wall with masking tape, painted the sheets with a shiny white acrylic paint, removed the tape when the sheets were dry, mounted them on foamcore, and reattached them to the wall. The built-up paint edge tracing the outline of masking tape and the ripped paper left

behind give witness to the process of creation. The various works in the *Classico* series differ in the organization of paper sheets, the configuration of tape traces, and the painted shape, yet they share an emphasis on the thinness of the support surface in its alignment with the wall and the monumentality conceived as an accumulation of parts.

Just as the Classico works were titled after the type of paper used as a medium, the so-called Surface Veil works were named for the brand of fiberglass upon which the smaller pieces in this group were painted. Surface Veil I, II, and III are among four 12-foot square paintings from the series that were executed not on fiberglass but on cotton or linen. In each of these works the pigment appears to form a membrane over the support due to the differing degrees of opacity and translucence in the white paint juxtaposed with areas where less of it has been applied, leaving the fabric exposed. These disruptions in the painting's skin often mark the literal pauses between the artist's working sessions.

Classico IV. 1968.

Acrylic on handmade Classico paper, mounted on foamcore; overall dimensions variable, approximately 91 x 89½ inches. Panza Collection. 91.3845.a-.l

Surface Veil I. 1970.

Oil and blue chalk on linen, 143 15/16 x 144 inches. Panza Collection. 91.3851

Surface Veil II, 1971.

Oil and blue chalk on linen, 144 x 144 inches. Panza Collection. 91.3854

Surface Veil III, 1971.

Oil and blue chalk on canvas, $144\frac{1}{4}$ x $144\frac{1}{4}$ inches. Panza Collection. 91.3855

David Salle b. 1952, Norman, Okla.

When David Salle emerged on the art scene in the early 1980s, his often oblique work was set squarely within the critical definition of postmodernism by virtue of its art-historical references and ambiguous combinations of original and appropriated imagery from both high and low traditions. Subverting the recognizable and allowing the familiar to become strange through odd juxtapositions, details, and illogical compositions, Salle's pictures leave the viewer to develop meaning out of layered images and surrealistic disjunctions. His repertoire has included erotically charged representations of nude women borrowed from pornographic magazines, quotations from Théodore Géricault's paintings of corpses, and actual pieces of furniture affixed to the canvas.

"What I like, if I like anything about a picture that I do, is the overall feeling of extreme cancellation." The left half of the diptych *Comedy* is executed in grisaille, a technique that has been historically used to render figures. In the right panel, a domestic scene derived from a 1950s advertisement for a bedroom set is turned on its side and, as in much of the artist's early work, layered with additional painted imagery: a black-and-white fashion photograph in which the female figure is, disconcertingly,

a headless mannequin; a garland of butterflies surrounding the "photo"; a ruffled harlequin collar of translucent cloth. The appearance of the harlequin costume in Salle's paintings of the early 1990s alludes to his own involvement with cinema and the performing arts, in particular, his collaborations with choreographer Karole Armitage.

Salle also created a pendent for the diptych entitled *Tragedy* (1995) with the same four grisaille figures in a similar arrangement but with different expressions and gestures; for example, the man who grins in an exaggerated fashion in *Comedy* likewise frowns in *Tragedy*. The paired titles may similarly refer to Salle's set and costume designs for theater and dance, as well as his venture into directing in the film *Search and Destroy* (1995). A cinematic influence can also be detected in Salle's juxtapositions of vignettes that evoke filmic montage in which visual elements are arranged to produce meaning not otherwise present in the individual images.

J.Y.

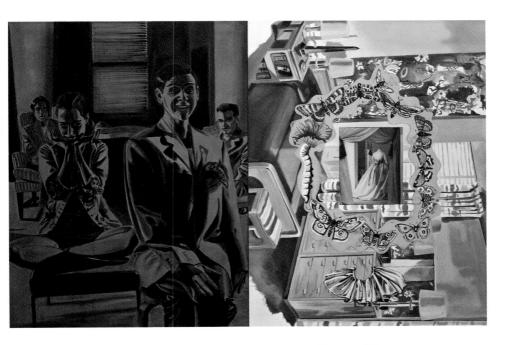

Comedy, 1995.

Oil and acrylic on canvas; two panels, 96 1/4 x 144 1/10 inches overall. Purchased with funds contributed by the International Director's Council, Mr. and Mrs. Edward V. Shufro, The Eli Broad Family Foundation, and Rachel Lehman. 96,4505.a.,b

Scale

Just as the scale of a road map reduces vast stretches of highway to scant cartographic lines, the perceptual scale established within a conventional easel painting can create hugely populated landscapes that disappear into the infinite reaches of the mind's eye. The beguiling effects of a finely painted miniature rely on the ability to maximize the scalar differential, etching great spaces and extraordinary physical presences on jewel-like surfaces no larger than the palm of one's hand.

If scale is the proportional arbiter of worlds of differing measure, it is also a sign of difference itself, calibrating the degree of dimensional discontinuity between those worlds. Many artists of the past century have

James Turrell, Roden Crater (survey frame 5752).

focused their attention on just such discontinuities, striving to eliminate, or bring into question, the perceptual veil that allows us to speak of a separate "world" of art. The highly polished paint surface associated with the great 19th-century fine-arts academies, in which the physical presence of pigment all but vanishes under a seamless film of representational illusion, gave way to rougher brushwork that proclaimed and celebrated the literal depths of paint on canvas. Likewise, art that directly examined the idea of scale as a proportional intermediary began to appear early in this century. The scale of Marcel Duchamp's readymade snow shovel is 1:1 by definition, an incursion into the dimensional space of the viewer, emphasized by the deliberate lack of a pedestal.

With the mural-size paintings of the Abstract Expressionists and the rigorous geometries of Minimalist sculpture, the viewer is subsumed into the spatial coordinates of the artwork itself. Scale becomes less a matter of proportional relationship than of sheer size and physical concordance with one's own bodily presence. Indeed, in the past four decades, scale—as a critical element in the confrontation of art with the viewer's body, the earth, and beyond—has become subject matter itself. As artists such as Joseph Beuys, Christo, Walter De Maria, Robert Morris, and James Turrell have extended the scope of art to encompass entire streets, cities, deserts, and distant stars, the proportional, ecological, and perceptual relationship of the viewer to the work of art—and through art to the world—rises to the most challenging scale imaginable.

JOSEPH THOMPSON

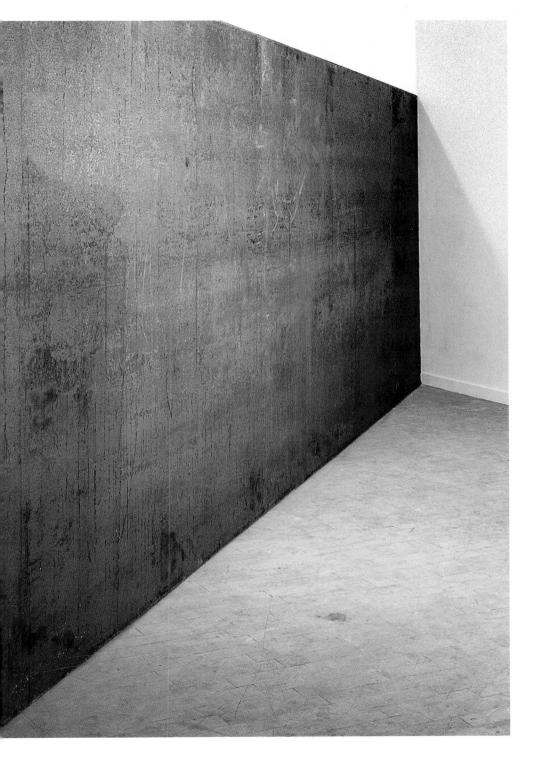

Richard Serra, Strike: To Roberta and Rudy, 1969–71 (detail).

Egon Schiele b. 1890, Tulln, Austria; d. 1918, Vienna

The subject of Egon Schiele's portrait is Johann Harms, his father-in-law. The painting demonstrates Schiele's sympathy for the 73-year-old man, a retired machinist with the Austrian railway. Although a family portrait, it conveys a somber monumentality. With a stateliness that transcends its subject, the painting is reminiscent of papal portraits by Raphael or Titian. The work is known as the first in a series of "painterly portraits," as opposed to earlier canvases that Schiele executed in a more graphic style.

Schiele designed the chair in the painting for his studio and used it several times for portraits. As a prop, it allowed the artist to push his subjects toward the picture plane, flattening and enlarging the contours of their bodies. The chair also recalls the furniture in Vincent van Gogh's paintings of his own bedroom; its handcrafted style reminds us of the importance of the decorative arts in Vienna at this time.

Schiele painted the portrait two years before his death from influenza. It is an example of his mature style and goes far in abolishing fixed notions of Austrian Expressionism as only an art of angst. It also demonstrates that Schiele could successfully depart from his well-known fascination with the physical and psychic dimensions of sexuality. In 1916, after initial difficulties in his marriage to Edith Harms, Schiele was beginning to enjoy a sense of domestic happiness that would lead to other intimate family portraits. Schiele's fondness for Johann Harms carried beyond this portrait—after the old man's death in 1917, Schiele made a death mask of his father-in-law.

C.L.

Portrait of Johann Harms, 1916. Oil with wax on canvas, 54 1/4 x 42 1/2 inches. Partial gift, Dr. and Mrs. Otto Kallir. 69.1884

Kurt Schwitters b. 1887, Hannover, Prussia; d. 1948, Kendal, England

An artist, poet, and typographer, Kurt Schwitters invented his own unique aesthetic style, which he dubbed Merz in 1919. Premised on the practice of assemblage—the union of sundry quotidian items with formal artistic elements—Merz exemplified Schwitters's quest for "freedom from all fetters," cultural, political, or social. The artist's collages, of which he produced more than 2,000, and his large-scale reliefs known as Merzbilder are kaleidoscopic, sometimes whimsical accretions of humble found material—tram tickets, ration coupons, postage stamps, beer labels, candy wrappers, newspaper clippings, fabric swatches, rusty nails, and the like—that bespeak the flux of contemporary society. In his early collages, such as Merz 163, with Woman Sweating and Merz 199, Schwitters subjected

"Every artist must be allowed to mold a picture out of nothing but blotting paper, for example, provided he is capable of molding a picture." his bits of flotsam to an organizing principle resembling the vertical scaffolding of Analytic Cubism, thus transforming the diverse components into formal elements. Embedded in each collage, however, are hints of narrative.

Merzbild 5B (Picture-Red-Heart-Church) contains many such abbreviated clues, which suggest that Schwitters was not the neutral, disengaged artist described by some historians. The graphic motifs—a red heart, a simple church, and the number "69"—can all be found in Schwitters's Dadaesque line drawings dating from the same year, which contain elements that are possibly autobiographical. Their reappearance in this collaged construction suggests the artist's dedication

year, which contain elements that are possibly autobiographical. Their reappearance in this collaged construction suggests the artist's dedication to his subject matter. The work also harbors specifically political intimations: it includes the partially concealed front page of the German newspaper Hannoverischer Kurier dated February 4, 1919 and describing the overthrow of the short-lived socialist republic of Bremen in a bloody insurrection led by conservative forces. Although Schwitters was not directly involved in this conflict, his acquaintance Ludwig Bäumer, of whom he created a Merz portrait in 1920, was a leading advocate of proletarian liberation. Bäumer's politicized, utopian aspirations were analogous, in a sense, to Schwitters's optimistic embrace of Merz as an aesthetic metaphor for free will. The artist even applied his strategy of accumulation to his own home, creating the fantastic, multicomponent, fully sculptural Merzbau in the interior of his house.

N.S.

Merzbild 5B (Picture-Red-Heart-Church). April 26, 1919. Collage, tempera, and crayon on cardboard, 32 1/4 x 23 1/4 inches. 52.1325

Merz 199, 1921.
Papers, fabrics, and paint on newspaper.
7 1/16 x 5 11/16 inches. Gift, Katherine S.
Dreier Estate. 53.1350

Merz 163, with Woman Sweating. 1920. Tempera, pencil, paper, and fabric collage mounted on paper, 61% x 41% inches. Gift, Katherine S. Dreier Estate. 53.1348

Richard Serra b. 1939, San Francisco

Richard Serra created *Belts*—tangled clusters of vulcanized rubber strips illuminated by an erratic curl of neon tubing—shortly after returning from a year of study in Italy, where he undoubtedly witnessed the very beginnings of Arte Povera. Like the artists who would come to be associated with that movement, Serra employed nontraditional materials in his

"In all my work the construction process is revealed. Material, formal, contextual decisions are self-evident." sculpture, in this case belts suspended from hooks on the wall. The piece's anthropomorphic quality—the belts suggest limp figures or twisted harnesses—indicates that Serra was also familiar with contemporaneous sculptural reflections on the human body made by Eva Hesse and Bruce Nauman. Serra's style would change radically in the ensuing years, but his sensitivity to the body, its capacity for action, and its crucial role in perception has remained a constant in the work.

Serra envisions sculpture as the physical manifestation of transitive verbs. In 1967 and 1968 he compiled a list of infinitives that served as catalysts for subsequent work: "to hurl" suggested the hurling of molten lead into crevices between wall and floor; "to roll" led to the rolling of the material into dense, metal logs. While the process of fabricating these pieces was, in essence, their very subject, Serra eventually deemed them too

picturesque and he shifted strategies once again. Continuing his employment of lead, Serra utilized another transitive verb: "to prop." Right Angle Prop is one of numerous lead constructions, the assemblage of which is dependent on leaning elements. Dispensing with carving and welding—conventional methods of delineating volume and securing mass—Serra created precarious sculptures that stand by virtue of equilibrium and gravity. Such pieces exist in a constant state of tension, ever revealing the process of their making, ever threatening to tilt off balance. Following the perilous choreography of propping, Serra engaged the verb "to cut" in a series of large-scale steel sculptures, variations of which he is still producing. Strike is essentially one tall, thin steel slice that, wedged into a corner, bisects the room and demands viewing from both sides. As one walks around the front of the piece, perception continually shifts: plane gives way to edge to plane again. This cut-steel sculpture is itself an implement for cutting space and, in this way, serves as an analogue for the sculptor himself, who stimulates vision by giving material form to the transitive verb.

Belts, 1966–67. Vulcanized rubber and neon, 84 x

288 x 20 inches. Panza Collection, 1991. 91.3863

Right Angle Prop, 1969.

Lead antimony, $72 \times 72 \times 34$ inches. Purchased with funds contributed by The Theodoron Foundation, 69.1906

Strike: To Roberta and Rudy, 1969-71.

Hot-rolled steel, $96 \times 288 \times 1$ inches. Panza Collection. 91.3871

Georges Seurat b. 1859, Paris; d. 1891, Paris

No understanding of Georges Seurat's development would be complete without consideration of the 85 oil studies he produced in the formative years prior to his first large painting, *Bathers* (1883–84). Agrarian workers and peasants are among the most consistent subjects of these early works, which reflect the important influence of Jean-François Millet, the Barbizon school painter of rural life. *Farm Women at Work* and *Peasant with Hoe* recall Millet's familiar iconographical theme of gleaners in the fields, while *Seated Woman* echoes on a small scale Millet's sense of monumentality.

Unlike Millet, who ventured deep into the countryside. Seurat found his subjects in the suburbs of Paris, which in the 1880s were zones marked by the clash of industrialization and displaced rural life. We may speculate that there is a subtle meaning in these depictions of suburban peasants who have lost their identity to modernization; yet there is also an undeniable reverie in Farm Women at Work and Peasant with Hoe. Both studies are characterized by the penetrating quality of a moment frozen in time in which the bounty of the harvest, the dignity of labor, and close communion with nature are unified. Seurat achieved his synthesis through innovative coloristic and painterly techniques. Working directly in the field, he followed the Impressionists' practice of painting outdoors to capture the fugitive effects of light; he also studied contemporaneous developments in physics, optics, and color theory assiduously. In accordance with scientific thinking, he applied pure hues rather than premixed pigments to the canvas and employed the technique of "optical mixing," in which complementary colors "vibrate" when placed in correspondence with one another. At this time. Seurat made his painting surface highly active through the use of short, crosshatched brushstrokes; he subsequently distilled these brushstrokes into tiny dots, a method now known as Pointillism

J.A.

Farm Women at Work, 1882–83. Oil on canvas, 15 1/8 x 18 1/4 inches. Gift, Solomon R. Guggenheim. 41.713

Peasant with Hoe, 1882. Oil on canvas, 1814 x 221/6 inches. Gift, Solomon R. Guggenheim. 41.716

Seated Woman, 1883. Oil on canvas, 15 x 18 ⅓ inches. Gift, Solomon R. Guggenheim. 37.714

Gino Severini b. 1883, Cortona, Italy; d. 1966, Paris

After moving from Rome to Paris in 1906, Gino Severini came into close contact with Georges Braque, Pablo Picasso, and the other leading artists of the avant-garde capital, while staying in touch with his compatriots who remained in Italy. In 1910 he signed the "Futurist Painting: Technical Manifesto" with four other Italian artists, Giacomo Balla, Umberto Boccioni, Carlo Carrà, and Luigi Russolo, who wanted their paintings to express the energy and speed of modern life.

In this painting of a train moving through the countryside, Severini split the landscape in order to impart a sense of the momentary fractured images that characterize our perception of a speeding object. The clash of intense contrasting colors suggests the noise and power of the train, which the Futurists admired as an emblem of vitality and potency.

"All subjects previously used must be swept aside in order to express our whirling life of steel, of pride, of fever and of speed." Severini's paintings—like Futurist work in general—are informed by the legacy of Cubism, building on the Cubists' deconstruction of the motif, their collage technique, and their incorporation of graphic signs. But the Futurists' interest in depicting motion, use of bright expressive color, and politically inspired dedication to bridging the gap between art and life departed decisively from Cubist aesthetic

practice, which focused on the rarefied world of the studio, investigating formal issues through often-somber portraits and still lifes.

Severini painted this canvas in the midst of World War I while living in Igny, outside Paris. Years later he recalled the circumstances: "Next to our hovel, trains were passing day and night, full of war *matériel*, or soldiers, and wounded." During 1915 he created many canvases in which he attempted to evoke war in paint, culminating in his January 1916 First Futurist Exhibition of Plastic Art of the War. This exhibition, held in Paris, included Red Cross Train Passing a Village.

J.B.

Red Cross Train Passing a Village. summer 1915. Oil on canvas, 35 x 45 1/4 inches. 44.944

Cindy Sherman b. 1954, Glen Ridge, N.J.

Cindy Sherman's *Untitled Film Stills* (1977–80) have been canonized as a hallmark of postmodernist art, which frequently utilized mass-media codes and techniques of representation in order to comment on contemporary society. In this series of 69 black-and-white photographs, Sherman posed herself in various melodramatic guises that recall the stereotypical feminine characters presented in 8 x 10 publicity stills for B-grade movies from the 1950s and 1960s. The personae she created range from ingenue lost in the big city to martini-wielding party girl to jilted lover to hausfrau. *Untitled Film Still*, #15 depicts the tough girl with a heart of gold. Contrary to the media images they appropriate, which may require a transparent sense of realism to sell an illusion, Sherman's stills have an artifice that is heightened by the often visible camera cord, slightly eccentric props, unusual camera angles, and by the fact that each image includes the artist, rather than a recognizable actress or model.

"Through a photograph you can make people believe anything." In the early 1980s Sherman continued to explore stereotypes of femininity and female representation found in popular culture, such as the centerfold format of pornographic magazines. She also began to use color in her work; her painterly sensibility is apparent in

Untitled, #112 and subsequent photographs. Untitled, #112 is also one of the first images in which the artist portrays a more masculine identity. This gender ambiguity, along with the way the unusually lit figure emerges from the black background, yields an unsettling sensation. These effects become ominous and even frightening in later works in which Sherman portrays more disheveled and malign characters.

Untitled, #167 is from Sherman's Disasters series, which directly investigates grotesque and disgusting subject matter. The sense of foreboding elicited by earlier works is more overt, suggesting the terror of horror films (a genre that significantly focuses on female victims). Untitled, #167 depicts the scene of a gruesome crime. Emerging from the dirt are the nose, lips, and red-painted fingertips of a blonde, apparently female, victim. A discarded Polaroid photographic sheath suggests documentation (either by a police officer or perhaps the villain, whose reflection appears in an open makeup compact), and obliquely implicates the artist as photographic voyeur. The very darkness of the image and the reflectiveness of the photograph's surface make it difficult for the viewer to scrutinize the scene. Untitled, #167 foreshadows Sherman's use of prosthetic body parts in her later works, as well as the gradual elimination of her own likeness.

J.B.

Untitled Film Still, #15, 1978.
Gelatin-silver print, 9 1/6 x 7 1/16 inches.
Edition 2/10. Purchased with funds contributed by the International Director's Council and Executive Committee
Members. 97.4573

Untitled, #167, 1986. Color photograph, 60 x 90 inches. Edition 5/6. Purchased with funds contributed by the International Director's Council and Executive Committee Members. 97.4575

Untitled, #112, 1982.
Color photograph, 45 ½ x 30 inches.
Artist's proof 1/2. Purchased with funds contributed by the International Director's Council and Executive Committee
Members. 97.4574

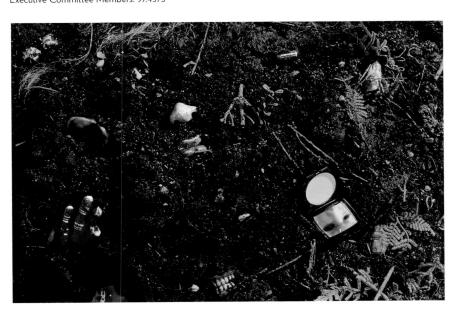

David Smith b. 1906, Decatur, Ind.; d. 1965, near Bennington, Vt.

David Smith was foremost among the welder-sculptors who came to prominence in the U.S. after World War II. Following the example set by Julio González and Pablo Picasso, who created welded-steel sculptures as early as 1928, the Americans constructed their work directly out of iron and steel sheets and wires rather than employing the traditional method of casting. In the 1930s and 1940s, influenced by Surrealism and Constructivism, Smith created hybrid figural sculptures and dramatic miseen-scènes. During the 1950s he began to work in stylistic series ranging from the complicated abstract drawings-in-space of the *Agricolas* to the anthropomorphic and totemic sculptures incorporating machine parts such as the *Sentinels* and *Tank Totems*. In the later part of the decade and into the 1960s his work became more volumetric and monolithic.

"My sculpture is part of my world. It's part of my everyday living; it reflects my studio, my house, my trees, the nature of the world I live in." Smith completed 28 works in his last series of monumental abstract structures, the *Cubis*, before his death in May 1965. These celebrated sculptures were composed from a repertoire of geometric cubes and cylinders of varying proportions. All of the *Cubis* are made of stainless steel, which Smith burnished to a highly reflective surface. He told critic Thomas Hess, "I made them and I polished them in such a way that on a dull day they take on a dull blue, or the

color of the sky in the late afternoon sun, the glow, golden like the rays, the colors of nature."

Some of the *Cubis* are vaguely figural, while others, such as *Cubi XXVII*, suggest architecture. This example is one of three *Cubis* usually referred to as "Gates" (although Smith called them "arches"), which rise like giant rudimentary doorways framing a central void. By counterbalancing a cylinder that appears to rest precariously on edge with two small tilted blocks that look equally unstable, Smith emphasized the potential energy captured through the welding technique. The artist activated the surface of the structure through the curling traces left by the polishing process, creating, in his words, "a structure that can face the sun and hold its own against the blaze and the power."

J.B.

Cubi XXVII, March 1965. Stainless steel, 111 3/4 x 87 3/4 x 34 inches. By exchange. 67.1862

Kiki Smith b. 1954, Nuremberg, Germany

The oft-proclaimed "return to the body" in artistic practice and critical discourse in the late 1980s was partly a response to the high rationality of Minimalism and Conceptual art, in which references to the human form were at most oblique, as well as to the theoretical feminist prohibition of representations of the female body, which was deigned hopelessly subject to patriarchal desire. The work of contemporary artists such as Robert Gober, Charles Ray, Cindy Sherman, and Kiki Smith concentrates on the body, fragmented and whole, depicted relatively realistically yet always suggestively altered. These artists are concerned with the connections and disruptions between private sensations of corporeality and socially constructed public identities, and the human form as a vessel for the expression of affect, rather than with traditional figurative representation.

"I think I chose the body as a subject, not consciously, but because it is the one form that we all share; it's something that everybody has their own authentic experience with."

In 1979 Smith turned to *Gray's Anatomy* as a source for drawings that depict aspects of the human body in cross-section and on a microscopic level. A few years later she produced sculptures of body parts and internal organs made of paper, plaster, resin, and various metals. Representations of human circulatory and nervous systems, among others, followed. In her transition from exploring the body's interior to its exterior, Smith began to investigate the skin

as a system and subsequently to create visceral, life-size figures (usually female). Smith's limbs, heads, organs, and flayed bodies might suggest the tools of medical education, except for the evocative materials from which they are made and the tender, homemade quality of their production. Like earlier feminist artists, she pointedly rehabilitates mediums and processes, such as clay and paper, glassmaking and embroidery, that were previously disdained as craft techniques unsuitable for high art.

Smith's delicate sculpture *Ribs* represents in terra-cotta the components of a rib cage, strung together and held up like a marionette suspended from the wall. The pink rib bones, disconnected from the sternum, some revealing repaired breaks, imply forensic evidence of trauma. The apparent fragility of Smith's piece evokes the transience of life itself. *Ribs* registers the passage of time both in the way that the unique rendering of the bones suggests that they might have belonged to a specific individual, and the manner in which its display evokes the natural-history museum and its fascination with the organic specimen as a link to a collective past.

J.B.

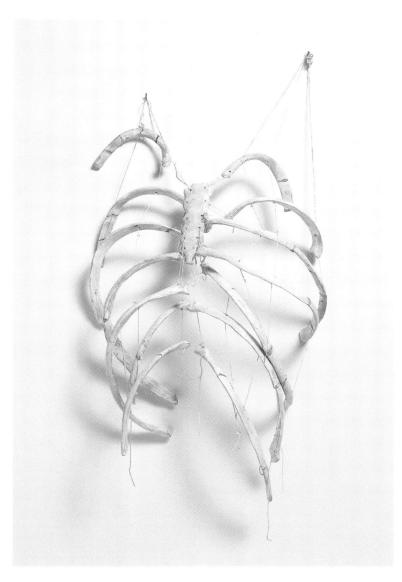

Ribs, 1987. Terra-cotta, ink, and thread, $22 \times 17 \times 10$ inches. Gift, Peter Norton Family Foundation, 93.4241

Robert Smithson b. 1938, Passaic, N.J.; d. 1973, Tecovas Lake, Tex.

Robert Smithson may be best known for his *Spiral Jetty* (1970), a monumental spiral of crushed rock gracing the waters of Utah's Salt Lake. But to characterize him simply as an Earthwork artist would be to miss the depth of his vision, which lies in the interstices between sculpture, Land art, photography, film, and the written word. Throughout his tragically

"The unnameable tonalities of blue that were once square tide pools of the sky have vanished into the camera, and rest in the cemetery of the printed page."

short career, Smithson mounted an attack against the strictures of art history, which venerates the static object and divides art from the exigencies of the real world. He searched for an aesthetic form that would be coterminous with the world at large. His "nonsites," fragments taken from a landscape and framed within a gallery, broke down the polarity between inside and outside, leaving open the possibility of a third term that would contain both. Time and the phenomenon of entropy were central to his project, and photography was the perfect medium through which to capture the process and effects of duration. The act of photographing—like the activities

of mapping, measuring, digging, pouring, mirroring, and writing—was an essential component of Smithson's practice. His photographic essay "A Tour of the Monuments of Passaic, New Jersey" (1967) describes tangible manifestations of entropic states—industrial structures that were already deteriorating at the time of their construction.

Hotel Palenque perfectly embodies the artist's notion of a "ruin in reverse." During a trip to Mexico in 1969, he photographed an old, eccentrically constructed hotel, which was undergoing a cycle of simultaneous decay and renovation. Smithson used these images in a lecture presented to architecture students at the University of Utah in 1972, in which he humorously analyzed the centerless, "de-architecturalized" site. Extant today as a slide installation with a tape recording of the artist's voice, Hotel Palenque provides a direct view into Smithson's theoretical approach to the effects of entropy on the cultural landscape.

While in Mexico, Smithson also created the Yucatan Mirror Displacements (1–9) by installing 12-inch-square mirrors on dispersed sites. The resulting series of nine color photographs was published in Artforum to accompany Smithson's essay "Incidents of Mirror-Travel in the Yucatan" (1969). The mirrors reflected and refracted the surrounding environs, displacing the solidity of the landscape and shattering its forms. Part Earthwork and part image, the displacements contemplate temporality; while the mirror records the passage of time, its photograph suspends time.

Hotel Palenque, 1969 (two images). Thirty-one chromogenic-development slides and audio tape; dimensions variable. Purchased with funds contributed by the International Director's Council and Executive Committee Members. 99.5268

Yucatan Mirror Displacements (1-9), 1969 (two images). Nine chromogenic-development slides. Purchased with funds contributed by the Photography Committee and with funds contributed by the International Director's Council and Executive Committee Members. 99.5269

N.S.

Spiritual

Much abstract art created in the opening decades of the 20th century emanated from artists' personal, passionate belief in the expression of spiritual issues via a non-objective language. In Germany, beginning around 1910–11, Vasily Kandinsky gradually abandoned recognizable forms, replacing them with obscured motifs dictated by what he called "inner aspiration." The writings of Helena P. Blavatsky and others in the Theosophical movement, which encouraged a deeper understanding of the relationship between nature and the spirit, profoundly influenced Kandinsky, as did the teachings of Anthroposophy's founder, Rudolf Steiner, who identified specific paths by which people could perceive spiritual worlds. Kandinsky in turn was inspired to write his 1911 treatise On the Spiritual in Art.

The Dutch artist Piet Mondrian's association with Theosophy encouraged him to develop non-objective imagery. His early works of 1908 to 1911 incorporate references to Theosophical notions about man's place in a spiritual hierarchy and progression toward higher insight. His grid paintings reduce this spiritual hierarchy to horizontal and vertical elements, primary colors, and black and white. In Russia Kazimir Malevich and his followers sought in their Suprematist paintings to capture visual equivalents for his notion of zaum, a state "beyond reason."

Dada and Surrealist artists were attracted to spiritual, occult, and mystical issues as well, although such elements make intermittent, rather than programmatic, appearances in their work. Many of these artists were profoundly affected by Freudian and/or Jungian analysis and alchemical and biomorphic studies, interests that were shared by postwar artists. Jackson Pollock's involvement with psychoanalysis and his fascination with Native American rituals were both manifested in his mythic paintings of the 1940s. Barnett Newman and Mark Rothko shared Pollock's fascination with "primitive" cultures, and their most abstract paintings may be linked, via their symbol-laden early works, to their psychoanalytical and tribal studies.

The painter Frank Stella prefers an abstraction characterized by what the audience perceives. Indeed the viewer's personal response becomes the spiritual arena addressed by much recent art, including Robert Ryman's gridded voids, the glowing environments generated by Dan Flavin's works, or Walter De Maria's symbolic configurations.

JUDI FREEMAN

Haim Steinbach b. 1944, Rechovot, Israel

Haim Steinbach's shelf sculptures are devices of endless variety, but their parameters are fixed. Typically, Steinbach chose banal objects from everyday life and arranged them on plastic-laminated triangular-wedge shelving units. The interior angles of the triangular units are constant—90, 50, and 40 degrees—and they always relate to the objects on top through volume and color. Steinbach has proposed parallels between the structure of his works and game boards, the sequence of pitches in musical scales, and the arrangement of goods on department-store shelves.

Ultra red #2, a typical Steinbach shelf sculpture, features four ruby-golden lava lamps, nine russet cooking pots, and six digital alarm clocks with blinking scarlet readouts. Just as the lava lamps and clocks continuously mutate, so too ultra red #2 resists any fixed meaning. A fundamental issue it raises is one of language. The title, perhaps citing the names given to paint colors, focuses attention on an element that is common to the objects and the shelves—they are all some shade of red. Steinbach's approach to "red" is similar to that of the linguist remarking on the many words for "snow" used by the Eskimos. It is an anthropological perspective. Steinbach is fascinated by the way physical reality invariably shapes local linguistic or cultural customs. Because "red" exists as an idea above and beyond its infinite physical variations, we can refer to the cooking pots and lava lamps as red, and thereby find a link between them.

Steinbach's work has often been understood in terms of its implied commentary on consumer culture and on the hidden aesthetic in consumer products. *Ultra red #2* bears this out with its reference to design from the 1960s through the 1980s. But this accounts for only one aspect of the work. Steinbach highlights the contiguous illogic of the placement of objects in the world, arranging the elements of his sculptures to reflect their original accidental juxtapositions. He has also explored other kinds of juxtapositions, using objects as metaphors for race, age, and culture.

By using items that are readily available and easily replaceable, Steinbach tried to undermine the fetishization of the art object. This monumental triptych made of household wares suggests that the artistic stacking of forms is as relative a construction as the development of different dialects.

C.L.

ultra red #2, 1986. Wood, plastic laminates, lava lamps, enamel pots, and digital clocks, 67 x 76 x 19 inches. Gift, Barbara and Eugene Schwartz. 88.3619

Frank Stella b. 1936, Malden, Mass.

In the late 1950s and early 1960s, Frank Stella broke the stronghold of Abstract Expressionism with his deceptively simple paintings of black stripes separated by narrow lines of unpainted canvas. With their

"My main interest [in these pictures] has been to make what is popularly called decorative painting truly viable in unequivocal abstract terms.

Decorative, that is, in the good sense, in the sense that it is applied to Matisse."

emphasis on control and rationalism, the *Black Paintings* opened genuinely new paths for abstraction and exerted a profound influence on the art of the 1960s. A major shift from this work began to develop in 1966 with his *Irregular Polygons*, canvases in the shapes of irregular geometric forms and characterized by large unbroken areas of color. As this new vocabulary developed into a more open and color-oriented pictorial language, the works underwent a metamorphosis in size, expressing an affinity with architecture in their monumentality. Stella also introduced curves into his works, marking the beginning of the *Protractor* series. *Harran II*

evinces the great vaulting compositions and lyrically decorative patterns that are the leitmotif of the series, which is based on the semicircular drafting instrument used for measuring and constructing angles.

Most of the paintings' titles are taken from the names of ancient cities in Asia Minor. A Roman numeral following the title indicates which of three design groups—"interlaces," "rainbows," or "fans"—encompasses its surface patterning. Harran II is composed of a full circle formed of two vertical protractors, each of which interlocks with a horizontal protractor shape. In turn, each protractor-shaped area contains eight concentric circular bands—the "rainbows"—that articulate the surface of the canvas.

Although the dominant motifs of the *Protractor* series are circular or curvilinear, every shape is actually defined by pairs of horizontal and vertical lines that intersect at right angles; the gridded rectilinear pattern that is formed is superimposed over the decorative arcs. Through the device of the protractor and the use of almost psychedelic color—a combination of acrylic and fluorescent pigments—Stella brought abstraction and decorative pattern painting into congruence in a manner that challenged the conventions of both traditions.

Harran II, 1967. Polymer and fluorescent polymer paint on canvas, 120 x 240 inches. Gift, Mr. Irving Blum. 82.2976

Clyfford Still b. 1904 Grandin, N. Dak.; d. 1980, Baltimore

By 1947, Clyfford Still had begun working in the format that he would intensify and refine throughout the rest of his career—a large-scale color field crudely applied with palette knives. Still liberated color from illusionary design by allowing large, uninterrupted tonal areas to interlock on a flat plane. He dispensed with typically "beautiful" colors in favor of more disquieting hues to create unsettling impressions. In 1948, visceral smears of brown, mustard, and dark crimson impasto seem to spread beyond the canvas. The painting's soaring scale and the energy of the roughly painted crags suggest the boundlessness the artist revered. The patches of earth tones in many canvases, including 1948, have been interpreted as organic shapes: parched riverbeds, frozen wastelands, swamps, and even flayed

"I never wanted color to be color. I never wanted texture to be texture, or images to become shapes. I wanted them all to fuse into a living spirit." skin. Wishing to avoid the possibility of such associations, Still left his paintings untitled, or identified them simply by the year of their creation. Evocative titles, in the artist's opinion, might influence the viewer's experience as they contemplate the palpable tension and sense of the infinite that can be found within the canvas.

Still espoused what he regarded as particularly American ideals such as absolute freedom and individuality, which were manifested in his works as well as in his artistic career. Although he was given solo

exhibitions at Peggy Guggenheim's Art of This Century gallery in 1946 and Betty Parson's Gallery in 1947, he disdained the commercial aspects of the art world and became increasingly aloof from the burgeoning New York School, to the point of refusing to exhibit for a period between 1952 and 1958. Although the artist scorned categorization, his expansive canvases dominated by jagged fields of color were influential among the Abstract Expressionist artists he was grouped with, in particular Barnett Newman and Mark Rothko, who shared his interest in the metaphysical sublime. These artists believed that a painting could convey meaning without reference to anything outside of its inherent formal and material qualities. Rather than capture a realistic representation of the world in his abstract paintings, Still sought to create a transcendental experience that was purely visual and impossible to describe with words.

J.Y.

1948, 1948. Oil on canvas, 70½ x 62¼ x 1¼ inches. Fractional gift. Barbara and Donald Jonas. 92.3986

Thomas Struth b. 1954, Geldern, Germany

Moving freely from one genre to another, intermingling them in exhibitions and publications, Thomas Struth always brings an intense level of visual exactitude to the images he creates. While the subject matter varies—from a mist-laden view of a Japanese temple and a close-up of a sunflower to a pensive family portrait and a picture of the Louvre crowded with visitors—the fundamental theme of his practice does not change. Struth's photography contemplates the science of observation. Eschewing narrative devices and intentional psychological allusions, the work augments vision itself by bringing into focus details too numerous

for the eye to capture in an instant. A Struth image does not freeze time in the conventional sense of documentary photography; instead it slows time down just enough to capture the myriad visual nuances that one can only experience through sustained examination.

"In general, my work is less about expanding the possibilities of photography than about re-investing it with a truer perception of things by returning to a simple method, one that photography has had from the beginning of its existence."

Struth's early black-and-white cityscapes—images of barren urban streets photographed from one central perspective—elicit comparisons to Bernd and Hilla Becher's typological studies of industrial structures. Struth had studied with the couple at the Academy of Fine Arts in Düsseldorf during the 1970s and shared their systematic, objective approach to subject matter. But it was another of Struth's professors at the Academy, Gerhard Richter, who made a lasting impression on the young artist's work. Richter's conceptual engage-

ment with the photographic and his practice of working in simultaneous series is evident in Struth's own ongoing series of landscapes, street scenes, flowers, portraits, museum interiors, and places of worship.

Struth's photographs of historic churches and temples, which function today as both religious sites and tourist destinations, always include people. Like his museum interiors, images of places such as San Zaccaria in Venice and the Buddhist monastery Todai-Ji in Nara portray visitors in various stages of absorption. In Milan Cathedral (Interior), these visitors turn away from the camera to survey their environment, observe the Renaissance paintings, study their guidebooks, or pray. Shot at an oblique angle and lit with the utmost clarity, this dynamic composition captures both the complexity of the cathedral's celebrated architecture and the many separate vignettes being enacted by the individuals present at the moment the photograph was taken.

N.S.

Milan Cathedral (Interior), 1999. Cibachrome print, 73 1/4 x 91 inches. Edition 4/10. Purchased with funds contributed by the Harriett Ames Charitable Trust and the International Directors Council and Executive Committee Members. 99.5301

Antoni Tàpies b. 1923, Barcelona

In the years after World War II, both Europe and America saw the rise of predominantly abstract painting concerned with materials and the expression of gesture and marking. New Yorkers dubbed the development in the U.S. Abstract Expressionism, while the French named the pan-European phenomenon of gestural painting Art Informel (literally "unformed art"). A variety of the latter was Tachisme, from the French word *tache*, meaning a stain or blot. Antoni Tàpies was among the artists to receive the label Tachiste because of the rich texture and pooled color that seemed to occur accidentally on his canvases.

Tapies reevaluates humble materials, things of the earth such as sand—which he used in *Great Painting*—and the refuse of humanity: string, bits

"And the most sensational surprise came when I suddenly discovered one day that my pictures, for the first time, had turned into walls." of fabric, and straw. By calling attention to this seemingly inconsequential matter, he suggests that beauty can be found in unlikely places. Tapies sees his works as objects of meditation that every viewer will interpret according to personal experience. "What I do attempt," he maintains, "is to create images that will cause the observer to look upon reality in a more contemplative way."

These images often resemble walls that have been scuffed and marred by human intervention and the passage of time. In *Great Painting*, an ocher skin appears to hang off the surface of the canvas; violence is suggested by the gouge and puncture marks in the dense stratum. These markings recall the scribbling of graffiti, perhaps referring to the public walls covered with slogans and images of protest that the artist saw as a youth in Catalonia—a region in Spain that experienced the harshest repression of the dictator Francisco Franco. Tapies has called walls the "witnesses of the martyrdoms and inhuman sufferings inflicted on our people." *Great Painting* suggests the artist's poetic memorial to those who have perished and those who have endured.

J.B.

Great Painting, 1958. Mixed media on canvas, 78 ½ x 103 inches. 59.1551

Technology

"Technology," as science historian Leo Marx has observed, can be a dangerous word. While it's tempting to reach for this shiny, neutral-sounding term when describing a century of artistic experimentation with industrial and electronic inventions, to do so encourages the false impression that these inventions operate free of cultural constraints. The greatest artistic contributions to new media have frequently been made by artists who have chosen to unpeel the ideological wrapper attached to a given device and "misuse" the technology for their own ends. However, the achievements of these artists consist not merely of new ways to arrange diodes and DVDs, but of unique ways to envision the world using these tools.

Still from **Brandon: A One**Year Narrative Project in
Installments, conceived by Shu
Lea Cheang, Guggenheim.org,
1998–2000.

In the electric decades of the early 20th century, the utopian promises of the second industrial revolution inspired Fernand Léger to film pumping pistons and László Moholy-Nagy to build a rotating "light-space modulator." By the second half of the century, electronics had replaced electricity as the technology identified with social progress. In the 1960s Billy Klüver and Robert Rauschenberg founded the Experiments in Art and Technology program in order to pair up artists and dancers with engineers at Bell Labs; while Nam June Paik bent television signals by using crossed wires and magnets in an attempt to make good on the medium's promise to expand rather than limit audiovisual horizons. The introduction of the Sony Portapak camera in 1968 made it easy to capture video images, and more recently video installations by such artists as Gary Hill, Steina and Woody Vasulka, and Bill Viola have upstaged painting and sculpture in many exhibitions and museum collections.

For artists to reach outside museum walls and compete with broadcast media, however, requires them to control distribution as well as production—which the personal computer made possible. In the 1990s accelerated processor speeds and plummeting hardware prices enticed artists to experiment with digital media. Just as critical was the research ethic of the early Internet, which privileged free circulation of ideas over copyrighted programs broadcast from a central location. A significant number of artists were already exchanging criticism and artwork in text form via online bulletin boards by the time the Internet became a visual medium with the introduction of the first graphical "Mosaic" browser in 1993, giving them an opportunity to shape a new medium at its very inception. Since the turn of the millennium artists have contributed to the proliferation of decentralized media through their innovations in Web design, streaming audio and video, and computer driven installations.

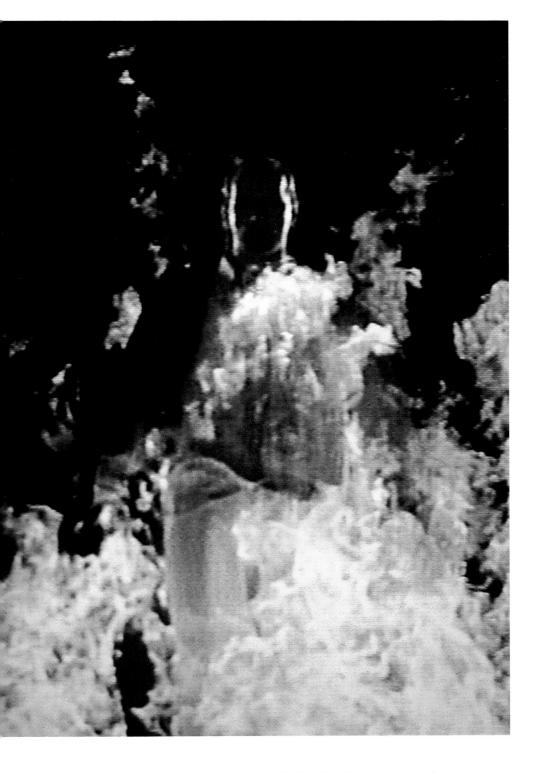

James Turrell b. 1943, Los Angeles

Manipulating light as a sculptor would mold clay, James Turrell creates works that amplify perception. Unlike pictorial art that replicates visual experience through mimetic illusion, Turrell's light works—one cannot call these shimmering events "objects" or "images"—give form to perception. Each installation activates a heightened sensory awareness that promotes discovery: what seems to be a lustrous, suspended cube is actually the conjunction of two flat panels of projected light; a rectangle of radiant color hovering in front of a wall is really a deep, illuminated depression in the space; a velvety black square on the ceiling is, in reality, a portal to the night sky. With such effects, Turrell hopes to coax the viewer into a state of self-reflexivity in which one can see oneself seeing.

"I have an interest in the invisible light, the light perceptible only in the mind. I want to address the light we see in dreams and make spaces that seem to come from those dreams." Turrell has consistently utilized the sparest formal means to perpetuate the consciousness of perception. As demonstrated by the projected geometric "cube" of *Afrum I*, in which light creates the illusion of volume, the artist's work derives its power from simplicity. Turrell's early inquiries into the psychological implications of perception involved sensory deprivation. In 1968 he participated in the Art & Technology program at the Los Angeles County Museum of Art. With scientist Edward Wortz, who was investigating the perceptual alterations encountered in space travel, he studied the lindeterminacy of the *Ganzfeld*—an optical phenomenon in which

visual indeterminacy of the *Ganzfeld*—an optical phenomenon in which there is nothing for the eye to focus on—with the goal of observing his own retinal activity.

Such phenomena are manifest in works involving structural cuts into existing architecture that allow outside light to penetrate and inhabit interior realms. Lunette is an opening to the sky at the end of a barrel-vaulted hall flanked by hidden fluorescent lights that accentuate the nuanced tones of dawn and dusk. This and all of Turrell's skyspaces hark back to ancient building techniques that deployed natural light—and the cycles of the cosmos—to create symbolic architecture. In other spatial interventions, such as Night Passage, Turrell uses wall partitions with rectangular windows opening onto contiguous areas filled with pure, colored light. Standing in what Turrell has called the "sensing space," the viewer encounters a Ganzfeld, the volume of colored light on the other side of the partition collapsing into what appears to be a floating, luminous plane with no surface or depth. The illusion is destabilizing yet mesmerizing; it is a tangible example of the artist's endeavor to produce sensations that are essentially prelingual, to create a transformative experience of wordless thought.

Afrum I, 1967. Xenon projection. Panza Collection, Gift. 92.4175

Lunette, Varese, 1974.
A vertical portal cut to outside sky, interior filled with natural and warm white neon light; portal cut: 35 ½ x 78 ½ inches; hallway: 98 x 98 ½ x 584 inches. Panza Collection, Gift, on permanent loan to Fondo per l'Ambiente Italiano. 92.4178

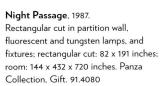

Cy Twombly b. 1929, Lexington, Va.

Cy Twombly's paintings of the early 1960s consist of white canvases upon which he has applied scribblings and scratches in a furious flurry of crayon, pencil, and paint. The pigments are squeezed from the tube, remaining as globules that appear to hang tenuously from the surface or, as in *Untitled*, ejaculations of paint that drip off the canvas and are invaded by crayon and pencil smears. Like Jasper Johns and Robert Rauschenberg, Twombly employed the Abstract Expressionists' liberating aleatory use of paint, but without their heroic pretensions or universalist goals. Twombly and his colleagues utilized an iconography of everyday life (such as representations of numbers and letters) and incorporated found objects into their work, embracing banal methods such as stenciling. The suggestion of carelessness and defilement inherent in Twombly's

paintings (they elicit comparisons with the sexual graffiti in a public latrine) is also present in the work of Rauschenberg, with whom Twombly traveled to Italy in 1953.

"Every line is thus the actual experience with its unique story. It does not illustrate; it is the perception of its own realization."

In 1957 Twombly settled in Rome, where he inspired a small school of calligraphic painters. Some of the main elements of his mature works—the graffitilike writing on a surface that suggests a wall, and an emphasis on the material properties of his mediums—dovetail with the leading concerns of continental painters, particularly of those associated with Informale (the Italian equivalent of Art Informel). Twombly's work is filled with references to his adopted home as well as to a broader neoclassical tradition; he often alludes to mythological subjects, Old Master painters, and local places or events through his titles and scrawled words or phrases on the surfaces of the works. Idyllic landscapes and their connotation of bacchanalian pleasures have consistently provided Twombly with inspiration. The palette of *Untitled*, for example, bears the faint echo of an 18th-century painting of a fête champêtre by Boucher or Fragonard in which sensual youths with powdered hair and strawberryand-cream complexions gambol in sylvan glades, the breezy subject loaded with erotic innuendo. In Twombly's painting the explosive sexual charge of splatters and scribbles is complicated by a hermetic language of modern charts and graphs as if, according to art critic Roberta Smith, "an overeducated bibliophiliac suddenly—graphically, nearly obscenely— [speaks] in tongues."

J.B.

Untitled, Rome, June 1960. Oil, pencil, and oil stick on canvas, 37 ½ x 40 1/16 inches. Gift, Michael and Elizabeth Rea. 91.3975

Vincent van Gogh b. 1853, Groot-Zundert, The Netherlands; d. 1890, Auvers, France

During the years preceding his suicide in 1890, Vincent van Gogh suffered increasingly frequent attacks of mental distress, the cause of which remains unclear. *Mountains at Saint-Rémy* was painted in July 1889, when van Gogh was recovering from just such an episode at the hospital of Saint-Paul-de-Mausole in the southern French town of Saint-Rémy. The painting represents the Alpilles, a low range of mountains visible from the hospital grounds. In it, van Gogh activated the terrain and sky with the heavy impasto and bold, broad brushstrokes characteristic of his late work.

Van Gogh advocated painting from nature rather than inventing a motif from the imagination. On a personal level, he felt that painting outdoors would help to restore his health, a sentiment he often voiced when writing to his brother, Theo. He mentioned this painting several times in his letters, relating it to a passage from Edouard Rod's *Le Sens de la vie*. In one note he wrote, "I rather like the 'Entrance to a Quarry'—I was doing it when I felt this attack coming on—because to my mind the somber greens go well with the ocher tones; there is something sad in it which is healthy, and that is why it does not bore me. Perhaps that is true of the 'Mountain' too. They will tell me that mountains are not like that and that there are black outlines of a finger's width. But after all it seemed to me it expressed the passage in Rod's book . . . about a desolate country of somber mountains, among which are some dark goatherds' huts where sunflowers are blooming."

Nature had a quasi-religious or transcendental significance for van Gogh. Unlike the earlier Impressionists, who often painted urban life, the artist felt that the city, in particular Paris, was a place of iniquity, inherently unhealthful. In the face of industrialization and modernization (the Eiffel Tower was built the same year that this canvas was painted), van Gogh longed nostalgically for a rural environment peopled with good-natured, Godfearing peasants such as those painted by Jean-François Millet, one of his heroes. This utopian ideal, based on a belief in the regenerative capacity of a "primitive" culture, was shared by van Gogh's friend Paul Gauguin, who sought redemption farther from home, among the people of Tahiti.

J.B.

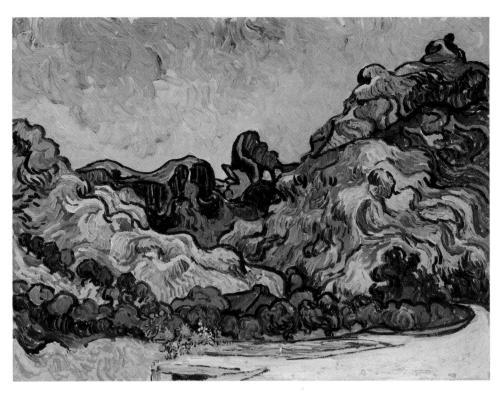

Mountains at Saint-Rémy, July 1889. Oil on canvas, 28½ x 35½ inches. Thannhauser Collection, Gift, Justin K. Thannhauser. 78.2514 T24

Bill Viola b. 1951, New York City

The work of Bill Viola successfully combines sophisticated video, film, and audio technology with primal archetypes and a mystical spirituality. In 1996 he was commissioned to create a large-scale video projection for Durham Cathedral in northern England. In this work, *The Messenger*, a nude male figure gradually emerges from the depths of a body of water and then takes a deep, resonant breath before sinking slowly back down to begin the cycle anew. The sacred atmosphere and cavernous medieval architecture of the original site underlined the ethereal aspect of these images, though their power is nearly as transcendent in a gallery setting. The spiritual and physical circuit of birth, life, and death—a theme that Viola continually examines in his work—comes across with particular visual and aural clarity in *The Messenger*.

"Time itself has become the materia prima of the art of the moving image." Similar motifs of earthly and spiritual renewal and the transcendent power of the moving image animate *The Crossing*, a dual video projection piece in which the visual force is amplified by high-intensity stereo sound. In the original installation, synchronized image sequences were projected onto both sides of a double-sided

screen, each of which showed a dark human form walking in slow motion toward the viewer. The figure eventually filled both displays, stopped, paused, and was slowly subsumed by a growing mass of roaring flames on one side, and by a trickle of water that swells into a rushing deluge on the other. In the 1997 exhibition *Bill Viola: Fire, Water, Breath* at the Guggenheim Museum SoHo, the projections were presented side-byside, playing the images against each other and allowing the viewer to absorb them simultaneously.

A pioneer in video art since the early 1970s, Viola says that he has "never lost faith in the image." He has embraced new mediums while maintaining classical aesthetic values. The repetition and extreme slow motion of *The Crossing* and *The Messenger* root the works in a mesmerizing temporality that displaces the space-time of the exhibition space and draws the viewer into visual sequences that seem to play out in perpetuity. Viola's imagery has an immediate visceral impact, but his ability to stretch and slow elemental sensory experience through the use of art and technology is what deepens his works into vehicles of spiritual meditation.

B.A.

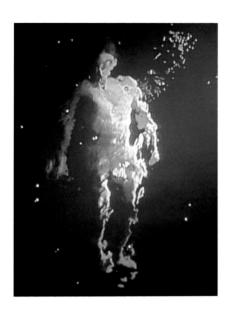

The Messenger, 1996.
Single-channel color video and stereosound installation, continuous loop; ideal room dimensions: 25 x 30 x 32 feet. Edition 2/3. Gift, The Bohen Foundation. 2000.60

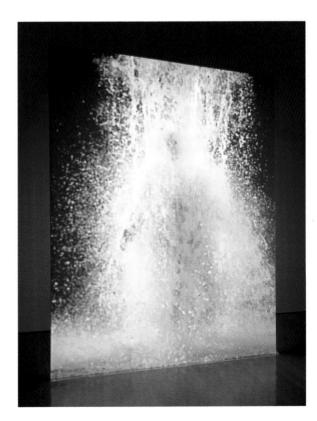

The Crossing, 1996.
Two-channel color video and stereosound installation, continuous loop; ideal room dimensions: 16 feet x 27 feet 6 inches x 57 feet. Edition 1/3. Gift, The Bohen Foundation. 2000.61

Andy Warhol b. 1928, Pittsburgh; d. 1987, New York City

Andy Warhol announced his disengagement from the process of aesthetic creation in 1963: "I think somebody should be able to do all my paintings for me," he told art critic G.R. Swenson. The Abstract Expressionists had seen the artist as a heroic figure, alone capable of imparting his poetic vision of the world through gestural abstraction. Warhol, like other Pop artists, used found printed images from newspapers, publicity stills, and advertisements as his subject matter; he adopted silkscreening, a technique of mass reproduction, as his medium. And unlike the Abstract Expressionists, who searched for a spiritual pinnacle in their art, Warhol aligned himself with the signs of contemporary mass culture. His embrace of subjects traditionally considered debased—from celebrity worship to food labels—has been interpreted as both an exuberant affirmation of American culture and a thoughtless espousal of the "low." The artist's perpetual examination of themes of death and disaster suggest yet another dimension to his art.

"I realized that everything I was doing must have been Death." Warhol was preoccupied with news reports of violent death—suicides, car crashes, assassinations, and executions. In the early 1960s he began to make paintings, such as *Orange Disaster #5*, with the serial application of images revolving around the theme of death.

"When you see a gruesome picture over and over again." he commented, "it doesn't really have any effect." Yet *Orange Disaster #5*, with its electric chair repeated 15 times, belies this statement. Warhol's painting speaks to the constant reiteration of tragedy in the media, and becomes, perhaps, an attempt to exorcise this image of death through repetition. However, it also emphasizes the pathos of the empty chair waiting for its next victim, the jarring orange only accentuating the horror of the isolated seat in a room with a sign blaring SILENCE.

Warhol's death and disaster pictures underscore the importance of the vanitas theme—that death will take us all—in his oeuvre. Self-Portrait, one of the last self-portraits Warhol painted before his death, may be considered the anxious meditation of an aging artist. (Other works he painted in his final year include a posthumous portrait of Joseph Beuys, who died in 1986, and a rendition of Leonardo da Vinci's Last Supper.) The monumental scale of Self-Portrait suggests that Warhol's obsession with celebrity encompassed himself. Yet unlike nearly all of his portraits, which commonly include the sitter's neck and shoulders, this otherworldly image presents the artist as spectral, his acid green, disembodied head like a skull looming out of the black background.

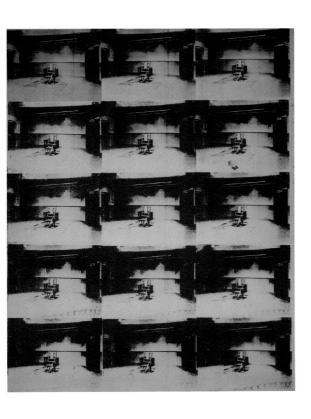

Orange Disaster #5, 1963. Acrylic and silkscreen enamel on canvas, 106 x 81½ inches. Gift, Harry N. Abrams Family Collection. 74.2118

Self-Portrait, 1986. Silkscreen ink on synthetic polymer paint on canvas, 106 x 106 inches. Gift, Anne and Anthony d'Offay. 92.4033

Lawrence Weiner b. 1942, Bronx, N.Y.

Lawrence Weiner is a sculptor whose medium is language. His texts describe material processes and physical conditions; they delineate space and indicate location. Since 1968, when he concluded that the actual construction of a work was not critical to its existence in the world, Weiner has authored hundreds of linguistic artworks. Prior to this time, his material sculptures had been prefaced by titles that dictated the means of their

"The work gains its sculptural qualities by being read, not by being written." fabrication. When the outdoor installation A SERIES OF STAKES SET IN THE GROUND AT REGULAR INTERVALS TO FORM A RECTANGLE—TWINE STRUNG FROM STAKE TO STAKE TO DEMARK A GRID—A RECTANGLE REMOVED FROM THIS RECTANGLE was damaged, Weiner realized that the essence of a work is textual and not physical. This led him to the

following formulation, first published in 1968, which continues to outline his conceptual approach to artmaking: "(1) The artist may construct the piece. (2) The piece may be fabricated. (3) The piece need not be built. Each being equal and consistent with the intent of artist, the decision as to condition rests with the receiver upon the occasion of receivership."

In a radical restructuring of the traditional artist/viewer relationship, Weiner shifted the responsibility of the work's realization to its audience, while also redefining standard systems of artistic distribution. A work such

FARTH TO FARTH ASHES TO ASHES DUST TO DUST

as A STAKE SET can be made or merely spelled out on a museum wall, but it can also be read in a book or heard if uttered aloud. Weiner's art can literally be disseminated by word of mouth. Much of the early work rehearses simple actions involving basic substances—pouring paint, digging trenches, removing plaster—and, like all subsequent examples, are stated in the past tense to avoid the authoritative tone of a command. Others are more spectacular, involving firecrackers and dynamite. THE RESIDUE OF A FLARE IGNITED UPON A BOUNDARY, a piece that Weiner actually executed in Amsterdam for the Stedelijk Museum's pivotal 1969 Conceptual Art exhibition Op Losse Schroven: Situaties en Cryptostructuren, is poetic in its ability to evoke vivid imagery, while at the time suggesting coded systems of communication. Weiner gradually extended his engagement with language to ready-made structures, such as idioms, clichés, and proverbs, which underscore the contingent nature of meaning when encountered in different contexts. The Christian burial recitation EARTH TO EARTH ASHES TO ASHES DUST TO DUST becomes, in nonliturgical circumstances, a simple meditation on materials and processes of transmutation.

Cat. #091 (1969) A STAKE SET, 1969.

Language + the materials referred to;

dimensions variable. Panza Collection, Gift. 92.4182

Cat. #029 (1969) THE RESIDUE OF A FLARE **IGNITED UPON A** BOUNDARY, 1969.

Language + the materials referred to; dimensions variable. Panza Collection, Gift. 92.4180

Cat. #151 (1970) EARTH TO EARTH ASHES TO ASHES **DUST TO DUST**, 1970.

Language + the materials referred to; dimensions variable. Panza Collection, Gift. 92.4184

Gilberto Zorio b. 1944, Andorno Micca, Italy

Gilberto Zorio exhibited his seminal work Pink-Blue-Pink in a Turin art gallery in 1967, just prior to his association with the Arte Povera group. Consisting of a concrete basin filled with cobalt chloride (which perpetually changes color in response to shifting levels of humidity in the room), the work reveals much about Zorio's concerns as an artist as well as his place within the development of contemporary Italian art. In art-historical terms, Pink-Blue-Pink refers to the works of the Italian enfant terrible Piero Manzoni, who used cobalt chloride in some of his radical wall pieces (known as Achromes) in order to redefine painting and its traditional role as a conveyor of predetermined meanings. Pink-Blue-Pink marks a continuation of the attempt to reconfigure art's role in society by demonstrating its essential malleability. The emphasis on instability and metamorphoses apparent in Pink-Blue-Pink would become the leitmotif of Zorio's subsequent artistic undertakings. Drawing upon the ancient science of alchemy for both form and content, he has created an oeuvre in which materials associated with chemical conversions—vessels containing water, alcohol, acids, and copper sulfate connected by suspended copper conduits—have become symbols for psychic and social transmutation. Zorio's belief in the potential for cultural change through art is apparent in the title Per purificare le parole (To Purify Words), which he has applied to numerous sculptures and performances since 1968.

Zorio's notion that language can be emptied of all extraneous or corrupt facets finds a visual analogue in his work, which can be reduced to an essential symbolic typology that he combines and recombines. His fundamental aesthetic vocabulary consists of the star, which alludes to the metaphysical; the javelin, which represents mortal power; and the canoe, which suggests passage between the two realms. However utopian this project may seem, one remains aware that danger and violence constitute the underside of beauty and of harmony. Perhaps this is why Zorio pierced the broken terra-cotta star with a javelin in *Star (To Purify Words)*.

N.S.

Star (To Purify Words), 1980.
Terra-cotta and metal, 195 inches diameter. Exxon Corporation Purchase Award with additional funds contributed by Sonnabend Gallery, New York. 82.2921.a-.z

Suggested Readings

Many of the art works reproduced in this book have been fully documented in the following Guggenheim Museum publications. In some cases, the authors used these books as primary sources. They will also be of interest to the reader seeking additional information on the collection.

Art of this Century: The Guggenheim Museum and its Collection. New York, 1993; reprinted 2001.

Barnett, Vivian Endicott. The Guggenheim Museum: Justin K. Thannhauser Collection. New York, 1978. 2nd ed. 1992; revised and expanded edition, Matthew Drutt, ed. Thannhauser: The Thannhauser Collection of the Guggenheim Museum, 2001.

——. Handbook: The Guggenheim Museum Collection 1900–1980, 1984.

Rudenstine, Angelica Zander. The Guggenheim Museum Collection: Paintings 1880-1945. 2 vols, 1976.

The following books and articles are suggested for those readers seeking additional information or viewpoints on the artists whose works are discussed in this guidebook. In many cases they were used by the authors as they wrote their entries.

Marina Abramović

lles, Chrissie, ed. *Marina Abramović: Objects, Performance, Video, Sound* (exh. cat.). Oxford: Museum of Modern Art. 1995.

Kaplan, Janet. "Deeper and Deeper: Interview with Marina Abramović." *Art Journal* (New York) 58, no. 2 (summer 1998), pp. 6–21.

McEvilley, Thomas, Hans Ulrich Obrist, Bojana Pejic, et al. *Marina Abramović, Artist Body: Performances* 1969-1998 (exh. cat., Kunstmuseum Bern). Milan: Charta, 1998.

Vito Acconci

Jones, Amelia. Body Art/Performing the Subject. Minneapolis: University of Minnesota Press, 1998.

Linker, Kate. Vito Acconci. New York: Rizzoli, 1994.

—. Vito Acconci: Photographic Works 1969–1970. New York: Brooke Alexander, Inc., 1988.

Josef Albers

Albers, Josef. Interaction of Color. New Haven: Yale University Press, 1975.

Bucher, François. Josef Albers: Despite Straight Lines: An Analysis of His Graphic Constructions.

New Haven: Yale University Press, 1961. Cambridge, Mass.: MIT Press, 1977.

Weber, Nicholas Fox, Fred Licht, et al. *Josef Albers: A Retrospective* (exh. cat.). New York: Guggenheim Museum, 1988.

Weber, Nicholas Fox, Fred Licht, and Brenda Danilowitz. *Josef Albers: Glass, Color, and Light* (exh. cat., Peggy Guggenheim Collection, Venice). New York: Guggenheim Museum, 1994.

Carl Andre

Bourdon, David. *Carl Andre: Sculpture 1959–1977* (exh. cat., Laguna Gloria Art Museum, Austin, Tex.). New York: Japp Reitman, 1978.

Carl Andre (exh. cat.). The Hague: Haags Gemeentemuseum, 1987.

Fuchs, Rudi H. Carl Andre: Wood (exh. cat.). Eindhoven: Van Abbemuseum, 1978.

Tuchman, Phyllis. "Background of a Minimalist: Carl Andre." *Artforum* (New York) 16, no. 7 (March 1978), pp. 29–33.

Waldman, Diane. Carl Andre (exh. cat.). New York: Guggenheim Museum, 1970.

Alexander Archipenko

Michaelsen, Katherine Jánszky, and Nehama Guralnik. Alexander Archipenko: A Centennial Tribute (exh. cat.). Washington D.C.: National Gallery of Art; Tel Aviv: Tel Aviv Museum, 1986.

Reff. Theodore. "Harlequins, Saltambiques, Clowns and Fools." *Artforum* (New York) 10, no. 2 (October 1971), pp. 30–43.

Jean Arp

Arp, Jean. Arp on Arp: Poems, Essays, Memories. Marcel Jean, ed. Trans. Joachim Neugroschel. New York: Viking Press, 1972.

Hancock, Jane, and Stefanie Poley. *Arp. 1886–1966* (exh. cat., Württembergischer Kunstverin, Stuttgart). Stuttgart: Hatje: Minneapolis: Minneapolis Institute of Arts, 1987.

Francis Bacon

Ades, Dawn, and Andrew Forge. Francis Bacon. New York: Harry N. Abrams, 1985.

Moorhouse, Paul. "A Magnificent Armature: The Crucifixion in Bacon's Art." *Art International* (Lugano), no. 8 (autumn 1989), pp. 23–37.

Peppiatt, Michael. Francis Bacon: Anatomy of an Enigma. New York: Farrar, Strauss and Giroux, 1997.

Sylvester, David. The Brutality of Fact: Interviews with Francis Bacon. London: Thames and Hudson, 1988.

Matthew Barney

Goodeve, Thyrza Nichols. "Travels in Hypertrophia." Artforum (New York) 33, no. 9 (May 1995), pp. 66–71.

Kimmelman, Michael. "The Importance of Matthew Barney." *New York Times Magazine*, October 10, 1999, pp. 62–69.

Matthew Barney: Pace Car for the Hubris Pill (exh. cat.). Rotterdam: Museum Boymans van Beuningen, 1996.

Matthew Barney: CREMASTER 5 (exh. cat.). Frankfurt am Main: Portikus; New York: Barbara Gladstone Gallery, 1997. Text by Thyrza Nichols Goodeve.

Matthew Barney: CREMASTER 1 (exh. cat.). Vienna: Kunsthalle Wien, 1998.

Matthew Barney: CREMASTER 2 (exh. cat.). Minneapolis: Walker Art Center, 1999. Text by Richard Flood.

Georg Baselitz

Calvocoressi, Richard. Georg Baselitz: Paintings, 1960-83 (exh. cat.). London: Whitechapel Art Gallery, 1983.

Dahlem, Franz. Georg Baselitz. Trans. Bernadette Martial, Norbert Messler, et al. Cologne: Taschen, 1990.

Kuspit, Donald. "Interview with Georg Baselitz." Artforum (New York) 33, no. 10 (summer 1995), pp. 74–79.

Waldman, Diane. Georg Baselitz (exh. cat.). New York: Guggenheim Museum, 1995.

William Baziotes

Hadler, Mona. "William Baziotes: A Contemporary Poet-Painter." *Arts Magazine* (New York) 51, no. 10 (June 1977), pp. 102–10.

Preble, Michael, et al. *William Baziotes: A Retrospective* (exh. cat.). Newport Beach, Calif.: Newport Harbor Art Museum, 1978.

Weiss, Jeffrey. "Science and Primitivism: A Fearful Symmetry in the Early New York School." Arts Magazine (New York) 57, no. 7 (March 1983), pp. 81–87.

William Baziotes: A Memorial Exhibition (exh. cat.). New York: Guggenheim Museum, 1965.

Bernd and Hilla Becher

Andre, Carl. "A Note on Bernd and Hilla Becher." Artforum (New York) 11, no. 4 (December 1972), pp. 59–61.

Becher, Bernd, and Hilla Becher. Water Towers. Cambridge, Mass.: MIT Press, 1988.

Bernd and Hilla Becher (exh. cat.). London: Arts Council of Great Britain, 1974.

Bernd and Hilla Becher (exh. cat.). Eindhoven: Stedelijk van Abbemuseum, 1981.

Max Beckmann

Buenger, Barbara C. "Max Beckmann's Ideologues: Some Forgotten Faces." *The Art Bulletin* (New York) 71, no. 3 (September 1989), pp. 453–79.

Phelan, Anthony, ed. *The Weimar Dilemma: Intellectuals in the Weimar Republic*. Manchester: Manchester University Press, 1985.

Stehlé-Akhtar, Barbara, Reinhard Spieler, et al. *Max Beckmann in Exile* (exh. cat.). New York: Guggenheim Museum, 1996.

Joseph Beuys

Adriani, Götz, Winfried Konnertz, and Karin Thomas. *Joseph Beuys: Life and Works*. Trans. Patricia Lech. Woodbury, N.Y.: Barron's Educational Series, 1979.

Borer, Alain. The Essential Joseph Beuys. London: Thames and Hudson, 1996.

Stachelhaus, Heiner. Joseph Beuys. New York: Abbeville Press, 1991.

Temkin, Ann, and Bernice Rose. *Thinking is Form: The Drawings of Joseph Beuys* (exh. cat., Philadelphia Museum of Art). New York: Thames and Hudson, 1993.

Tisdall, Caroline. Joseph Beuys. London: Thames and Hudson, 1979.

Ross Bleckner

Bleckner, Ross. "Transcendent Anti-Fetishism." Artforum (New York) 17, no. 7, (March 1979), pp. 50–55.

Dennison, Lisa, ed. Ross Bleckner (exh. cat.). New York: Guggenheim Museum, 1995.

Halley, Peter. "Ross Bleckner: Painting at the End of History." Arts Magazine (New York) 56, no. 9 (May 1982), pp. 132–33.

Watson, Simon. "An Interview with Ross Bleckner." *Art and Text* (Prahran, Australia), no. 38 (January 1991), pp. 77–79.

Pierre Bonnard

Newman, Sasha M., ed. *Bonnard: The Late Paintings* (exh. cat.). Washington, D.C.: Phillips Collection; Dallas: Dallas Museum of Art, 1984.

Watkins, Nicholas. Bonnard. London: Phaidon Press, 1994.

Whitfield, Sarah, and John Elderfield. Bonnard (exh. cat.). London: Tate Gallery, 1998.

Louise Bourgeois

Bourgeois, Louise. Destruction of the Father/Reconstruction of the Father: Writings and Interviews, 1923–1997. Cambridge, Mass.: MIT Press, 1998.

"Collaboration Louise Bourgeois." *Parkett* (Zurich), no. 27 (1991), pp. 26–76. Special issue with essays by Manuel J. Borja-Villel, Josef Helfenstein, Christiane Meyer-Thoss, Mignon Nixon, and Harald Szeemann.

Meyer-Thoss, Christiane. Louise Bourgeois: Designing for the Free Fall. Zurich: Ammann, 1991.

Wye, Deborah. Louise Bourgeois (exh. cat.). New York: The Museum of Modern Art, 1982.

Constantin Brancusi

Bach, Friedrich Teja, Margit Rowell, and Ann Temkin. *Constantin Brancusi: 1876–1957* (exh. cat.). Philadelphia: Philadelphia Museum of Art, 1995.

Balas, Edith. Brancusi and Rumanian Folk Traditions. Boulder, Colo.: East European Monographs, 1987.

Chave, Anna. Constantin Brancusi: Shifting the Bases of Art. New Haven: Yale University Press, 1993.

Hultén, Pontus, Natalia Dumitresco, and Alexandre Istrati. Brancusi. New York: Harry N. Abrams, 1987.

Georges Braque

Cooper, Douglas. The Cubist Epoch. London: Phaidon Press, 1970.

Golding, John. Cubism: A History and an Analysis, 1907-1914. London and Boston: Faber, 1988.

Golding, John, et al. *Braque: The Late Works* (exh. cat., Royal Academy of Arts, London). New Haven: Yale University Press, 1997.

Leymarie, Jean. Georges Braque (exh. cat.). New York: Guggenheim Museum, 1988.

Rubin, William. *Picasso and Braque: Pioneering Cubism* (exh. cat.). New York: The Museum of Modern Art. 1989.

Alberto Burri

Calvesi, Maurizio. Alberto Burri. Trans. Robert E. Wolf. New York: Harry N. Abrams, 1975.

Corà, Bruno. Burri e Fontanta (exh. cat., Centro par l'Arte Contemporanea). Milan: Skira, 1996. In Italian and English.

Nordland, Gerald. *Alberto Burri: A Retrospective View 1948–77* (exh. cat.). Los Angeles: Frederick S. Wight Gallery, University of California, 1977.

Alexander Calder

Calder, Alexander, and Jean Davidson. Calder: An Autobiography with Pictures. New York: Pantheon, 1966.

Lipman, Jean. Calder's Universe (exh. cat.). New York: Whitney Museum of American Art, 1976.

Prather, Marla. Alexander Calder 1898–1976 (exh. cat.). Washington D.C.: National Gallery of Art; New Haven: Yale University Press, 1998.

Paul Cézanne

Cachin, Françoise. Cézanne (exh. cat.). Philadelphia: Philadelphia Museum of Art, 1996.

Loran, Erle. Cézanne's Composition. Berkeley and Los Angeles: University of California Press, 1944.

Rewald, John. Cézanne: A Biography. New York: Harry N. Abrams, 1986.

Rubin, William, ed. Cézanne: The Late Work (exh. cat.). New York: The Museum of Modern Art, 1977.

Marc Chagall

Chagall, Marc. Marc Chagall: My Life, My Dream, Berlin and Paris, 1922–1940. Trans. Elisabeth Abbott. New York: Prestel, 1960.

Compton, Susan. Chagall (exh. cat.). London: Royal Academy of Arts, 1985.

Kagan, Andrew. Marc Chagall. New York: Abbeville Press, 1989.

Rosensaft, Jean Bloch. *Chagall and the Bible* (exh. cat., Jewish Museum, New York) New York: Universe Books. 1987.

John Chamberlain

Auping, Michael. *John Chamberlain: Reliefs 1960–1982* (exh. cat.). Sarasota, Fla.: John and Mable Ringling Museum of Art, 1983.

Sylvester, Julie. John Chamberlain: A Catalogue Raisonné of the Sculpture, 1954–1985. New York: Hudson Hills Press, in association with The Museum of Contemporary Art, Los Angeles, 1986.

Tuchman, Phyllis. "An Interview with John Chamberlain." *Artforum* (New York) 10, no. 6 (February 1972), pp. 38–43.

Francesco Clemente

Dennison, Lisa, ed. Clemente (exh. cat.). New York: Guggenheim Museum, 1999.

Katz, Vincent. Life is Paradise: The Portraits of Francesco Clemente. New York: Power House Books, 1999.

Percy, Ann, and Raymond Foye. Francesco Clemente: Three Worlds (exh. cat.). Philadelphia: Philadelphia Museum of Art, 1990.

Joseph Cornell

Ashton, Dore. A Joseph Cornell Album. New York: Viking Press, 1974.

Bonk, Ecke, Lynda Roscoe Hartigan, et al. *Joseph Cornell, Marcel Duchamp: In Resonance* (exh. cat.). Houston, Tex.: Menil Foundation: Philadelphia: Philadelphia Museum of Art, 1999.

Caws, Mary Ann, ed. *Joseph Cornell's Theater of the Mind: Selected Diaries, Letters, and Files.* New York: Thames and Hudson, 1993.

McShine, Kynaston, ed. Joseph Cornell (exh. cat.). New York: The Museum of Modern Art, 1980.

Solomon, Deborah. *Utopia Parkway: The Life and Work of Joseph Cornell*. New York: Farrar, Strauss and Giroux, 1997.

Willem de Kooning

Cummings, Paul, Jörn Merkert, and Clair Stoullis. Willem de Kooning: Drawings, Paintings, Sculpture (exh. cat.). New York: Whitney Museum of American Art, 1983.

Hess, Thomas B. Willem de Kooning. New York: George Braziller, 1959.

Prather, Marla, David Sylvester, and Richard Shiff. Willem de Kooning: Paintings (exh. cat.). Washington, D.C.: National Gallery of Art; New Haven: Yale University Press, 1994.

Rosenberg, Harold. Willem de Kooning. New York: Harry N. Abrams, 1974.

Yard, Sally. Willem de Kooning. New York: Rizzoli, 1997.

Robert Delaunay

Buckberrough, Sherry A. Robert Delaunay: The Discovery of Simultaneity. Ann Arbor, Mich.: UMI Research Press, 1978.

Delaunay, Robert, and Sonia Delaunay. *The New Art of Color: The Writings of Robert and Sonia Delaunay*. Arthur A. Cohen, ed. Trans. David Shapiro and Arthur A. Cohen. New York: Crown, 1978.

Hoog, Michel. R. Delaunay. Trans. Alice Sachs. New York: Crown Publishers, 1976.

Vriesen, Gustav, and Max Imdahl. *Robert Delaunay: Light and Color*. Trans. Maria Pelikan. New York: Harry N. Abrams, 1967.

Walter De Maria

Beeren, W.A.L. *Walter De Maria* (exh. cat.). Rotterdam: Museum Boymans-van-Beuningen, 1988. In Dutch and English.

De Maria, Walter. "The Lightning Field." Artforum (New York) 18, no. 8 (April 1980), pp. 52-59.

Meyer, Franz. Walter De Maria (exh. cat.). Frankfurt am Main: Museum für Moderne Kunst, 1991. In German and English.

Jim Dine

Celant, Germano, Clare Bell, et al. *Jim Dine: Walking Memory, 1959–1969* (exh. cat.). New York: Guggenheim Museum, 1999.

Haskell, Barbara. Blam: The Explosion of Pop, Minimalism, and Performance 1958–1964 (exh. cat.).

New York: Whitney Museum of American Art, 1984.

Kirby, Michael. Happenings: An Illustrated Anthology. New York: Dutton, 1966.

Livingstone, Marco. Jim Dine: The Alchemy of Images. New York: Monacelli Press, 1998.

Shapiro, David. Jim Dine: Painting What One Is. New York: Harry N. Abrams, 1981.

Stan Douglas

Augaitis, Dalina, Stan Douglas, George Wagner, and William Wood. *Stan Douglas* (exh. cat.). Vancouver: Vancouver Art Gallery, 1999.

Birnbaum, Daniel. "Daily Double: The Art of Stan Douglas." *Artforum* (New York) 38, no. 5 (January 2000), pp. 90–95.

Fiske, John, and Scott Watson. *Stan Douglas: Monodramas and Loops* (exh. cat.). Vancouver: Fine Arts Gallery, University of British Columbia, 1992.

Glover, Carol J., Diana Thater, and Scott Watson, et al. Stan Douglas. London: Phaidon Press, 1998.

Jean Dubuffet

Jean Dubuffet: Paintings (exh. cat., Tate Gallery, London). London: Arts Council of Great Britain, 1966.

Rowell, Margit. Jean Dubuffet: A Retrospective (exh. cat.). New York: Guggenheim Museum, 1973.

Selz, Peter Howard. The Work of Jean Dubuffet (exh. cat.). New York: The Museum of Modern Art, 1962.

Marcel Duchamp

Damisch, Hubert. "The Duchamp Defense." October (Cambridge, Mass.), no. 10 (fall 1979), pp. 5-28.

D'Harnoncourt, Anne, and Kynaston McShine. *Marcel Duchamp* (exh. cat.). Philadelphia: Philadelphia Museum of Art; New York: The Museum of Modern Art, 1973.

Schwarz, Arturo. The Complete Works of Marcel Duchamp. New York: Greenidge Editions, 1996.

Tomkins, Calvin. Marcel Duchamp: A Biography. New York: Henry Holt, 1996.

Fischli/Weiss

Armstrong, Elizabeth, Arthur Danto, and Boris Groys. *Peter Fischli and David Weiss: In a Restless World* (exh. cat.). Minneapolis: Walker Art Center, 1996.

Bossé, Laurence, and Boris Groys. *Peter Fischli and David Weiss* (exh. cat.). Cologne: Verlag der Buchhandlung Walther König; Paris: Musée d'Art Moderne de la Ville de Paris. 1998.

"Collaboration Peter Fischli/David Weiss." Parkett (Zurich), no. 17 (1988), pp. 20–87. Special issue with

essays by Berhard Johannes Blume, Germano Celant, Bice Curiger, Patrick Frey, Karen Marta, Jeanne Silverthorne, and Sidra Stich.

Dan Flavin

Dan Flavin, fluorescent light, etc (exh. cat.). Ottawa: National Gallery of Canada, 1969.

Flavin, Dan. "'in daylight or cool white.' an autobiographical sketch." *Artforum* (Los Angeles) 4, no. 4 (December 1965), pp. 21–24.

Poetter, Jochen, Madeleine Deschamps, et al. new uses for fluorescent light with diagrams, drawings and prints from Dan Flavin (exh. cat.). Staatliche Kunsthalle: Baden-Baden, 1989. In German and English.

Ragheb, J. Fiona, ed. *Dan Flavin: Architecture of Light* (exh. cat., Deutsche Guggenheim Berlin). New York: Guggenheim Museum, 1999.

Lucio Fontana

Ballo, Guido. Lucio Fontana. New York: Praeger, 1971.

Billeter, Erika. *Lucio Fontana, 1899–1968: A Retrospective* (exh. cat.). New York: Guggenheim Museum, 1977. Cotter, Holland. "Fontana's Post-Dada Operatics." *Art in America* (New York) 75, no. 3 (March 1987), pp. 80–85.

Whitfield, Sarah. Lucio Fontana (exh. cat.). London: Hayward Gallery, 1999.

Paul Gauguin

Becker, Christop, ed. *Paul Gauguin: Tahiti* (exh. cat., Staatsgalerie Stuttgart). Ostfildern-Ruit: G. Hatje, 1998. Bretell, Richard, Francoise Cachin, et al. *The Art of Paul Gauguin* (exh. cat.). Washington, D.C.: National Gallery of Art 1988.

Eisenman, Stephen. Gauguin's Skirt. New York: Thames and Hudson, 1997.

Solomon-Godeau, Abigail. "Going Native." *Art in America* (New York) 77, no. 7 (July 1989), pp. 118–29. Varnedoe, Kirk. "Gauguin." In "*Primitivism*" in *Twentieth-Century Art: Affinity of the Tribal and the Modern* (exh. cat.). Vol. 1. William Rubin, ed. New York: The Museum of Modern Art, 1984, pp. 179–209.

Alberto Giacometti

Fletcher, Valerie J., Silvio Berthoud et al. *Alberto Giacometti 1901–1966* (exh. cat., Hirshhorn Museum and Sculpture Garden). Washington, D.C.: Smithsonian Institution Press, 1988.

Krauss, Rosalind E. "Giacometti." In "*Primitivism*" in *Twentieth-Century Art: Affinity of the Tribal and the Modern* (exh. cat.). Vol. 2. William Rubin, ed. New York: The Museum of Modern Art, 1984, pp. 503–33. Lord, James. *Giacometti: A Biography*. New York: Farrar, Strauss and Giroux, 1985.

Schneider, Angela, ed. *Alberto Giacometti: Sculpture, Paintings, Drawings*. New York: Prestel, 1997. Sylvester, David. *Looking at Giacometti*. New York: Henry Holt, 1996.

Gilbert and George

"Collaboration Gilbert and George." *Parkett* (Zurich), no. 14 (1987), pp. 24–83. Special issue with essays by Duncan Fallowell, Mario Codognato, Jeremy Cooper, Demosthenes Davvetas, Wolf Jahn, and Paul Taylor. Jahn, Wolf. *The Art of Gilbert and George, or: An Aesthetic of Existence*. London: Thames and Hudson, 1989. Ratcliff, Carter. *Gilbert and George: The Complete Pictures, 1971–1985*. New York: A. McCall, 1986.

Richardson, Brenda. Gilbert and George (exh. cat.). Baltimore: Baltimore Museum of Art, 1984.

Violette, Robert, ed. The Words of Gilbert and George. London: Violette Editons, 1998.

Natalia Goncharova

Bowlt, John E., ed. and trans. Russian Art of the Avant-Garde: Theory and Criticism 1902–1934.

New York: Thames and Hudson, 1988.

Bowlt, John, Matthew Drutt, et al. *Amazons of the Avant-Garde* (exh. cat.). New York: Guggenheim Museum, 2000.

Chamot, Mary. Goncharova: Stage Designs and Paintings. London: Oresko Books, 1979.

Dabrowski, Magdalena. "The Formation and Development of Rayonism." *Art Journal* (New York) 34, no. 3 (spring 1975), pp. 200–7.

Gray, Camilla. *The Russian Experiment in Art, 1863–1922*. Revised by Marian Burleigh-Motley. New York: Thames and Hudson, 1986.

Felix Gonzalez-Torres

Avgikos, Jan. "This is My Body: Felix Gonzalez-Torres." *Artforum* (New York) 29, no. 6 (February 1991), pp. 79–83.

"Collaboration Felix Gonzalez-Torres." *Parkett* (Zurich), no. 39. (1994), pp. 24–69. Special issue with essays by Nancy Spector, Simon Watney, and Susan Tallman.

Corrin, Lisa. Felix Gonzalez-Torres (exh. cat.). London: Serpentine Gallery, 2000.

Nikas, Robert. "Felix Gonzalez-Torres: All the Time in the World." Flash Art (Milan)

24, no. 161 (November/December 1991), pp. 86-89. Interview.

Spector, Nancy. Felix Gonzalez-Torres (exh. cat.). New York: Guggenheim Museum, 1995.

Peter Halley

Halley, Peter. Collected Essays 1981-1987. New York: Sonnabend Gallery, 1989.

Miller, John. "Lecture Theatre: Peter Halley's Geometry and the Social." *Artscribe International* (London), no. 74 (March/April 1989), pp. 64–65.

Reynolds, Cory, ed. Peter Halley: Maintain Speed. New York: Distributed Art Publishers, 2000.

Wei, Lilly, "Talking Abstract: Part Two." Art in America (New York) 75, no. 12 (December 1987), pp. 120, 171.

Ann Hamilton

Cooke, Lynne, and Karen Kelly, eds. *Ann Hamilton: tropos* (exh. cat.). New York: Dia Center for the Arts, 1995.

Cottingham, Laura. "Ann Hamilton: A Sense of Imposition." Parkett (Zurich), no. 30 (1991), pp. 130-34.

Nesibtt, Judith, and Neville Wakefield. Ann Hamilton: mneme (exh. cat.). Liverpool: Tate Gallery, 1994.

Rogers, Sara J. The Body and the Object: Ann Hamilton, 1984–1996 (exh. cat.) Columbus, Ohio: Wexner Center for the Arts, 1996.

Stewart, Susan. Ann Hamilton. San Diego: Museum of Contemporary Art, 1991.

Eva Hesse

Baier, Lesley K, ed. Eva Hesse: A Retrospective (exh. cat.). New Haven: Yale University Art Gallery and Yale University Press, 1992.

Barrette, Bill. Eva Hesse: Sculpture. New York: Timken Publishers, 1989.

Chave, Anna. "Striking Poses: The Absurdist Theatrics of Eva Hesse." In *Sculpture and Photography: Envisioning The Third Dimension*. Geraldine A. Johnson, ed. New York: Cambridge University Press, 1998, pp. 166–80.

Lippard, Lucy. Eva Hesse. New York: Da Capo Press, 1976.

Nemser, Cindy. "An Interview with Eva Hesse." Artforum (New York) 8, no. 9 (May 1970), pp. 59-63.

Wagner, Anne M. Three Artists (Three Women): Modernism and the Art of Hesse, Krasner, and O'Keeffe. Berkeley: University of California Press, 1996.

Hans Hofmann

Goodman, Cynthia. Hans Hofmann. New York: Abbeville Press, 1986.

Goodman, Cynthia, Irving Sandler, et al. *Hans Hofmann* (exh. cat.). New York: Whitney Museum of American Art. 1990.

Greenberg, Clement. Hans Hofmann. Paris: G. Fall, 1961.

Hofmann, Hans. Search for the Real and Other Essays. Sarah T. Weeks and Barlett Hays, eds. Cambridge, Mass., MIT Press, 1967.

Jaffe, Irma B. "A Conversation with Hans Hofmann." *Artforum* (New York) 9, no. 5 (January 1971), pp. 34–39.

Jenny Holzer

"Collaboration Jenny Holzer." Parkett (Zurich), no. 40/41 (1994), pp. 78-97. Essay by Joan Simon.

Foster, Hal. "Subversive Signs." Art in America (New York) 70, no. 11 (November 1982), pp. 88-92.

Holzer, Jenny. Writing = Schriften. Noemi Smolik, ed. Ostfildern-Ruit: Cantz, 1996. In German and English.

Joselit, David, Renata Salecl, and Joan Simon. Jenny Holzer. London: Phaidon Press. 1998.

Waldman, Diane. Jenny Holzer (exh. cat.). New York: Guggenheim Museum, 1989.

Rebecca Horn

Celant, Germano. "Rebecca Horn: Dancing on an Egg." *Artforum* (New York) 23, no. 2 (October 1984), pp. 48–55.

Celant, Germano, Nancy Spector, et al. *Rebecca Horn* (exh. cat.). New York: Guggenheim Museum, 1995. "Collaboration Rebecca Horn." *Parkett* (Zurich), no. 40–41 (1994), pp. 98–117. Special issue with essays by Gilbert Lascault and Werner Spies.

Haenlein, Carl, ed. *Rebecca Horn: The Glance of Infinity* (exh. cat.). Zurich: Kestner Gesellschaft; New York: Scalo, 1997.

Roni Horn

Bossé, Laurence, Nancy Spector, et al. *Events of Relation* (exh. cat.). Paris: Musée d'Art Moderne de la Ville de Paris, 1999. In French and English.

"Collaboration Roni Horn." *Parkett* (Zurich), no. 54 (1998/1999), pp. 26–73. Special issue with essays by Jerry Gorovoy, Styrmir Gunnarsson, Collier Schorr, Nancy Spector, and Diane Lewis.

Goldstein, Ann, and Klaus Kertess. *Roni Horn* (exh. cat.). Los Angeles: The Museum of Contemporary Art. 1990.

Howard, Jan. Roni Horn: Inner Geography (exh. cat.). Baltimore: Baltimore Museum of Art, 1994.

Neri, Louise, Lynne Cooke, and Thierry de Duve. Roni Horn. London: Phaidon Press, 2000.

Vasily Kandinsky

Barnett, Vivian Endicott. Kandinsky at the Guggenheim. New York: Guggenheim Museum, 1983.

Barnett, Vivian Endicott, Christian Derouet, et al. *Kandinsky in Paris: 1934–1944* (exh. cat.). New York: Guggenheim Museum, 1985.

Dabrowski, Magdalena. Kandinsky Compositions (exh. cat.). New York: The Museum of Modern Art, 1995.

Lindsay, Kenneth C., and Peter Vergo, eds. *Kandinsky: Complete Writings on Art.* 2 vols. New York: Da Capo Press, 1994.

Long, Rose-Carol Washton. *Kandinsky: The Development of an Abstract Style*. New York: Oxford University Press, 1980.

Mike Kelley

"Collaboration Mike Kelley." *Parkett* (Zurich), no. 31 (1992), pp. 62–107. Special issue with essays by Diedrich Diederichsen, Trevor Fairbrother, Bernard Marcadé, Lane Relyea, and Julie Sylvester.

Krauss, Rosalind, E. "Georges Bataille's Concept of Abjection and the Art of Cindy Sherman and Mike Kelley." *October* (Cambridge, Mass.), no. 78 (fall 1996), pp. 89–105.

Lee, Pamela M. "Mike Kelley's Name Dropping." Word & Image (London) 11, no. 3 (July–September 1995), pp. 300–19.

Singerman, Howard, and John Miller. Mike Kelley: Three Projects: Half a Man, From My Institution to Yours, Pay for Your Pleasure (exh. cat.). Chicago: The Renaissance Society, 1988.

Sussman, Elizabeth, ed. *Mike Kelley: Catholic Tastes* (exh. cat.). New York: Whitney Museum of American Art, 1993.

Welchman, John C., Isabelle Graw, and Anthony Vidler. Mike Kelley. London: Phaidon Press, 1999.

Ellsworth Kelly

Bois, Yve-Alain. *Ellsworth Kelly: The Early Drawings, 1948–1955* (exh. cat.). Cambridge, Mass.: Harvard University Art Museums; Winterthur: Kunstmuseum Winterthur, 1999.

Bois, Yve-Alain, Jack Cowart, and Alfred Pacquement. *Ellsworth Kelly: The Years in France, 1948–1954* (exh. cat.). Washington, D.C.: National Gallery of Art, 1992.

Coplans, John. Ellsworth Kelly. New York: Harry N. Abrams, 1973.

Sims, Patterson, and Emily Rauh Pulitzer. *Ellsworth Kelly: Sculpture* (exh. cat.). New York: Whitney Museum of American Art, 1982.

Waldman, Diane. Ellsworth Kelly: A Retrospective (exh. cat.). New York: Guggenheim Museum, 1996.

Anselm Kiefer

Cacciari, Massimo, and Germano Celant. *Anselm Kiefer* (exh. cat., Museo Correr, Venice). Milan: Charta, 1997. In Italian and English.

Huyssen, Andreas. "Kiefer in Berlin." October (Cambridge, Mass.), no. 62 (fall 1992), pp. 84-101.

— . "Anselm Kiefer: The Terror of History, the Temptation of Myth." *October* (Cambridge, Mass.), no. 48 (spring 1989), pp. 25–45.

Rosenthal, Mark. Anselm Kiefer (exh. cat.). Chicago: Art Institute of Chicago: Philadelphia: Philadelphia Museum of Art: 1987.

Ernst Ludwig Kirchner

Deutsche, Rosalyn. "Alienation in Berlin: Kirchner's Street Scenes." *Art in America* (New York) 71, no. 1 (January 1983), pp. 64–72.

Gordon, Donald E. Ernst Ludwig Kirchner: A Retrospective Exhibition (exh. cat.). Boston: Museum of Fine Arts, 1968.

-----. Ernst Ludwig Kirchner. Cambridge, Mass.: Harvard University Press, 1968.

Masheck, Joseph. "The Horror of Bearing Arms: Kirchner's *Self-Portrait as a Solider*: The Military Mystique and the Crisis of World War I (With a Slip-of-the-Pen by Freud)." *Artforum* (New York) 19, no. 4 (December 1980), pp. 56–61.

Paul Klee

Aichele, K. Porter. "Paul Klee's Operatic Themes and Variations." *The Art Bulletin* (New York) 68, no. 3 (September 1986), pp. 450–66.

Dennison, Lisa, and Andrew Kagan. *Paul Klee at the Guggenheim Museum* (exh. cat.). New York: Guggenheim Museum, 1993.

Kagan, Andrew. Paul Klee: Art and Music. Ithaca and London: Cornell University Press, 1983.

Lanchner, Carolyn, ed. Paul Klee (exh. cat.). New York: The Museum of Modern Art, 1987.

Werckmeister, O.K. The Making of Paul Klee's Career 1914–1920. Chicago: University of Chicago Press, 1989.

Yves Klein

McEvilley, Tom, and Nan Rosenthal, eds. Yves Klein (exh. cat.). Houston: Rice University, Institute for the Arts, 1982.

McShine, Kynaston, Pierre Descargues, and Pierre Restany. Yves Klein (exh. cat.). New York: The Jewish Museum, 1967.

Restany, Pierre. Yves Klein. Trans. John Shepley. New York: Harry N. Abrams, 1982.

Stich, Sidra. Yves Klein (exh. cat., Ludwig Museum, Cologne). Ostfildern-Ruit and New York: Cantz, 1994.

Franz Kline

Anfam, David. Franz Kline: Black & White, 1950–1961 (exh. cat.). Houston: Menil Collection in association with Fine Art Press, 1994.

Gaugh, Harry F. Franz Kline: The Color Abstractions (exh. cat.). Washington, D.C.: Phillips Collection, 1979.

——. The Vital Gesture: Franz Kline (exh. cat., Cincinnati Art Museum). New York: Abbeville Press, 1985.

Kingsley, April. "Franz Kline: Out of Sight, Out of Mind." Arts Magazine (New York) 60, no. 9

(May 1986), pp. 41–45.

Oskar Kokoschka

Calvocoressi, Richard, and Katharina Schulz. Oskar Kokoschka (exh. cat.). New York: Guggenheim Museum, 1986.

Kokoschka, Oskar. My Life. Trans. David Britt. New York: Macmillan, 1974.

Strobl, Alice, and Alfred Weidinger. Oskar Kokoschka, Works on Paper: The Early Years, 1897–1917 (exh. cat.). New York: Guggenheim Museum, 1994.

Joseph Kosuth

Hapgood, Susan. "Joseph Kosuth: Language and its (Dis)contents." *Contemporanea* (Bologna) 2, no. 7 (October 1989), pp. 44–49.

Joseph Kosuth: The Making of Meaning. Selected Writings and Documentation of Investigations on Art Since 1965 (exh. cat.). Stuttgart: Staatsgalerie. 1981.

Kosuth, Joseph. Art After Philosophy and After: Collected Writings, 1966–1990. Gabriele Guercio, ed. Cambridge, Mass.: MIT Press, 1991.

Rose, Arthur R. [pseudonym for Kosuth]. "Four Interviews with Barry, Huebler, Kosuth, Weiner." *Arts Magazine* (New York) 43, no. 4 (February 1969), pp. 22–23.

Jannis Kounellis

Jacob, Mary Jane, and Thomas McEvilley. *Jannis Kounellis* (exh. cat.). Chicago: Museum of Contemporary Art, 1986.

Jones, Alan. "Kounellis Unbound: Dialogue of the Old World and the New." *Arts Magazine* (New York) 64, no. 6 (February 1990), pp. 21–22.

Moure, Gloria, ed. Kounellis. New York: Rizzoli, 1990.

Barbara Kruger

Goldstein, Ann, ed. *Barbara Kruger* (exh. cat.). Los Angeles: The Museum of Contemporary Art; Cambridge, Mass.: MIT Press, 1999.

Kruger, Barbara. Remote Control: Power, Cultures, and the World of Appearances. Cambridge, Mass.: MIT Press, 1993.

Linker, Kate. Love for Sale: The Words and Pictures of Barbara Kruger. New York: Harry N. Abrams, 1990.

Mitchell, W. J. T. "An Interview with Barbara Kruger." *Critical Inquiry* (Chicago) 17, no. 2 (winter 1991) pp. 434–48.

Owens, Craig. "The Medusa Effect, or, The Specular Ruse." *Art in America* (New York) 72, no. 1 (January 1984), pp. 97–105.

František Kupka

Henderson, Linda Dalrymple. "An Alternative View Among the Cubists: The Theosophist Kupka." In *The Fourth Dimension and Non-Euclidean Geometry in Modern Art.* Princeton, N.J.: Princeton University Press, 1983, pp. 103–9.

——. "X Rays and the Quest for Invisible Reality in the Art of Kupka, Duchamp, and the Cubists." Art Journal (New York), no. 47 (winter 1988), pp. 323–40.

Kosinski, Dorothy, ed. *Painting the Universe: František Kupka, Pioneer in Abstraction* (exh. cat., Dallas Museum of Art). Ostfildern-Ruit: Hatje, 1997.

Mladek, Meda, and Margit Rowell. František Kupka, 1871–1957: A Retrospective (exh. cat.). New York: Guggenheim Museum, 1975.

Wifredo Lam

Day, Holliday T., and Suzanne Garrigues. "Wifredo Lam 1902–1982." In *Art of the Fantastic: Latin America, 1920–1987* (exh. cat.). Bloomington, Ind.: Indianapolis Museum of Art, 1987, pp. 103–6.

Fouchet, Max-Pol. Wifredo Lam. New York: Rizzoli, 1976.

Sims, Lowery. "Wifredo Lam: Transpositions of the Surrealist Proposition in the Post–World War II Era." *Arts Magazine* (New York) 60, no. 4 (December 1985), pp. 21–25.

Yau, John. "Please Wait by the Coatroom: Wifredo Lam in the Museum of Modern Art." *Arts Magazine* (New York) 63, no. 4 (December 1988), pp. 56–59.

Fernand Léger

Green, Christopher. Léger and the Avant-Garde. New Haven and London: Yale University Press, 1976.

Kosinski, Dorothy, ed. *Fernand Léger, 1911–1924: The Rhythm of Modern Life* (exh. cat., Kunstmuseum Wolfsburg). Munich and New York: Prestel, 1994.

Lanchner, Caroline, Jodi Hauptman, et al. Fernand Léger (exh. cat.). New York: The Museum of Modern Art, 1998.

Serota, Nicholas, ed. Fernand Léger: The Later Years (exh. cat., Whitechapel Art Gallery, London). Munich: Prestel-Verlag, 1987.

Sol LeWitt

Batchelor, Daivd, Rosalind E. Krauss, et al. *Sol LeWitt: Structures 1962–1993* (exh. cat.). Oxford: The Museum of Modern Art, 1993.

Garrels, Gary, ed. Sol LeWitt: A Retrospective (exh. cat.). San Francisco: San Francisco Museum of Modern Art; New Haven: Yale University Press, 2000.

Kaiser, Franz, and Trevor Fairbrother. *Sol Lewitt: Drawings 1958–1992* (exh. cat.). The Hague, Netherlands: Haags Gemeentemuseum, 1992.

Sol Lewitt, Twenty-Five Years of Wall Drawings, 1968–1993 (exh. cat.). Andover, Mass.: Addison Gallery of American Art, Phillips Academy; Seattle: University of Washington Press, 1993.

Roy Lichtenstein

Alloway, Lawrence. Lichtenstein. New York: Abbeville Press, 1983.

Coplans, John, ed. Roy Lichtenstein. New York: Praeger, 1972.

Swenson, G. R. "What Is Pop Art? Answers from Eight Painters, Part I." *Art News* (New York) 62, no. 3 (November 1963), pp. 24–27.

Waldman, Diane. Roy Lichtenstein (exh. cat.). New York: Guggenheim Museum, 1993.

El Lissitzky

Debbaut, Jan, Caroline de Bie, et al. *El Lissitzky, 1890–1941: Architect, Painter, Photographer, Typographer* (exh. cat., Van Abbemuseum, Eindhoven). London: Thames and Hudson, 1990.

Lissitzky, El. About Two Squares: In Six Constructions: A Suprematist Tale. Cambridge, Mass.: MIT Press, 1991.

Lissitzky-Küppers, Sophie, ed. *El Lissitzky: Life, Letters, Texts*. Trans. Helene Aldwinckle and Mary Whittall. London: Thames and Hudson, 1980.

Nisbet, Peter. El Lissitzky, 1890–1941 (exh. cat.). Cambridge, Mass.: Harvard University Art Museums, 1987. Tupitsyn, Margarita, ed. El Lissitzky: Beyond the Abstract Cabinet. New Haven: Yale University Press, 1999.

Richard Long

Brettell, Richard, and Dana Friis-Hansen. *Richard Long: Circles, Cycles, Mud Stones* (exh. cat.). Houston: Contemporary Arts Museum, 1996.

Fuchs, R. H. *Richard Long* (exh. cat.). New York: Guggenheim Museum; London: Thames and Hudson, 1986.

Long, Richard. From Time to Time. Ostfildern-Ruit: Cantz, 1997.

Richard Long: Walking in Circles (exh. cat., Hayward Gallery, London). New York: George Braziller, 1991.

Morris Louis

Elderfield, John. Morris Louis (exh. cat.). New York: The Museum of Modern Art, 1987.

Fried, Michael. Morris Louis. New York: Harry N. Abrams, 1971.

Greenberg, Clement. "Louis and Noland." Art International (Lugano) 4, no. 5 (May 1960), pp. 26–29.

Swanson, Dean. Morris Louis: The Veil Cycle (exh. cat.). Minneapolis: The Walker Art Center, 1977.

Upright, Diane. *Morris Louis: The Complete Paintings* (catalogue raisonné). New York: Harry N. Abrams. 1985.

Kazimir Malevich

Andersen, Troels. Malevich (exh. cat.). Amsterdam: Stedelijk Museum, 1970.

D'Andrea, Jeanne, ed. *Kazimir Malevich 1878–1935* (exh. cat.). Los Angeles: Armand Hammer Museum of Art and Cultural Center; Seattle: University of Washington Press, 1990.

Douglas, Charlotte. Kazimir Malevich. New York: Harry N. Abrams, 1994.

Hilton, Alison, Kazimir Malevich, New York: Rizzoli, 1992.

Milner, John. Kazimir Malevich and the Art of Geometry. New Haven: Yale University Press, 1996.

Edouard Manet

Cachin, Françoise, Charles S. Moffett, and Juliet Wilson Bareau. *Manet: 1832–1883* (exh. cat.). New York: Metropolitan Museum of Art, 1983.

Clark, Timothy J. *The Painting of Modern Life: Paris in the Art of Manet and His Followers*. Princeton, N.J.: Princeton University Press, 1999.

Fried, Michael. Manet's Modernism, or the Face of Painting in the 1860s. Chicago: University of Chicago Press, 1996.

Hamilton, George Heard. Manet and His Critics. New Haven: Yale University Press, 1954.

Robert Mangold

Gruen, John. "Robert Mangold: A Maker of Images—Nothing More and Nothing Less." *Art News* (New York) 86, no. 6 (summer 1987), pp. 132–38.

Shiff, Richard. Robert Mangold. London: Phaidon Press, 2000.

Singer, Susanna, and Alexander van Grevenstein, eds. *Robert Mangold: Schilderijen/Paintings 1964–1982*. Amsterdam: Stedelijk Museum, 1982. In Dutch and English.

Waldman, Diane. Robert Mangold (exh. cat.). New York: Guggenheim Museum, 1971.

Robert Mapplethorpe

Celant, Germano. Robert Mapplethorpe (exh. cat.). London: Hayward Gallery, 1996.

Danto, Arthur C. *Playing with the Edge: The Photographic Achievement of Robert Mapplethorpe*. Berkeley: University of California Press, 1996.

Indiana, Gary. "Robert Mapplethorpe." Bomb (New York), no. 22 (winter 1988), pp. 18-23. Interview.

Kardon, Janet, David Joselit, and Kay Larson. *Robert Mapplethorpe: The Perfect Moment* (exh. cat.). Philadelphia: Institute of Contemporary Art. University of Pennsylvania. 1989.

Franz Marc

Levine, Frederick S. The Apocalyptic Vision: The Art of Franz Marc as German Expressionism. New York: Harper & Row, 1979.

Moffitt, J. F. "Fighting Forms: The Fate of the Animals': The Occultist Origins of Franz Marc's 'Farbentheorie'." *Artibus et Historiae* (Venice), no. 12 (1986), pp. 107–126. In English.

Rosenthal, Mark. Franz Marc. Munich: Prestel, 1989.

Selz, Peter. German Expressionist Painting. Berkeley and Los Angeles: University of California Press, 1957.

Brice Marden

Kertess, Klaus. Brice Marden: Paintings and Drawings. New York: Harry N. Abrams, 1992.

Shearer, Linda. Brice Marden (exh. cat.). New York: Guggenheim Museum, 1975.

Smith, Roberta. "Brice Marden." In *Brice Marden: Paintings, Drawings and Prints 1975*–90 (exh. cat.). London: Whitechapel Art Gallery, 1981, pp. 45–53.

Yau, John. "A Vision of the Unsayable." In *Brice Marden: Recent Paintings & Drawings* (exh. cat.). London: Anthony d'Offay Gallery, 1988, pp. 5–17.

Agnes Martin

Alloway, Lawrence. "Agnes Martin." In Agnes Martin (exh. cat.). Philadelphia: Institute of Contemporary Art, 1973, pp. 9–12.

Ashton, Dore. "Agnes Martin." In Agnes Martin: Paintings and Drawings (exh. cat.). London: Hayward Gallery, 1977, pp. 7–14.

Haskell, Barbara, Rosalind E. Krauss, and Anna Chave. *Agnes Martin* (exh. cat.). New York: Whitney Museum of American Art, 1992.

McEvilley, Thomas. "Grey Geese Descending: The Art of Agnes Martin." *Artforum* (New York) 25, no. 10 (summer 1987), pp. 94–99.

Henri Matisse

Cowart, Jack, and Dominique Fourcade. *Henri Matisse: The Early Years in Nice, 1916–1930* (exh. cat.). Washington, D.C.: National Gallery of Art. 1986.

Elderfield, John. Henri Matisse: A Retrospective (exh. cat.). New York: The Museum of Modern Art, 1992.

Flam, Jack. Matisse: The Man and His Art, 1869-1918. Ithaca, N.Y.: Cornell University Press, 1986.

Schneider, Pierre. Matisse. Trans. Michael Taylor and Bridget S. Romer. New York: Rizzoli, 1984.

Spurling, Hilary. The Unknown Matisse: A Life of Henri Matisse, The Early Years, 1869–1908. New York: Knopf, 1998.

Gordon Matta-Clark

Diserens, Corrinne, ed. Gordon Matta-Clark (exh. cat.) Valencia: IVAM Centre Julio González, 1993.

Jacob, Mary Jane, ed. Gordon Matta-Clark: A Retrospective (exh. cat.) Chicago: Museum of Contemporary Art, 1985.

Lee, Pamela M. Object to Be Destroyed: The Work of Gordon Matta-Clark. Cambridge, Mass.: MIT Press. 2000.

Zevi, Adachiara. "The Meteor Gordon Matta-Clark: Anarchitecture as Action Architecture." L'Architettura (Rome) 44, no. 513–514 (July/August 1998). pp. 473–81. In English.

Mario Merz

Celant, Germano. The Knot: Arte Povera at P.S.1 (exh. cat.). Long Island City, N.Y.: Institute for Art and Urban Resources, 1985.

Corà, Bruno, and Mary Jane Jacob. *Mario Merz at MOCA* (exh. cat., The Museum of Contemporary Art, Los Angeles). Milan: Fabbri Editori, 1989.

Tisdall, Caroline. "'Materia': The Context of Arte Povera." In Emily Braun, ed., *Italian Art in the Twentieth Century: Painting and Sculpture, 1900–1988* (exh. cat., Royal Academy of Arts, London). Munich: Prestel 1989

Annette Messager

Conkleton, Sheryl, and Carol S. Eliel. *Annette Messager* (exh. cat.). Los Angeles: Los Angeles County Museum of Art; New York: The Museum of Modern Art, 1995.

Lebovici, Elisabeth. *Annette Messager: Faire Parade, 1971–95* (exh. cat.). Paris: Musée d'Art Moderne de la Ville de Paris, 1995. In French and English.

Leoff, Natasha. "Annette Messager." Journal of Contemporary Art (New York) 7, no. 2 (winter 1995), pp. 5–11.

Joan Miró

Dupin, Jacques. Joan Miró: Life and Work. Trans. Norbert Guterman. New York: Harry N. Abrams, 1962.

Dupin, Jacques, et al. Joan Miró: A Retrospective (exh. cat.). New York: Guggenheim Museum, 1987.

Rowell, Margit, and Rosalind E. Krauss. *Joan Miró: Magnetic Fields* (exh. cat.). New York: Guggenheim Museum, 1972.

Rowell, Margit, ed. *Joan Miró: Selected Writings and Interviews*. Trans. Paul Auster and Patricia Mathews. Boston: G.K. Hall, 1986.

Weelen, Guy. Miró. Trans. Robert Erich Wolf. New York: Harry N. Abrams, 1989.

Amedeo Modigliani

Hall, Douglas. Modigliani. London: Phaidon Press, 1998.

Hobhouse, Janet. "Amedeo Modigliani." In *The Bride Stripped Bare: The Artist and the Nude in the Twentieth Century.* New York: Weidenfeld & Nicolson, 1988, pp. 135–66.

Schmalenbach, Werner. Amedeo Modigliani: Paintings, Sculptures, Drawings (exh. cat., Kunstsammlung Nordrhein-Westfalen, Düsseldorf). Trans. David Britt, Caroline Beamish, et al. Munich: Prestel, 1990.

Sichel, Pierre. Modigliani: A Biography of Amedeo Modigliani. New York: Dutton, 1967.

László Moholy-Nagy

Caton, Joseph Harris. The Utopian Vision of Moholy-Nagy. Ann Arbor, Mich.: UMI Research Press, 1984.

Kostelanetz, Richard, ed. Moholy-Nagy: An Anthology. New York: Da Capo Press, 1991.

Moholy-Nagy, László. Vision in Motion. Chicago: P. Theobald, 1947.

Piet Mondrian

Blotkamp, Carel. Mondrian: The Art of Destruction. New York: Harry N. Abrams, 1995.

Bois, Yve-Alain, Joop Joosten, et al. *Piet Mondrian, 1872–1944* (exh. cat., National Gallery of Art, Washington, D.C.). Boston: Little, Brown and Company, 1994.

Carmean, E. A., Jr. Mondrian: The Diamond Compositions (exh. cat.). Washington, D.C.: National Gallery of Art, 1979.

Cheetham, Mark A. "The Mechanisms of Purity I: Mondrian" and "Purity as Aesthetic Ideology." In *The Rhetoric of Purity: Essentialist Theory and the Advent of Abstract Painting*. Cambridge and New York: Cambridge University Press, 1991, pp. 40–64, 102ff.

Krauss, Rosalind E. "Grids." In *The Originality of the Avant-Garde and Other Modernist Myths*. Cambridge, Mass., 1985, pp. 8–22.

Mondrian, Piet. The New Art—The New Life: The Collected Writings of Piet Mondrian. Ed. and trans. Harry Holtzman and Martin S. James. Boston: G.K. Hall, 1986.

Welsh, Robert P., Joop Joosten, et al. *Piet Mondrian, 1872–1944: Centennial Exhibition* (exh. cat.). New York: Guggenheim Museum, 1971.

Robert Morris

Berger, Maurice. Labyrinths: Robert Morris, Minimalism, and the 1960s. New York: Harper & Row, 1989.

Compton, Michael, and David Sylvester. Robert Morris (exh. cat.). London: Tate Gallery 1971.

Karmel. Pepe, and Maurice Berger. Robert Morris: The Felt Works (exh. cat.). New York: Grey Art Gallery and Study Center, New York University, 1989.

Krauss, Rosalind E., Maurice Berger, David Antin, et al. Robert Morris: the Mind/Body Problem (exh. cat.). New York: Guggenheim Museum, 1994.

Mayo, Marti. Robert Morris: Selected Works 1970–1980 (exh. cat.). Houston: Contemporary Arts Museum, 1982.

Morris, Robert. Continuous Project Altered Daily: The Writings of Robert Morris. Cambridge. Mass.: MIT Press; New York: Guggenheim Museum, 1993.

Robert Motherwell

Carmean, E. A., Jr. "Robert Motherwell's Spanish Elegies." *Arts Magazine* (New York) 50, no. 10 (June 1976), pp. 94–97.

Caws, Mary Ann. *Robert Motherwell: What Art Holds.* New York: Columbia University Press, 1996. Flam, Jack. *Motherwell.* New York: Rizzoli. 1991.

Gaugh, Harry F. "Elegy for an Exhibition." *Art News* (New York) 85, no. 3 (March 1985), pp. 71–75. Mattison, Robert Saltonstall. *Robert Motherwell: The Formative Years*. Ann Arbor, Mich.: UMI Research Press, 1987.

Bruce Nauman

Benezra, Neal, Kathy Halbreich, Robert Storr, et al. *Bruce Nauman* (exh. cat., Museo Nacional Centro de Arte Reina Sofía, Madrid). Minneapolis: Walker Art Center, 1994.

van Bruggen, Coosje. Bruce Nauman. New York: Rizzoli, 1988.

Livingston, Jane, and Marcia Tucker. *Bruce Nauman: Work from 1965 to 1972* (exh. cat.). Los Angeles: Los Angeles County Museum of Art, 1972.

Masséra, Jean-Charles, Vincent Labaume, Christine van Assche, et al. *Bruce Nauman* (exh. cat.). London: Hayward Gallery, 1998.

Richardson, Brenda. Bruce Nauman: Neons (exh. cat.). Baltimore: Baltimore Museum of Art, 1982.

Simon, Joan, and Jean-Christophe Ammann. *Bruce Nauman* (exh. cat.). London: Whitechapel Art Gallery, 1986.

Tucker, Marcia. "pheNAUMANology." Artforum (New York) 9, no. 4 (December 1970), pp. 38-44.

Louise Nevelson

Glimcher, Arnold B. Louise Nevelson. New York: Praeger, 1972.

Nevelson, Louise. *Dawns + Dusks: Louise Nevelson*, taped conversations with Diana MacKown. New York: Scribner. 1976.

Wilson, Laurie. Louise Nevelson: Iconography and Sources. New York: Garland, 1981.

Isamu Noguchi

Altshuler, Bruce. Isamu Noguchi. New York: Abbeville Press, 1994.

Ashton, Dore. *Noguchi, East and West*. With special photographs by Denise Browne Hare. New York: Knopf, 1992.

Grove, Nancy, and Diane Botnick. *The Sculpture of Isamu Noguchi, 1924–1979, A Catalogue.* New York and London: Garland, 1980.

Noguchi, Isamu. The Isamu Noguchi Garden Museum. New York: Harry N. Abrams, 1999.

Cady Noland

Avgikos, Jan. "Degraded World." *Artscribe International* (London), no. 78 (November/December 1989), pp. 54–57.

Bonami, Francesco. "Cady Noland: Claustrophobic Lawn." Flash Art (Milan) 31, no. 201 (summer 1998), pp. 122–25.

"Collaboration Cady Noland." *Parkett* (Zurich), no. 46 (1996), pp. 71–115. Essays by Lane Relyea, Robert Bogdan, Thyrza Nichols Goodeve, and Robert Nikas.

Relyea, Lane. "Hi-Yo Silver: Cady Noland's America." Artforum (New York) 31, no. 5 (January 1993), pp. 50-55.

Claes Oldenburg

van Bruggen, Coosje. Claes Oldenburg (exh. cat.). Frankfurt am Main: Museum für Moderne Kunst, 1991.

Celant, Germano, Dieter Koepplin, et al. *Claes Oldenburg: An Anthology* (exh. cat.). New York: Guggenheim Museum, 1995.

Celant, Germano. Claes Oldenburg, Coosje van Bruggen (exh. cat., Museo Correr, Venice). Milan: Skira 1999.

Rose, Barbara. Claes Oldenburg (exh. cat.). New York: The Museum of Modern Art, 1970.

Francis Picabia

Borràs, Maria Lluisa. Picabia. New York: Rizzoli, 1985.

Camfield, William A. Francis Picabia, His Art, Life and Times. Princeton, N.J.: Princeton University Press. 1979.

Felix, Zdenek, ed. Francis Picabia: The Late Works 1933–1953 (exh. cat., Deichtorhallen, Hamburg). Ostfildern-Ruit: Cantz. 1998.

Hultén, Pontus. *The Machine as Seen at the End of the Mechanical Age* (exh. cat.). New York: The Museum of Modern Art. 1968.

Pablo Picasso

Barr, Alfred H., Jr. Picasso: Fifty Years of His Art. New York: The Museum of Modern Art, 1946.

Daix, Pierre, and Joan Rosselet. *Picasso: The Cubist Years. A Catalogue Raisonné of the Paintings and Related Works.* Boston: New York Graphical Society, 1979.

Golding, John. Cubism: A History and an Analysis, 1907–1914. New York: G. Wittenborn, 1959.

Penrose, Roland, and John Golding, eds. Picasso in Retrospect. New York: Praeger, 1973.

Richardson, John. A Life of Picasso: Volume I, 1881–1906; Volume II: 1907–1917, The Painter of Modern Life. New York: Random House, 1991; 1996.

Schwarz, Herbert. *Picasso and Marie-Thérèse Walter, 1925–1927* (exh. cat.). Sillery, Quebec: Editions Isabeau, 1988.

Camille Pissarro

Brettell. Richard. "Pissarro, Cézanne, and the School of Pontoise." In *A Day in the Country: Impressionism and the French Landscape* (exh. cat.). Los Angeles: Los Angeles County Museum of Art, 1984.

-----. Pissarro and Pontoise: The Painter in a Landscape. New Haven: Yale University Press, 1990.

Lloyd, Christopher, ed. *Studies on Camille Pissarro*. London and New York: Routledge & Kegan Paul, 1986. Pissarro, Joachim. *Camille Pissarro*. New York: Rizzoli. 1992.

Michelangelo Pistoletto

Celant, Germano. *Pistoletto: Division and Multiplication of the Mirror* (exh. cat.). Long Island City, N.Y.: Institute for Contemporary Art, P.S. 1 Museum; Milan: Fabbri Editori, 1988.

-----. Pistoletto. Trans. Joachim Neugroschel. New York: Rizzoli, 1989.

Poli, Francesco. "Reflections Unlimited." *Contemporanea* (Bologna), no. 9 (December 1989), pp. 40–49. Schwabsky, Barry. "Pistoletto Through the Looking Glass: A Conversation on the Art of Subtraction." *Arts Magazine* (New York) 63, no. 4 (December 1988), pp. 36–41.

Jackson Pollock

Clark, Timothy J. "Jackson Pollock's Abstraction." In *Reconstructing Modernism: Art in New York, Paris, and Montreal 1945–1964.* Serge Guilbaut, ed. Cambridge, Mass.: MIT Press, 1990, pp. 172–238.

Landau, Ellen G. Jackson Pollock. New York: Harry N. Abrams, 1989.

O'Connor, Francis V., and Eugene Victor Thaw, eds. *Jackson Pollock: A Catalogue Raisonné of Paintings, Drawings and Other Works*. 4 vols. New Haven: Yale University Press, 1978.

Varnedoe, Kirk, and Pepe Karmel, eds. *Jackson Pollock: New Approaches* (exh. cat.). New York: The Museum of Modern Art, 1999.

Liubov Popova

Bowlt, John, Matthew Drutt, et al. *Amazons of the Avant-Garde* (exh. cat.). New York: Guggenheim Museum, 2000.

Dabrowski, Magdalena. Liubov Popova (exh. cat.). New York: The Museum of Modern Art, 1991.

Sarabianov, Dimitri, and Natalia Adaskina. *Liubov Popova*. Trans. Marian Schwartz. New York: Harry N. Abrams, 1990.

Martin Puryear

Benezra, Neal, and Robert Storr. *Martin Puryear* (exh. cat.). New York: Thames and Hudson; Chicago: Art Institute of Chicago, 1991.

Danto, Arthur C. "Martin Puryear, or the Quandaries of Craftsmanship." In *Embodied Meanings: Critical Essays & Aesthetic Meditations*. New York: Farrar, Strauss and Giroux, 1994, pp. 289–95.

Davies, Hugh M., and Helaine Posner. *Martin Puryear* (exh. cat.). Amherst, Mass.: University Gallery, University of Massachusetts at Amherst, 1984.

Robert Rauschenberg

Alloway, Lawrence. Robert Rauschenberg (exh. cat.). Washington, D.C.: National Collection of Fine Arts, Smithsonian Institution, 1976.

Feinstein, Roni. Robert Rauschenberg: The Silkscreen Paintings 1962–64 (exh. cat.). New York: Whitney Museum of American Art, 1990.

Hopps, Walter. *Robert Rauschenberg: The Early 1950s* (exh. cat., The Corcoran Gallery of Art, Washington, D.C.), Houston: The Menil Collection, 1991.

Hopps, Walter, Susan Davidson, et al. *Robert Rauschenberg: A Retrospective* (exh. cat.). New York: Guggeneheim Museum, 1997.

Rose, Barbara. An Interview with Robert Rauschenberg. New York: Vintage Books, 1987.

Tomkins, Calvin. Off the Wall: Robert Rauschenberg and the Art World of Our Time. Garden City. N.Y.: Doubleday & Co., 1980.

Ad Reinhardt

Bois, Yve-Alain, *Ad Reinhardt* (exh. cat., The Museum of Modern Art, New York). New York: Rizzoli, 1991. Lippard, Lucy. *Ad Reinhardt*. New York: Harry N. Abrams, 1981.

Reinhardt, Ad. Art as Art: The Selected Writings of Ad Reinhardt. Barbara Rose, ed. New York: Viking, 1975.

Gerhard Richter

Friedel, Helmut and Ulrich Wilmes, eds. Atlas of the Photographs, Collages and Sketches of Gerhard Richter (catalogue raisonné). New York: Distributed Art Publishers, 1997.

Nasgaard, Roald, Benjamin H.D. Buchloh, et al. *Gerhard Richter: Paintings* (exh. cat.). Chicago: Museum of Contemporary Art. 1988.

Richter, Gerhard. Gerhard Richter: The Daily Practice of Painting: Writings and Interviews, 1962–1993. Hans-Ulrich Obrist, ed. Trans. David Britt. London: Thames and Hudson, 1995.

Schwarz, Dieter. *Gerhard Richter: Drawings 1964–1999* (catalogue raisonné). Trans. David Galloway, et al. Winterthur: Kunstmuseum Winterthur; Düsseldorf: Richter Verlag, 1999.

Storr, Robert. Gerhard Richter: October 18, 1977 (exh. cat.). New York: The Museum of Modern Art, 2000.

Mark Rothko

Anfam, David. Mark Rothko: The Works on Canvas: Catalogue Raisonné. New Haven: Yale University Press; Washington, D.C.: National Gallery of Art, 1999.

Ashton, Dore. About Rothko. New York: Da Capo Press, 1996.

Chave, Anna. Mark Rothko: Subjects in Abstraction. New Haven: Yale University Press, 1989.

Waldman, Diane. Mark Rothko, 1903–1970: A Retrospective (exh. cat., Guggenheim Museum).

New York: Harry N. Abrams, 1978.

Weiss, Jeffrey S. Mark Rothko (exh. cat., National Gallery of Art, Washington, D.C.). New Haven: Yale University Press, 1998.

Henri Rousseau

Rubin, William, Roger Shattuck, Henri Béhar, et al. *Henri Rousseau* (exh. cat.). New York: The Museum of Modern Art, 1988.

Shattuck, Roger. The Banquet Years. New York: Random House, 1979.

Robert Ryman

Garrels, Gary. Robert Ryman (exh. cat.). New York: Dia Art Foundation, 1988.

Grimes, Nancy. "White Magic." Art News (New York) 85, no. 6 (summer 1986), pp. 86-92.

Spector, Naomi. Robert Ryman (exh. cat.). Amsterdam: Stedelijk Museum, 1974.

——. Robert Ryman (exh. cat.). London: Whitechapel Art Gallery, 1977.

Storr, Robert. *Robert Ryman* (exh. cat.). New York: The Museum of Modern Art; London: Tate Gallery, 1993. Waldman, Diane. *Robert Ryman* (exh. cat.). New York: Guggenheim Museum, 1972.

David Salle

Fuchs, Rudi, Frederic Tuten, and Arjen Mulder. *David Salle* (exh. cat.). Amsterdam: Stedelijk Museum, 1999. Liebmann, Lisa. *David Salle*. New York: Rizzoli, 1994.

Schjeldahl, Peter. Salle. New York: Elizabeth Avedon Editions/Vintage Contemporary Artists, 1987.

Tuten, Frederic. "David Salle: At the Edges." *Art in America* (New York) 85, no. 9 (September 1997), pp. 78–83.

Egon Schiele

Comini, Alessandra. Egon Schiele's Portraits. Berkeley and Los Angeles: University of California Press, 1974.

Dabrowski, Magdalena and Rudolf Leopold. *Egon Schiele: The Leopold Collection, Vienna* (exh. cat.). New York: The Museum of Modern Art, 1997.

Kallir, Jane. Egon Schiele: The Complete Works. New York: Harry N. Abrams, 1998.

——. Egon Schiele (exh. cat., National Gallery of Art, Washington, D.C.). New York: Harry N. Abrams, 1994.

Kurt Schwitters

Elderfield, John. Kurt Schwitters. New York: Thames and Hudson, 1985.

Meyer-Büser, Susanne, and Karin Orchard, eds. In the Beginning was Merz: From Kurt Schwitters to the Present Day (exh. cat., Sprengel-Museum, Hannover). Trans. Fiona Elliott. Ostfildern-Ruit: Cantz, 2000.

Richard Serra

Ferguson, Russell, ed. *Richard Serra: Sculpture, 1985–1998* (exh. cat.). Los Angeles: The Museum of Contemporary Art, 1998.

Foster, Hal, and Gordon Hughes, eds. Richard Serra. Cambridge, Mass.: MIT Press, 2000.

Güse, Ernst-Gerhard, ed. Richard Serra, New York: Rizzoli, 1987.

Krauss, Rosalind E., Laura Rosenstock, and Douglas Crimp. Richard Serra: Sculpture (exh. cat.).

New York: The Museum of Modern Art, 1986.

Taylor, Mark, Lynne Cooke, and Michael Govan. Richard Serra: Torqued Ellipses (exh. cat.).

New York: Dia Center for the Arts, 1997.

Weyergraf-Serra, Clara, and Martha Buskirk, eds. *The Destruction of Tilted Arc: Documents*. Cambridge, Mass.: MIT Press, 1991.

Georges Seurat

Broude, Norma, ed. Seurat in Perspective. Englewood Cliffs, N.J.: Prentice-Hall, 1978.

Herbert, Robert L. Georges Seurat, 1859-1891 (exh. cat.). New York: Metropolitan Museum of Art, 1991.

Leighton, John, and Richard Thomson. Seurat and the Bathers (exh. cat.). London: National Gallery, 1997.

Rewald, John. Seurat: A Biography. New York: Harry N. Abrams, 1990.

Smith, Paul. Seurat and the Avant-Garde. New Haven: Yale University Press, 1997.

Thomson, Richard. Seurat. London: Phaidon Press, 1990.

Gino Severini

Apollonio, Umbro, ed. Futurist Manifestos. Trans. Robert Brain, et al. New York: Thames and Hudson, 1973.

Fraquelli, Simonetta, and Christopher Green. *Gino Severini: From Futurism to Classicism* (exh. cat.). London: Hayward Gallery, 1999.

Hanson, Anne Coffin. Severini Futurista, 1912-1917 (exh. cat.). New Haven: Yale University Art Gallery, 1995.

Perloff, Marjorie. The Futurist Moment: Avant-Garde, Avant Guerre, and the Language of Rupture.

Chicago: University of Chicago Press, 1986.

Severini, Gino. The Life of a Painter: The Autobiography of Gino Severini. Trans. Jennifer Franchina. Princeton, N.J.: Princeton University Press, 1995.

Cindy Sherman

Cruz, Amada, Elizabeth A.T. Smith, and Amelia Jones. *Cindy Sherman: Retrospective* (exh. cat., The Museum of Contemporary Art, Los Angeles). New York: Thames and Hudson, 1997.

Danto, Arthur, Untitled Film Stills, New York: Rizzoli, 1990.

Krauss, Rosalind E. Cindy Sherman, 1975-1993. New York: Rizzoli, 1993.

Schampers, Karel, and Talitha Schoon, eds. *Cindy Sherman* (exh. cat.). Rotterdam: Museum Boymans-van Beuningen, 1996.

Schjeldahl, Peter, and Lisa Phillips. *Cindy Sherman* (exh. cat.). New York: Whitney Museum of American Art, 1987.

David Smith

Carmean, E. A., Jr. David Smith (exh. cat.). Washington, D.C.: National Gallery of Art, 1982.

Krauss, Rosalind E. *Terminal Iron Works: The Sculpture of David Smith*. Cambridge, Mass.: MIT Press. 1971.

Smith, David. David Smith by David Smith. Cleve Gray, ed. New York: Thames and Hudson, 1972.

Wilkin, Karen. David Smith. New York: Abbeville Press, 1984.

Kiki Smith

Bradley, Jessica. Kiki Smith (exh. cat.). Toronto: The Power Plant, 1994.

Isaak, JoAnna. Kiki Smith (exh. cat.). London: Whitechapel Art Gallery, 1995.

Posner, Helene. Kiki Smith. Boston: Bulfinch, 1998.

Shearer, Linda, and Claudia Gould. *Kiki Smith* (exh. cat.). Williamstown, Mass.: Williams College Museum of Art; Columbus, Ohio: Wexner Center for the Arts, 1992.

Robert Smithson

Hobbs, Robert. Robert Smithson: A Retrospective (exh. cat.). Ithaca, N.Y.: Herbert F. Johnson Museum of Art, Cornell University, 1983.

Smithson, Robert. "Insert: Robert Smithson, Hotel Palenque, 1969–72." *Parkett* (Zurich), no. 43 (1995), pp. 117–32.

——. Robert Smithson: The Collected Writings. Jack Flam, ed. Berkeley and Los Angeles: University of California Press, 1996.

Sobieszek, Robert A. Robert Smithson: Photoworks (exh. cat.). Los Angeles: Los Angeles County Museum of Art; Albuquerque: University of New Mexico Press, 1993.

Wakefield, Neville. "Yucatan is Elsewhere: On Robert Smithson's Hotel Palenque." *Parkett* (Zurich), no. 43 (1995), pp. 133–38.

Haim Steinbach

Dubost, Jean Pierre, Joshua Decter, and Trevor Smith. *Haim Steinbach* (exh. cat.). Klagenfurt: Kunsthalle Ritter Klagenfurt. 1995.

Goldstein, Ann, and Mary Jane Jacob. A Forest of Signs: Art in the Crisis of Representation (exh. cat., The Museum of Contemporary Art, Los Angeles). Cambridge, Mass.: MIT Press, 1989.

Morgan, Robert. Haim Steinbach (exh. cat.). Bordeaux: Musée d'Art Contemporain de Bordeaux, 1989.

Frank Stella

Fried, Michael. "Art and Objecthood." Artforum (New York) 5, no. 10 (summer 1967). Reprinted in Art and Objecthood: Essays and Reviews. Chicago: University of Chicago Press, 1998.

——. Three American Painters: Kenneth Noland, Jules Olitski, Frank Stella (exh. cat.). Cambridge, Mass.: Fogg Art Museum, Harvard University, 1965.

Guberman, Sidney. Frank Stella: An Illustrated Biography. New York: Rizzoli, 1995.

Rubin, William S. Frank Stella (exh. cat.). New York: The Museum of Modern Art, 1970.

Clifford Still

Auping, Michael. "Beyond the Sublime." In Abstract Expressionism: The Critical Developments.

New York: Harry N. Abrams, 1987, pp. 144-66.

Clyfford Still (exh. cat.). San Francisco: San Francisco Museum of Modern Art, 1976.

O'Neill, John P., ed. Clyfford Still (exh. cat.). New York: Metropolitan Museum of Art, 1979.

Sandler, Irving. "Clyfford Still." In *The Triumph of American Painting: A History of Abstract Expressionism*. New York: Harper and Row, 1970, pp. 158–174.

Antoni Tàpies

Agustí, Anna. Tàpies: The Complete Works, Volume 1: 1943–1960. Barcelona, 1989. Volume 2: 1961–1968. Barcelona: Fundacío Antoni Tàpies and Edicions Polígrafa, 1989; 1990.

Barrio-Garay, José Luis. Antoni Tàpies: Thirty-Three Years of his Work (exh. cat.). Buffalo, N.Y.: Albright-Knox Art Gallery, 1977.

Cembalest, Robin. "Master of Matter." Art News (New York) 89, no. 6 (summer 1990), pp. 142-47.

Giménez, Carmen, ed. Antoni Tàpies (exh. cat.). New York: Guggenheim Museum, 1995.

James Turrell

Adcock, Craig. James Turrell: The Art of Light and Space. Berkeley: University of California Press, 1990.

——. Mapping Spaces: A Topological Survey of the Work by James Turrell (exh. cat.). Basel: Kunsthalle Basel in association with Peter Blum Edition, New York, 1987.

Andrews, Richard. James Turrell: Sensing Space (exh. cat.). Seattle: Henry Art Gallery, 1992.

Birnbaum, Daniel, Georges Didi-Huberman, et al. *James Turrell: The Other Horizon* (exh. cat.). Vienna: MAK, Österreichisches Museum für Angewandte Kunst, 1998. In German and English.

Brown, Julia, ed. *Occluded Front: James Turrell* (exh. cat.). Los Angeles: The Museum of Contemporary Art and The Lapis Press, Larkspur Landing, Calif., 1985.

Herbert, Lynn M., John H. Leinhard, et al. *James Turrell: Spirit and Light* (exh. cat.). Houston: Contemporary Arts Museum, 1998.

Cy Twombly

Barthes, Roland. Cy Twombly: Paintings and Drawings 1965–1977 (exh. cat.). New York: Whitney Museum of American Art. 1979.

Szeemann, Harald, ed. Cy Twombly: Paintings, Works on Paper, Sculpture. Munich: Prestel, 1987.

Varnedoe, Kirk. Cy Twombly: A Retrospective (exh. cat.). New York: The Museum of Modern Art, 1994.

Vincent van Gogh

The Complete Letters of Vincent Van Gogh. 3 vols. Greenwich, Conn.: New York Graphic Society, 1958.

Pickvance, Ronald. Van Gogh in Saint-Rémy and Auvers (exh. cat.). New York: Metropolitan Museum of Art, 1986.

Rewald, John. *Post-Impressionism: From Van Gogh to Gauguin*. New York: The Museum of Modern Art, 1978.

Bill Viola

London, Barbara, ed. *Bill Viola: Installations and Videotapes* (exh. cat.). New York: The Museum of Modern Art. 1987.

Sellars, Peter, ed. Bill Viola (exh. cat.). New York: Whitney Museum of American Art, 1997.

Sparrow, Felicity. *Bill Viola: The Messenger* (exh. cat.). Durham: Chaplaincy to the Arts and Recreation in North East England. 1996.

Viola, Bill. Reasons for Knocking at an Empty House: Writings 1973–1994. Robert Violette, ed. Cambridge, Mass.: MIT Press. 1995.

Andy Warhol

Bourdon, David. Warhol. New York: Harry N. Abrams, 1989.

Crow, Thomas. "Saturday Disasters: Trace and Reference in Early Warhol." In *Reconstructing Modernism: Art in New York, Paris, and Montreal 1945–1964*. Serge Guilbaut, ed. Cambridge, Mass.: MIT Press, 1990, pp. 311–26.

Foster, Hal. "Death in America." October (Cambridge, Mass.), no. 75 (winter 1996), pp. 36-59.

McShine, Kynaston, ed. Andy Warhol: A Retrospective (exh. cat.). New York: The Museum of Modern Art, 1989.

Printz, Neil. Andy Warhol: Death and Disasters (exh. cat.). Houston, Tex.: Menil Collection and Fine Art Press. 1988.

Lawrence Weiner

Alberro, Alexander, David Batchelor, Benjamin H.D. Buchloh, et al. *Lawrence Weiner*. London: Phaidon Press, 1998.

Martin, Jean-Hubert. Werke und Rekonstruktionen/Works and Reconstructions: Lawrence Weiner (exh. cat.). Bern: Kunsthalle Bern, 1983.

Pelzer, Birgit. "The Statements/Sculptures of Lawrence Weiner." Trans. John Goodman. *October* (Cambridge, Mass.), no. 90 (fall 1999), pp. 77–108.

Rorimer, Anne. "Lawrence Weiner: Displacement." In *Robert Lehman Lectures on Contemporary Art.* No. 1. New York: Dia Center for the Arts, 1996, pp. 19–41.

Schwarz, Dieter. Lawrence Weiner: Books 1968–1989: Catalogue Raisonné. Cologne: Walter Konig; Villeurbanne: Le Nouveau Musée. 1989.

Weiner, Lawrence. Statements. New York: Seth Siegelaub, Lois Kellner Foundation, 1968.

Gilberto Zorio

Celant, Germano. The Knot: Arte Povera at P.S.1 (exh. cat.). Long Island City, N.Y.: Institute for Art and Urban Resources, 1985.

-----. Gilberto Zorio (exh. cat.). Valencia: IVAM Centre del Carme, 1991.

Eccher, Danilo, and Roberto Ferrari. *Gilberto Zorio* (exh. cat., Galleria Civica di Arte Contemporanea, Trento). Turin: Hopefulmonster, 1996.

Glossary of Terms

Starting dates for styles and art movements are given.

Abstract Expressionism (New York, ca. 1940). The designation Abstract Expressionism encompasses a wide variety of postwar American painting through which the U.S. first became the center of the avant-garde. Critic Clement Greenberg, a major proponent of the New York School (another name for American artists working in this manner), preferred the term Painterly abstraction in order to describe the formal qualities of this painting: its lack of figuration and loose brushwork. The related term Action Painting was coined by critic Harold Rosenberg to refer to the gestural act of painting, which he considered the artist's unconscious outpouring or enactment of some personal drama. The expressive aspect of this art has been linked to the subjective heroism of earlier forms of Expressionism as well as to the Surrealist technique of automatic writing. The influence of Surrealists and other artists who fled Europe for New York in the late 1930s and the 1940s was integral to the development of Abstract Expressionism.

In the late 1940s and early 1950s Jackson Pollock, considered the foremost Abstract Expressionist, placed his canvases on the floor to pour, drip, and splatter paint onto them and to work on them from all sides, which set him apart from the tradition of vertical easel painting. Other painters who worked in gestural modes were William Baziotes, Willem de Kooning, Arshile Gorky, Adolph Gottlieb, Philip Guston, Franz Kline, and Robert Motherwell. Another component of the Abstract Expressionist school used large planes of color, often to evoke invisible spiritual states. These Color-field painters include Barnett Newman and Mark Rothko. Their lead was followed by Helen Frankenthaler, Morris Louis, and others who poured thin acrylic stains onto unprimed canvases in order to make color an inherent part of their paintings. The term Abstract Expressionism has also been applied to the work of sculptors such as Herbert Ferber and David Hare.

Art Brut (raw art: France, ca. 1950). The term Art Brut was first used by the painter Jean Dubuffet to refer to a range of art forms outside the conventional dictates of the art world. He amassed a large collection of graffiti art and art made by the mentally ill, prisoners, children, and other naive (untrained) artists, whose raw or innocent vision and directness of technique he admired. In turn, he sought to emulate these qualities in his own work, and in 1948 he established a society to encourage the study of Art Brut. This kind of art has also been referred to as "outsider art"; that designation has been applied to Dubuffet's own work and that of Adolf Wölfli and others.

Arte Povera (poor or impoverished art; Italy, mid-1960s). The term Arte Povera was first used by Italian art critic Germano Celant to describe a broad category of art being produced by an international cross section of artists in the late 1960s through the 1970s, although it is now generally used to apply only to Italian art of this period. Celant related street theater and other antielitist, "poor" forms of expression and protest to this artistic style; the term "poor" also referred to the humble, often ephemeral materials employed and the anti-institutional quality that originally pervaded this art. Arte Povera usually incorporates organic and industrial materials in ways that reveal the conflicts between the natural and the man-made. Through sculpture, assemblage, and performance, Arte Povera artists became engaged in subjective investigations of the relationships between life and art and between seeing and thinking. They include Giovanni Anselmo, Alighiero E Boetti, Luciano Fabro, Jannis Kounellis, Mario Merz, Marisa Merz, Giulio Paolini, Giuseppe Penone, Michelangelo Pistoletto, and Gilberto Zorio.

Art Informel ("unformed" art; Europe, 1950s). In 1952 French writer Michel Tapié authored the book Un Art autre (Art of Another Kind) and organized an exhibition of the same name, which included paintings by Karel Appel, Camille Bryen, Alberto Burri, Jean Dubuffet, Jean Fautrier, Ruth Francken, Willem de Kooning, Jean-Paul Riopelle, and Wols, among other artists. Tapié was trying to define a

tendency in postwar European painting that he saw as a radical break with all traditional notions of order and composition—including those of Modernism—in a movement toward something wholly "other." He used the term Art Informel (from the French *informe*, meaning unformed or formless) to refer to the antigeometric, antinaturalistic, and nonfigurative formal preoccupations of these artists, stressing their pursuit of spontaneity, looseness of form, and the irrational.

Art Informel tends toward the gestural and expressive, with repetitive calligraphic marks and anticompositional formats related to Abstract Expressionism, which is often considered its American equivalent. It eventually took root in France, Germany, Italy, Japan, and Spain, and was known in its various manifestations as Gesture Painting, Lyrical Abstraction, Matter art, and Tachisme (from the French *tache*, meaning a spot or stain). Artists who became associated with Art Informel include Enrico Donati, Lucio Fontana, Asger Jorn, Emil Schumacher, Kazuo Shiraga, Antoni Tàpies, and Jiro Yoshihara.

Bauhaus (Germany, 1919). The Bauhaus was founded in Weimar in 1919 as a state-sponsored school of art, architecture, and design. Architect Walter Gropius served as its director until 1928. The school's curriculum was organized on the principle that the crafts were united with the arts on an equal footing (as they had been in medieval times), on the guild system of workshop training under the tutelage of "masters." and on the ideas concerning the relationship of art to society developed by the German industrial-design association Deutscher Werkbund, which was greatly influenced by the Arts and Crafts movements in England, Austria, and the Netherlands. The Bauhaus's utopian aims included raising the quality of everyday life through the production of buildings, design objects, and art works according to an aesthetic of modernity and universality. Lyonel Feininger, Vasily Kandinsky, Paul Klee, and Oskar Schlemmer were among the first "masters" or teachers at the school. The addition of such artists as László Moholy-Nagy and Josef Albers to the faculty in 1923 and after reinforced a shift away from Expressionism and toward the functional and technology-based aesthetics of Constructivism and De Stijl. The school was forced to relocate to Dessau in 1925. In April 1933, when conditions imposed by the Nazis made continued operation impossible, the faculty decided to close the Bauhaus, and several of its professors, including Albers, Gropius, and Ludwig Mies van der Rohe, emigrated to the U.S., where they assumed important teaching posts. In 1937 the New Bauhaus opened in Chicago under the direction of Moholy-Nagy.

Conceptual art (international, ca. 1966). Conceptual art is based on the notion that the essence of art is an idea, or concept, and may exist distinct from and in the absence of an object as its representation. It has also been called Idea art, Post-Object art, and Dematerialized art because it often assumes the form of a proposition (i.e., a document of the artist's thinking) or a photographic document of an event. Conceptual art practices emerged at a time when the authority of the art institution and the preciousness of the unique aesthetic object were being widely challenged by artists and critics. Conceptual artists interrogated the possibilities of art-as-idea or art-as-knowledge, and to those ends explored linguistic, mathematical, and process-oriented dimensions of thought and aesthetics, as well as invisible systems, structures, and processes. Artists such as Joseph Kosuth and members of the Art & Language group wrote theoretical essays that questioned the ways in which art has conventionally acquired meaning. In some cases such texts served as the art works themselves. Other figures associated with Conceptual art include Mel Bochner, Hanne Darboven, Agnes Denes, Jan Dibbets, Hans Haacke, On Kawara, Les Levine, Sol LeWitt, and Lawrence Weiner.

Constructivism (Russia, ca. 1918). Vladimir Tatlin and some of his colleagues, such as Lev Bruni, Ivan Kliun, and Ivan Puni, influenced by Pablo Picasso's Cubist sculptures, began to make abstract, nonutilitarian constructions in Russia in the years just before the 1917 revolution. This aesthetic, allied with a geometric vocabulary based on Kazimir Malevich's Suprematism, developed into a rational,

materialist, utilitarian approach to socially committed art, led by Tatlin and Aleksandr Rodchenko. After the revolution many Constructivist artists were placed in important pedagogical and administrative positions, where they advocated a culture based on new principles in art, design, typography, and architecture. In attempting to link art with industry, technology, and the ideals of a classless society through the production of socially useful objects, they developed the notion of the artist-as-engineer. The First Constructivist Art Exhibition was held in Moscow in 1921. Artists affiliated with this group included Aleksei Gan, Konstantin Medunetsky, Georgy and Vladimir Stenberg, and Varvara Stepanova, among others. The Constructivists also included another group—led by Vasily Kandinsky together with Naum Gabo and his brother Antoine Pevsner—who shared Malevich's commitment to art as a primarily spiritual activity. Other important Constructivist artists were Aleksandra Ekster and Olga Rozanova and, in Germany, László Moholy-Nagy.

Cubism (France, ca. 1907). Georges Braque and Pablo Picasso originated the style known as Cubism, one of the most internationally influential innovations of 20th-century art. Other practitioners of Cubism in its varied forms include painters Albert Gleizes, Juan Gris, Fernand Léger, Jean Metzinger, and (in his early work) Piet Mondrian, and sculptors Alexander Archipenko, Henri Laurens, and Jacques Lipchitz. The advent of this style marked a rupture with the European traditions, traceable to the Renaissance, of pictorial illusionism and the organization of compositional space in terms of linear perspective. Its initial phase (ca. 1908–12), known as Analytic Cubism (referring to the "analysis" or "breaking down" of form and space), developed under the influence of Paul Cézanne's and Georges Seurat's formal innovations. The Cubists fragmented objects and pictorial space into semitransparent, overlapping, faceted planes of pigment, thought by some to show the spatial shift from different perspectives within the same time and space and to emphasize the canvas's real two-dimensional flatness instead of conveying the illusory appearance of depth.

With Analytic Cubism, Braque's and Picasso's attempts to depict the conceptual planes of figures and objects in space developed into an austere, depersonalized pictorial style. They at first employed a limited palette of ochers, browns, greens, grays, and blacks, which were considered less expressive than a full range of color, and in 1911 began experimenting with simulated textures, shadows, and modern stenciled typography. The elements within Cubist compositions often inverted the devices of artistic illusionism as if mocking the codelike qualities of two-dimensional representation. In 1912, as part of their exploration of the ambiguities of real and representational space, they adopted the technique of papier collé (from the French coller, meaning to paste or glue), wherein overlapping and fragmented pieces of newspaper, wallpaper, tickets, cigarette packages, and other detritus were arranged, altered, and adhered to the ground of paper or canvas, disrupting Modernism's inviolate picture plane. By 1913 Analytic Cubism was succeeded by Synthetic Cubism, in which the "analysis" of objects was abandoned and replaced by "constructing" or "synthesizing" them through the overlapping of larger, more discrete forms that seemed as if they might have been cut and pasted to the canvas. This new form of Cubism, which featured brighter colors, ornamental patterns, undulating lines, and rounded as well as jagged shapes, was common into the 1930s.

Dada (New York and Western Europe, ca. 1915). One of the first large-scale movements to translate art into provocative action, Dada produced some of the most antibourgeois, antirational, anarchic, playful works to come out of the 20th century. It began in 1916 in Zurich's Cabaret Voltaire, where expatriate artists, poets, and writers gathered in refuge from World War I. Dada started as an indictment of the bourgeois values responsible for the horrors of the war, and assumed many forms, including outrageous performances, festivals, readings, erotic mechanomorphic art, nonsensical chance-generated poetry, found objects, and political satire in photomontage. Over several years it developed in New York

as well as many European cities—primarily Zurich, Berlin, Cologne, Paris, and Hannover—through the activities of such artists and writers as Jean Arp, Hugo Ball, Marcel Duchamp, Max Ernst, George Grosz, Raoul Hausmann, John Heartfield, Hannah Höch, Man Ray, Francis Picabia, Kurt Schwitters, and Tristan Tzara.

De Stijl (the style; Holland, 1917). The Dutch review *De Stijl* was founded in 1917 by Theo van Doesburg, and the name has come to represent the common aims and utopian vision of a loose affiliation of Dutch and international artists and architects. The central figures of De Stijl—van Doesburg and Piet Mondrian—strove for a universal form that would correspond to their spiritual vision. Neo-Plasticism (meaning "a new plastic art") was the term adopted by Mondrian to describe the qualities that De Stijl artists endeavored to achieve in their work. The essential idea underlying De Stijl's radical utopian program was the creation of a universal aesthetic language based in part on a rejection of the decorative excesses of Art Nouveau in favor of a simple, logical style that emphasized construction and function, one that would be appropriate for every aspect of modern life. It was posited on the fundamental principle of the geometry of the straight line, the square, and the rectangle, combined with a strong asymmetricality; the predominant use of pure primary colors with black and white: and the relationship between positive and negative elements in an arrangement of non-objective forms and lines. Some scholars have considered the philosophical grounds of De Stijl in terms of theosophical spiritualism, while others view it in relation to Hegel's philosophy of the dialectic. Other artists affiliated with De Stijl include Vilmos Huszár, J. J. P. Oud, Gerrit Rietveld, Bart van der Leck, and Georges Vantongerloo.

Ecole de Paris (School of Paris; France, ca. 1910). During the first decade of the 20th century, numerous painters and sculptors migrated to Paris, which had become the international nexus for avantgarde art. The French capital was appealing to those artists who sought to liberate themselves from the provincial or academic training of their homelands. Foremost among these were Jules Pascin (Julius Pincas). Chaim Soutine, and other artists associated with the peintres maudits (accursed painters). Following World War I, some Surrealist painters, including Max Ernst, were counted among the school. Bringing with them their variegated customs, these artists converged upon the Montmartre and Montparnasse districts to absorb and contribute to the latest artistic developments, often fusing new elements with aspects of their respective traditions in their works. Not surprisingly, considering their various backgrounds, these artists did not adhere to one fixed style typical of a "school"; however, they were united in defiance against academicism. Despite diverse stylistic approaches, many relied upon the human figure and immediate social conditions as subjects, dealing with themes such as poverty, moral dissolution, personal alienation, and the spectacle of the changing city itself. However, with the end of World War II and the advent of Abstract Expressionism and the New York School, these primarily figurative painters were displaced from the center of the avant-garde. Others associated with the School of Paris include Marc Chaqall, Tsuguharu (Léonard) Foujita, and Amedeo Modigliani.

Expressionism (primarily Germany, and Austria, first decade of 20th century). The very elastic concept of Expressionism refers to art that emphasizes the extreme expressive properties of pictorial form in order to explore subjective emotions and inner psychological truths. Although much influenced by the work of Vincent van Gogh, Paul Gauguin, and Edvard Munch, the artists who pioneered Expressionism departed even further from traditional notions of recording the appearance of reality than had the Post-Impressionists or the Symbolists. They were also influenced by Henri Matisse and the other Fauves, the Cubists, African and Oceanic art, and the folk art of Germany and Russia. In conjunction with poets, dramatists, and other writers, they championed idealist values and freedom from the constricting forces and repressive materialism of bourgeois society. One prominent Expressionist group, Die Brücke (The Bridge), which was active as a group from 1905 to 1913, included founders Fritz Bleyl.

Erich Heckel, Ernst Ludwig Kirchner, and Karl Schmidt-Rottluff as well as Otto Müller, Emil Nolde (for a brief period), and Max Pechstein. Members of Die Brücke conveyed pictorially the Modernist themes of alienation, anxiety, and social fragmentation. They employed emotion-charged images, a "primitive" simplification of form, a deliberate crudeness of figuration, agitated brushwork, and powerful, often violent juxtapositions of intense color.

Artists involved in the more stylistically diverse Der Blaue Reiter (The Blue Rider), founded in 1911 in Munich by Vasily Kandinsky, Franz Marc, and Gabriele Münter, sought to convey spiritual states through the abstraction of forms. Alexej Jawlensky and August Macke were associated with the group, and many others participated in the Blue Rider exhibitions. Other important Expressionists in Germany were Käthe Kollwitz and Paula Modersohn-Becker, and in Austria Oskar Kokoschka and Egon Schiele.

Fauvism (France, ca. 1905). The Fauves (wild beasts) were so-named in a statement made by French art critic Louis Vauxcelles in reaction to a group of their paintings at the 1905 Salon d'Automne (Autumn Salon). Although their subject matter was conventional—mostly landscape and still life—the way they painted was radical for the time, favoring nonassociative and often jarring juxtapositions of luminous color patches interspersed with exposed portions of canvas, and brushwork accentuated by broad strokes. Under the influence of Paul Cézanne's art and the Divisionist technique developed by Georges Seurat and his followers, the Fauve painters pursued the expression of sensations before nature in terms of pure color. Fauvism included Georges Braque, Charles Camoin, André Derain, Maurice de Vlaminck, Raoul Dufy, Othon Friesz, Henri Charles Manguin, Albert Marquet, Henri Matisse, and Kees van Dongen.

Fluxus (U.S. and Europe, ca. 1961). Fluxus has been described as an attitude and a style, subversive in its casual, spontaneous quality that challenges institutionally framed understandings of art. It developed as a loose affiliation of artists who gathered around the central figure of George Maciunas. Like the Situationists, their primary goal was to upset bourgeois routine in life and in art. Fluxus experiments explored connections between the visual arts, poetry, music, dance, theater, and the more radical forms of performance, such as actions, often combining them in guerrilla theater and street spectacles. The elements of chance and humor so prominent in Marcel Duchamp's visual experiments and John Cage's musical compositions played important roles in the Fluxus approach to art making. Major figures associated with Fluxus in the U.S. and Europe include Joseph Beuys, George Brecht, Walter De Maria, Dick Higgins, Ray Johnson, Alison Knowles, Charlotte Moorman, Yoko Ono, Nam June Paik, Ben Vautier, Wolf Vostell, Robert Watts, Robert Whitman, and La Monte Young.

Futurism (Italy, 1908). In a stylistic idiom that integrated some of the techniques of Cubism and Divisionism, the Futurists glorified the energy and speed of modern life together with the dynamism and violence of the new technological society. In their manifestos, art, poetry, and theatrical events, they celebrated automobiles, airplanes, machine guns, and other phenomena that they associated with modernity; they denounced moralism and feminism, as well as museums and libraries, which they considered static institutions of an obsolete culture. The Futurists sought to represent the experience of the modern metropolis—namely, the overstimulation of the individual's sensorium—by portraying multiple phases of motion simultaneously and by showing the interpenetration of objects and their environment through the superimposition of different chromatic planes. Artists and poets affiliated with Futurism include Giacomo Balla, Umberto Boccioni, Carlo Carrà, Filippo Tommaso Marinetti (the movement's founder), Luigi Russolo, and Gino Severini. Balla led a second generation of Italian Futurists, including Fortunato Depero, Gerardo Dottori, and Enrico Prampolini, in the 1920s and 1930s.

Almost concomitantly with Italian Futurism, a Russian version of Futurism developed under the leadership of Kazimir Malevich, who described most of his work from 1912 to 1915 as "Cubo-Futurist."

This Cubist fragmentation of space allied to the Futurist simultaneity of shifting forms was also taken up briefly by Liubov Popova and other Russian artists. Futurism, however, was more prevalent among Russia's poets than its painters.

Happenings (U.S. and Europe, 1959). The term Happening was coined by New York artist Allan Kaprow in 1959 as a name for the antinarrative theatrical pieces that he and such artists as Jim Dine, Red Grooms, Dick Higgins, Claes Oldenburg, and Robert Whitman staged in studios, galleries, and offbeat locations, usually with direct audience involvement. These multimedia performance events radically altered the conventional role of audience members, who, in the tradition of Antonin Artaud's Theater of Cruelty, were assaulted by an array of auditory, visual, and physical phenomena. Composed out of the absurdities and banalities of everyday life and filtered through the gestural vocabulary of Abstract Expressionism, these spectacles incorporated junk materials, found and manipulated objects, and live or electronic music, sometimes in elaborate constructed environments intended to break down the boundaries between art and life. They explored the objectification of mundane movements and play-related activities, as well as the depersonalization of their participants.

Hard-edge painting (U.S., late 1950s). The term Hard-edge painting was coined in 1959 by art historian Jules Langsner to characterize the nonfigurative work of four artists from California in an exhibition called *Four Abstract Classicists*. The term then gained broader currency after British critic Lawrence Alloway used it to describe contemporary American geometric abstract painting featuring an "economy of form." "fullness of color," "neatness of surface," and the nonrelational, allover arrangement of forms on the canvas. This style of geometric abstraction refers back to the work of Josef Albers and Piet Mondrian. Artists associated with Hard-edge painting include Al Held, Ellsworth Kelly, Alexander Liberman, Brice Marden, Kenneth Noland, Ad Reinhardt, and Jack Youngerman.

Impressionism (France, ca. 1870s). The Impressionists were a group of painters who, in general, departed from the traditional pursuit of reproducing an illusion of real space in paintings of academic subjects, choosing instead to exploit the possibilities of paint to explore the fleeting effects of nature and the vagaries of visual sensation in, for the most part, rapidly executed works. Among the several dozen painters who participated in this loosely defined group—most of whom are unknown today—were Mary Cassatt, Paul Cézanne, Edgar Degas, Claude Monet, Berthe Morisot, Camille Pissarro, and Pierre Auguste Renoir. These artists were associated principally through their group exhibitions (although some, like Cézanne, never showed their work in the so-called Impressionist exhibitions) and were perceived by some critics of the time as sharing certain stylistic devices, such as employing loose brushwork to produce the illusion of the artist's spontaneous recording of natural light on the canvas and rejecting the practice of chiaroscuro (modeling in light and dark). In their pursuit of modernity, some of them borrowed formal devices used in photography and Japanese prints, such as radical foreshortening, cropping, and keyhole or bird's-eye perspective.

The work of the Impressionists was indebted to the Barbizon school of artists active in the 1850s in developing plein-air (out-of-doors) painting, although even the Impressionists who were most celebrated for painting directly from nature, such as Monet, often completed their canvases in the studio. The Impressionists moved away from the Barbizon school's romantic naturalism and themes of rural peasant life to more urban subject matter, especially scenes of Parisian leisure and entertainment, city parks, and suburban landscapes.

Minimalism (New York, 1960s). Though never a self-proclaimed movement, Minimalism refers to painting or sculpture made with an extreme economy of means and reduced to the essentials of geometric abstraction. It applies to sculptural works by such artists as Carl Andre, Dan Flavin, Donald

Judd, Ellsworth Kelly, John McCracken, Robert Morris, Richard Serra, Tony Smith, and Anne Truitt; to the shaped and striped canvases of Frank Stella; and to paintings by Jo Baer, Ellsworth Kelly. Robert Mangold, Brice Marden, Agnes Martin, and Robert Ryman. Minimalist art is generally characterized by precise, hard-edged, unitary geometric forms; rigid planes of color—usually cool hues or commercially mixed colors, or sometimes just a single color; nonhierarchical, mathematically regular compositions, often based on a grid; the reduction to pure self-referential form, emptied of all external references; and an anonymous surface appearance, without any gestural inflection. As a result of these formal attributes, this art has also been referred to as ABC art, Cool art, Imageless Pop, Literalist art, Object art, and Primary Structure art. Minimalist art shares Pop art's rejection of the artistic subjectivity and heroic gesture of Abstract Expressionism. In Minimal art what is important is the phenomenological basis of the viewer's experience, how he or she perceives the internal relationships among the parts of the work and of the parts to the whole, as in the gestalt aspect of Morris's sculpture. The repetition of forms in Minimalist sculpture serves to emphasize the subtle differences in the perception of those forms in space and time as the spectator's viewpoint shifts in time and space.

Neo-Conceptualism (U.S. and Europe, late 1970s). By the end of the 1970s, Modernism's utopian principles of innovation, artistic authenticity, and individual expression had become increasingly suspect in a critical culture attuned to late capitalism's production of desire. Postmodernist theory—articulated in fields as diverse as architecture, comparative literature, semiotics, and political science—questioned and dismantled the grand narrative of Western culture and had a profound impact on the visual arts. A number of different yet related aesthetic strategies (known variously as "Appropriation art" and "Neo-Geo") emerged at this time to signal the apparent demise of Modernism and to critique its legacy. Some artists flagrantly appropriated the works of others and called these their own in order to demonstrate the myth of originality and the death of the authorial voice. Others exploited the commodification of their work to underscore the inescapable effects of commerce on the art world. In a Duchampian mode, these artists incorporated ready-made objects drawn directly from the commercial realm into their sculptures and installations. Still others produced abstract, geometric canvases (as emblems of Modernism) to demonstrate that painting, like any representational system, is a code or text that could be endlessly replicated. Additionally there is a fundamental compatibility between Postmodernism's critique of cultural authority and the feminist critique of sexual difference. Hence a number of women artists associated with Neo-Conceptualism used its strategies of appropriation, pastiche, and simulation to challenge the auratic quality of the autonomous art object and the (male) cult of the artist. Ross Bleckner, Peter Halley, Jenny Holzer, Jeff Koons, Barbara Kruger, Louise Lawler, Sherrie Levine, Richard Prince, Cindy Sherman, Haim Steinbach, and Philip Taaffe are some of the principal artists whose work has been categorized as Neo-Conceptual.

Neo-Dada (international, 1950s). The term Neo-Dada, first popularized in a group of articles by Barbara Rose in the early 1960s, has been applied to a wide variety of artistic works, including the pre-Pop Combines and assemblages of Robert Rauschenberg and Jasper Johns, Happenings, Fluxus, Pop art, Junk art, and Nouveau Réalisme, as well as other Conceptual and experimental art forms. The unifying element of Neo-Dada art is its reinvestigation of Dada's irony and its use of found objects and/or banal activities as instruments of social and aesthetic critique.

Neo-Expressionism (New York, Italy, and West Germany, late 1970s). Rejecting the restrictions against imagery and gestural treatment set by their Minimalist and Conceptual teachers and contemporaries, the Neo-Expressionists revived the formal elements of German Expressionism and Abstract Expressionism, often on a heroic scale. As the "new" Expressionism this style reiterated the subjectivism associated with the earlier forms, marked by flamboyant textural brushwork and distorted

figures. In their work the Neo-Expressionists took up a variety of cultural-mythological, nationalist-historical, erotic, and "primitivizing" themes. Some critics welcomed this art for its return to the personal and its lifting of what had become aesthetic taboos; others criticized its aura of nostalgia and its depoliticized, ahistorical tendencies. Georg Baselitz, Sandro Chia, Francesco Clemente, Enzo Cucchi, Jörg Immendorff, Anselm Kiefer, Markus Lüpertz, A. R. Penck, and Julian Schnabel are among the primary figures of Neo-Expressionism.

Neue Sachlichkeit (new objectivity; Germany, late 1910s). The term Neue Sachlichkeit was first used by museum director Gustav Hartlaub in 1923 in preparation for an exhibition of recent paintings that he said were grounded in the depiction of reality. The artists themselves were not organized in a formal group and worked in many locales. Two major trends were identified under Neue Sachlichkeit. The so-called Verists, including Otto Dix and George Grosz, aggressively attacked and satirized the evils of society and those in power and demonstrated in harsh terms the devastating effects of World War I and the economic climate upon individuals. Max Beckmann was connected with these artists. A second term, Magic Realists, has been applied to diverse artists, including Heinrich Maria Davringhausen, Alexander Kanoldt, Christian Schad, and Georg Schrimpf, whose works were said to counteract in a positive fashion the aggression and subjectivity of German Expressionist art. They employed a controlled manner and naturalistic coloring in painting unpeopled city views, seemingly airless spaces, escapist themes, portraits, and family scenes. Neue Sachlichkeit was replaced by the conservative style prescribed by the Nazis.

Nouveau Réalisme (new realism; Paris, late 1950s). In 1960 French art critic Pierre Restany first used the term Nouveau Réalisme in a manifesto for an exhibition at the Galleria Apollinaire in Milan. In this exhibition he brought together artworks created through the appropriation of ordinary materials and objects by artists such as Arman, César, Christo, Niki de Saint-Phalle, François Dufrêne, Raymond Hains, Yves Klein, Mimmo Rotella, Daniel Spoerri, Jean Tinguely, and Jacques de la Villeglé, among others. Like the Dadaists and the Surrealists, these artists performed archaeological excavations of everyday life; their works ranged from torn and lacerated posters, wrapped objects, and accumulations of found objects to assemblages of junk materials and urban detritus (automobile parts, fabrics, rope, dishes, etc.). As a result of its vernacular bias, Nouveau Réalisme is often considered a counterpart to Neo-Dada and Pop art.

Orphism (France, ca. 1912). In 1912 the poet Guillaume Apollinaire applied the French term Orphisme to the visionary and lyrical paintings of Robert Delaunay, relating them to Orpheus, a poet and musician in Greek mythology. It also applies to the paintings of Sonia Terk Delaunay and is often mentioned in connection with František Kupka and a group of then-contemporary American and Canadian artists, called Synchromists, who painted according to a system of "color harmonies" that equated hues to musical pitches. The term Orphic Cubism is sometimes used instead of Orphism because of Robert Delaunay's roots in a Cubist style. Departing from the limited palette of Georges Braque's and Pablo Picasso's initial phase of Cubism, the Delaunays' paintings are full of brightly colored circular forms, the color combinations of which are based on the "law of simultaneous contrast of colors." developed in the 19th century by French chemist Michel-Eugène Chevreul; Chevreul's theories had already influenced painters such as Eugène Delacroix and Georges Seurat.

Performance (international; late 1960s). Performance has its roots in the staging of deliberately provocative public events by Futurist and Dada artists in the early 20th century. These actions are often regarded as the origins of the Happenings and Fluxus events of the 1950s, and of Yves Klein's Anthropometries—paintings composed by the "living brushes" of nude women covered in blue paint.

By the early 1970s performance had evolved into a primary rather than adjunct means of expression for artists to convey their dissatisfaction with the commercial gallery system and the commodification of the art object. By eliminating the object, performance was thought to facilitate direct communication between artist and viewer. Its increased popularity in America during the late 1960s and early 1970s also coincided with the emancipation of the individual from obsolete moral and social conventions. Feminist artists seeking alternatives to the male dominated realms of painting and sculpture at this time embraced performance as a vehicle to celebrate their essential, biological differences as well as to express their outrage at the gender inequity prevalent in this country. The manifestations of performance continue to be international and vary widely in theme, encompassing under the same rubric the shamanstic and sadomasochistic body art of Viennese Actionism; the seemingly playful "living sculptures" of Gilbert & George; Laurie Anderson's experimentation with multimedia technologies in the 1970s and 1980s; and the monologic social criticism of Eric Bogosian. The category is notoriously vague, and no set rules easily circumscribe it. Broadly speaking, the term connotes art that employs a combination of movement, theater, cinema, music, and/or other forms of public expression, sometimes in tandem with plastic media, so as to act out concepts before an audience in a usually choreographed fashion. Other artists associated with performance include Marina Abramović, Vito Acconci, Joseph Beuys, Chris Burden, Rebecca Horn, Ana Mendieta, Bruce Nauman, Dennis Oppenheim, Gina Pane, and Hannah Wilke.

Pop art (Great Britain and U.S., 1950s). Pop art was pioneered in London in the mid-1950s by Richard Hamilton and Eduardo Paolozzi (members of the Independent Group), and in the 1960s by Peter Blake, Patrick Caulfield, David Hockney, Allen Jones, and Peter Phillips. It was supported by such critics as Lawrence Alloway and Reyner Banham. In the early 1960s Pop art took off in the U.S., exemplified by the work of Jim Dine, Robert Indiana, Roy Lichtenstein, Claes Oldenburg, Mel Ramos, James Rosenquist, Ed Ruscha, Andy Warhol, and Tom Wesselmann. With its roots in Dada—and the immediate precedent of Jasper Johns's Neo-Dada adaptations of such things as beer cans and the American flag—Pop art explored the image world of popular culture, from which its name derives. Basing their techniques, style, and imagery on certain aspects of mass reproduction, the media, and consumer society, these artists took inspiration from advertising, pulp magazines, billboards, movies, television, comic strips, and shop windows. These images, presented with (and sometimes transformed by) humor, wit, and irony, can be seen as both a celebration and a critique of popular culture. In the early 1960s German artists Konrad Lueg, Sigmar Polke, and Gerhard Richter explored a Pop-related style, which they called Capitalist Realism.

Post-Impressionism (France, ca. 1880s). For an exhibition in 1910–11 British art critics Roger Fry and Desmond MacCarthy classified the art of Paul Cézanne, Paul Gauguin, Georges Seurat, and Vincent van Gogh (and in a second exhibition in 1912, early works by Henri Matisse and Pablo Picasso) under the somewhat clumsy rubric of Post-Impressionism. The Post-Impressionists were seen as being less interested than the Impressionists in recording the shifting patterns of nature, placing fresh emphasis on the "subjective" effects of objects rather than the scientific reproduction of visible phenomena. The artists were thought to embrace the idea of art as a process of formal design with purely expressive aims.

Post-Minimalism (U.S.; late 1960s). Coined by the art historian and critic Robert Pincus-Witten, Post-Minimalism refers to a general reaction by artists in America beginning in the late 1960s against Minimalism and its insistence on closed, geometric forms. These dissenting artists eschewed the impersonal object for more open forms. Rather than adhere to pure formalism, Post-Minimalist artists often made explicit the psychical and physical processes involved in the actualization of art and often reflected personal and social concerns in their works. In his 1987 book *Postminimalism to Maximalism:*

American Art. 1966–1986, Pincus-Witten describes its progression as threefold: pictorial/sculptural, epistemological, and ontological (e.g., conceptual theater/body art). The first, developing circa 1968, emphasized the manufacturing of art and the use of unconventional materials, frequently manifesting a newfound consideration of themes and media previously deemed too feminine, or "soft," according to the Minimalist canon, as can be seen in Eva Hesse's rope and latex pieces and Barry Le Va's scatter installations. The second, beginning circa 1970, reassessed the applicability of theoretical constructs to art production, as evidenced in Sol LeWitt's wall drawings, which exist as descriptions until they are realized by a second party. The third, beginning around 1968, involved the physical presentation of concepts and intentions via the artist's body, which in effect became the medium, as in the performances of Vito Acconci and Bruce Nauman. Artists grouped under this category are often also associated with Land art, Performance, Process art, and other forms of expression that resist the authority of the singular art object.

Post-painterly abstraction (U.S. and Canada, mid-1950s). The term Post-painterly abstraction was coined by critic Clement Greenberg in conjunction with an exhibition of the same name at the Los Angeles County Museum of Art in 1964, featuring contemporary American and Canadian artists. In his essay for the catalogue Greenberg distinguished between Painterly abstraction—his preferred designation for what others have called Abstract Expressionism—and the artistic work that it precipitated by such artists as Gene Davis, Paul Feeley, John Ferren, Sam Francis, Helen Frankenthaler, Alfred Jensen, Morris Louis, Jules Olitski, Frank Stella, and others. Some of these artists continued the painterly, loose facture of color and contour pursued by Jackson Pollock and Willem de Kooning, while others moved toward a more hard-edged style. What they shared, according to Greenberg, was the kind of linear clarity and physical openness of design that had begun with Painterly abstraction and continued in its wake, as well as a new tendency to stress contrasts of pure hues, and a rejection of the tactile application of paint in favor of staining the canvas with diluted paint. Often they also sought a flat, anonymous style of execution.

Primitivism (Western Europe, late 19th century). "Primitivism" is less an aesthetic movement than a sensibility or cultural attitude that has informed diverse aspects of Modern art. It refers to Modern art that alludes to specific stylistic elements of tribal objects and other non-Western art forms. With roots in late-19th-century Romanticism's fascination with foreign civilizations and distant lands, particularly with what were considered to be naive, less-developed cultures, it also designates the "primitive" as a myth of paradise lost for late-19th- and 20th-century culture. Behind this captivation with the "other" was a belief in the intrinsic goodness of all humankind, a conviction inspired by French philosopher Jean-Jacques Rousseau's notion of the Noble Savage. At the same time, however, industrialized Western culture evoked the "primitive" as a sign on which to map what it had socially and psychologically repressed: desire and sexual abandon. The problematic nature of "primitivism" can be illustrated by the example of Paul Gauguin, who spurned his own culture to join that of an "uncivilized" yet more "ingenuous" people. Although he sought spiritual inspiration in Tahiti, he showed a more earthy preoccupation with Tahitian women, often depicting them nude. This eroticization of the "primitive" was amplified in the work of the German Expressionist group Die Brücke and in Pablo Picasso's proto-Cubist paintings, particularly Les Demoiselles d'Avignon (1907).

The influence of tribal fetishes on Modern painters and sculptors, such as Constantin Brancusi, Alberto Giacometti, Henri Matisse, and Picasso, has been the subject of much art-historical and critical debate. While the formal impact of ritual objects on these artists is undeniable, recent attempts to locate affinities between the "primitive" and the Modern have been perceived as suspect because they evince a certain ethnocentrism. Moreover, the usage of the word "primitive" to describe cultures and creations

outside of the European tradition can be seen to be degrading. For this reason, "primitivism" and "primitive" appear within quotation marks in this book.

Process art (U.S. and Europe, mid-1960s). Process art emphasizes the "process" of making art (rather than any predetermined composition or plan) and the concepts of change and transience, as elaborated in the work of such artists as Lynda Benglis, Eva Hesse, Robert Morris, Bruce Nauman, Alan Saret, Richard Serra, Robert Smithson, and Keith Sonnier. Their interest in process and the properties of materials as determining factors has precedents in the Abstract Expressionists' use of unconventional methods such as dripping and staining. In a ground-breaking essay and exhibition in 1968, Morris posited the notion of "anti-form" as a basis for making art works in terms of process and time rather than as static and enduring icons, which he associated with "object-type" art. Morris stressed this new art's de-emphasis of order through nonrigid materials, pioneered by Claes Oldenburg, and the manipulation of those materials through the processes of gravity, stacking, piling, and hanging.

Process artists were involved in issues attendant to the body, random occurrences, improvisation, and the liberating qualities of nontraditional materials such as wax, felt, and latex. Using these, they created eccentric forms in erratic or irregular arrangements produced by actions such as cutting, hanging, and dropping, or organic processes such as growth, condensation, freezing, or decomposition.

Purism (France, 1918). Purism is the aesthetic approach that was advocated and practiced by the architect Charles-Edouard Jeanneret (later called Le Corbusier) and Amédée Ozenfant. Jeanneret and Ozenfant first described the principles of Purism in 1918 in a small book entitled Après le cubisme (After Cubism). They sought to eliminate the picturesque, decorative aspects of Cubism that had become prevalent in painting after 1914 in favor of an art that stressed mathematical order, purity, and logic. To achieve this sense of fundamental order they systematized their expression of visual phenomena into a precise arrangement of modern, impersonal, "universal" forms, especially images of simple machinemade objects from everyday life. Jeanneret and Ozenfant shared with Fernand Léger an enthusiasm for the beauty of the machine aesthetic and precisely delineated forms, but they went even further in reducing such elements to a simplified geometry and combining them to produce compositions of unruffled harmony. Purism's movement away from the radical vocabulary of the preceding decade can be seen as part of a pervasive desire for a "return to order" after World War I and the consequent widespread neoclassical tendency among European artists of the period.

Site-specific art/Environmental art (pioneered in U.S., and international, mid-1960s). Site-specific or Environmental art refers to an artist's intervention in a specific locale, creating a work that is integrated with its surroundings and that explores its relationship to the topography of its locale, whether indoors or out, urban, desert, marine, or otherwise. In its largest sense it applies to a work made by an artist in the landscape, either by radically manipulating the terrain in a remote area to produce an "earthwork" (such as Robert Smithson's Spiral Jetty) or by creating ephemeral or removable tableaux along particular pathways so that the terrain is not permanently altered (Richard Long's circles or lines of stones, Christo's fabric walls or umbrellas). Other artists known for such work include Walter De Maria, Michael Heizer, Nancy Holt, Mary Miss, Robert Morris, Dennis Oppenheim, and James Turrell. The term also applies to an environmental installation or sculpture created especially for a particular gallery space or public site, by such artists as Joseph Beuys, Daniel Buren, Dan Flavin, Joseph Kosuth, Jannis Kounellis, Mario Merz, Claes Oldenburg, and many others. No matter which approach an artist takes, Site-specific art is meant to become part of its locale, and to restructure the viewer's conceptual and perceptual experience of that locale through the artist's intervention.

Situationism (Western Europe, ca. 1957). In Italy in 1957 a group of artists, filmmakers, architects, and intellectuals from the avant-garde groups Lettriste Internationale and the International Movement for an Imaginist Bauhaus forged an alliance called the Internationale Situationiste (IS). The IS condemned the deterioration of culture brought about by the pernicious effects of corporate capitalism—especially its role in turning people into passive consumers of media-created spectacle—and formed the highly theoretical movement of Situationism to counteract it. Extracting elements from Dada and Surrealism, the theater of Bertolt Brecht, and the writings of Comte de Lautréamont, Situationists invented new kinds of art works and performance intended to critique, disrupt, and change conventional Western bourgeois society. The IS developed notions of psychogeography and unitary town planning, emphasizing the effects of environment on the emotions and behavior of individuals. Their concept of the *dérive* (drifting), a "transient passage" through territory ordinarily untraversed, was related to Surrealist excursions through Paris and unearthing the uncanny in chance encounters, while their technique of *détournement* consisted in the alteration of pre-existing aesthetic material, often based on refiguring the relationship between image and text (for example, in comics or film).

Situationists in the 1960s turned increasingly to political organizing and theoretical writing: Guy Debord, an IS leader, codified Situationist cultural and political theory in his 1967 book *Society of the Spectacle*. In May 1968, during the student uprisings in Paris, Situationist ideas proliferated in the form of street posters, graffiti, and cartoons. Among the members of the IS are Michèle Bernstein, Nieuwenhuys Constant, Asger Jorn, Attila Kotányi, Giuseppe Pinot-Gallizio, the Spur Group, Raoul Vaneigem, and René-Donatien Viénet.

Suprematism (Russia, ca. 1914). Around 1914, after two years of painting in a Cubo-Futurist style, Russian artist Kazimir Malevich began to work in an abstract style, which he called Suprematism. For Malevich, the guiding principle of Suprematism was "the supremacy of pure sensation in creative art," best represented by the square, which he considered the most elementary, basic, and thus supreme formal element; but he increasingly combined the square with the circle, other geometric shapes, and even curved lines. He began by limiting himself in his Suprematist paintings to black, white, gray, and red, but he expanded his palette as his compositions became more complex. Malevich, like other artists of his time, believed that the external world could no longer serve as the basis for art, which had, instead, to explore pure non-objective abstraction in the search for visual analogues to experience, both conscious and unconscious. As he wrote in 1915, "Nothing is real except sensation . . . the sensation of non-objectivity." He first showed his Suprematist works at 0.10: The Last Futurist Exhibition in St. Petersburg in December 1915. The exhibition, which included a broad sampling of then-current tendencies in Russian avant-garde painting, has become famous for inaugurating the two directions that would largely govern artistic production in Russia (including architecture, graphic design, theater, and the decorative arts) for the next seven years: Suprematism, and the closely related (although more socially oriented) movement Constructivism. Other artists affiliated with Suprematism include Ilya Chashnik, Ivan Kliun, El Lissitzky, Liubov Popova, Ivan Puni, Aleksandr Rodchenko, Olga Rozanova, Nikolai Suetin, and Nadezhda Udaltsova.

Surrealism (primarily France, ca. 1924). Surrealism, which had many international manifestations and which began as a literary movement before developing into an artistic one, was pioneered in France under the leadership of André Breton in the 1920s. Breton's circle of poets and artists was deeply influenced by Comte de Lautréamont's vision of unexpected poetic combinations of objects. In their visual and written work the Surrealists explored Sigmund Freud's notions of the dream-work and the uncanny, stressing the relationship of the unconscious to lived reality and using techniques of psychic automatism as a way of tapping into the unconscious and detaching themselves from habitual thought

processes. They were inspired by the poetry of Stéphane Mallarmé and Arthur Rimbaud, the writing of Guillaume Apollinaire (from whom the notion of surreality derived), Symbolism, Giorgio de Chirico's metaphysical painting, and then-current notions of ethnography. Advocating an art of pure imagination, Surrealists deployed the imagery of hysteria, "primitive" art, hallucinatory experiences, and phenomena associated with the radically "other" to effect a revolution in everyday consciousness based on a critique of rationalist thought. This critique, also posed by Georges Bataille and the dissident Surrealists, took the form of disturbing images and juxtapositions to disrupt stable, conventional notions of form. Through the influence of Joan Miró's paintings and Jean Arp's sculptures and reliefs, the abstract realm of biomorphic forms also became a primary element in much Surrealist work. Artists affiliated with Surrealism include Hans Bellmer, Salvador Dalí, Max Ernst, Alberto Giacometti, Frida Kahlo, Paul Klee, Wifredo Lam, Dora Maar, René Magritte, Man Ray, André Masson, Matta, Meret Oppenheim, Pablo Picasso, Yves Tanguy, and Dorothea Tanning, among others.

Symbolism (Europe, 1880s). Symbolism originated as a literary movement. Its beginnings are often ascribed to the publication of Charles Baudelaire's poems Les Fleurs du Mal (Flowers of evil) in France in 1857. As suggested by Baudelaire's title, Symbolism explored the darker, more introspective aspect of human emotions through mythical or religious themes and reveled in dreamlike or allusive imagery. Subsequent theoretical developments in the nascent field of psychology fed the movement's obsession with erotic, turbulent, or suffocating content and heightened its fixation on the femme fatale, an iconic fin-de-siècle image of the "destructive" woman, which many artists took as their subject. Among those credited for influencing the Symbolist idiom are the French painters Gustave Moreau and Pierre Puvis de Chavannes, both recognized for their intentionally ambiguous yet evocative images. While these artists' styles differ, each was reacting to Naturalism and the concomitant beliefs in positivism and materialism, pursuing instead what art historian Robert Goldwater has called a "philosophical idealism." They in turn inspired a younger generation of artists to make work that was more spiritual and mysterious, and which is usually characterized by flattened forms, nonrepresentational color, and undulating lines. While Symbolism is most often associated with French writers and artists, the movement had a widespread reach, eventually encompassing figures from Belgium to Poland, and included artists such as Jean Delville, Ferdinand Hodler, Fernand Khnopff, Lucien Lévy-Dhurmer, and Carlos Schwabe, and impacted to varying degrees the careers of artists as diverse as Paul Gauquin, Gustav Klimt, Edvard Munch, Odilon Redon, Auguste Rodin, and Giovanni Segantini.

Photographic Credits and Copyright Notices

The reproductions in this book are based on photographs by David Heald and Ellen Labenski, with the following exceptions: p. 21: courtesy Sean Kelly Gallery, NY; p. 39: courtesy the artist; p. 86: Ken Schles; p. 87: James Franklin; p. 97 (top left and bottom): courtesy David Zwirner Gallery, NY; p. 97 (top right): courtesy the artist; p. 103 (bottom): courtesy Galerie Hauser & Wirth, Zurich; p. 121: Dan Dennehy, courtesy the artist; p. 126: courtesy The Museum of Modern Art/Film Stills Archive; p. 133: courtesy Sean Kelly Gallery, NY; p. 143 (top): courtesy the artist; p. 143 (bottom): courtesy Matthew Marks Gallery, NY; p. 146: courtesy the artist; p. 148: courtesy Kunsthaus Zürich; p. 149: Estate of Robert Smithson, courtesy James Cohan Gallery, NY; p. 197: Giorgio Colombo; p. 216: Cathy Carver; p. 249 (top and bottom left): Giorgio Colombo; p. 260: Erika Barahona; p. 275: Attilio Maranzano; pp. 284–85: courtesy the National Gallery of Art, Washington, D.C.; p. 302: courtesy Barbara Gladstone Gallery, NY; pp. 320–21: Estate of Robert Smithson, courtesy James Cohan Gallery, NY; p. 325: David Lubarsky; p. 337 (top left): courtesy the artist; p. 337 (top right and bottom) and p. 346 (left): Giorgio Colombo; p. 346 (right): courtesy the artist.

Following is a partial listing of copyright notices for works of art reproduced in this book.

© 2001 Artists Rights Society (ARS), NY/ADAGP, Paris:

Jean Arp: Pierre Bonnard: Constantin Brancusi; Georges Braque: Marc Chagall; Jean Dubuffet: Marcel Duchamp: Alberto Giacometti; Natalia Goncharova: Vasily Kandinsky: Yves Klein: František Kupka: Fernand Léger: László Moholy-Nagy: Francis Picabia: Gino Severini; Antoni Tàpies.

© 2001 Artists Rights Society (ARS), NY/VG Bild-Kunst, Bonn: Max Beckmann; Joseph Beuys; Paul Klee; El Lissitzky; Kurt Schwitters.

Licensed by VAGA, NY, NY:

- © Carl Andre; © Louise Bourgeois; © The Joseph and Robert Cornell Memorial Foundation;
- © Estate of Hans Hofmann; © Donald Judd Estate; Robert Motherwell © Dedalus Foundation;
- © Robert Rauschenberg; © David Salle; © Estate of David Smith; © Estate of Robert Smithson.
- © 2001 The Josef and Anni Albers Foundation/Artists Rights Society (ARS), NY; © 2001 Estate of Alexander Archipenko/Artists Rights Society (ARS), NY; © 2001 Estate of Francis Bacon/Artists Rights Society (ARS), NY; © 2001 Estate of Alexander Calder/Artists Rights Society (ARS), NY; © 2001 John Chamberlain/Artists Rights Society (ARS), NY; © 2001 Willem de Kooning Revocable Trust/Artists Rights Society (ARS), NY; Robert Delaunay © 2001 L & M Services B.V. Amsterdam; © 2001 Estate of Dan Flavin/Artists Rights Society (ARS), NY; © 2001 Estate of Franz Kline/Artists Rights Society (ARS), NY: Oskar Kokoschka © 2001 Artists Rights Society (ARS), NY/Pro Litteris, Zurich; © 2001 Joseph Kosuth/Artists Rights Society (ARS), NY; © 2001 Sol LeWitt/Artists Rights Society (ARS), NY; © 2001 Estate of Roy Lichtenstein (for Grrrrrrrrrr!! © 2001 The Solomon R. Guggenheim Foundation); © 2001 Richard Long; © 2001 Robert Mangold/Artists Rights Society (ARS), NY; © The Estate of Robert Mapplethorpe; © 2001 Brice Marden/Artists Rights Society (ARS), NY; Henri Matisse © 2001 Succession H. Matisse/Artists Rights Society (ARS), NY; Piet Mondrian © 2001 Artists Rights Society (ARS), NY/Beeldrecht, Amsterdam; © 2001 Robert Morris/Artists Rights Society (ARS), NY; © 2001 Bruce Nauman/Artists Rights Society (ARS), NY; © 2001 Estate of Louise Nevelson/Artists Rights Society (ARS), NY; Pablo Picasso © 2001 Estate of Pablo Picasso/Artists Rights Society (ARS), NY; Jackson Pollock © 2001 Pollock-Krasner Foundation/Artists Rights Society (ARS), NY; © 2001 Estate of Ad Reinhardt/Artists Rights Society (ARS), NY; Mark Rothko © 2001 Kate Rothko Prizel and Christopher Rothko/Artists Rights Society (ARS), NY; © 2001 Robert Ryman; © 2001 Richard Serra/Artists Rights Society (ARS), NY; © 2001 Frank Stella/Artists Rights Society (ARS), NY; © 2001 James Turrell; © 2001 Andy Warhol Foundation for the Visual Arts/Artists Rights Society (ARS), NY; © 2001 Lawrence Weiner/Artists Rights Society (ARS), NY.

The Solomon R. Guggenheim Foundation

Honorary Trustees in Perpetuity

Solomon R. Guggenheim Justin K. Thannhauser Peggy Guggenheim

Honorary Chairman

Peter Lawson-Johnston

Chairman

Peter B. Lewis

Vice-Presidents

Wendy L-J. McNeil John S. Wadsworth, Jr.

Vice-President and Treasurer

Stephen C. Swid

Director

Thomas Krens

Secretary

Edward F. Rover

Honorary Trustee

Claude Pompidou

Trustees Ex Officio

Dakis Joannou Benjamin B. Rauch

Director Emeritus

Thomas M. Messer

Trustees

Giovanni Agnelli Jon Imanol Azua Peter M. Brant Mary Sharp Cronson Gail May Engelberg Daniel Filipacchi Martin D. Gruss Barbara Jonas David H. Koch Thomas Krens

Peter Lawson-Johnston Peter Lawson-Johnston II

Samuel J. LeFrak

Peter B. Lewis Howard W. Lutnick Wendy L-J. McNeil Edward H. Meyer Frederick W. Reid Richard A. Rifkind Denise Saul Terry Semel James B. Sherwood Raja W. Sidawi Seymour Slive Stephen C. Swid John S. Wadsworth, Jr. Cornel West John Wilmerding William T. Ylvisaker

The International Director's Council

The International Director's Council is the Guggenheim Museum's primary acquisition committee devoted to augmenting and strengthening the contemporary collection in all mediums. Founded in 1995, the council is comprised of art collectors from around the world who share a commitment to the museum's mission, which involves acquiring and preserving a collection that reflects the most important aesthetic achievements of 20th and 21st-century visual culture. Their acquisitions have ranged from painting and sculpture to photography and video installations, many of which are featured in this guide. The International Director's Council has a two-tiered membership: a general level and an Executive Committee, which votes on proposed acquisitions. The credit lines for works purchased by the International Director's Council include the names of the Executive Committee members who were serving on the council at the time of acquisition. Due to space limitations in this publication, which utilizes brevity in order to include as much information as possible, the individual names were omitted. They are listed here along with the years each member has served on the Executive Committee.

Dakis Joannou (President, 1995–present) Elaine Terner Cooper (Vice-President, 1995–present)

Executive Committee

Ann Ames (1999–present) Edythe Broad (1998–present) Eli Broad (1995–1998)

Henry Buhl (1999-2000)

Beat Curti (1996)

Dimitris Daskalopoulos (2000-present)

Harry David (2000-present)

Gail May Engelberg (2000-present)

Linda Fischbach (1997-present)

Ronnie Heyman (1995-present)

J. Tomilson Hill (1997-1998)

Cindy Johnson (1998-1999)

Barbara Lane (1997-present)

Linda Macklowe (1998-present)

Brian McIver (1998)

Robert Mnuchin (1995-1996)

Peter Norton (1995-present)

Willem Peppler (1998-present)

Alain Perrin (1998)

Tonino Perna (2000-present)

Denise Rich (1999-present)

Inge Rodenstock (1995–1996)

Rachel Rudin (1998)

Simonetta Seragnoli (1999-present)

David Teiger (1998-present)

Thomas Walther (1997)

Ginny Williams (1996-present)

Elliot Wolk (1998-present)

General Membership

(as of December 2000)

Diane Ackerman

Tiqui Atencio

Karen Berger

Giulia Borghese

Celeste W. Cheathan

Babs Cohen

Gerard Cohen

Beat Curti

Anna Dell'Orto

Janice Diamond

Milton H. Dresner

Beatrice Habermann

Fern K. Hurst

Cindy Johnson

Janet Karatz

Miryam Knutson

Robert Knutson

Rachel Lehmann

Phyllis Mack

Sondra Mack

Caraill MacMillan

Donna MacMillan

Brian McIver

Dara Perlbinder

George Ross

Rachel Rudin

Keith Sacks

Carolyn Wade

Alicia Winegardner

Honorary Members

Ulla Dreyfus-Best

Frank Gehry

Gheri Sackler

Contributors

Bridget Alsdorf is Collections Curatorial Assistant at the Guggenheim Museum.

Jan Avgikos is an art critic and art historian who lives in New York City.

Jennifer Blessing is an art historian and independent curator who lives in New York City.

Matthew Drutt is Associate Curator for Research at the Guggenheim Museum.

Cornelia Lauf is an art historian and independent curator who lives in Rome.

J. Fiona Ragheb is Associate Curator at the Guggenheim Museum.

Nancy Spector is Curator of Contemporary Art at the Guggenheim Museum.

Joan Young is Assistant Curator at the Guggenheim Museum.

Dore Ashton is Professor of Art History at the Cooper Union in New York.

Julie Ault is an artist who independently and collaboratively organizes exhibitions and multi-form projects.

Germano Celant is Senior Curator of Contemporary Art at the Guggenheim Museum.

Lisa Dennison is Deputy Director and Chief Curator at the Guggenheim Museum.

Judi Freeman is an independent curator living in Boston.

Gary Garrels is Chief Curator, Department of Drawings, and Curator, Department of Painting and Sculpture, at The Museum of Modern Art, New York.

Michael Govan is Director of the Dia Center for the Arts, New York City.

Linda Dalrymple Henderson is David Bruton, Jr. Centennial Professor in Art History and Distinguished Professor at the University of Texas at Austin.

Jon Ippolito is Assistant Curator for Film and Media Arts at the Guggenheim Museum.

Liz Kotz teaches in the Department of Cultural Studies and Comparative Literature at the University of Minnesota in Twin Cities.

Rosalind Krauss is Meyer Schapiro Professor of Modern Art and Theory at Columbia University in New York.

Rose-Carol Washton Long is Professor of 19th- and 20th-Century European Art at The Graduate School, The City University of New York.

John Miller is an artist and writer who lives in New York City.

Bruce Books Pfeiffer is Director of the Frank Lloyd Wright Archives.

Joseph Thompson is Director of the Massachusetts Museum of Contemporary Art, North Adams.

Coosje van Bruggen is an artist and writer who lives in New York City.

Diane Waldman is an independent curator and writer who lives in New York City.